False Flat
Why Dutch Design Is So Good

Aaron Betsky
with Adam Eeuwens

HAPPY CHAOS

Optimists view the constant flux of The Netherlands's burgeoning multicultural society as a fertile ground for continuous creative development, conceiving a world in which the pursuit of culture is accepted as a viable economic engine.

BRILLIANT ORANGE

Finding freedom in limited space is a skill the Dutch learn early on. For some designers, the constraints of this densely populated and highly regulated country are the inspiration and foundation of their creative activity.

DO NORMAL

"Normalism" is a term that could be used to characterize the particular strand of modernism one encounters in The Netherlands: no matter what modern innovation brings, it must make itself relevant in the arena of popular culture and fit the mold of everyday life.

CHICKEN & EGG

Is it possible to envision a contemporary "Dutch Master"? Or does today's genius rest not in a single person but rather in collaborative networks and the schools of thought they spawn?

DOORS OF PERCEPTION

The Netherlands is a "lab(oratory)-land," a country with the wealth and social agenda to appropriate knowledge and inventions from around the world, and experiment freely with their implications. It is a country that has the luxury to focus on process, rather than on end product.

WE ARE THE WORLD

In a shrinking world of internationalized mass media channels, Dutch design transcends national boundaries and success-fully incorporates universal influences to posit a model and attitude in which all voices can be heard.

4

Surfing the False Flat

Introduction I work in the center of the Dutch city of Rotterdam. From my office, I look out over the city's cultural core, where museums, hospitals, and schools help create an eminently civilized society. In the distance I see the cranes and refinery stacks of the harbor that feeds these efforts. Around me I see fragments of great architecture: hotels, housing blocks, and museums in which design articulates function, setting, and construction so that we can understand what these buildings are, how they came into being, and what their relationship with the rest of the environment is. My job, as director of the <u>Netherlands Architecture Institute</u> (NAi), is to oversee an entity that collects, researches, exhibits, and discusses the heritage of and current experimentation in Dutch architecture. My office is located in a building designed by state architect <u>Jo Coenen</u>, completed in 1988, which inhabits the middle of this cultural center. As I sit in my modern glass aerie, I survey a scene that teaches us how we can make a good society by design. The Dutch call it the "polder model." It is a political phrase, but also a real one. The institute sits in a polder, or a piece of land reclaimed by humans. It would be riding the waves if human ingenuity did not keep sea and river at bay.

I live in a house on the eastern edge of Rotterdam. It also sits in a polder. When it is not raining too hard, I bike to work. As I set out into what seems to be a flat landscape of housing developments, small industrial areas, and an occasional park, I often lose my breath. I struggle past the office blocks interspersed with houses, counting each building as I slowly make my way to the center of town. At night, after a day organizing events about Dutch architecture, it's usually the reverse; I zoom home in an effortless glide. Two facts of nature conspire to make my trip easier at night: the wind in The Netherlands, though changeable, usually comes from the west, and, more important, my house sits in a polder eighteen feet below sea level. My office, which itself is "only" a few feet below sea level, is also separated from my house by three major dikes, which once divided land from water and would do so again in an emergency. ⁶ To get to work, I have to struggle against the wind, uphill, and over the barriers humans have made to keep nature in its place.

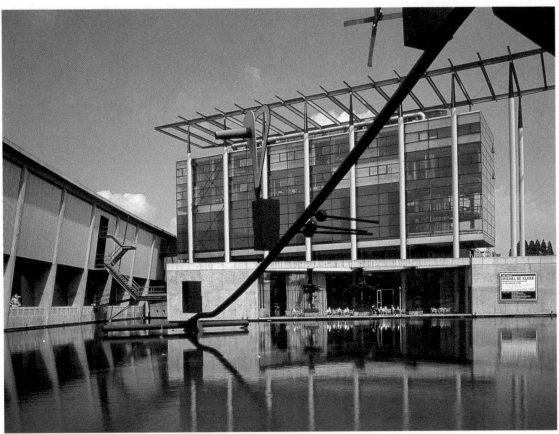

Netherlands Architecture Institute, Rotterdam, by Jo Coenen, 1988
Signage for the Netherlands Architecture Institute, by Dietwee, 2003

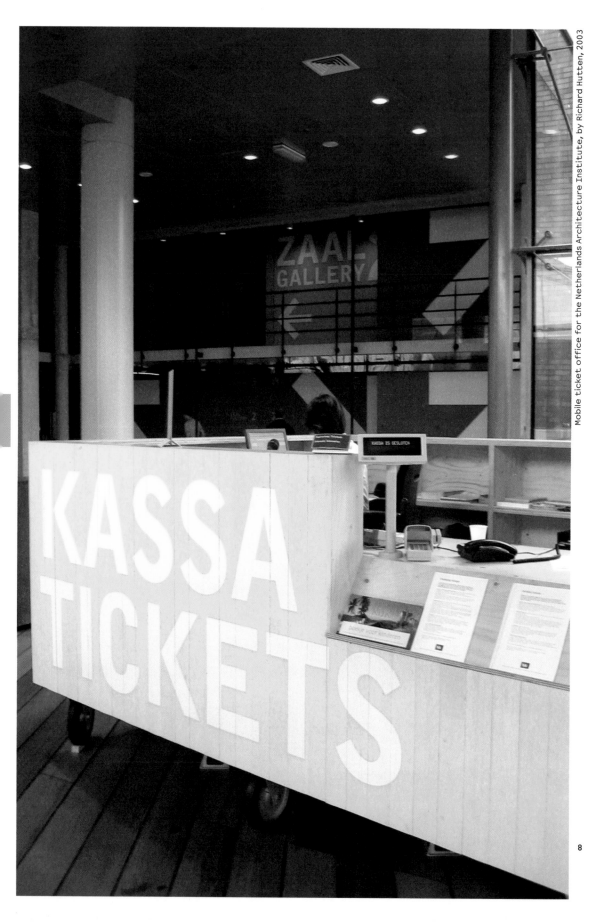

Everything you always wanted to know

Were it not for the dikes and a series of unseen water pumps working away day and night, my house would also disappear beneath the combined waters of the North Sea and the Rhine. I live in the delta of Europe's great watery aorta, but that artery is also out of sight. Around my house, picturesque ponds and a grid of small canals remind me of the system of drainage that has made this place safe for human occupation for the last few centuries. A small gray box with a red light next to the house is evidence of the technology that makes our landscape look so serene. It contains an emergency switch for the pumps. Once a week, men in uniform come to check it, and there are strict instructions on what to do should the light ever go on.

This area was once a swamp. Slowly, starting in the early Middle Ages, human occupation and changes in the climate dried it out. People built dikes around the marshes, pumped out the water, and farmed the resulting lush, green meadows. Then, in the fourteenth century, nature had its revenge. A series of disastrous floods inundated large portions of the new land. The Dutch struck back, building higher dikes and perfecting their techniques for reclaiming land. They also built towns around the locks and dams they used in that effort, such as the dam on the small Rotte river. The towns did not take the form of small roads fanning out from castles or market squares, nor did they build up from the broad rivers. Rather, they replicated the grid of irrigation ditches and meadows on which they sat. The towns' most remark-able features were dams, locks, and quays, making the mana-gement of water an excuse for urban activity. Cities such as Rotterdam used their position near one of the larger branches of the Rhine to lay claim to the trade coming down the river and going out into the hinterlands.

Detail of a 250-guilder banknote, by Ootje Oxenaar and J. J. Kruit, 1985

The Netherlands became a self-invented country. First, it created itself physically, fighting back the sea and the rivers to make land. Then, it built itself politically. Fighting the sea demanded an organization that led to the founding of *heemraadschappen*, groups of farmers united to regulate the process of keeping the water at bay. These groupings provided a political and social alternative to the hierarchical fiefdoms that governed most of Europe at the time. Every inch of land was used productively and governed more and more cooperatively. There were few estates, and little unused land. The country prospered.

The wealth this intensive agriculture produced soon flowed into larger and larger cities. By the sixteenth century, The Netherlands was the most urbanized part of Europe. In Amsterdam, Delft, Gouda, Rotterdam, Haarlem, and the other cities of Holland (the historic core of the country), the money was used to finance increasingly ambitious trading companies that in turn produced fantastic returns, making the towns rich and powerful. Here the artifice of craft converted the products not only of the immediate hinterland but also of the Baltics, Eastern Europe, and, later, Africa and the Indies into finished goods. Art that proudly and meticulously displayed the resulting bounty of goblets, plates, fruit, tapestries, maps, and furniture fixed the image of The Netherlands as a country in which human beings could make a complete and controlled universe.

Yet it was not entirely autonomous. Through a series of dynastic marriages, The Netherlands was ruled by the Hapsburgs in far-away Spain, even though its strongest trading ties were with England, Italy, and the cities of the Hanseatic League. By the sixteenth century, the Dutch had developed a distinct political, economic, and aesthetic culture and felt constrained by their foreign masters. Finally, during the Eighty Years' War that broke out in the middle of the sixteenth century, the Dutch freed themselves from their Spanish overlords. In doing so, they became the first republic in Europe. A complicated political structure emerged in which rural and urban interests competed with city holders who, though elected by the cities and provinces, took the role of national leaders. This loosely organized structure provided the foundation for an accumulation of wealth, power, and culture that the Dutch later came to see as their golden age.

Still, not everything could be known and controlled. Before I set out in the morning, I go up to my study on the second floor to look at the sky. The Dutch were fond of painting this ever-changing vista. In Vermeer's famous *View of Delft*, the complex array of blues, grays, and whites that races over the carefully gridded landscape below takes up almost two-thirds of the canvas. The wind always blows here, producing a sky that reminds the Dutch of the unpredictability of nature, and of the larger forces against which they must struggle.

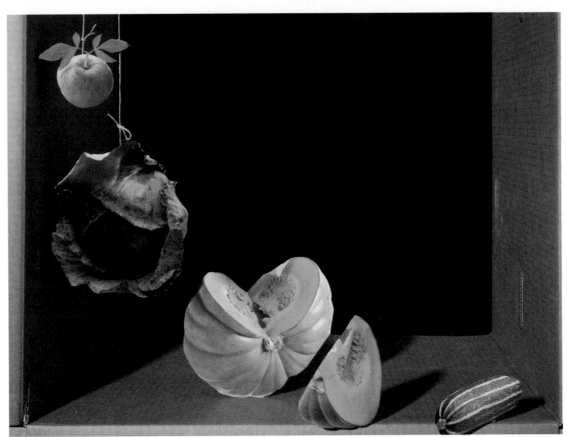

Still Life, a collage of elements from traditional Dutch painting, by Maurice Scheltens, 2003
Detail of View of Delft, by Johannes Vermeer, c. 1660

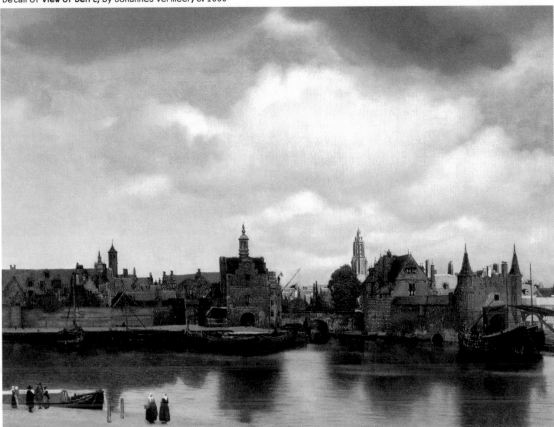

Delfts Blue Bowl, by Hella Jongerius, 2001

Nature, both internal and external, has always caused the Dutch to feel ambivalent. The land around them they can control, but the sky and the water remain indomitable. The Dutch are a fairly homogeneous people sharing a well-defined culture, but the country's role as a trading hub has always exposed it to a plethora of outside influences. During the seventeenth century, the Dutch engaged in debates to decide not just whether one could speak directly to God, as did the Protestants and Catholics; they wanted to know if one was predestined to be saved or damned at birth, or if all one's hard work could create a perfect soul (as well as a perfected landscape). The ultimate question at stake in this discussion was whether the unknown could be controlled or whether fate prevailed. In the end, the Dutch found themselves overwhelmed by much larger forces, divine or not. They lived at the end of a river and had to accept the currents and winds that flowed over the land from elsewhere. In fighting those currents they both gained and lost much of their power and wealth.

When I decide the skies are friendly enough and bike to work, I first follow the straight road that used to connect Rotterdam to the central bishopric of Utrecht via the market town of Gouda. In many ways, The Netherlands is a country marked by linear development along dikes, roads, and now highways, connecting points where first water and now traffic is controlled. In this tapestry, the dikes and the houses perched on the banks make up the weft, the strings of irrigation ditches separating the meadows the woof, and the dams and sluices the knots. The particular highway I turn onto does not run along a dike, but it is slightly raised. A line of train tracks and another highway run parallel to it, just beyond the shopping mall and the row of office buildings that form the modern equivalent of a dike, screening all movement in the surrounding residential neighborhoods.

Facade of the Alexandrium shopping mall, Rotterdam, by VVKH Architecten, 1996

As I turn west toward Rotterdam's downtown, I ride through the middle of a suburban extension of the city that started to take shape in the 1960s. Though the housing developments I pass betray the styles and preoccupations of their times— large apartment blocks for the older areas, complex geometric quasi villages from the late 1970s and early 1980s, and abstract, fragmentary geometries turning into small building blocks in the 1990s—as I bike along them, I sense a certain rhythm. These blocks, rows, and little towers, and their surrounding parking lots or parks, all have a familiar measure. It is the order of meadows interspersed with drainage canals running perpendicular to the main road that is the dominant tone of most of the Dutch landscape. When the city of Rotterdam expropriated these meadows starting in the late 1960s, they used the existing landscape structure as the base for the new housing estates.

In some places, if I look to my left, down toward the Rhine, I can still see the remnants of small canals or branches of the river, older trees, and houses signaling their age running along the backyards of apartment buildings. These remaining fragments of a network of waterways are now where the rich people live. Their idiosyncratic adjustments to a history of ownership, the height of the dike, and the more mature vegetation give the houses some cachet.

Within the grid, the houses are often abstractions and elong- ations of the familiar rural building type: brick wall, tile roof. The brick is made of clay dug from the banks of the Rhine: when the river floods every spring, it leaves deposits of loam leached from as far away as the Alps. Even if the buildings are modern in appearance, their form and material give them a distinct local flavor that distinguishes them from the housing developments in other parts of Europe or the United States.

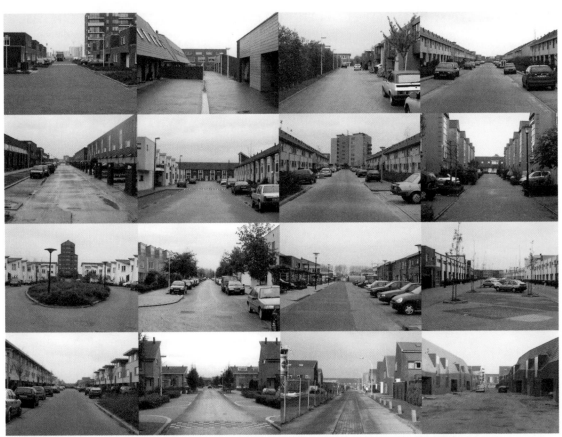

Contributions to the exhibition **Viva Vinex** in Almere, charting the developments of new residential neighborhoods in The Netherlands, by Schie 2.0, 2000

The housing's hidden structure is as much a technological marvel as the invisible pumps that keep the area dry. After the Second World War, the Dutch had to build quickly and cheaply to repair the devastation wrought by German and Allied bombing. They adopted and adapted French and English building systems matching concrete frames with standardized facades. The frames went up on site, while facades, complete with windows, doors, and lintels, were delivered to the construction areas in one piece. Cooperative building companies such as De Nieuwe Unie, which built the houses in my part of Rotterdam, mirrored the cooperatives farmers formed in the Middle Ages to dredge the marshes and protect the resulting meadows.

My neighborhood is not as simple as its planners had imagined. A high-speed tram now sweeps by the park near my house; it is dammed in by a broad traffic artery and rows of higher apartment buildings. At the tram stops, shops, offices, and stores appear, like miniature versions of the towns that grew up along the dams. Where the Metro, as this hybrid of subway and high-speed tramline is called, crosses the main east-west highway, a large shopping mall, an office complex, and now even a thirty-two-story apartment building have appeared. It is a veritable "edge city," like anywhere else in the world. All the Dutch can do—and it is quite an accomplishment—is contain this growth by planning the various tall buildings and sprawling malls so they appear on top of each other, around the freeway and the train line, and within the grid the meadows once proscribed. It is not a beautiful sight, but it works. Go a few blocks past the mall, and it has disappeared behind a row of houses.

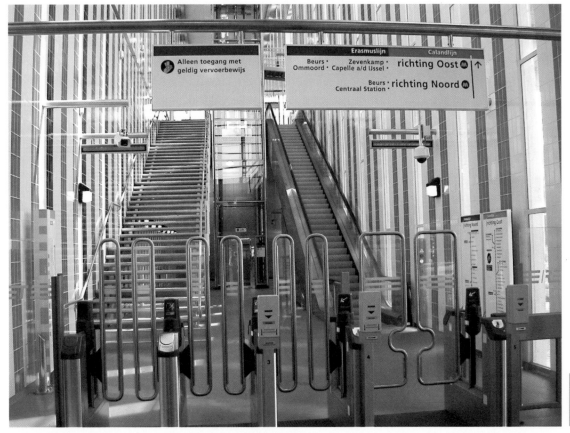

Signage for the Rotterdam Metro, by Bureau Mijksenaar, 1999–present

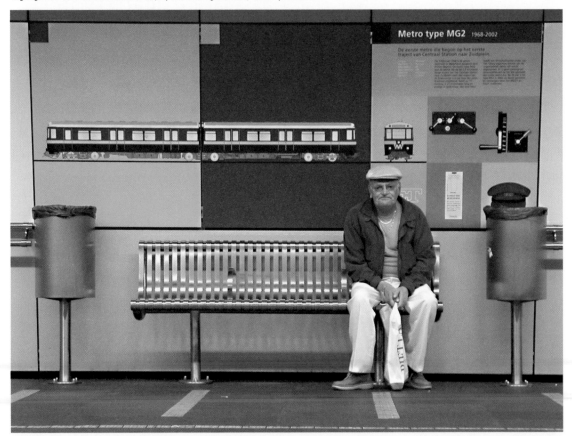

Once I pass underneath the highway a few kilometers to the west of my house, I am in the older part of the city. Housing gives way to a park. Ponds and stands of trees give refuge to a family of chickens, once no doubt part of a farm, now independent residents of the city's green preserve. They greet me every morning with a few lusty warning cackles. An occasional pheasant or heron mixes with the swans gliding on the ponds, increasing the sense that nature is present but tamed. Here I encounter another incline: after the Second World War, the city piled up the rubble from the bombings in the park. Over time, shrubs and then trees took root on the bricks and concrete remnants, creating a small hillock on the otherwise flat land. The horror of the war has been domesticated and used to create a slight natural variation. After cresting this hill, I do not come all the way down, for I am now very slowly moving up to the level of the city, built not just on higher ground but on centuries of garbage and other refuse of human settlement. I then sweep by a large lake.

This body of water did not exist a few centuries ago. It is the southernmost link in a chain of small lakes that are the result of a long tradition of peat digging. The practice became more intense in the nineteenth century, as peat was used to fuel the industrial-izing cities of The Netherlands. Hordes of poor tenant farmers who had seen their land depleted and subdivided by centuries of agriculture turned to digging up the very fields that had sustained the country. Vast stretches were given back to water so that the cities could stay warm. Flying over The Netherlands, one can still see the characteristic reversal of the familiar rhythm of irrigation ditches and meadows that resulted: rows of low embankments, used to reach the "peat fields," coursing through the middle of what became, after the peat had been dug out, lakes. Today, these lakes are the province of pleasure boats and second homes, or urban amenities, as with this one, Kralingen Lake. What was once part of a system of production has now become a place of recreation. Centuries of agriculture and trade have led to a country so prosperous it can indulge in leisure.

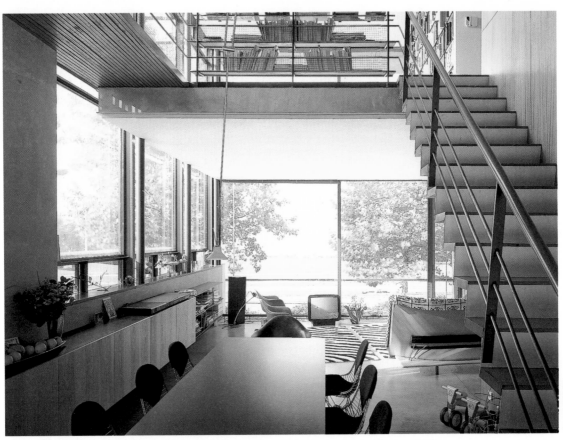

Interior and exterior of the Francine Houben House on Kralingen Lake, Rotterdam, by Mecanoo, 1991

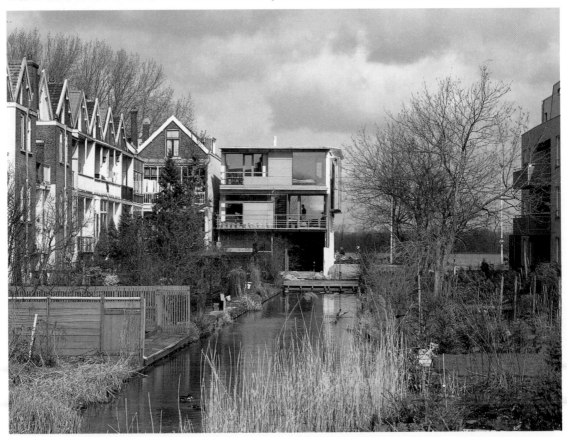

As it turns out, the biggest luxury in The Netherlands is <u>space</u>. Not only is most of the land in the country's core—the provinces of North and South Holland—man-made, but this is also one of the most densely populated countries in the world. So the Dutch are always trying to find more room. They have become masters at reusing the same space for myriad purposes and at putting disparate things next to each other. Next to Kralingen Park runs a highway; on the other side of the road, the main regional postal sorting facility is visible above the trees. The park itself, though, offers a precious commodity: empty space, a carefully designed version of the flat landscape made accessible to all. The peat diggers were a blessing in disguise, as they created great voids in the landscape that cannot be turned into more housing estates or office parks. They remain empty, mirroring that ever-changing sky and reminding the Dutch of something beyond their plans. So attractive is this model that the government of Groningen, in the north of the country, is planning to flood a vast stretch of meadows, not only to provide better water storage in an age of rising sea and groundwater levels, but also to create the central amenity for new recreation and residential expansion.

Yet as the Dutch government and developers try to give more citizens more space to call their own, such voids are endangered. The Dutch treasure what they call the "green heart": the area surrounded by the large cities of Rotterdam, The Hague, Haarlem, Amsterdam, and Utrecht, which is still predominantly rural. They have enshrined the myth of this pristine place in literature, painting, and government policy, decreeing it as empty territory that will buffer the cramped conditions of the city. They are even spending nearly two billion dollars to route the <u>high-speed train line</u> from Paris to Amsterdam under rather than through the green heart, so as not to disturb this bucolic idyll.

The reality is somewhat different. Within the green heart lie old cities like Delft, Leiden, and Gouda, as well as newer ones such as Zoetermeer and Alphen-aan-de-Rijn, all quickly growing with new housing developments. Springing up along the highways are small distribution centers and office parks that are part of the global network of trade and commerce. Yet something of the old landscape always manages to remain amid this seemingly chaotic jumble of new structures. You can leave the highway, zoom by one of the banal warehouses or office blocks, swing around a new housing estate, and suddenly find yourself on a narrow road on which cars have to edge by each other to avoid falling into the irrigation ditches or hitting the windmills that dot the heavily cultivated fields. Then you come around a bend and another town appears, its ring of brick row houses built in the last decade giving way to a historic market center founded in the early Middle Ages. The intensity and variety of ways in which the land is used are startling.

Photographs documenting the effects of the construction of the high-speed train line on the landscape, by Bas Princen, 2003

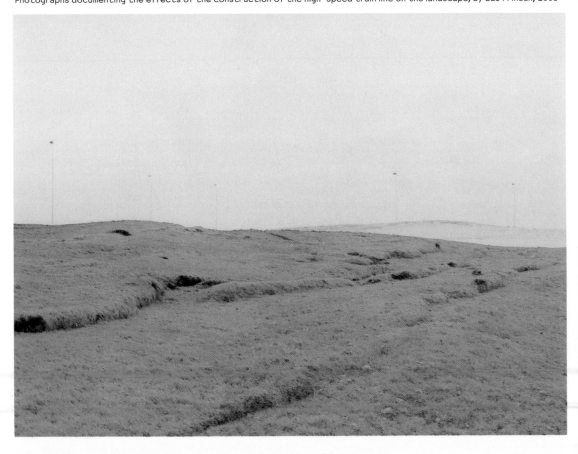

32nd INTERNATIONAL **FILM FESTIVAL** ROTTERDAM
22 JANUARI - 2 FEBRUARI 2003

www.filmfestivalrotterdam.com

Alternative emblem for the city of Rotterdam, by 75B, 2001

ROTTERDAM

In Rotterdam, though, everything is bigger and farther apart. Kralingen Park is an oasis, a playground for the wealthy who live along its western edge. It is the green heart in miniature: a serene space bounded by small canals, industry, dense housing projects and redolent with the history of damming and digging, poldering and peat winning, production and pleasure, bombing and planting. It is the great front yard of the city.

As I leave the lake behind, the home to the largest port in the world announces itself over the trees with a distant view of bridges, office towers, and the cranes loading and unloading container ships. Here the scale shifts from the semirural and semisuburban to a crowded urban scene. The bucolic interlude was just a momentary pause in the urban rythm. As I leave the park and ride up over one of the dikes that protects the city, I face the results of nineteenth-century industrialization. The houses here are three and four stories tall, the streets are narrow, and the patterns of both nature and human intervention seem to disappear.

As urban planner and historian Frits Palmboom points out, this particular part of Rotterdam, between the regular meadows where I live and the center of the city, still reflects the way the land was transformed by man. Around the dams and the bends of the river that converge here, the fields were not laid out in a regular grid but fanned out to make the most efficient use of the land. The patchwork nature of the first polders, before the more organized efforts of later centuries, is still evident in the street patterns developers laid out as they bought up polder after polder. There was little room for wasted space here, as every inch had to be rented out. Today, most of the families that once came to this neighborhood from the surrounding countryside in order to work in the city have long since moved on. Instead, I pass women in chardors taking their children to school. This neighborhood is now mostly home to immigrant families. Algerian, Moroccan, Turkish, and other predominantly Islamic communities occupy these rather grim rows of apartments. By the end of this decade, over half the population of Rotterdam will be *allochtoon*, from another place. A forest of satellite dishes pulls images of faraway lands into the cramped apartments of those forced to live in this urban structure so different from their homelands.

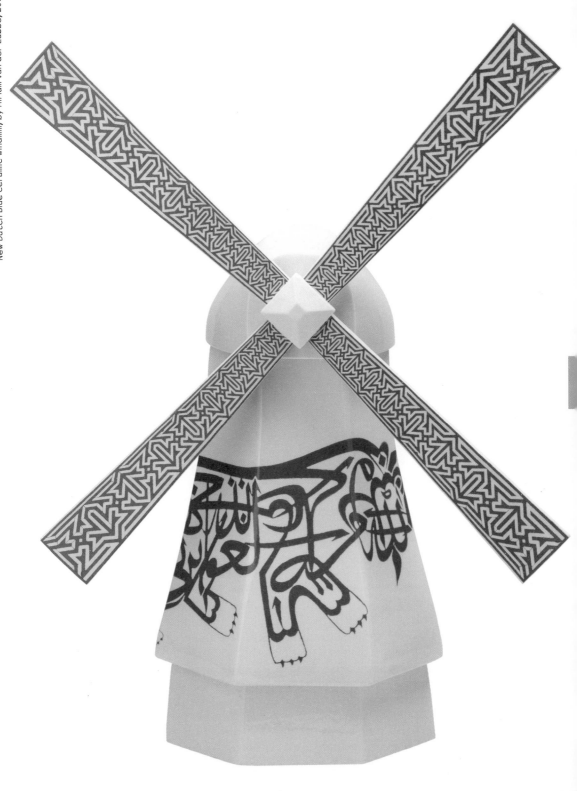

New Dutch Blue ceramic windmill, by Miriam van der Lubbe, 2003

The Netherlands has always been a place of refuge. As a seafaring nation, the terminus of the Rhine, and a country that invented itself, it was an attractive place for those who did not feel at home or could not feed themselves elsewhere. Huguenots, Jews, and Germans came early, and today refugees from all over the world are accommodated in carefully designed refugee centers before being integrated into the population at large. Not that the Dutch are an ideally tolerant people. Racism and prejudice are a reality and the non–native born are at the low end of the economic scale. Two years ago, a xenophobic populist politician received over a third of the votes in local elections, and, even after he was assassinated by an environmental extremist, his party still became the second largest in the country. The Dutch press and politicians worried loudly about whether there was still a real Netherlands that had shared "norms and values"—vague code words used by conservatives to denote proper "Dutch" ways of thinking and behaving. The party that said it wanted to resurrect such an abstract set of binding principles, the Christian Democrats, handily won the last two elections. The Dutch want to believe that they can accommodate all of these immigrants and their cultures within a carefully constructed order and that they can make them share the Dutch dream of a golden age. "Dirty foreigner," a Dutchman biking past said under his breath one day as I was strolling, speaking English, with a friend along Kralingen Lake.

The seeming uniformity of the Dutch social scene hides, like its not-quite-flat landscape, a lively variety of cultures. Even the most xenophobic Dutch enjoy the food, the slang, and the music the immigrants bring with them. Dutch society has always been open and exists as much as a refinement of other countries as it does as a self-contained entity. Its architecture, its language, and its styles are almost all derived from Germany, France, England, the Jewish diaspora, and, more recently, the United States. It is the ability of the Dutch to assimilate all these influences that makes the country cohere.

The ambivalence about what is Dutch and what is not has long been part of Dutch culture. Like the rivers and the sea, to many Dutch the rest of the world is something that deposits wealth and opens up new possibilities but is also threatening. Particularly in the nineteenth century, the Dutch worried about their identity. They invented the myth of a golden age, the period during and right after the Eighty Years' War lasting from 1568 to 1648, and set out to give it form. They rewrote history to show that the current borders of the state were a historical inevitability, though they turn out to have been a historic accident. The Dutch language, which is basically a dialect of German with a lot of French borrowings, was codified and cleaned up. Architectural theorists decided that there was a national style that married German neo-Gothic influences with certain agricultural traits and inventions that were "Dutch," such as the stepped gable. A distant branch of the family that had served as the elected "city holders" under the seventeenth-century republic was proclaimed a royal house at the Congress of Vienna in 1815, thus giving a divinely irreproachable veneer to what was an artificial leadership engineered by the European powers after the fall of Napoléon. While the notion of Dutchness was being invented, the southern part of the country revolted and became the independent (and Catholic) Kingdom of Belgium in 1830. The idea of a historic Netherlands received borders describing a national core almost completely defined by the Rhine delta, with the addition of an eastern hinterland and a northern appendage, Friesland. Monuments such as the National Museum (Rijksmuseum) were built in a style that was meant to reflect "ancient" traditions, though architect P. J. H. Cuypers adapted the brick elements to reflect his own Catholicism and the new scale of the big city. Finally, at the beginning of the twentieth century, architects such as A. A. Kok set about rebuilding Amsterdam's core to reflect their idea of what the city had looked like in the seventeenth century. Working without clear documentation, they invented whole sections of the "canal zone," creating the homogeneous and picturesque image now so popular with tourists.

Rotterdam escaped Amsterdam's fate of becoming an artificial version of what it may or may not have once been because its core had never been as large as Amsterdam's—it was a relatively small town until the Industrial Revolution. It was also not as rich, and could not support the kind of patrician homes the Amsterdam burghers built. Finally, Rotterdam prides itself on its no-nonsense business ethic and thus has never been afraid to tear anything down. If that was not enough to frustrate any marketing department looking for tourist dollars, the central business district disappeared at the beginning of the Second World War, when the Germans carpet-bombed the city, destroying most of the center in a few hours. The Dutch got the message and capitulated; the Allies later bombed what was left. Eighty percent of what had been central Rotterdam was in ruins by the end of the war.

Tussen Twee Culturen (Between Two Cultures) stamps for the Dutch Post Office (PTT), by Irma Boom, 2001

UIT: HET LAND VAN HERKOMST
1935

[IK WEET ALLEEN ZEKER DAT WANNEER IK OOIT IN HUN LAND TERUGKOM, IK ANDERS, MET ONEINDIG MEER SYMPATIE EN AANDACHT, TEGENOVER HEN ZAL STAAN DAN IK VROEGER DEED.]

E. DU PERRON 2001

80 C

NEDERLAND

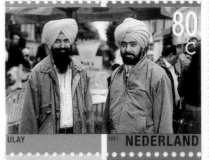

ULAY 2001

80 C

NEDERLAND

ALBERT CUYP MARKT
AMSTERDAM, 2000

UIT: APOLLIEN
1995

" ZIJ LIET MIJ AMSTERDAM ZIEN, EEN ZACHTE, OMNIVORE, DIERBARE, OVERHEERSENDE STAD. ZIJ LIEP TROTS MET MIJ ROND: DAT WAS IN EEN TIJD DAT WIJ EMIGRANTEN NOG ENIGE EXOTISCHE AANTREKKINGSKRACHT HADDEN. "

HAFID BOUAZZA 2001

80 C

NEDERLAND

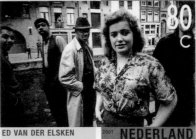

ED VAN DER ELSKEN 2001

80 C

NEDERLAND

GROENBURGWAL
AMSTERDAM, 1956

UIT: HET BELOOFDE LAND
1990

WIJ ZIJN VREEMDEN VOOR DE BLANKEN, VREEMDEN IN HUN KEUKEN, VREEMDEN IN HUN HUISKAMER, VREEMDEN IN HUN TUIN. ZE WETEN NIETS VAN ONS. MAAR ZIJ ZIJN GEEN VREEMDEN VOOR MIJ. IK WEET PRECIES HOE ZIJ DENKEN.

ADRIAAN VAN DIS 2001

80 C

NEDERLAND

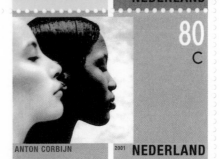

ANTON CORBIJN 2001

80 C

NEDERLAND

CHRISTY & NAOMI
DUBLIN, 1993

UIT: DE REIS VAN DE LEGE FLESSEN
1997

' WE WAREN INEENS UIT EEN CULTUUR WAARIN ALLES ACHTER GORDIJNEN GEBEURDE, IN EEN HALFNAAKTE SAMENLEVING GEVALLEN.

KADER ABDOLAH 2001

80 C

NEDERLAND

CÉLINE VAN BALEN 2001

80 C

NEDERLAND

FIGEN, ZAANDAM /
CHIMA, AMSTERDAM, 1998

UIT: VROUWVREEMD
['HORTEND BESTAAN'], 1994

[IK HEB AL MIJN ZOMERKLEREN BEWAARD, WANT THUIS KUN JE DIE HET HELE JAAR AAN. ALS IK TERUGGA HEB IK VOOR JAREN GENOEG. DE MODE IS HIER TOCH VOORUIT.)

ELLEN OMBRE 2001

80 C

NEDERLAND

CAS OORTHUYS 2001

80 C

NEDERLAND

JAKARTA
INDONESIË, 1947

8 714341 005366

AANVANG VERKOOP: 14 MAART 2001
ARTIKELNUMMER: 210361

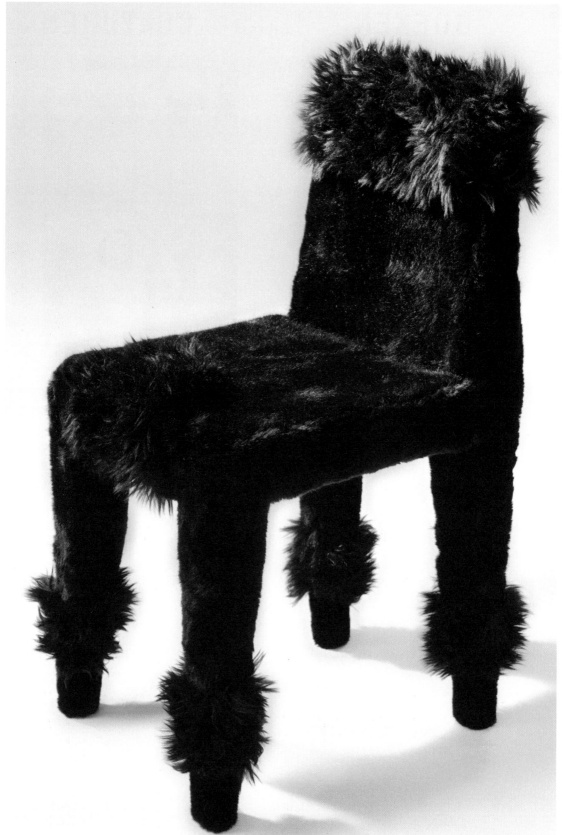

As I bicycle past the still-intact nineteenth-century neighborhoods, I rise up to the second line of dikes around the city, getting ever closer to my downtown destination. Here space opens up, the scale increases, and I feel as if I am in a modern environment. This is the area built after the Second World War. What is now a mixed neighborhood of residential structures, office buildings, and some facilities, such as schools and clinics, was once a compact neighborhood of homes sheltering below that dike. It was bombed by German forces in May 1940.

Rebuilding began during the war and took off after the city's liberation in May 1945. The rubble was cleared, and new streets were laid out that rationalized the existing web around the original dam. Many of the inner-city harbors were filled in, and roads were laid over new bridges and dikes. The myth of Rotterdam today is that, against the re-created golden age of Amsterdam, it offers a modern metropolis. It is supposed to be a rational and modernist environment dedicated to big business. (There is a joke that in Rotterdam you can only buy shirts with the sleeves already rolled up.) Modern architecture and planning reflect the glories of integrated economic, social, and aesthetic systematizing of all urban needs. Or so the story goes.

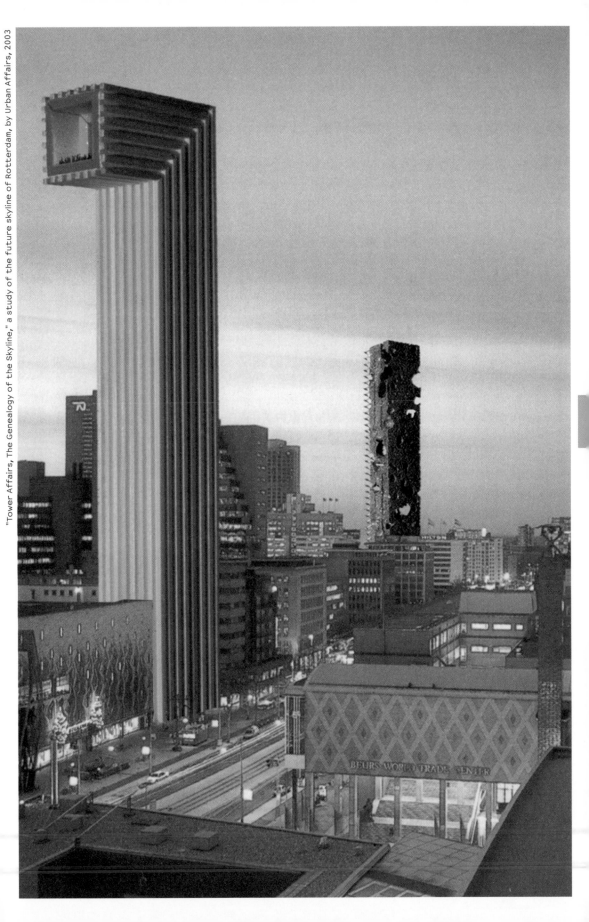

I bicycle into the heart of the rebuilding zone, coming from the northwest, curving through what is called the East Square and onto the strangely broad boulevard that leads from there to the market square at the edge of the downtown business district. Somehow, the world around me looks considerably more confusing than all the talk of rational, modern planning processes would have you think. The apartment blocks that sit back from the street with their strip of green to buffer them from the traffic sprout gabled roofs and decorative screens over their entrances. Stone lintels and elaborate brick patterns appear on geometric volumes. The main street, Groenendaal, can't seem to make up its mind whether it is a broad traffic artery or a more picturesque, landscaped avenue akin to the spaces that appeared in the nineteenth century where the city walls had once stood. Everywhere, tradition and modernity seem to slip past one another.

To a certain extent this is the result of the epic struggle in the Dutch architecture world that raged in the 1930s, 1940s, and 1950s. Dutch architects such as J. J. P. Oud, Gerrit Rietveld, Cornelis van Eesteren, the firms of Brinkman and Van der Vlugt and later Van Broek and Bakema, and, later on, Aldo van Eyck became famous for their stripped-down, heavily geometric housing projects and factories. They proclaimed the logic of mass production, rational design, and functional detailing. Yet they were opposed at every turn by the so-called Delft School. Headed by M. J. Granpré Molière, a tradition-minded professor at the Delft University of Technology, this school of architects called for the integration of picturesque planning principles, traditional building methods, and human-scaled ornament to help alleviate the standardized appearance of new buildings. As I bike along, I pass by a masterpiece of this movement, the Bank Mees, designed by A. J. Kropholler right before the Second World War. It is a brick block with a vaguely classical exterior and a moody interior full of shadow and heavy structural elements.

It is only a fragment of a scale, texture, and complexity in detailing that the traditionalists had hoped would bring back the idea of an organic cityscape. Rotterdam was a center for "the new building," as the modernist movement was called. Before the war, patrons such as C. H. van der Leeuw commissioned the Van Nelle Factory, which came closer than any other industrial building in Europe to expressing the excitement of the new economy. Designed by Brinkman and Van der Vlugt, it presented a place of production as a composition of glass and steel elements with canted ramps connecting the various parts of the complex. The modernist architecture office that succeeded the designers of that factory was called Van Broek and Bakema and was headquartered in Rotterdam. It laid out vast stretches of housing estates—including the first plans for my neighborhood. Van der Leeuw, the head of a group of progressive city leaders, took charge of the rebuilding efforts after the war, and the city proudly proclaimed its love of the new. As a new core they planned the Lijnbaan, a pedestrian district made up of a tartan weave of glass-fronted stores surmounted by offices and homes and interspersed with tall apartment slabs set in parks. Experts from all over the world came to admire this model of a rational and integrated shopping, business, and living core for a modern city.

Walking down the Lijnbaan, though, what you notice is the intimate scale, which is not unlike that of the traditional street patterns of Dutch towns. The apartment blocks sit in parks that have the scale of the small courtyards often left over from monasteries and other religious complexes. These spaces alleviate the density of such towns. The lack of monumental structures—beyond one department store designed by Marcel Breuer—is a reminder that, in The Netherlands, grand statements have never been of much use. Rotterdam may be all new, but it seems vaguely familiar.

This is not just because the modernists were sensitive to the past. It turns out that the traditionalists fought the modernists in every committee and every political meeting that decided the nature of postwar Rotterdam. This being The Netherlands, these debates were not violent and were solved not by one party or the other proclaiming victory but through the integration of features from both schools of design into the final plan. The system of small courtyards, the massing of volumes to create vistas and visual rhythms as well as efficient ground use, and the use of vernacular elements softened, but also confused, the clarity of planning based on pseudoscientific principles. None of the unified visions the modernist heroes from Germany and France dreamed of, none of the unified urban scenography the architect H. P. Berlage decreed for Amsterdam in the 1920s, found a place here, but neither did the city dissolve into a play of geometric lines, as happened to several cities replanned by Van Broek and Bakema.

One could say that Rotterdam is a mess as a result. There is no clear structure, no characteristic style, and lots of strange collisions of materials, forms, and traffic patterns. No grand axes, no coating of brick or three-dimensional composition of concrete lines suspended in space bring it all together, nor does some underlying system provide a hidden code to the city's plan or appearance. Not that this is necessarily a bad thing. The very confusion of principles produced a collage of urban moments that seems open to interpretation, use, and change. More important, there is a modernist vernacular here: a way of making things that grew up, one compromise at a time, starting right before the Second World War and gaining momentum during the rebuilding process. It is one of concrete frames, brick infill, prefabricated wood facade elements, expressed structure, and geometric patchwork plans. It is connected enough to traditional images and building materials to make sense but rational and open enough to allow for new modes of urban living to take root. This is not an extreme modernism but one that is reasonable and, at times, even cozy. To me, it seems very Dutch.

This is the landscape I travel between nineteenth-century neighborhoods and downtown. When I pass underneath the "stilt houses" designed by Piet Blom in 1978, things start to fall apart. Blom was an eccentric architect who believed that modern techniques of standardization should be used to revitalize older housing types. He went beyond both the formal compromises that became the mainstay of Dutch planning and what he felt was a dishonest and stultifying vernacular to offer radical solutions. The stilt complex is one of the few he managed to realize. It is a series of cubes placed on their vertices and mounted on columns, clustered into a "forest" that rises out of a concrete bridge arching over the road I bike down. Here the traditional gabled roof has been doubled, flipped, and turned into a perfect geometric emblem multiplying into a solid mass of construction. Below the eccentric cubic dwelling units, the bridge supports a labyrinth of what are supposed to be communal spaces. It was a noble experiment, and only in The Netherlands would the city government (not to mention the inhabitants) support such a project. The structure works as an icon, and as I come home at night a bar located under this concrete overpass is always full. As a whole, however, the forest of homes divorces itself radically from the city while separating the commercial core from the western radial neighborhoods.

After emerging from this forest, I find myself crossing through another extreme: a barren wasteland that a few times a week is occupied by a market. This is the Market Square Binne Rotte, designed a decade ago by the landscape firm West 8 on top of the submerged north-south railroad line. Sinking the railroad removed a barrier that crossed the urban core, but left a patch of land it is almost impossible to build upon because of the cost of spanning over the tracks below. The city decided to use part of the area to house the market, as this was near its traditional site, but the vast scale means that most of the time it is just a sweep of emptiness. The entrance to the railroad station below is made up of glass walls and an expressive, unremarkable steel canopy, and the surrounding buildings are a low-rise hodgepodge out of which one glass iceberg, housing small apartments for the wealthy, sticks out with melodramatic bravura. Most of the stores along the square's perimeters are empty. The whole area feels like a graveyard of good intentions.

In other words, not everything in The Netherlands works. The stilt houses and the unspeakably bland office blocks that line the long street after the square were constructed during the 1970s and 1980s, when the Dutch seemed to have lost their way. The most famous of these generic midrise mistakes were designed by Carel Weeber, a bombastic architect of gimmicky buildings (a housing block in the form of a paper clip, for instance) with garish tile patterns splashed across their faces; and by Wim Quist, a well-meaning and sometimes elegant modernist who managed to make restrained homes for cultural institutions but seemed to run out of ideas when he had to design for business. Quist's gray-white Maritime Museum of 1988 sits among the office buildings I pass. It is earnest but rather timid in this landscape of what look like plastic facades. It faces a green office building he also designed, which tries to behave itself among a collection of third-rate postmodern behemoths, even though it has few intrinsic qualities and no relation to its surroundings. I could be anywhere on my way to nowhere.

Market Square Binne Rotte, Rotterdam, by West 8, 1995
Residential building De Peperklip, Rotterdam, by Carel Weeber, 1982

The amazing thing is that the Dutch fought their way back. They managed to turn the tide on this flood of architectural mediocrity despite the fact that, after the devastations of the upheavals in education in 1968 and the financial crisis of the 1970s, they had few good schools of architecture and little financial incentive to make good buildings. They fought back because the public cared that their cities were being disfigured and because the discussion about the qualities of urban space was picked up by critics and their readers. Making a collective space had always been a central part of what the Dutch did, and they knew when something was going wrong. Finally, the government drafted a policy paper, accepted by Parliament in 1992, specifically calling for an upgrade in the quality of architecture. They brought in experts, gave them power to help decide on architects and designs, and commissioned good work for their own ministries. Slowly, Dutch architecture regained its footing.

One man played a central part in this process. Rem Koolhaas was originally a journalist and a filmmaker who went to study architecture in London. There he founded the Office for Metropolitan Architecture (OMA) with the conscious aim of recapturing the myth of modernism. To him, the core of that movement was the idea that the excitement of the modern, the new, and the ever-changing could and should be the very animating force of the city. The unknowable and uncontrollable forces through which economic and political powers shape our landscape could, he believed, be incorporated into the manipulation of function, technology, and materials to produce buildings that were intensified collages of urban fragments.

To build this new metropolis, Koolhaas moved his office to Rotterdam, occupying an anonymous office building right next to the bike path that runs through the central business district. Ironically, he did not build in this city for ten years, until his Kunsthal opened in 1992 along the sea dike a little farther west. Instead, he made his name through his writings and such large structures as Euralille, a mixed-use complex completed in 1990. His office became a clearinghouse for young architects, producing waves of daring and committed modernists. As I pedal past the mistakes of the 1980s, I pass by the building sites where two of them, Kees Christiaanse and Willem-Jan Neutelings, have planned major high-rises and lesser designers have recently completed serviceable structures inspired by the stripped-down, compositionally slipping and sliding mixed-use buildings Koolhaas and OMA made possible. Their work brings a sense of the articulation of modern forms with traditional material, such as brick, back to the Rotterdam scene. It does so, however, in a way that makes us aware of the nature of the compromises and the strangeness of a collage city by stretching, cantilevering, and otherwise playing with the basic building blocks out of which it is composed.

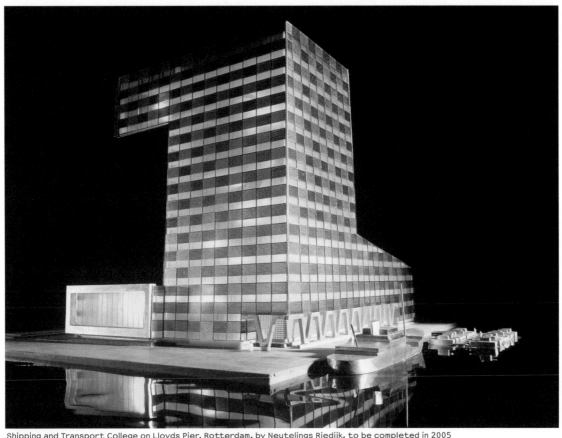

Shipping and Transport College on Lloyds Pier, Rotterdam, by Neutelings Riedijk, to be completed in 2005
Redevelopment program for Wijnhaven Island, Rotterdam, by Kees Christiaanse, 2002-ongoing

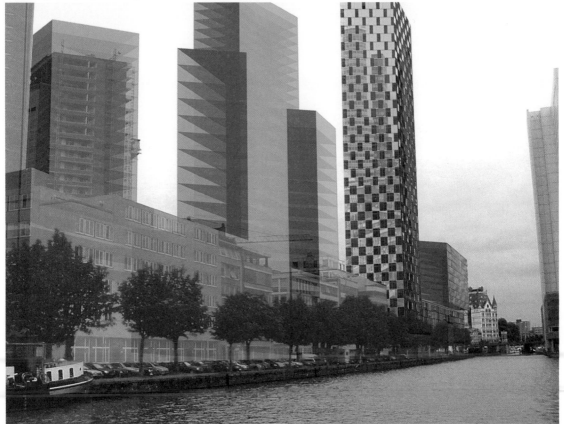

As I near the end of my journey to work, I reach the corner where another group of architects who worked (if only briefly) for Koolhaas has built two expressive fragments that frame either side of the street. The Delft-based firm Mecanoo designed the addition to the Park Hotel in 1990, and the four-story apartment slab across the street two years later. Together, these compositions of metal and glass break out of the messy confusion to state a clear relationship of building elements in space. They sum up and abstract the housing blocks to the west and transform them to a height and a composition where they become part of the landscape of the central business district to the east. They are simple, well detailed, and both have just enough of a curve to free them from the gridded context in which they stand. They are harbingers of the new, the world of well-executed modern architecture that has made The Netherlands so famous in the last few years.

When I finally arrive at my office, I feel as if I had traversed the history of Dutch design. I have emerged from the swamp that was cleared to make agricultural territory. I have passed through the housing estates and the parks that make The Netherlands a country where everybody can be at home in a well-apportioned and proportioned space. I have risen up across the dikes into the urban mess and then seen that confusion celebrated and coalesced into the new and the modern. Now I am ready to understand why the false flat of the Dutch landscape, in its seeming sameness, has so much to offer us. Through it we can understand how our reality is essentially artificial, and how we have to make sense out of this created world. It underscores the importance of space, that most invisible of goods, in our culture. It offers an aesthetic model in which the accurate mapping, representation, organization, and framing of what already exists is the point of what one does as an artist or designer. It gives us examples of both the necessity for and the danger of compromise in shaping our environment, and the need to express that process. It shows the importance of design as a way of letting us find our way through an increasingly complex world. It may even offer a model of how we can learn to love our modern world.

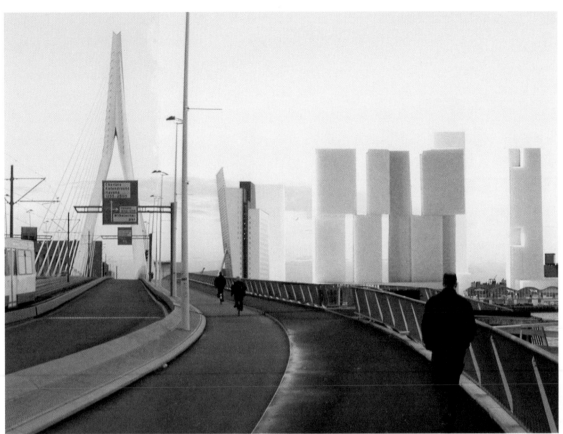

Study for the multipurpose building complex De Rotterdam, Rotterdam, by Rem Koolhaas/OMA, to be completed in 2006
Computer-generated image of the multipurpose building Montevideo (right), Rotterdam, by Mecanoo, to be completed in 2005

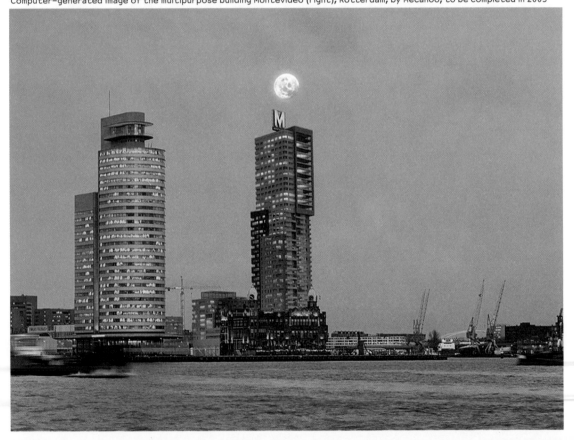

boost to the relative importance

Illustration taken from the study "Airport Island," by Rem Koolhaas/OMA, 1999

HAPPY CHAOS

Floor Wesseling — As long as there is open debate, and as long as people can look together for middle ground, then there is a way forward. Happy Chaos is an organization run by university students and editors of the weekly magazine **Vrij Nederland** ("Free Netherlands," a publication that grew out of the Dutch resistance in World War II). The foundation aims to engage youth in political debate, influencing a new and more critical generation that is "certain to mature into a new order likely to upset a tottering establishment." Since 2000 they have been holding sold-out events with themes like "Brandname NL," "Europe: Night of Power," and "Faith and Power." In his three promotional posters for Happy Chaos, Floor Wesseling, a graduate of the Rietveld Academy in Amsterdam, captures the mood of this initiative. By melding his street-grown graffiti skills with the rich and rigid typography lessons of his instructors at the academy and the age-old symbols of universal faiths, Wesseling's powerful Happy Chaos designs express a sensitive graphic interpretation of this new movement.

(020) Ontwerpers — The design collective (020) Ontwerpers was founded in 1999 by Naïm Niebuur, Gijs Kuijper, Anneke Krull, and Arjan Groot. Together they shared not only an area code (Amsterdam's 020) but also office space, as well as the occasional project. For their first job together, the redesign of the magazine **Credits**, they decided that rather than just create a final product, they would illustrate the process by which a magazine is made. Taking this concept even further, they printed on the cover of the magazine an image of the undeveloped photo rolls containing the cover image itself. The effort was immediately rewarded with the prestigious Art Directors Club Netherlands prize. Another striking project is Groot's UNFR, originally conceived in 2000 as his Rietveld Academy graduation project. UNFR stands for Universal Authority for National Flag Registration, a fictitious organization that systematizes the design of national flags. By abstracting common designs, devices, and colors, Groot's impressive final publication presents 177,489 potential patriotic banners. In 2003 the designers of (020) Ontwerpers decided to no longer function as a collective and have since pursued their careers independently (although they still share the same studio).

Vanessa van Dam — Stamps for the Dutch Post Office, flyers for a hard-hitting club night, and hundreds of windshield wipers on an office building for a public art project: Vanessa van Dam, a 1996 Rietveld graduate, creates designs striking in both aesthetic and concept. For the BNO book 2001/2002—the biennial trade publication presenting Dutch designers in six design disciplines—Van Dam and Anneke Saveur filled seven volumes with arresting stock photography and cogent titles aiming to capture the humble essence of each design discipline. For graphic design: "Causing one to have a clear picture in mind"; for illustration: "Often more useful than words for expressing meaning"; for industrial design: "Developed out of existing or potential needs and desires of culture." The set is wrapped in a plastic bag featuring an image of a hitchhiking blonde soliciting an approaching truck, with the words "Carrying Dutch design from place to place" superimposed.

Joseph Plateau — Since 1989 four graduates of the Rietveld Academy—Eliane Beyer, Rolf Toxopeus, Wouter van Eyck, and Peter Kingma—have worked together as Joseph Plateau. In 1991 each member received a "start stipendium," a grant for recently graduated designers. While this grant is often used to set up shop and subsidize the purchase of startup equipment, it also affords young designers the independence to develop their own style and voice without bowing to the pressures of demanding clients. When I visited Joseph Plateau in 1997, the group blushingly admitted to still not having spent the entirety of their grants. This dedicated sense of humility and discipline is reflected in their impressive body of work, which already includes a continuing series of posters for the Academie voor Bouwkunst in Amsterdam, a commissioned array of postage stamps, the identities for the Doors of Perception conferences, and prestigious books for NAI publishers.

Roelof Mulder — Trained as a fine artist, Roelof Mulder discovered graphic design as a tool to express his conceptual thinking. He has since emerged as an internationally acclaimed graphic designer who "delves deeply…to both communicate and innovate at a higher level not previously possible." Mulder is an outspoken proponent of the idea that designers not only package a message but also must be deeply involved in the essential substance of the process. His work as a designer and editor for **Frame,** an international interior-design magazine, exhibits Mulder's committed philosophy, opening vistas of discovery, adding visual layers of substance to intent and content.

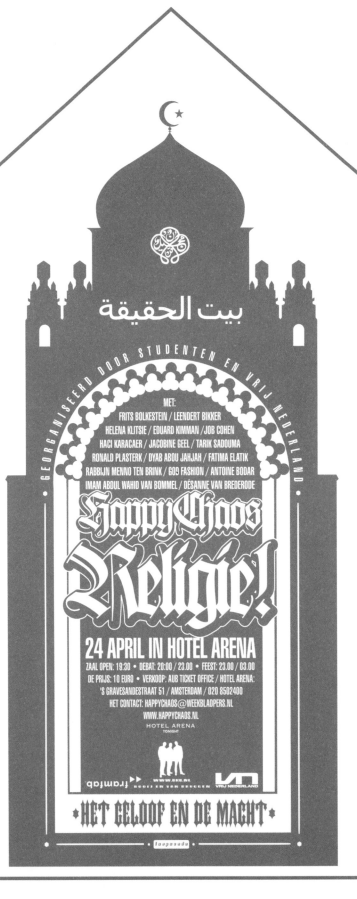
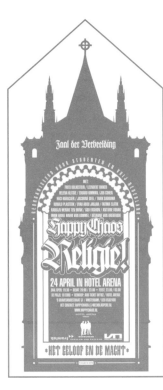
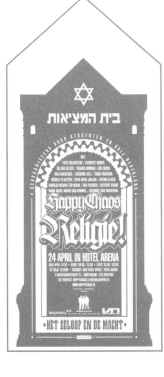

Happy Chaos poster series, by Floor Wesseling, 2003

Blvd.

Size matters

Sofia Coppola
grote vader,
kleine film

Máxima!
alles over onze
queen to be

Mega Reportage
wie heeft de
grootste?

APRIL 2000
6.95 GULDEN
140 BEF
3.15 EURO

THINK BIG!

_ GROTE TASSEN _ GROTE BRILLEN _ GROTE SCHOENEN _ GROTE DROMEN _ GROTE DADEN

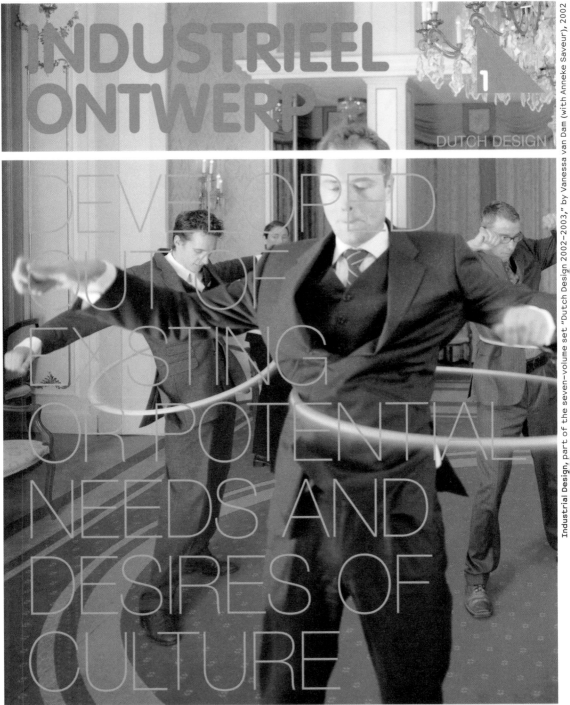

INDUSTRIEEL
ONTWERP

1

DUTCH DESIGN

DEVELOPED
OUT OF
EXISTING
OR POTENTIAL
NEEDS AND
DESIRES OF
CULTURE

INDUSTRIAL DESIGN

Industrial Design, part of the seven-volume set "Dutch Design 2002–2003," by Vanessa van Dam (with Anneke Saveur), 2002

CAPITA SELECTA april - mei 2002

Academie van Bouwkunst Amsterdam

Waterlooplein 211, 1011 PG Amsterdam. Telefoon: 020-5318218

GIL M DORON Writer, artist
Transgressive Architecture group, London
'The Dead Zone & The Architecture
of Transgression'

18 april 2002

YORAM SHOHAM V.P. External Relations,
Shell International Exploration and Production Inc.
'Energy Globalisation and the emerging
Technology Renaissance'

25 april 2002

DAMIR SAGOLJ Journalist and
Photographer, Reuters, Sarajevo
'Settlements by force : Kosovo,
Afghanistan, Persia, Iraq, Gaza'

2 mei 2002

JOOST MEUWISSEN Architect
Amsterdam, Hoogleraar stedenbouw en
ontwerpen Technische Universiteit Graz
'Urbanism and Where Does It Stop'

16 mei 2002

JOEP VAN LIESHOUT
Atelier van Lieshout
'AVL-Ville', Rotterdam

23 mei 2002

M. ROUW & D. V DARSIK
GNU Architecten
A. REIJNDORP Socioloog

Final Debate on Settlements
30 mei 2002

SETTLEMENTS

Settlements are acts of
expansion, ways of
physical determination,
ideological happenings
and political statements.

Settlements are steps to a new
notion of existence, a path to
exploration and implemen-
tation for the simple reason of
development or survival.

Settlements are inhabiting
the hostile, the deserted
or the free areas. They are a
final choice but not an
irreversible one.

In this lecture series the goal is to learn
more about settlements in relation to
our profession. A broader observation /
inquiry is essential for a total
understanding of the act of settling.

The outcome of the lecture series provides
a starting point for a debate on the
definition of Settlement and how it relates
to our professions: Landscape architecture,
Architecture and Urban planning.

By settling, territory is defined.
Building the environment is an
act of settlement! What is the
role of architecture in the
implementation of settlements?

Coordination: Arjen Oosterman
The Capita Selecta Team:
Ran Meron, Sasa Radenovic,
Ofri Earon, Thorsten Lang,
Pim van Oppenraaij

Alle lezingen beginnen om 20.00 uur • toegang is gratis • reserveren is niet mogelijk

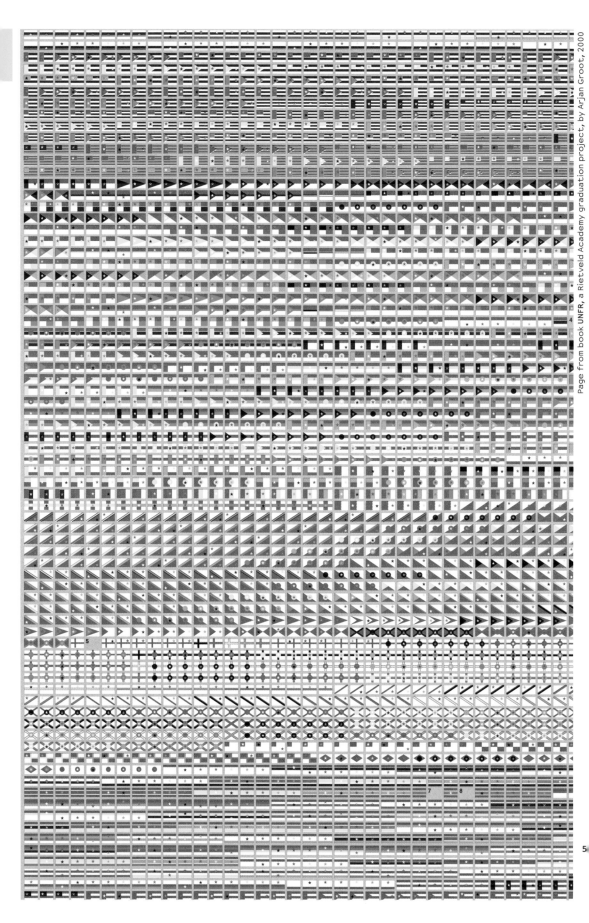

5

FRAM∃

MAR/APR 2002

THE INTERNATIONAL MAGAZINE OF INTERIOR ARCHITECTURE AND DESIGN

Banal is Beautiful

EU €15
UK £10
Canada $20
USA $15
Japan ¥2,400
Korea WON30,000
Printed in the Netherlands

25>

8 710966 241141

Hella Jongerius — In 2003 Hella Jongerius won the Rotterdam Design Prize, had solo exhibitions at the London Design Museum and the Cooper-Hewitt, National Design Museum, in New York, cochaired the International Design Conference in Aspen, and saw the publication of a book devoted to her work. In **Metropolis** magazine, Museum of Modern Art design curator Paola Antonelli pronounced Jongerius a "unique talent who has no rivals." In the same article, Jongerius is also called "the new Vermeer." The cause for this praise and adoration is Jongerius's ability to meld the old with the new, high tech with low tech, first world with third world, craft with industrial process, intuition with expertise, to create products she calls "new antiques." These are modern artifacts that hold an ingrained value, foster an immediate emotional attachment, and are imbued with a meaning that does not merely reflect the latest design trends.

Ineke Hans — While working for three months at the European Ceramics Work Centre, Ineke Hans developed her "Black Gold Modular Porcelain" series, a "kind of ceramic LEGO system." Allowing for infinite combinations, the easily reproducible vases, coffeepots, saucers, and so on are all cast in the notoriously sensitive black porcelain, a tricky material that exerts its own will in the final form. Architectural critic and curator Lucy Bullivant aptly describes Hans as a "designer with the impulses of a sculptor and the industrial experience needed to define products with a commercial life." After working on mass-produced furniture and product collections for Habitat UK, Hans founded her own studio in 1998. Witty yet sober, her work reveals the interplay between function and form, exposing archetypes and exploring materials, techniques, and established codes.

and in the process changing their function and their meaning. Celebrated examples include his Handbag Annie (two dustpans tied together with a piano hinge to form a lady's handbag) and Coathammer Jut (a hammer with the head reversed and a nail attached to form a coat hanger). Stallinga cherishes the anecdote of a Russian cosmonaut meeting an American astronaut, the latter showing off NASA's latest million-dollar invention: a ballpoint pen that could write upside down or in weightless conditions; in response, the Russian showed him a pencil. Stallinga sympathizes with the Russian. The practical runs much deeper than does the whimsical in his work. This is as much a social commentary against the wasting of resources as it is a fresh look at function and form. An independent designer ever since he left the Rietveld Academy in 1993, Stallinga is also principal creative director at Design Machine, a strategic brand-building studio with offices worldwide.

Henk Stallinga — An objector to the collective nature of Droog Design, Henk Stallinga is most likely the "driest" designer of them all, taking everyday objects, giving them a slight twist,

Niels van Eijk — **WAT (Working Apart Together)** was the title of Miriam van der Lubbe and Niels van Eijk's 2002 exhibition at the Vivid Gallery in Rotterdam. The two share an old farmhouse in the countryside, each pursuing their own iconic ideas, while occasionally collaborating on exceptional projects. As students at the Design Academy in Eindhoven in the mid-'90s, they became immersed in the Droog Design school of thought and left as natural masters of its teachings. Van Eijk's cow chair from 1997 became one of the classics of Droog's collection. More recently, his Bobbin Lace Lamp uses not lightbulbs but glass fiber as a conduit of light, while his stoves evoke memories of props in a van Gogh painting. Van Eijk's designs take the core characteristics of the source material and forge an intimate bond between form and function, past and present, raw and refined. The resulting creations are both elegant and enchanting.

Miriam van der Lubbe — A keen observer of the peculiarities of her surroundings and fellow human beings, Miriam van der Lubbe uses her products to reflect on the madness of our everyday lives. Wineglasses get a piercing, a lady's handbag is pistol shaped; her furry Poodle Chair can be shaved to accommodate its owner's aesthetic desires. She is not interested in creating new form; she wishes only to take what already exists and add her (often biting) commentary: she has rematerialized the iconic, disproportionately slim Barbie doll as a chocolate calorie bomb and decorated the ubiquitous Dutch windmill with Islamic, Chinese, and African symbols. When Van der Lubbe adorns napkins with historical Delft Blue figurines, the characters skate no longer on ice but on a skateboard, they light up not a clay pipe but a joint, and the classic bridge in the background is transformed into the unmistakable Erasmus Bridge.

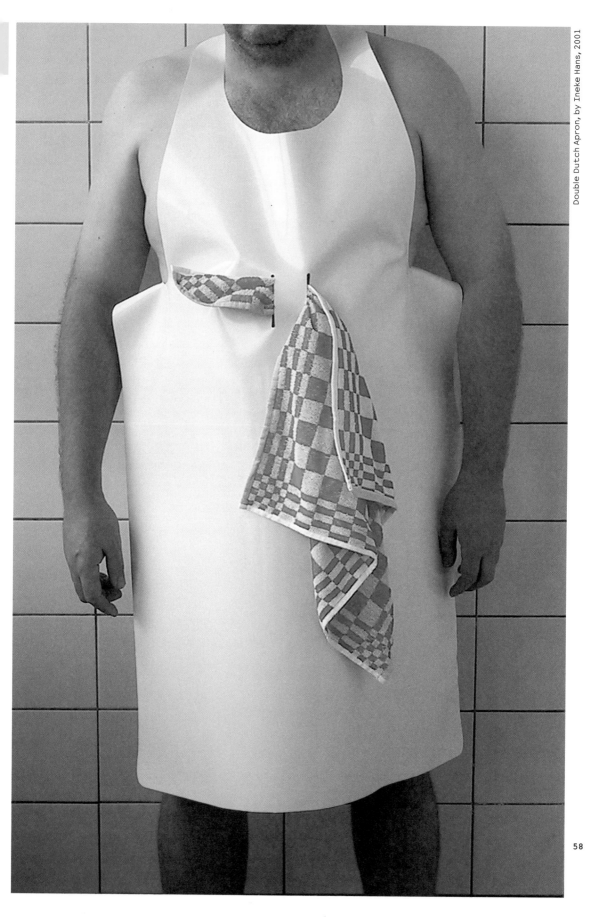

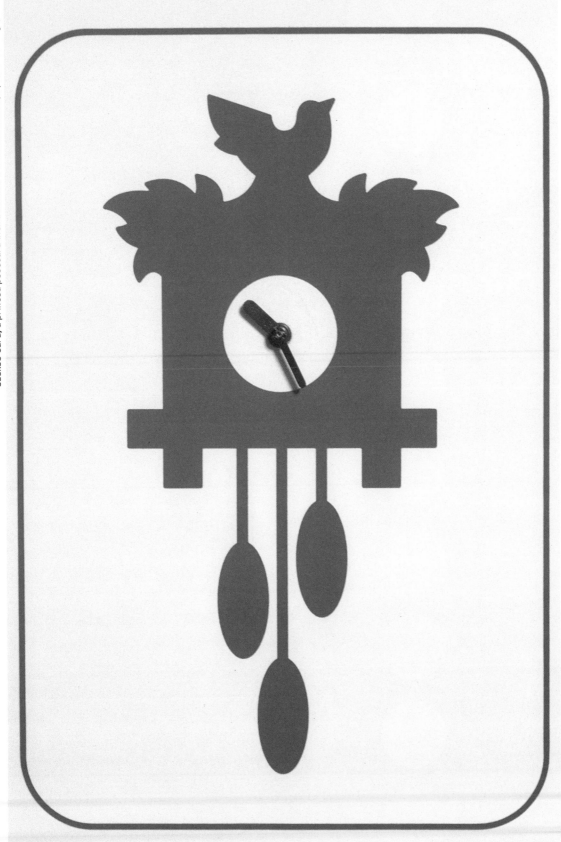

Repeat upholstery design for textile company Maharam, by Hella Jongerius, 2002

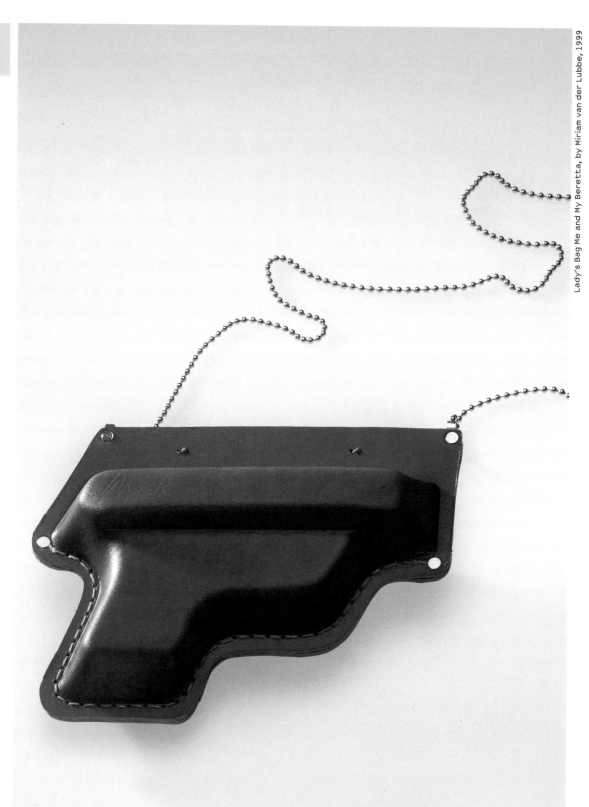

ARCHIS

IS

DUTCH

round-breaking Dutch arch
much make physical buildi
alysis.

A·B

U NOT

LIBRARY OF
THE MUSEU

VOL 1

BIBLIOT
DU M

BETA

IJZ

IJ2

MSTERDA
THOMAS
ELISA
ET MARK R
JA NUFA

THIJS WÖLTGENS

L b F

VAN DE

FORT ASPEREN 2003
ARMOUR
DE FORTIFICATIE VAN DE MENS

DESIGN
ACADEMY
EINDHOVEN
graduation
2000

UN
STUDIO
EOID

NEDERLANDS ONTWERP
ONTWERP
DUTCH DESIGN 2000/01

Archis — **Archis** magazine is not an easy read, but this suits the designers of this publication on architecture, the city, and visual media just fine. In their view, only friction will give shine. The editorial mission of the magazine is to be an engine for cultural debate, and designers Maureen Mooren and Daniel van der Velden have interpreted this by prodding their readers into (inter)action—for instance by making them tear out and recombine perforated sections—thereby forging new landscapes in which information can be disseminated. Simultaneously, they refuse to "just" act as designers and instead always insert their voice by taking on the role of author and editor, intervening and commenting at will. This daring and uncompromising experiment often risks "dying in beauty," as the Dutch would say: it can be unpractical, self-indulgent, and heady. Nevertheless, the magazine's lofty ambitions have succeeded in making **Archis** a world-class publication.

Artimo — In 2003 the Nomination Committee for the Rotterdam Design Prize awarded the Artimo foundation their first **Voordrachtsprijs** (nomination prize), which recognizes an initiative, project, or organization that performs a stimulating role for design as a whole. The foundation is a rare private initiative, funded by a single philanthropist who in ten years has generously supported a remarkable series of art books designed by the likes of Goodwill and Mevis & Van Deursen and published the magazines **Re-Magazine**, **Archis**, and **Foam**, among others. A patron and promoter of emerging artists and an enabler of cultural innovation, Artimo was lauded by the jury for being an ideal client, "almost autistic in its desire to give artists (and designers) the opportunity to produce and distribute books that are of vital importance for the further development of their career."

design"; at the bottom, "applied design"; on the outer left, "technique"; and on the outer right, "concept." In the middle of the quadrant, Kuilman locates Droog Design, an initiative he feels balances the forces of creativity, skill, professionalism, and commercialism. Yet he believes that the majority of Dutch designers are located in the top right corner: they are ideating, intuitive, and independent. Tasked with writing a design-policy advisory and forming the official Dutch Design Institute, Kuilman hypothesizes that the success of Dutch design may be delusional, induced by a haze of pseudophilanthropic government support that has led to an abundance of small, elitist, and mannered projects that are essentially irrelevant. He hopes to shift the emphasis more toward the middle of the quadrant, concentrating his design policy on work that creates tangible value, in both the commercial and the practical sense.

Dingeman Kuilman — Dingeman Kuilman, director of the Premsela Foundation for Dutch Design, draws a quadrant to explain the nature of Dutch design. At the top he writes "autonomous

Anthon Beeke/Lidewij Edelkoort — Lidewij Edelkoort, the director of the Design Academy in Eindhoven, is an internationally revered trend watcher based in Paris. Dubbed the high priestess of lifestyle trends, she blends intuition and analysis to forecast the tastes and behavioral patterns of the global public. Partner in her publishing venture United Publishers is Dutch design legend Anthon Beeke. He designs all her printed matter, be it her trend reports **View on Color** and **Bloom;** a catalog for the Design Academy; a collaboration with UN Studio Van Berkel & Bos on their book **Unfold;** or the identity for the remarkable exhibition **Armour, The Fortification of Man.** The couple form a power block whose missives have garnered such influence that they have almost become self-fulfilling prophesies.

René Knip — After working for Anthon Beeke for three years (alongside Dingeman Kuilman and Niels "Shoe" Meulman), René Knip set up his own studio in 1995, often initiating his own projects when his ideas could not wait for a commission. As he once explained to **Graphis** magazine, he "lives, thinks and designs in the second and a half dimension...that intangible place where flatness and depth meet and merge." Knip calls the designs that emerge "typographic furniture, spatial typography, or architectural graphics." His typefaces (which are used only once, then destroyed) purposefully approach letters architecturally, adhering rigorously to mathematical and geometric equations and providing unique solutions that are as timeless as they are soulful.

Spreads from issue 4 of Archis magazine, by Maureen Mooren and Daniel van der Velden, 2002

DESIGN
ACADEMY
EINDHOVEN

graduation
2000

Graduation catalog cover for the Design Academy Eindhoven, by Anthon Beeke, 2000

Vuurkorf (Fire Basket), by René and Edgar Knip, 2002

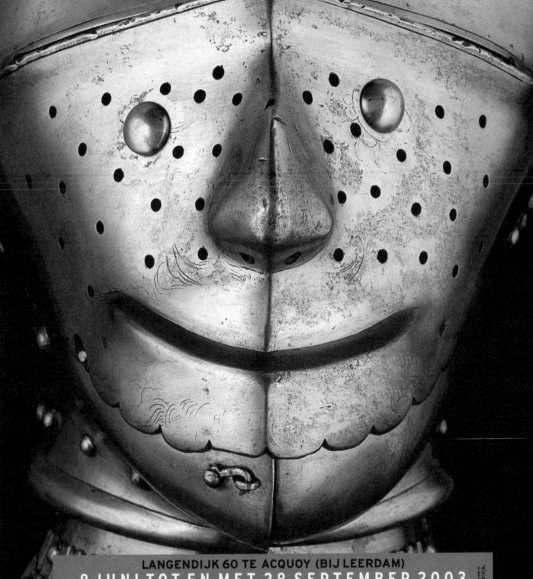

FORT ASPEREN 2003
ARMOUR
DE FORTIFICATIE VAN DE MENS

LANGENDIJK 60 TE ACQUOY (BIJ LEERDAM)
8 JUNI TOT EN MET 28 SEPTEMBER 2003
www.armour.nl

BIS Publishers — A design and architecture publisher based in Amsterdam, BIS found its niche by deciding not to embrace the well-established system of subsidies, instead seeking out collaborations with trade organizations and commercial agencies. One such undertaking is the series of Dutch Design Books, which BIS has published every two years since 1990 with BNO, the Association of Dutch Designers. BIS has also specialized in publishing monographs on design studios, including Dietwee, Thonik, and Koeweiden Postma. In addition, it publishes periodicals, among others the Dutch-language design magazine **Items** (designed by Studio Dumbar, after a long reign by Opera Ontwerpers), very much focused on being a no-nonsense, impartial trade magazine; the interior-architecture and design magazine **Frame**; and, in London, **Graphic Magazine**, dedicated to contemporary visual arts.

010 Publishers — "The only thing the Dutch are good at is their promotion, plus the fact that every single doodle they sketch leads to a publication" was the malicious whisper overheard by a Dutch architect during a lecture at Los Angeles's SCI-Arc. Partly responsible for this envy is 010 Publishers from Rotterdam, who over the last twenty years have published more than five hundred books on the most wide-ranging aspects of Dutch architecture, interior design, planning, land-scape design, urbanism, photography, industrial design, graphic design, and the visual arts. To realize their publications, both 010 and their collaborating authors and designers feed off the infrastructure of subsidies anchored in the governmental policy to export Dutch culture as a commercial product. Without a doubt, 010's specialization in the promotion of Dutch culture plays an important part in the recognition, commissions, and inevitable criticism it has come to enjoy.

Ben Laloua — The North African name Samira Ben Laloua is in itself an exotic addition to the Dutch design scene. Born to a Moroccan father and a Dutch mother, Ben Laloua grew up in the traditionally Roman Catholic south of The Netherlands, a factor that further distinguished her from her fellow designers, who for the large part seem to have their origins in the more Protestant north. Nevertheless, design critic Ineke Schwartz describes Ben Laloua's work—cosigned by Didier Pascal—as part of a conceptual strain deeply ingrained in the Dutch design tradition. As an example Schwartz cites Ben Laloua's posters for a series of debates on image culture for Zaal de Unie: breaking with the traditional rules of poster making, they are illegible from a distance and do not unveil their intent in a drive-by glance. But they do attract your attention and your curiosity. Schwartz points out, however, that Ben Laloua's working method is decidedly unprotestant: rather than apply the customary analytical design solution, she conceives and executes her ideas with refined intuition.

Stout/ Kramer — On its Web site, the Rotterdam design studio Stout/ Kramer always introduces itself with a flow of catchy, conceptual words in yellow, blue, pink, or green type: "Basic. Absolute. Charming. Cool. Dedicated. Modern. Deep. Ambivalent. Different. Possible. Involved. Confused. Resolute. Simple. Active. Effective. Less. Usual. New. Fuzzy. Alive. Moody. Normal. Perfect. Small. Diverse. Sexy. Coincidental. Full. Original. Sincere..." Marco Stout and Evelyn Kramer are all of these things and more, and although they are both trained graphic designers, they consciously view themselves as "editors and directors of communication. As editor the designer inter-prets the content of a message. As director the designer is responsible for the appropriate means of communication." Since the studio's inception in 1999, it has created a sound portfolio of publications and identities mainly for cultural institutions, most notably the catalog and stationary for the exhibition **Commitment,** which in 2002 celebrated the work of designers who received grants from the Dutch Foundation for Visual Arts (Fonds BKVB). Stout/ Kramer's style, in a few words, can be described as: Analytical. Rational. Simple. Clear. Without fuss. Dutch.

Vivid — Located at the edge of Rotterdam's museum quarter, the independent gallery and design center Vivid focuses on presenting new directions in design, offering both national and international designers a platform to present their latest ideas, concepts, and products. Hella Jongerius moved her whole studio to the Vivid space to show her concept of "My Soft Office," allowing the audience to witness and interact with the process of design; Richard Hutten, Miriam van der Lubbe, and Niels van Eyk, have also had solo exhibitions here; and Vivid themselves curated the first retrospective of the legendary Dutch designer Kho Liang Ie (known for his 1960s furniture design for Schiphol Airport). Moreover, Vivid's Web site offers the most comprehensive image collection of current Dutch industrial design. All this is remarkable, especially as it repre-sents one man's efforts: Vivid's creative director, Aad Krol.

APPLES &
best dutch graphic design
ORANGES

01

Book, Apples & Oranges, Best Dutch Graphic Design, by Thonik, 2001

Zaal de Unie

debat podium van de RKS

Zaal de Unie 3
Mauritsweg 3
3012 JT Rott
reserveren
van 11
(010) 433
T

19

Ma – 06 mei
Aanvang: 20.00
Toegang: gratis
De thermometer
Voordat de koortsige
onvrede die Rotterdam
en Nederland nu teistert
een kookpunt bereikt, zal
stad en land op gezette
tijden worden
getemperatuurd in een
regelmatig terugkerend
debat: De Thermometer.
**Deel 1:
Kiezers op drift**
Nieuwe burgerlijke
betrokkenheid of overmaat
aan egoisme? Tijd om de
temperatuur te meten met
onder anderen Nebahat
Albayrak PvdA Tweede
Kamerlid; Henri Beunders,
prof. media-maatschappij
EUR; Daan van der Staaij
(red. binnenland Agemeen
Dagblad) en Fred Teeven,
lijsttrekker Leefbaar
Nederland. Uw gastvrouw
is Liesbeth Levy.

Za – 11 mei
Aanvang: 20.00
Toegang: gratis
Locatie: Remonstrantse
kerk, Museumpark 3,
Rotterdam
**Benjamin Barber
Jihad vs McWorld**
Benjamin Barber, de auteur
van Jihad vs McWorld geeft
een lezing. Debat met
Jan Willem Duyvendak,
dir. Verwey-Jonkerinstituut,
bijzonder hoogleraar
Grondslagen Opbouwwerk,
Erasmus Universiteit;
Yassin Hartog, coördinator
Islam en Burgerschap;
Percy B. Lehning,
hoogleraar politieke
filosofie Erasmus
Universiteit Rotterdam
en Paul Scheffer, publicist,
lid PvdA. Het debat wordt
geleid door Pieter Hilhorst,
publicist.

20

Ma – 13 mei
Aanvang: 20.00
Toegang: gratis
**Godsdienstonderwijs:
gevaar voor
integratie?**
Welke positie neemt dit
onderwijs in binnen onze
multiculturele
samenleving? Hoe bang
moeten we zijn voor
(negatieve) beïnvloeding?
Is het wel of niet
bevorderlijk voor de
integratie? Het panel:
dominee Hans Visser; Theo
Neelen, directeur openbaar
onderwijs Rotterdam;
Ibrahim Spalburg, directeur
SPIOR en Nico Stuij,
directeur Humanistisch
vormingsonderwijs.

21

Do – 23 mei
Aanvang: 16.00
Toegang: gratis
**Kenniscentrum
Sociaal Investeren**
Het Kenniscentrum
organiseert in Zaal de Unie
een reeks debatten. Het
onderwerp is deze middag:
Wat zijn de gevolgen van
het collegeprogramma voor
de sociale sector?
Moderator is
George Brouwer. Kijk voor
de sprekers op de website
van het Kenniscentrum:
www.kenniscentrum.com

Vr – 24 mei
Aanvang: 20.00
Off Screen
Eens per maand wordt in
De Unie een filmavond
georganiseerd waar films,
die nauwelijks elders te
zien zijn, worden getoond
en besproken. Bovendien
zijn de makers aanwezig
die in een gesprek met
Christiaan van Schermbeek
meer vertellen over de films
dan we op het eerste
gezicht kunnen zien.

Do – 30 mei
Aanvang: 20.00
Toegang: gratis
**ArchitectuurCases
Rotterdam
Euromast en
Parkhaven op de
schop?**
Wat zijn de consequenties
van dit Urban-
entertainment-paradijs
voor de inmiddels tot
gemeentelijk monument
bestempelde Euromast van
architect Huig Maaskant?
En wat is de betekenis voor
het vermaarde negentiende-
eeuwse park van land-
schapsarchitect Zocher,
een rijksmonument?
Sprekers: Kees Kleinman,
Ruurd Gietema,
Kees Christiaanse,
Wim Straasheim
Moderator: Enno Zuidema.

22

Ma – 27 mei
Aanvang: 20.00
Toegang: gratis
**Phenix Publieke
Verkenningen**
Deel 1: Chris Keulemans in
gesprek met Wendy Steiner
over kunst en schoonheid.
In haar recente boek Venus
in Exile poneert Wendy
Steiner (cultuurcriticus,
University of Philadelphia)
de stelling dat de avant-
garde in de 20e eeuw
schoonheid en de vrouw
als symbool hiervan uit de
kunst heeft verbannen.
Hoe is dit pleidooi voor
schoonheid te vatten en
te praktiseren binnen de
multiculturele context van
kunst in de huidige wereld?

Wo – 29 mei
Aanvang: 20.00
Toegang: gratis
**Een zaak van
cultureel
vertrouwen?**
Na vele jaren van experi-
menteren met even zo vele
uiteenlopende methoden
om meer beleidsmatige
aandacht te genereren
voor kunstuitingen van
allochtonen, wordt er sinds
1997 in Rotterdam serieus
aandacht besteed aan de
vraag hoe richting en vorm
te geven aan multicultureel
kunstbeleid.

23

Zo – 02 juni
Aanvang: 13.00 16.00
Toegang: 5,00
Šimek op Zondag
Martin Šimek gaat voor
zijn nieuwe serie televisie-
programma's Šimek op
Zondag het land in en zoekt
gasten en publiek. Šimek
ziet zijn gasten voor het
eerst en is door de redactie
op geen enkele manier
voorbereid. Het spontane
karakter van de
ontmoetingen is het
vertrekpunt van het
programma.

Wo – 05 juni
Aanvang: 20.00
Toegang: gratis
**De Nieuwe
Wethouders**
In De Unie start de tournee
van de Nieuwe Wethouders
langs culturele instellingen.
Zij geven het publiek een
blik in hun plannen en
ambities. Een avond voor
iedereen die wil
kennismaken met de
wethouders.

24

Do – 13 juni
Aanvang: 10.00
Aanvang: 20.00
Toegang: gratis
WiMBY!
WiMBY! (Welcome into My
Backyard) is het motto van
de internationale
Bouwtentoonstelling die
van 2001-2010 de
herstructurering van
Hoogvliet zal begeleiden
met vernieuwende,
versterkende en
verrassende projecten op
het gebied van stedenbouw
en architectuur, onderwijs,
beeldende kunst, natuur en
bedrijfsleven. WiMBY! wil
een voorbeeld zijn voor
steden en wijken binnen en
buiten Nederland. Deze
avond is bedoeld om de
culturele instellingen van
Rotterdam te informeren
over de werkwijze van
WiMBY! Met medewerking
van Michelle Provoost,
Wouter Vanstiphout en
Felix Rottenberg.

Vr – 14 juni
Aanvang: 20.00
Toegang: gratis
Off Screen
Vanavond de laatste
Off Screen van dit theater-
seizoen. De samenstellers
zullen proberen een zonnig
programma te maken
waarna in de pauze en na
afloop gedronken kan
worden op een geslaagd
Off Screen seizoen.

25

Wo – 19 juni
Aanvang: 20.00
Toegang: gratis
**Patriot én
kosmopoliet
tegelijkertijd**
Geen twijfel mogelijk: de
hedendaagse samenleving
laat zich niet in grenzen
vangen. De kosmopoliet
staat open voor vele ideeën
die over de drempels van
natiestaat en het etnocen-
trisme reiken. Maar de
hedendaagse lokale
complexiteit van een
multiculturele stad en staat
roept ook om lokale en soms
om vaderlandse trots. Een
lezing door professor
Tariq Modood (Universiteit
van Bristol) en een debat.

26

Wo – 26 juni
Aanvang: 20.00
Toegang: gratis
Locatie: Auditorium,
Academie van Bouwkunst
Rotterdam, G.J. de
Jonghweg 4-6, Rotterdam
**ArchitectuurCases
Rotterdam
Het nieuwe
ziekenhuis**
Hoboken, de plek waar het
Dijkzigt-ziekenhuis en het
Sophia Kinderziekenhuis nu
staan zal de komende jaren
een metamorfose
ondergaan. Sprekers:
Kirsten van den Berg
(stedenbouwkundige dS+V)
zal de stedenbouwkundige
aspecten van het plan
toelichten. Bas Molenaar
(EGM) (onder voorbehoud)
zal als projectarchitect de
interne logistiek bespreken.
Annet Tijhuis (architectuur-
critica) zal als panellid
inzetten op de consequen-
ties van een dergelijke
operatie voor de stad.
Zef Hemel (directeur
Academie van Bouwkunst)
zal het debat leiden.

Do – 27 juni
Aanvang: 16.00
Toegang: gratis
**Kenniscentrum
Sociaal Investeren**
Vanmiddag het laatste
debat uit de reeks die het
Kenniscentrum in De Unie
organiseert. Het onderwerp
is: Sociale integratie kan
niet zonder organisaties van
migranten. Gespreksleider
is George Brouwer.
Kijk voor de sprekers op
de website van het
Kenniscentrum:
www.kenniscentrum.com

mei/juni 2002

RKS

Dirk Braeckman / V.B.-P.A.(2)-96 / 120 x 100 cm / zilvergelatineprint op aluminium

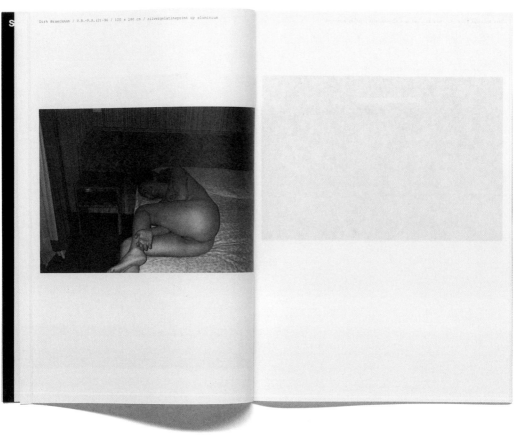

Peter Tscherkassky / Outer Space, 1999 / filmstill

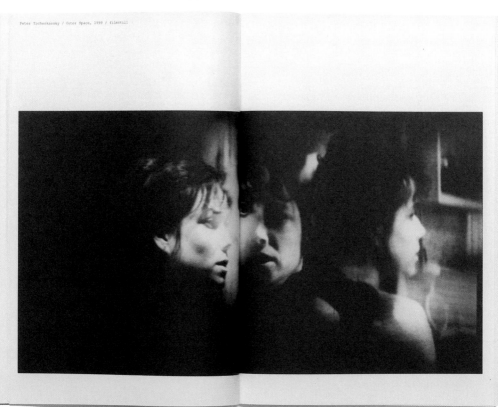

Exactitudes® – Ari Versluis & Ellie Uyttenbroek

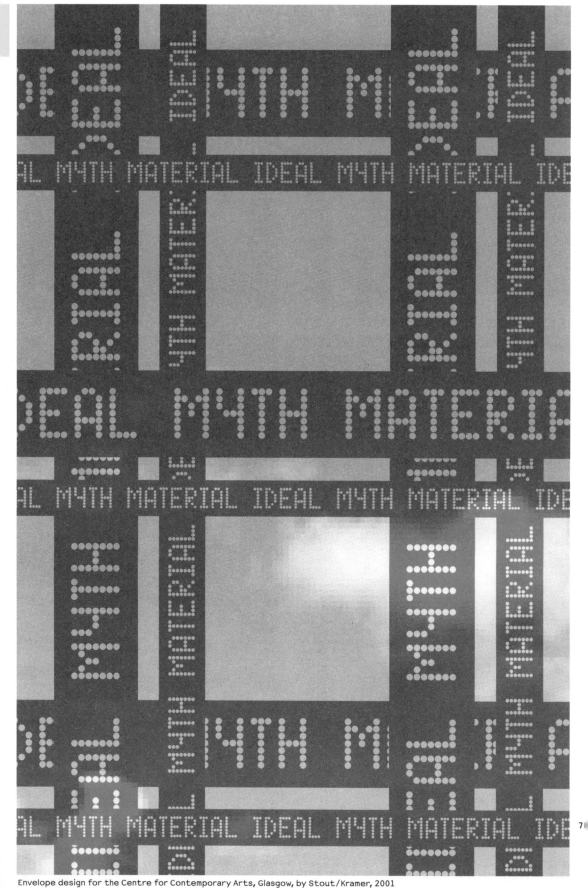

Envelope design for the Centre for Contemporary Arts, Glasgow, by Stout/Kramer, 2001

Vroom-Vroom in the Boom-Boom Years

Next to the train station in The Hague stands a monolithic building. The home of the Ministry of Spatial Planning, Housing, and the Environment (its initials in Dutch, VROM, remind me of a car revving before a race), it is an immense block whose bulk is cut only by panels of glass running from the bottom of its fifteen-story height all the way to the top. It takes its place among the other bureaucratic bunkers whose presence in the center of this city mark The Hague as the capital of The Netherlands. Like many government structures and the bureaucrats they house, the ministry seems closed and a bit haughty, somewhat divorced from the world it governs.

But this is still The Netherlands. The VROM building actually opens up at ground level to allow a lively street—leading from the train station to the heart of the city—to run through it. A supermarket, a drugstore, and a café line its base. A tram glides by the back, cutting through the facades of the line of neighboring ministries. Everywhere, the scale of these seemingly closed boxes breaks down. The structures are strangely unmonumental, suggesting the Dutch couldn't make anything imposing even if they tried. That's just as true at the top of the government hierarchy: the prime minister's office is a small turret added to the medieval houses of parliament during a nineteenth-century renovation. Even this tiny hideaway is derided as being too isolated and therefore elitist. In The Netherlands, power has a hard time asserting itself.

VROM, which introduces the line of blocks running between the train station and that little turret, is also hollow. It was designed after the Dutch adopted similar environmental laws to those the Germans developed in the late 1970s. Here, every-body has the right to sit close to a window. The ministry's architect, Jan Hoogstad, solved the problem of how to make a big building in which everybody has natural light by organizing the structure around a full-height atrium. The building's heart and soul is not some grand staircase or rotunda, just as its exterior is not a facade festooned with pediments and columns. It is a void filled with more people-friendly functions like cafés and banks. The Ministry of Spatial Planning, Housing, and the Environment must, after all, show us how to be at home in space.

The notion of space is central to the ministry's task. As an extremely rare commodity in a small country, where most people inhabit land made artificially through poldering, its uses and its nature must be carefully considered. If it was man-made, it was expensive; making more of it would be difficult, and maintaining what one has costs a great deal of time, ingenuity, and money. All this means that zoning must weigh the demands for new uses against the need to preserve existing urban and rural patterns. The primary need is for dwellings, as the Dutch have a perennial housing shortage. They planned to build half a million units by 2004, but they are already running way behind schedule. The second need is to preserve what is left of the country's open space and to make it safe and enjoyable for all. Enter VROM, a ministry that decides how space is used, preserved, and inhabited. I know of no other country in the world where these functions are combined in one ministry—and in one of the "power ministries" at the heart of the government, moreover.

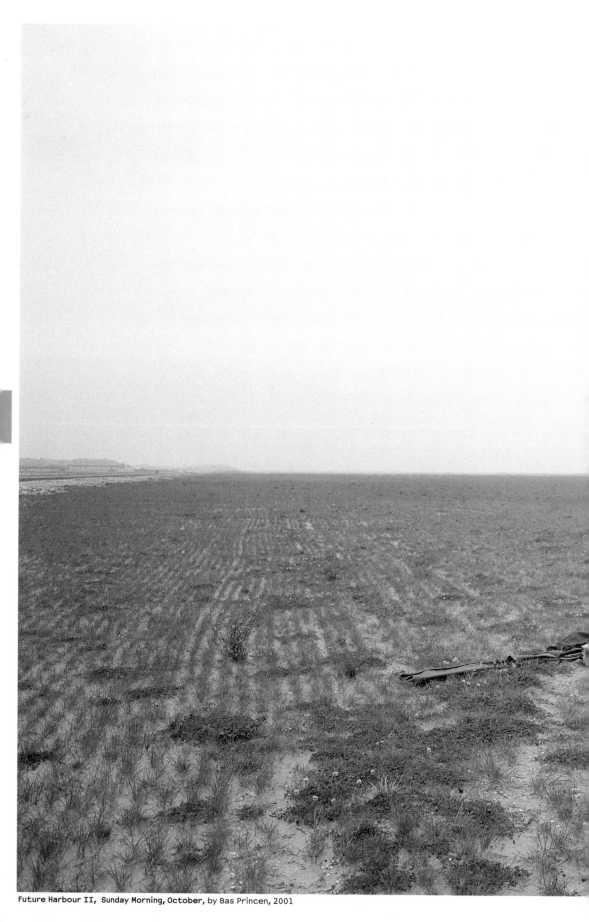

Future Harbour II, Sunday Morning, October, by Bas Princen, 2001

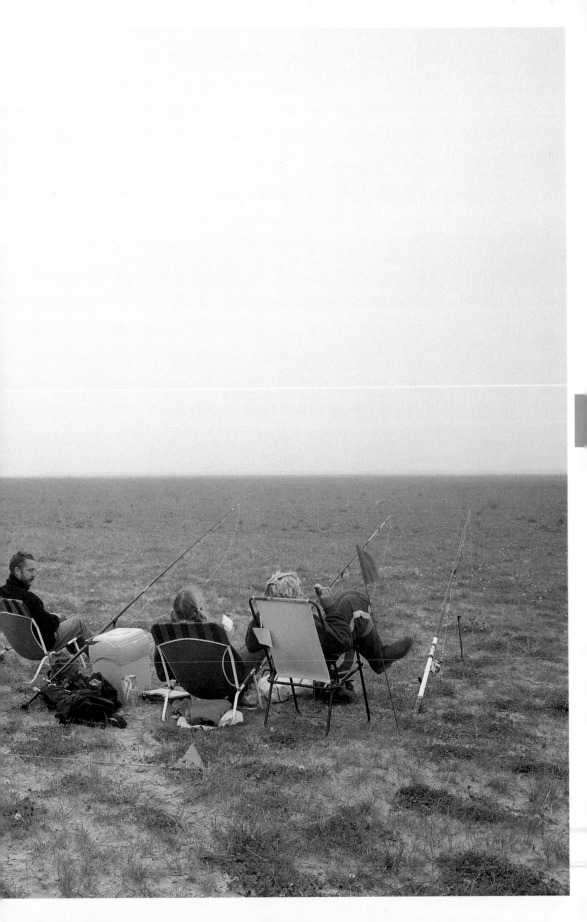

Founded in 1988 by unifying several departments from other ministries, VROM is the result of both a long tradition of thinking about the uses of space and the political realities of the last century. It combines a concern for the engineering of the land with social-democratic ideals that make the provision of living and leisure space central to the achievements of the modern state. In many countries, such concerns have become buried in rhetoric about freedom of choice, in which the need for housing opposes the demands to preserve open space, and the government can only try to restrain developers. In other situations, planning is an instrument of economic policies that cut through requests for a coherent, sensible, and sensitive urban fabric—requests that could dampen the demand for more buildings. The Dutch, by contrast, see planning as a complex web of considerations that establish the very foundation of their state. Development is not something done by evil builders, but is part and parcel of the fabric of the country. Land itself is an artifice that the Dutch enjoy and want to preserve. Though there are now voices rising up even in VROM itself, calling for more freedom for developers and an end to state planning in favor of what the director of the Spatial Planning Bureau—VROM's in-house research arm—calls "accommodation planning," making and apportioning the physical land is still the prime concern of the state, preceding the regulation and management of what has already been built.

The creation of space is a fundamental part not just of government policies, but of the land itself. There is an old saying that God made the world, but the Dutch made Holland. To a certain extent, this is true. Without the elaborate system of dikes, dams, and flood-control gates the country has developed over the last millennium, almost two-thirds of it would be underwater. To me, the most expressive example of how the Dutch see the space they occupy as an artifice that they can manipulate at will is the fact that, at times, they have flooded the land themselves. When fighting the Spanish for independence in the seventeenth century, the Dutch flooded the polders around the besieged city of Leiden, flushing out the Spanish troops and letting a band of guerrilla-like sea captains in small warships come to the aid of the city. They did it again, with somewhat less success, a century later, when the French were trying to take over the country. After the First World War, the government tried to build this defense system into the fabric of the country. They designed a line of forts that ran along the eastern edge of the country's industrial and population core, all the way from the Rhine to the Zuider Zee. A set of locks and canals connected these small fortifications and, if the Germans were ever not to respect the neutrality of this small country, the Dutch planned to open the floodgates. They would then retreat behind a line of battlements [8] that stood watch over a lake behind which Amsterdam, Utrecht, Rotterdam, and The Hague would shelter.

Buckthorn City, a proposal for new land that could be created in front of The Hague in the North Sea, by West 8, 1995

It never quite worked out that way. When the Germans came in 1940, they skipped right over the Water Line and bombed Rotterdam with airplanes, forcing the Dutch to surrender without a fight. Today, the ministry of VROM, along with the Ministry for Transportation and Water Management (another uniquely Dutch hybrid), is trying to figure out what to do with the Water Line. Everybody agrees that it should remain as part of the country's cultural heritage. The more radical thinkers see it as a line of defense, not against a military foe, but against the urbanization that is creeping east from the large cities. There are now serious proposals to actually use the system to create that big lake. It would serve as a buffer to the cities and help restore wildlife through the creation of new wetlands and marshes. This being The Netherlands, it would not remain a pristine area. Housing estates could be built along and even on the water, so that the needs for more housing and more recreational areas could coexist with environmental protection and the creation of empty space. It is a perfect VROM project.

Spatial organization is a way of thinking about the reality one inhabits in a three-dimensional and abstract way. The concept was adapted from the German idea of *Raumplanung* that sought to integrate the coordination of all physical resources in space. Exported to The Netherlands during the Second World War, it had already been embraced by the planner Jo de Casseres, who laid the foundations for Dutch planning during the 1930s. *Raumplanung* understands space as an artificial void that is essentially made by humans and can have any number of uses. This is fundamentally different from the Anglo-Saxon tradition, in which land, or nature, is seen as a void that has to be replaced with a three-dimensional reality made up of man-made objects. The Dutch see a three-dimensional chess game; Americans and the British see a collection of objects sitting in fields.

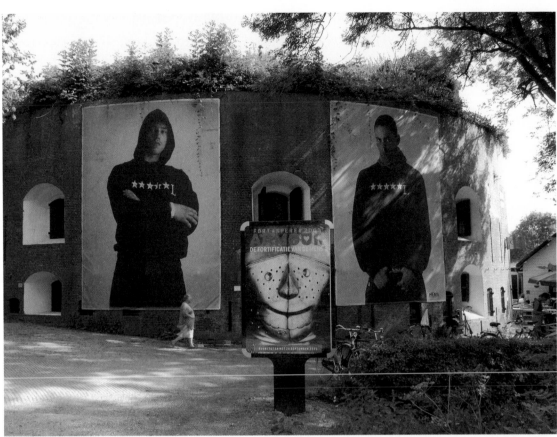

Armour, **The Fortification of Man,** an exhibition curated by Li Edelkoort in Fort Asperen, one of the fortifications that makes up the Water Line; featuring works Amour (above), by Versluis, Uyttenbroek & Carlier, and Bomb Chandelier (below), by Hans van Bentem, 2003

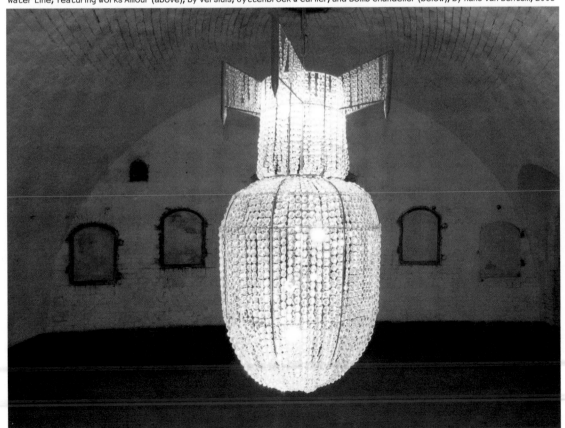

Spatial organization has political aspects as well. Beginning in the Middle Ages, the need to create polders out of the marsh and to keep the water at bay led to a political situation in which local cooperation became more important than hierarchical governance. As in almost every culture, compact towns appeared in the countryside as places where the value produced by the land was realized through trade, through taxes to the lords, and through the manufacture of finished goods. In Holland, though, the scale was fundamentally different. Towns appeared often within a day's walk of each other and never reached the scale of a great metropolis. Trade among the towns was so intense that very few of them had any sense of isolation. The fingering out of the Rhine into a delta became the basis for an intensive network of communications that mimicked these intertwined strands of water cutting through the barely dry land. Even the cities were not solid bulwarks within this floating land; they were themselves networks of rivers, dams, and canals that merely intensified and defined, with walls of houses, the water network already present.

One result is a striking lack of monuments in the Dutch urban scene. Historically, there have been few castles in the Dutch landscape, and even fewer palaces or grand institutional structures. It is, of course, more work to build something big in a reclaimed swamp. There were also no vast, empty, and fallow stretches of land that could be made dependent to and help pay for the building projects of one ruler. The division of power into smaller structures mirrored the overall development patterns that prevailed in this part of Europe.

What does emerge from the land is a collection of church spires and windmills. Almost everywhere you stand in Holland you can see one or the other, and usually several at the same time. The churches of The Netherlands are on the whole unremarkable. There are few of the grand cathedrals one finds in Germany or France, but also few of the finely wrought parish churches one comes across in England. Dutch places of worship are mostly sober affairs built of brick that rarely have distinguishing characteristics. There are many of them, and they are very closely spaced, as the split between Catholics and Protestants gave way to a splintering of the latter denomination into countless sects. It is only inside that Dutch churches differentiate themselves. Stripped of all decoration during the Reformation, they are havens of airy white walls and columns, clear glass, and grids of soft gray stone tiles. In the paintings of Pieter Saenredam they are places where there are no views to the outside world and where people are only small interruptions in the perfect order of blankness and emptiness.

Today, few new churches are built, and it is becoming more and more difficult to find such havens in the busyness of the business city. Spirituality has disappeared into art, which is highly valued by the Dutch. They have the highest concentration of museums in the world. It was Piet Mondrian who proclaimed that first the city would disappear, then the building, then painting, until pure spirit would reign. It seems as if the ideal of Dutch space is to build such emptiness into the fabric of the city, but there are fewer and fewer excuses to do so.

Such pure space has not appeared quite yet, but there exists a good example of the modern church. At the Delft University of Technology, the firm Mecanoo has lifted a piece of meadow up to house a library underneath. They started with the need to create a strong void that would let one of the few expressive monuments on campus, a central lecture hall designed by Van Broek and Bakema in 1954, stand out while not offending the rows of houses that stand across the canal. They also realized that technology has made empty space possible; the computer, which works in seemingly invisible ways and is very space-efficient, is a compact object around which space can float.

Mecanoo pushed all the library's real books into tightly packed storage under the basement, lifted the grass up into a triangular field, and created a large space between these two. Here is the modern equivalent of the airy church interior (though the architects compare it to an airport), whose altar is a blue-painted wall in front of which the most-used books stand. To complete the analogy, a conical spire rises up from the middle of the reading room, piercing the roof, and emerging as a tower above the meadows, echoing the spires of the churches Vermeer once painted.

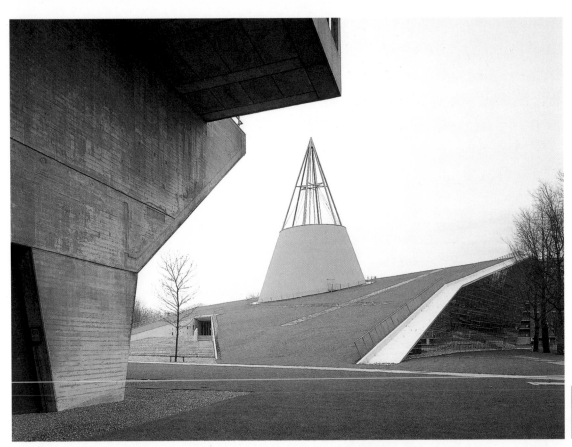

Exterior and interior of the Delft University of Technology's Central Library, by Mecanoo, 1997

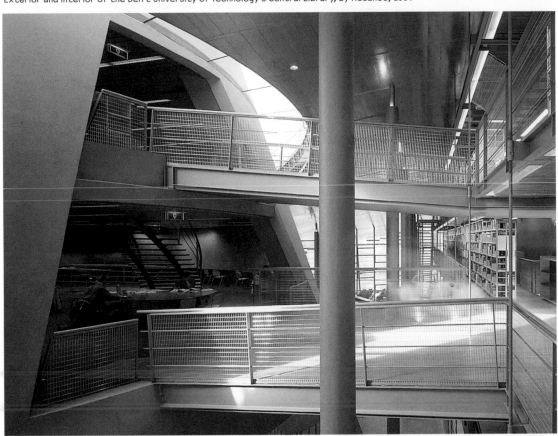

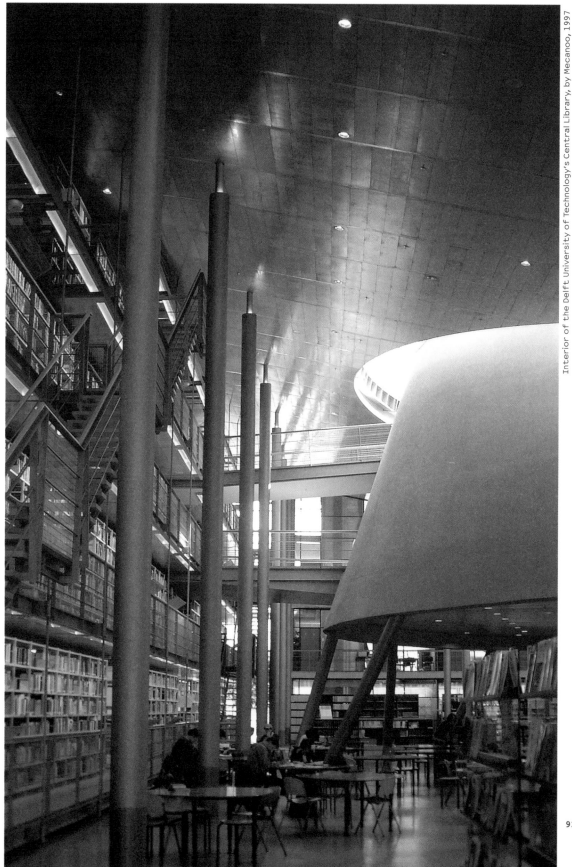

centraal museum

If the church brings a little bit of heaven into the middle of the city, the windmill reminds us of all the hard work needed to create the ground beneath our feet. Windmills were not invented to pump water, but they proved very effective at this task. The poldering of the area lost to the St. Elizabeth's Day Flood of 1421, and of the areas north of Amsterdam in the fifteenth and sixteenth centuries, produced the lines of rotating crosses that have become so beloved. Ubiquitous and slightly enigmatic in their engineering, the windmills appear as abstract markers on the land, their simple shape and repetition creating an order all their own.

In this way, churches and windmills mark two aspects of space in The Netherlands. The first represent a disciplined spirituality, while the latter signify the vast engineering project that made the fruitful land. They are two signs of the invisible, two celebrations of empty space. One of them represents an absolute and essentially unknowable void, that of God and soul, and the other a potentially productive one, that of the meadows that produced wealth from the watery void. Today one is the inward-turned icon of Dutch space, a remnant of a former system of beliefs, while the other is a reminder to inhabitant and tourist alike of what makes the spatial arrangements possible.

The windmills are also the only vertical elements in a predominantly horizontal order. That order includes the dikes around the rivers— usually two or three layers of them, so that some meadows can be used in the summer and later be flooded—the major drainage canals and their tributary ditches, which also serve to bring water to the crops, and the locks and sluices that regulate the flow of all this water. It is a patchwork system of local necessity, responding to the complex flows of the various rivers. Only in the nineteenth century did the scale of the polders increase in areas such as the Haarlemmer-meer, just west of Amsterdam, while larger canals were built purely to facilitate shipping. Finally, in the twentieth century, the Dutch started to impolder the Zuider Zee, turning it into IJsselmeer. Here they developed a rationalized, abstracted, and larger (and thus modern) version of the traditional polder landscape.

Mondriaan stamps for the Dutch Post Office (PTT), by Walter Nikkels, 1994

The first major piece of new land in IJsselmeer was the Northeast Polder. After it was completely reclaimed in 1937, the polder was laid out in a pattern that mimicked the traditional landscape, though the meadows and the grid of irrigation ditches were slightly larger. It is as if the nature of the Dutch landscape became clearer and more visible here. What is most beautiful about this area are the farms, each one designed to look alike. In each, the house is a brick structure with a sloping tile roof, but one that is so abstracted that it looks like a child's drawing. The barns have concrete faces whose grid has, over the years, been filled in with various windows and exhausts. The agricultural vernacular has turned into a repetitive and open order that incorporates the grid of irrigation ditches.

After the Second World War, the Southeast Polder was re-claimed, and modernists and traditionalists fought the same battle as they had in Rotterdam, arriving at compromises that here encompassed complete landscapes. Picturesque layouts and traditional row houses mingled with grids and "superblocks" in towns such as Lelystad, creating strange hybrids that never quite reached the level of creative messiness of Rotterdam—there was so much more land here that things could happen in widely separated spaces.

Yet the new polders did recapture the excitement of making a new land. When I was a child growing up in The Netherlands in the late 1960s, I saw the last polder, the Southwest, slowly appear. First we watched the dredging equipment from the shore. Then we drove along the enclosing dike, with water on both sides of us. We came back a year later, and the water had given way to reeds. Still later, green fields appeared, and th en rows of trees cutting through them. Modernist landscape architect Alle Hosper designed this polder as a patchwork of agricultural areas, newly planted woods, and towns. It was a collage of different forms of green. It was also, to me, all new, big, and miraculous in its finished quality so soon after it had been just water.

NEDERLAND 80c
De Elfstedentocht
...staat voor heroïek. Journalist Jan Feith zag bij de eerste officiële tocht (1909) al 'zwarte schimmen' in de 'griemelige mist'. De barre tocht van 1963 is legendarisch,

NEDERLAND 80c
De bevrijding, 1945
...vond trouwens officieel plaats op zes en niet op vijf mei. De gevoelens van saamhorigheid en eenheid die volgden hielden niet echt stand, maar de afkeer

NEDERLAND 80c
De Deltawerken, 1953-1997
...bleken noodzaak na de ramp van 1953. 'Het leeft in alle oorden, van Dokkum tot Maastricht, van hier tot Hindeloopen; Beurzen open, dijken dicht.' Het volk was

NEDERLAND 80c
De autoloze zondag, 1973 en 1974
...was een reactie op de Arabische olie-boycot. De auto stond stil. De zonzijde was dat we die tien dagen nauwelijks verkeers-slachtoffers kenden. We rijden nu weer

NEDERLAND 80c
De Nederlandse ruimtevaart
...toonde zich met de Astronomische Nederlandse Satelliet (1974) op zoek naar jonge, zeer hete sterren. Een sterk techno-logisch staaltje, maar het volk stond met

Hoogtepunten uit de 20e eeuw (Highlights of the Twentieth Century) stamps for the Dutch Post Office (PTT), by UNA, 1999
Reclaiming of the Southwest Polder, c. 1969

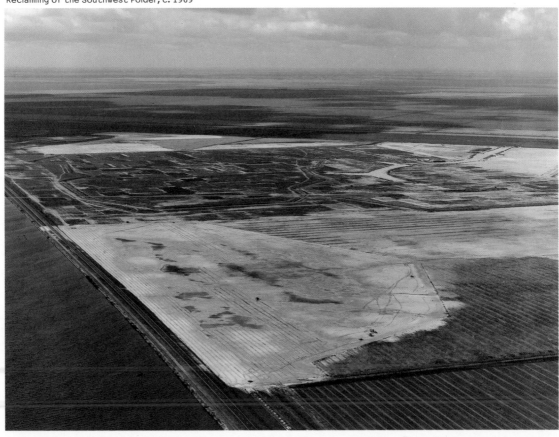

At the southern tip of this polder, a new town arose. Called Almere, it was meant as an exurb of Amsterdam. It had been envisioned by Cornelis van Eesteren, but was laid out by Teun Koolhaas, who still lives and works there. Koolhaas (a nephew of Rem Koolhaas) viewed the town as a series of clusters that warped and turned inward the vast stretches of the surrounding polder. In his plans, the tension between logical arrangement and picturesque planning were to become unified in one rambling but logical accumulation of what he called "living nodules."

In the late 1970s, one could visit the first clusters of homes, designed to resemble small suburban enclaves huddled together in the vastness of this new land. Then a town center appeared, complete with a train station and a shopping mall. A town hall, a hospital, and a square all found their place in the plan, though their architecture was not particularly noteworthy. The neighborhoods consisted of rows of two-story houses, just like you could find anywhere in The Netherlands, lined by small canals and irrigation ditches. Schools and community swimming pools interspersed the neat grid.

Yet there was room for experimentation here. Architects built what they called "wild" (as opposed to sanctioned and standard) houses, and the swimming pools had arched roofs, exposed wooden beams, and other expressive elements. As the town developed (it is now home to more than 200,000 people and is supposed to grow to 500,000), people complained, planners changed their minds, and new neighborhoods took on radically different forms. A new kind of picturesque planning appeared: tall apartment buildings lined curving lakes, little cul-de-sac streets were sheltered behind the large boulevards, and undulating berms hid the bus lanes that circled the city. The brick row began to fragment and change shape, the roofs took on strange slants, and all kinds of distortions appeared. Some houses were even round or had columns in front of them.

Today in Almere, one first comes across a round metal office building, designed by De Architecten Cie. It is the best of the bunch in an office campus that could be anywhere. A tall apartment building, designed by Rudy Uytenhaak, beckons on the horizon. At the center of Almere, a town barely thirty years old, bulldozers are tearing up buildings. Here Rem Koolhaas/OMA has designed a new city center, complete with multifunction buildings that are meant to bring a sense of excitement to this artificial town. The buildings he and his team are putting down on this flat land are warped, confusing, and contradictory. They turn planning on its head, wrapping the structures in on themselves. Almere is turning from town into metropolis by careful design.

On the outskirts, architects such as Liesbeth van der Pol are importing foreign images—including grain silos she saw in the midwestern United States and Airstream trailers—and converting them into housing blocks. This gives new inhabitants something recognizable to call their own. Ben van Berkel designed a line of metal-clad bungalows whose complex geometries turn in on themselves, creating (expensive) moments of privacy. Across a small irrigation canal from these modernist houses are rows of brightly colored homes, designed by Laura Weeber. These buildings give owners the possibility of not only identifying their own home but also adding on to either end of the house, creating a degree of individuality within seried ranks.

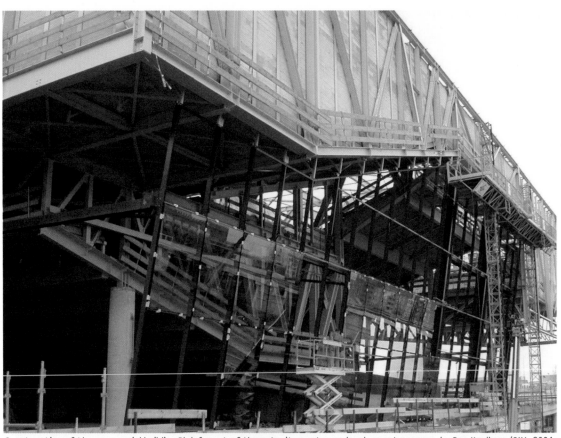

Construction of the commercial building Blok 6, part of Almere's city center redevelopment program, by Rem Koolhaas/OMA, 2004
Housing built as part of the Gewilde Wonen (Desired Living) project for the Almere Expo 2001, Almere, by Laura Weeber, 2001

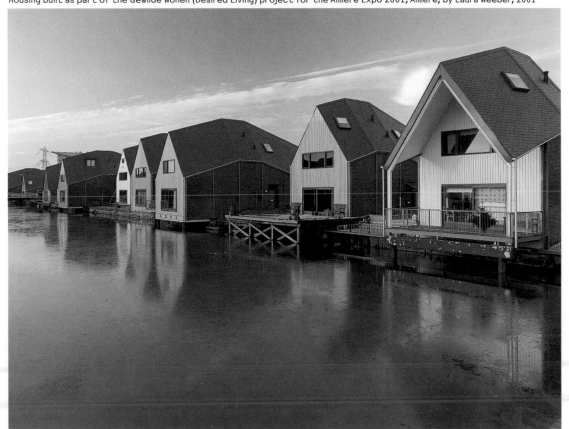

Red Rascal residential buildings, Almere, by Liesbeth van der Pol, 1998

Outside of town, works of art stand in the middle of the polder. Architect Daniel Libeskind slashed a diagonal through one of Alle Hosper's gridded forests, creating an allusion to another, unknowable order at a vast scale. Richard Serra did the opposite, aligning the top of his diagonal slash through the green fields with sea level, so that viewers could understand that the land they occupy while looking at the piece is actually, but for the grace of human artifice, underwater.

But something is missing in all of this increasing complexity. The spatial puzzle gets more and more intricate, but the tracts of open land through which one moves and by which one understands the whole game of three-dimensional organization are disappearing. Though Hosper's dramatic grids of trees and long rural boulevards are still visible, agricultural space is under seige. Some 70 percent of The Netherlands is still agricultural, but more than two-thirds of that land is not productive. It is subsidized not only so that the Dutch can maintain the myth that they grow their own food (over 80 percent of the food consumed in The Netherlands is actually produced elsewhere, while an equal amount of the country's agricultural products are exported); it is a way of preserving open space. As the population grows, that artificial emptiness is increasingly coming under attack.

New subdivisions are appearing on polders and meadows all across the country. Five years ago, the VROM ministry decided that the country needed half a million new homes. They designated plots of land next to most major cities as VINEX locations (named for the Fourth Policy Paper on Spatial Arrangement Extra, or Revision). The first neighborhoods appeared almost instantly and were disastrous monocultures of brick sameness. They were built in places that were not always the most logical but were chosen, it now appears, because of the collusion between developers and bureaucrats. Dutch planning was beginning to look like the desperate attempts to control sprawl one finds all over the industrialized world.

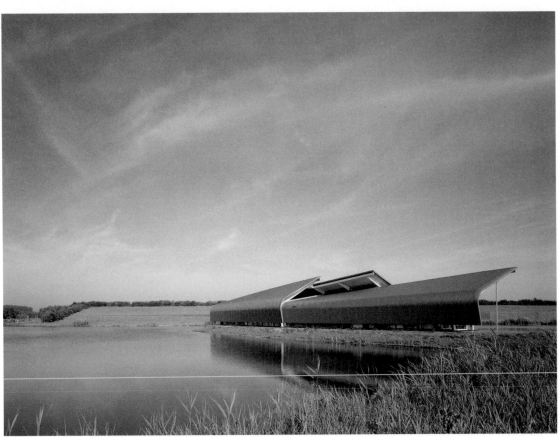

De Verbeelding Art Pavilion, Zeewolde, by René van Zuuk, 2000
Sea Level, Zeewolde, by Richard Serra, 1996

By now, planners have learned from their mistakes (something the Dutch, who are very self-critical, seem especially adept at) and have made much more complex places. The best of the bunch is Leidsche Rijn. Operating under the directorial authority of former Rotterdam city planner Riek Bakker, the young architecture and urbanism firm Maxwan designed the new town's master plan, which was then implemented by the likes of Frits Palmboom and former OMA employee Kees Christiaanse. Instead of razing what was there, these planners created new rows of housing within the existing meadow structure: the inhabitants look from their backyards at meadows filled with sheep, and the straight roads running through the new neighborhood turn into narrow country lanes lined with willows. In the hands of various young architects, the normal brick housing rows were distorted and reinterpreted, but the planners' respect for the grid of meadows, which they maintained as they laid out the building plots, controls the excesses of form.

A sense of what humans can do with the established order gives life to an otherwise rather rigid geometry. This becomes especially clear in the "artworks," as the Dutch call the infrastructural interventions that are needed to create privacy and mobility between these plots: the artificial dikes that hold back not the river but the noise of the adjacent highways; the carefully planted access boulevard that leads into the area; and the design of the roads, bicycle paths, and walkways in Leidsche Rijn itself. A set of bridges, designed by Maxwan, separates car, bicycle, and pedestrian lanes from one another, as if the the road system were coming apart. The dike that separates the new neighborhood from the highway that runs to its south is a dramatic piece of landscape sculpture. It is an abstract, elongated version of the prototypical dike. Where it ends, the planners left Leidsche Rijn open to the view from the highway approaching from the west. Driving toward the nearby city of Utrecht, you can see the lines of new houses, mixed with carefully spaced towers, standing against the sky like a rationalized version of the traditional village, with its windmills and church spires. The east side of Leidsche Rijn is slated to become a completely new landscape bridging over the bordering highway. Artists and landscape architects will collaborate to make art out of infrastructure.

The Dutch love the word *ontsluiten*, which means to unlock or open up. Documents can be opened, but so can cities. Infrastructure, in the view of the bureaucrats at VROM and their colleagues at the Ministry of Transportation and Water Management, is a form of unlocking a community. As such, it should not just make things accessible but also reveal itself and what is hidden beneath. A road becomes a way not just to get somewhere but to make clear how the path itself works. Infrastructure is the means by which one can understand the work that goes into making this artificial land. Thus to many Dutch, the structures that make the roads, the sound barriers, and the bridges are not a necessary evil that allow them to move through and inhabit the land, but rather beautiful marks on the land. They painted them in the seventeenth century, and now the government is commissioning artists to document the construction of the high-speed rail line through the middle of the country. In a culture that eschews monuments, infrastructure is the source of the often large-scale objects still open for public experience. As these objects meet the demands of traffic and the force of water, they are what curves away from the geometrically defined flatness.

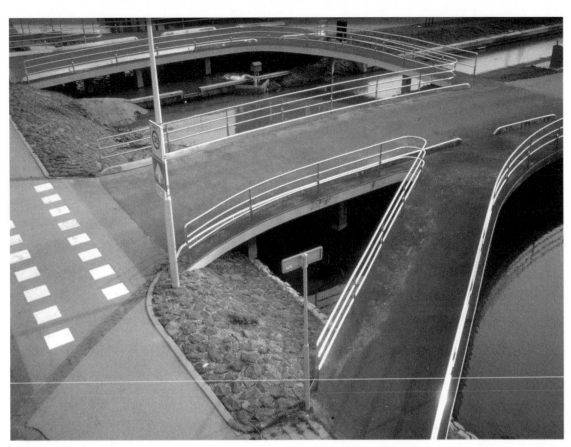

Bridges in Leidsche Rijn, by Maxwan, 2001

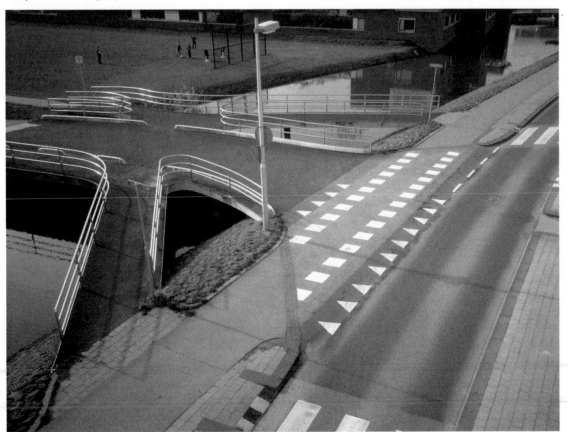

Film stills from **Railmovie,** an abstract animation of the moving landscape as seen through a window of a high-speed train, conceived for the High-Speed Line (Atelier HSL), by Lust, 2002

Lining the edges of the polders is a new generation of windmills, their gently swooshing, completely abstract forms generating clean electricity. Along the major roads, sound barriers offer modern versions of the dike, though they also isolate motorists from the surrounding landscape. The high-speed train line is leaving bridges, tunnels, and other large accumulations of concrete in its wake as it surges north from Paris to Amsterdam.

This is not a new phenomenon. The building of new infrastructure, land, and dwellings has always had a heroic quality in The Netherlands. The legend of Hans Brinker placing his finger in the dike has become a fixed image of The Netherlands around the world, but to the Dutch the dike and other infrastructural elements are the result of a collective effort in which they take great pride. When I was young, the Delta Works were under construction. This was a huge project to control the sea that periodically swells around and over the islands and peninsulas of the province Zeeland. A large flood in 1953 killed thousands there and created the political will to finally dam the branches of the Rhine at their outlet. When the sluices and dams were ready, I drove over them. There were no precipitous drops, as at Hoover Dam, to thrill tourists visiting man's monuments to a victory over nature. There were no industrial structures towering over us. There was just a new road, and a way to walk on what had been water.

The Dutch are now finding new ways to structure and celebrate their battle with water. At the building site for the last of the dams, Neeltje Jans, the architect Lars Spuybroek has used advanced computer-aided design techniques to shape a Water Pavilion. It is part of a complex of educational structures in a landscape laid out by Paul van Beek to look like a rationalized version of dunes. Unlike most Dutch structures, this Pavilion is not made out of brick. It is a slithering, metal-clad sea creature that nestles in the artificial hillocks and rows of grass. Inside this snake-like building, there are only sloping surfaces and mist. It is a fluid place; space here has become completely unstable. It is the continuum the computer makes possible and economists tell us the new economy demands. It is also the supremely Dutch space of water—but now it is contained and has turned into architecture itself.

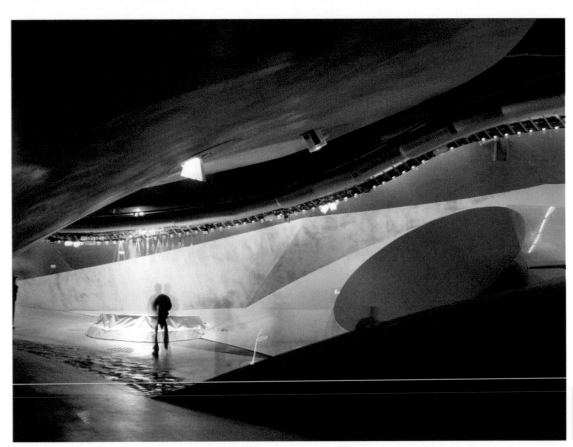
Interior of the Freshwater Pavilion, Neeltje Jans, by Lars Spuybroek/NOX, 1997

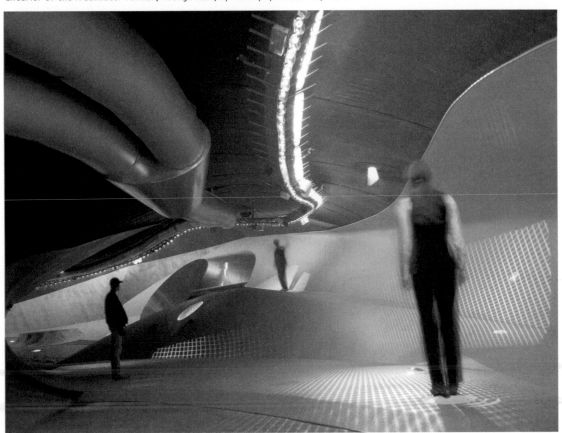

Exterior of the Freshwater Pavilion, Neeltje Jans, by Lars Spuybroek/NOX, 1997

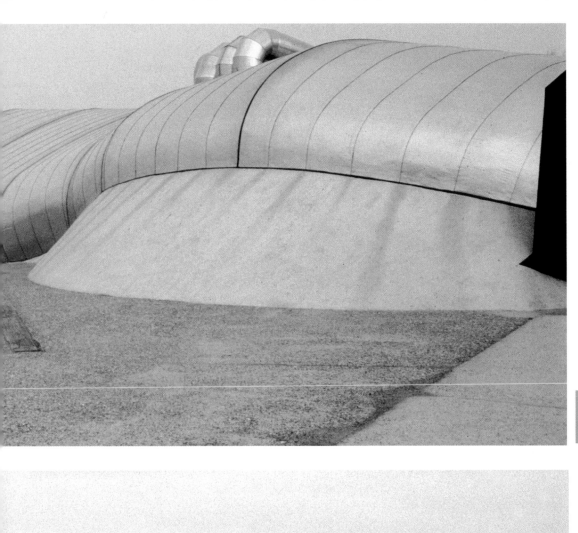

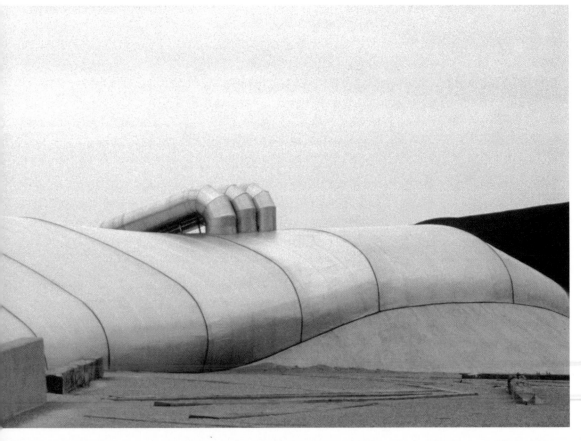

The Erasmus Bridge, connecting the northern and southern shores of Rotterdam echoes this fluid space. The southern shore of the city has always been the less privileged, working-class area. As the harbor has moved farther to the west to accommodate larger and larger container ships and refineries, it has left behind land ripe for redevelopment. The same team that planned Leidsche Rijn, Bakker and Christiaanse, has turned the northern section of this area into a dense residential neighborhood, leaving fragments of old warehouses and harbors to give focus and order to this vast new landscape. To connect the new district to the business core on the other side of the river, the city asked architects Ben van Berkel and Caroline Bos to design a bridge. In 1996, they came up with a single-stay suspension bridge, the pylon leaning back like a person straining to hold up the slim bridge deck. Painted light blue, the bridge has an ethereal quality.

The combination of anthropomorphic and sculptural qualities has made the Erasmus Bridge the new icon of Rotterdam. What makes it work so well as a visual icon is the complete integration of this over ninety-meter tall tower with the city's infrastructure. The bridge starts with the road rising off the false flat, imperceptibly at first, then freeing itself from the dike and moving over the water. As it rises up, it sheds the complexity of street furniture and lighting systems. Soon, all that is left is an unfolding of that street into concrete barriers and divisions, a curling up of tentacles of steel to form lights, and a plane suspended from the spreading web of cables. As the bridge arches over the Maas River, it takes part of the city with it, forming a parking garage underneath its deck, a market next to it, and a concrete bunker for a harbor-tour company.

The bridge is also a heroic marker announcing the beginning of one of The Netherlands's grandest landscapes. If one crosses the Erasmus Bridge and follows the harbor as it flees the city for the shipping lanes of the North Sea, one reaches the province of the powerful Port Authority of Rotterdam. Here, along the new freight line built to connect rail traffic to the harbor, lies the Southern Distribution Center, one of the most remarkable of Dutch spaces. It looks like a normal industrial area whose anonymous boxes could contain anything from cans of soup to sneakers to bales of hemp, with trucks shuttling back and forth between them and the adjacent highway. To the south of this little complex is a serpentine wall. It was built out of rubble from the old harbor. Rising above the warehouses, it screens off any view of the rest of the world. But there is one narrow gap where two curves don't quite meet. Walk through it, and you are suddenly in another world. A small irrigation ditch separates you from meadows where cows graze. In the distance is a small village with a church, a few green-houses, and, even farther, a little factory. It is a perfect view of a Dutch landscape, separated by a fragment of the "unlocking" mechanism of the Rotterdam harbor from the industrial might to the north. The construction of the harbor, the opening up of possibilities for trade and commerce, have not destroyed but instead made possible a carefully framed view of the landscape.

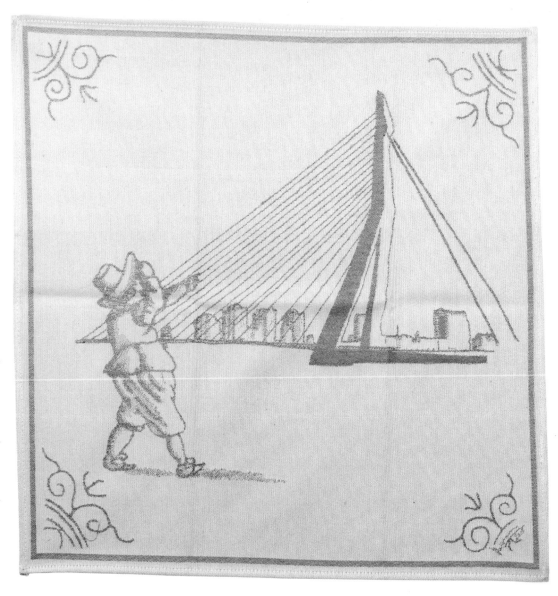

Napkin featuring the Erasmus Bridge in the seventeenth-century Delft Blue style, by Miriam van der Lubbe, 2003

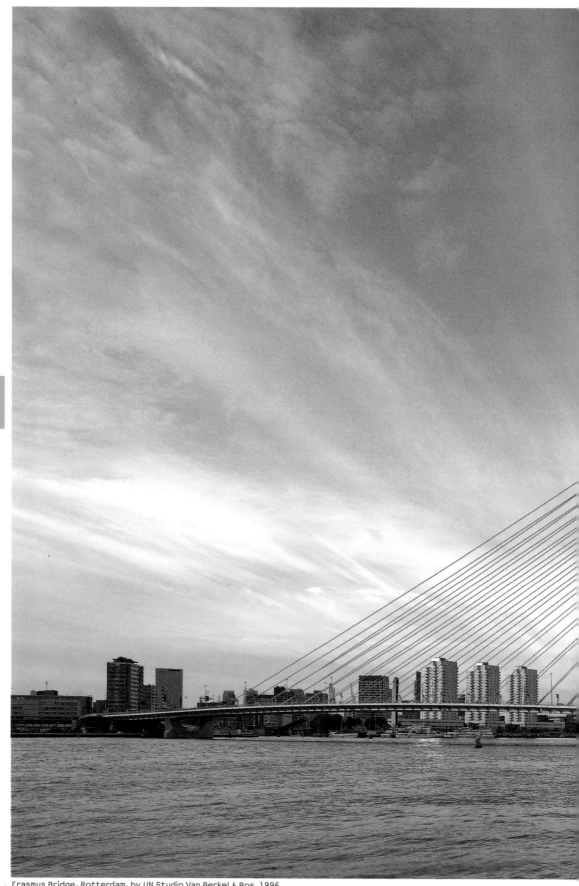

Erasmus Bridge, Rotterdam, by UN Studio Van Berkel & Bos, 1996

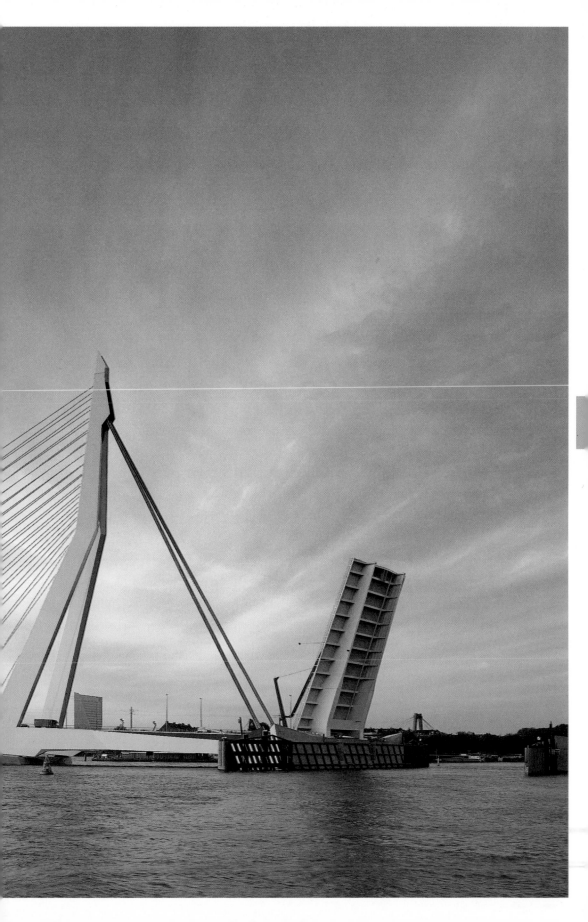

Farther toward the west, that same mechanism of using infrastructure both to make and to preserve land but also to unlock and frame an understanding of existing spaces becomes monumental. A giant rotating dam can close the whole river off in case of a flood. Alongside it is a kilometer-long row of twenty-meter-tall concrete columns. Closely spaced, they look like pieces of sculpture meant to mark the land. They are a windscreen, designed by Maarten Struijs, that helps shelter riverboats as they move up a side canal to unburden the large container ships of their cargo. Infrastructure again becomes sculpture.

At the end of the road is the Europort, or the Maas Expanse. This is a new polder, larger than all of Rotterdam itself, that is not meant for agriculture. Instead, the expanse of sand is being carved up into harbors. Along the new inlets, robotic trucks glide back and forth, unloading container ships taller than skyscrapers with the help of only one or two people. Mounds of iron ore stain the new land red. It is a landscape of heroic industry. It is also a major stopping point for migratory birds, and VROM has negotiated the preservation of just enough of this new space to let the birds find a temporary home between the cranes.

As at the Southern Distribution Center, a different world lurks just around the corner from this hybrid landscape. A line of dunes protects the harbor against water and wind. Here the landscape of infrastructure disappears, except for the view of dozens of ships "parked" in the sea waiting to come into the harbor. The dunes look as if they have always been there, though they are only a few decades old. Hang gliders, windsurfers, and nude bathers have discovered the five-mile stretch of new and unused beach in front of the dunes. Industry and leisure, new land that looks like nature; here the old ideas of polders, windmills, and churches have given way to a new reality.

This new space is still being built. Beyond the Maas Expanse a second landscape is planned. It will be even bigger and will turn this beach into just a little strip of land within an even larger recreation area and nature preserve. This will be the next frontier for a country always expanding its artificial flatness. Next on the drawing boards over at VROM is an entire airport out in the sea, or a new city in front of The Hague. The horizon ever recedes; space is always made and occupied. At VROM they figure out how the Dutch might live on, organizing and protecting the space they create every day.

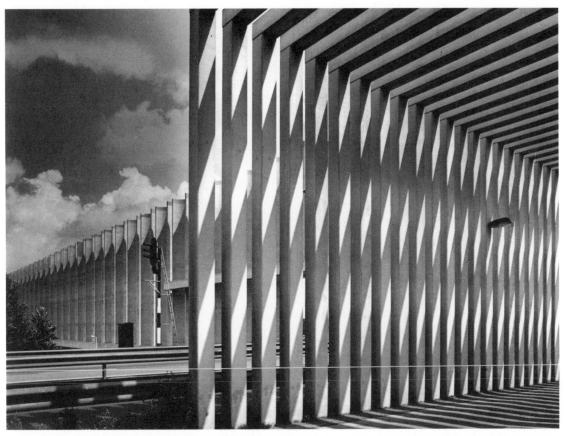

Windscreen along Caland Canal, Rotterdam, by Maarten Struijs, 1985

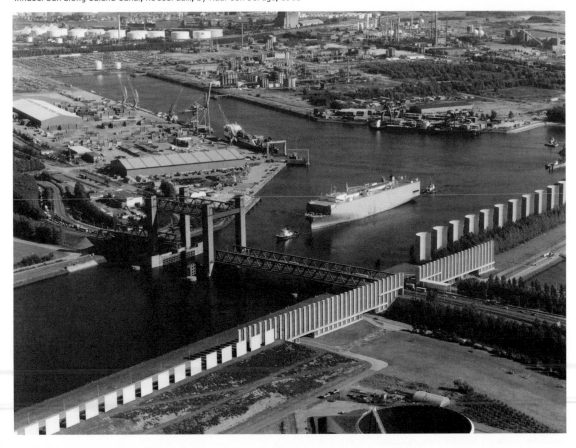

Detail from **Dyke II, Sunday Morning, December,** by Bas Princen, 2001

BRILLIANT ORANGE

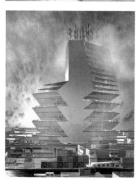

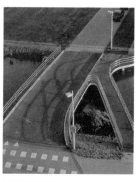

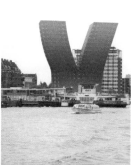
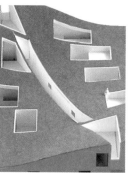

Gerard Hadders — In the '80s, a design critic for a national Dutch newspaper called for the imprisonment of graphic designer Gerard Hadders, then member of the legendary design group Hard Werken. His crime? An explosive book-cover design for Umberto Eco's novel **The Name of the Rose**. It might have been better if the critic had ordered Hadders executed on the spot; it would have avoided the national embarrassment caused by the designer's subsequent cover for the book **Mart Stam's Trousers**, a refreshing look into Dutch moral modernism, on which Hadders had the audacity to place an image (his own photo) of Rotterdam's "urban toleration zone," where specially conceived parking spots allow drug-addicted street prostitutes to service their clients. For the WiMBY! project headed by architectural historians Crimson, Hadders photographed many of the inhabitants of the decrepit satellite town of Hoogvliet and exhibited them on oversize banners throughout the city. These banners not only added a (photo)graphic and humane dimension to Hoogvliet's streets but also emphasized the procedural complexities of working in an open society with many stakeholders.

Crimson — Enter the offices of Crimson, a team of architectural historians in Rotterdam, and the keen observer will notice a picture of the '70s soccer star Johan Cruijff. The captain of the legendary Dutch squad that introduced the total-football concept to the sport, Cruijff helped conceive their revolutionary way of creating infinite space within the limited boundaries of the pitch. Crimson possesses a likewise incomparable logic, which is authoritatively pointing the way to unexplored possibilities in urban planning and architecture. The latest example is WiMBY! (Welcome into My Back Yard!), a project for the restructuring of the industrial satellite town of Hoogvliet that constituted the firm's contribution to the International Building Exhibition (IBE). Fighting the reigning phenomenon of NiMBY ("not in my backyard")—the individual fear of collectivity prevalent among urban dwellers—Crimson wants to "seek out a new design and organization culture in which complexity is deliberately confronted in order to discover and apply innovative and pioneering possibilities." What's more, "the scale, complexity and duration of the urban restructuring of Hoogvliet make it unique in the Netherlands and exemplary of many urban conditions throughout the world. That is what makes WiMBY! primarily a quest to discover a potential future for all those New Towns, satellite towns, Trabantenstädte, Garden Cities, Villes Nouvelles, and growth hubs that have been built in the twentieth century."

Maxwan — For the creation of thirty thousand dwellings in the new town of Leidsche Rijn, the architects and urban planners at Maxwan first developed a master plan establishing the common ground and vision of all stakeholders. Basing themselves on Crimson's Orgware (Organizationware) theories, they concentrated on the administrative, commercial, and political factors that precede the implementation of certain ideas and knowledge (software) and the construction and deployment of physical elements (hardware). Maxwan's method focuses less on centrally controlling the details of every structure and more on negotiating a set of urbanistic qualities that the many stakeholders have to agree on and commit to. "The negotiations were not done in order to get the design realized; the design was made to negotiate with, to get the city built," writes Wouter Vanstiphout, principal of Crimson. Their scheme is the living embodiment of the famed "Polder Model," which Maxwan developed further in the "Logica" project for the International Building Exhibition Hoogvliet. Logica is an "urban planning manual for the housing structure, traffic system, green areas and borders of Hoogvliet" that charted the input of and gave voice to all stakeholders, delivering twenty-four scenarios and four recommendations for possible futures of Hoogvliet.

NL Architects — As students they commuted together from Amsterdam to their architecture school at Delft University, a daily one-hour drive. It led to ideas such as a voluptuous, one-hundred-meter-long woman revealing herself in a freeway sound wall made of red bicycle reflector lights; or turning the omnipresent **M** for McDonald's upside down and creating "W," so-called Wild Spots, adventure lands where parents could drop off their kids. Together now for over a decade, the friends became NL Architects, translating their play with aspects of everyday life into forms that become iconographic sculptures. In one of their award-winning projects, the Basketbar at the Utrecht University complex Uithof, they unearthed an unexpected possibility for the obligatory handicap ramp, turning it into an orange-painted skate ramp. For WiMBY! they designed the Pilot Plant, a concept for a structure that "creates a concrete and visionary picture of the relationship between city, knowledge, industry and harbor in the twenty-first century. The intention of the Pilot Plant project is to reinforce the connections between the town of Hoogvliet and the port and industrial complex of Rotterdam."

T(c)H & M — Graphic designer Felix Janssens is the driving force behind T(c)H & M, the Office for Tele(communication), Historicity & Mobility, which researches, develops, and builds communication structures. In interdisciplinary teams of writers, critics, philosophers, architects, artists, and Web designers, the office works on projects in the field of city branding and conceives identity programs for cultural institutions. For Leidsche Rijn they developed "Beyond Leidsche Rijn," a conceptual freeware, infrastructure, and tool kit for the residents of the neighborhood to become part of the communication and decision process that is creating the identity for the newly built city. T(c)H & M's identity programs take a stand against the usual top-down approach of branding, handing all parties involved open and transparent tools with which to express their own diversity, in order to create a coherent social reality that reflects its inherent heterogeneous makeup. As Janssens states: "Culture is the motor of any city, and through design one can help the new inhabitants make their own connections and shoot roots in the community."

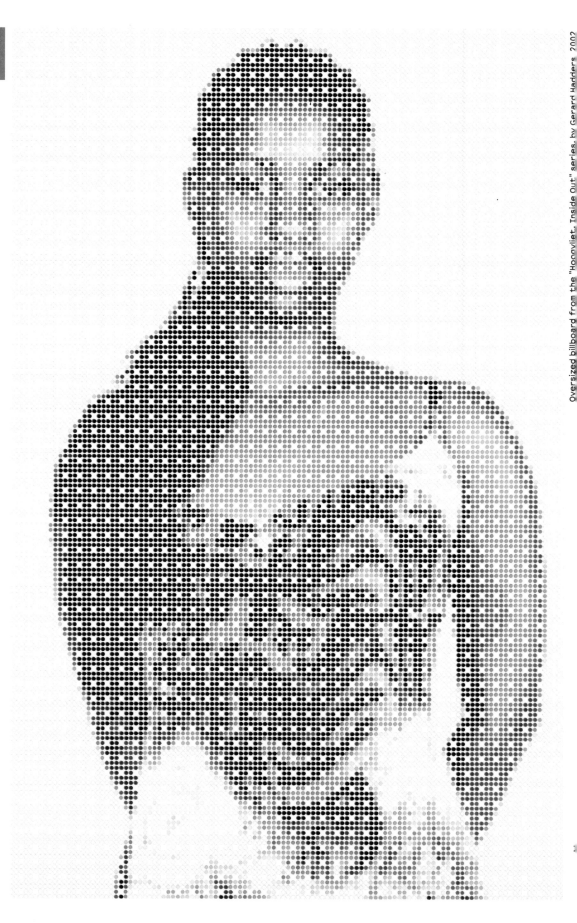

Crimson

with Michael Speaks and Gerard Hadders

Mart Stam's Trousers:
Stories from behind the Scenes
of Dutch Moral Modernism

010 Publishers

Heerlijkheid Hoogvliet

Een zomerdorp in Hoogvliet waar mensen feesten, sporten, honden trainen, zwemmen, duivenmelken, kunst maken, muziek spelen, in het gras naar films kijken en nog veel meer.

WIMBY! Welcome into My Backyard!

Heerlijkheid Hoogvliet (Loveliness Hoogvliet) poster, introducing the summer community Hoogvliet, by Floor Houben and Minke Themans, 2002

01-W0G0B0V0

02-W0G0B0V1

03-W0G0B0V2

04-W0G0B1V0

05-W0G0B1V1

06-W0G0B1V2

07-W0G1B0V0

08-W0G1B0V1

09-W0G1B0V2

10-W0G1B1V0

11-W0G1B1V1

12-W0G1B1V2

13-W1G0B0V0

14-W1G0B0V1

15-W1G0B0V2

16-W1G0B1V0

17-W1G0B1V1

18-W1G0B1V2

19-W1G1B0V0

20-W1G1B0V1

21-W1G1B0V2

22-W1G1B1V0

23-W1G1B1V1

24-W1G1B1V2

When the world influences you, but you can't influence the world

plug!

Join the majority, Only a minority is connected to the global networks

www.tchm.nl/undo

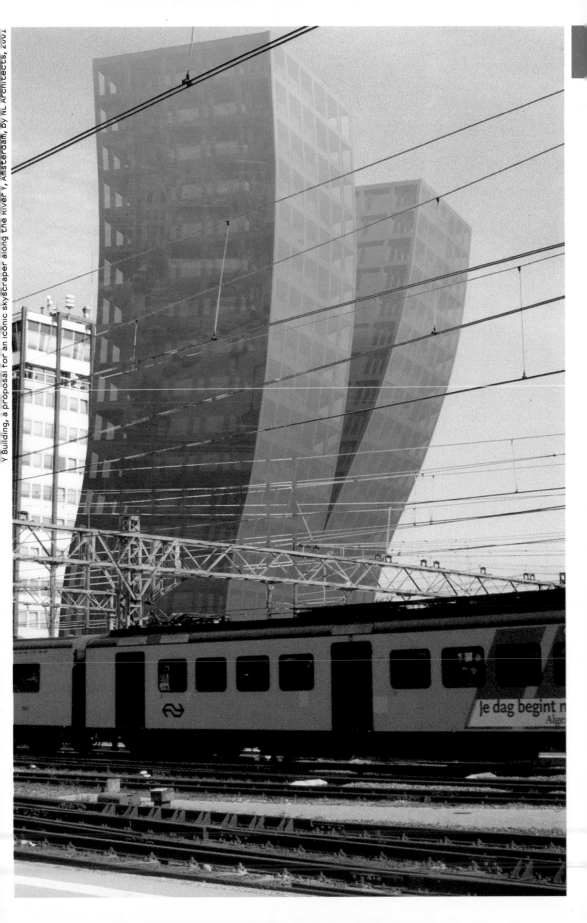

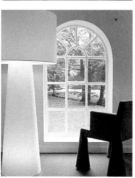

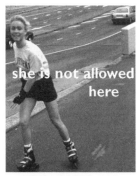

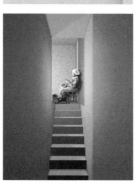

Droog Design — In the early '90s, at the Design Academy in Eindhoven, teachers Renny Ramakers and Gijs Bakker noticed a common approach in the work of a new generation of product designers such as Richard Hutten, Jurgen Bey, and Piet Hein Eek. Present was a "sparing use of resources; the frequent recycling of materials, products, and typologies; a deliberate lack of style; and the makeshift nature of some designs." The reigning sentiment in the designs was the dry twist the designers added to existing archetypes, taking rather than making form, always including a subtle commentary as part of the solution, telling a truth that exceeded the confines of the object. Thus Droog Design was born, as a way to package this work and sell it to the world. Financed by a fast-growing number of cultural funds, Droog Design has become synonymous with the worldwide success of Dutch design over the last ten years. Yet they are more than their national identity; they are becoming a global brand that connects with a network of like-minded people. Under the curatorship of Ramakers and Bakker, the likes of Hella Jongerius and Marcel Wanders were launched on to their own stratospheric careers, and the practice of design has grown richer with Droog Design's recent concepts on "space, fresh air, physical exertion, silence, slowness, time, handcraft...concepts that represent the true luxury of our day."

Marcel Wanders — Just before the 2003 blackout in New York, Marcel Wanders, during his lecture at the industrial design event IDSA, slowly undressed before a thrilled audience. **Business Week** reckons Marcel Wanders is "one of the most innovative people in Europe." The Dutch lifestyle magazine **Man** proclaimed him man of the year in 2002. Who is Marcel Wanders? In an interview with **Architectural Record**, he describes himself better than anyone else can: "I do not consider myself a Dutch designer. I am who I am, and, of course, what surrounds me influences me, but we live in a large world. When I was a child, I listened to the stories of Grimm, music of Vivaldi, went on vacation in Bordeaux, followed football in the UK. When I was older, I started reading Ken Wilber and Nietzsche, came across Tony Robbins and Deepak Chopra, learned lessons from the Dalai Lama. I am the poetry of my past days, a careful assembly of all these encounters...I like to make things light and with a sense of humor, but never a joke...There is only one Marcel Wanders: He is a designer, father, lover, writer, poet, troublemaker, friend. I can only be that all at once. I try with my designs to make a connection to real life and to contribute to the lives of people."

Jurgen Bey — "I can't come up with anything new; I only regroup what is already there," says Jurgen Bey, whose idiosyncratic concepts and designs have been a staple of the Droog Design collection since its inception. He feeds off the tradition and history of everyday objects, always slightly changing their narrative. Thus he gives old lamps a new lease on life by rolling a cylinder of semitransparent film around them, which becomes opaque when the light is off and seductively revealing when the light is on, and revitalizes decomposing leaves by compressing them into a biodegradable garden bench. Of particular interest is Bey's reuse of old furniture, which arises in many of his projects. Louis XIV chairs are wrapped together with a new high-tech polyurethane skin; the backs of chairs are stuck in raw tree trunks. In the book on the project "Bright Minds, Beautiful Ideas," author Louise Schouwenberg muses that "being deeply interested in the emotional meaning of things, Bey creates new images and works that provoke thinking and discussions about the value of the contemporary production machine."

Schie 2.0 — Schie 2.0 is a network of designers that researches the relationship between freedom and responsibility, sustainability and consumerism, nature and urbanism. After starting out with Jurgen Bey as Konings + Bey, and continuing on with Lucas Verweij and Ton Matton as Schie 2.0, industrial designer Jan Konings now leads the network on his own. "We don't need to invent anything," says Konings. "All we need to do is apply what is already there, and then actually do it." In his view, the obstacle to achieving anything in the supposedly liberal Netherlands is the labyrinth of institutional restrictions that lead to a lack of freedom and to passivity. To illustrate this, Schie 2.0 created 120 black-and-white images of everyday life, accompanied by a sentence referring to a certain rule. Ironically, the ministry responsible for most of these regulations invited Schie 2.0 to exhibit this work prominently in their lobby, causing Konings to remark, "One gets cuddled to death here. We wanted to formulate a counterpoise to overregulation and comfortism and start a debate on freedom. We think society should offer more freedom to people. Freedom involves responsibility, the responsibility to take care of yourself. An excess of given rules kills personal responsibility and ingenuity. It makes everything just average. We are governed by the average, we are one big compromise."

Urban Affairs — The architects Marco Vermeulen and Theo Hauben of Urban Affairs find themselves at the start of their career in a country with one foot "in a modernist heritage, built by the idealistic adage of light, air and space, and another in the more nostalgic and sentimental qualities of the charming and cozy, where a rich past is considered a precondition for character." They are concerned with the ways in which cities choose to brand themselves, often importing foreign icons rather than developing qualities already present in the urban fabric. Vermeulen and Hauben are interested in the role the architect plays in designing and cultivating an urban identity, in "everything that initiates, activates and reanimates urban life." Like their industrial (Droog) design brethren, Urban Affairs also "displays a belief in a world that can be reproduced rather than invented, a world that, in all its richness, simply requires rearranging." This is finely illustrated with their "airy apartment for a single" in a high-rise in Eindhoven, where the design of a combined kitchen unit and bath resulted in an almost six-meter-long granite butcher's table that integrates sink, hot plate, and bath.

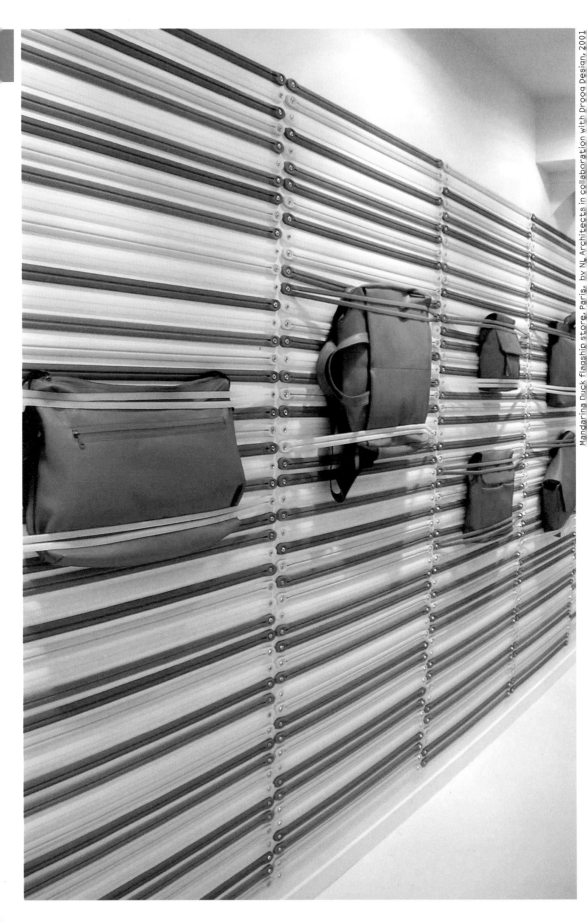

Mandarina Duck flagship store, Paris, by NL Architects in collaboration with Droog Design, 2001

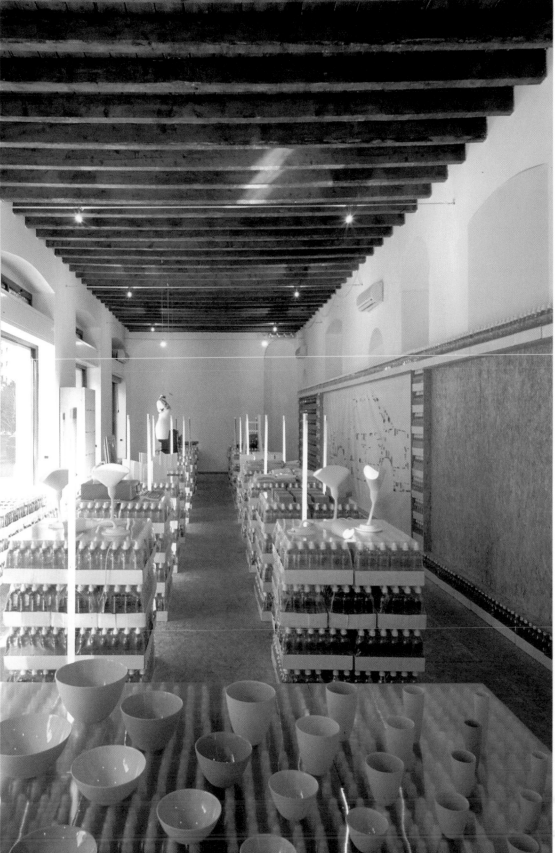

Droog water (Dry water) bottle and installation for the Droog Design exhibition, Salone del Mobile 2003, Milan, by Concrete, 2003

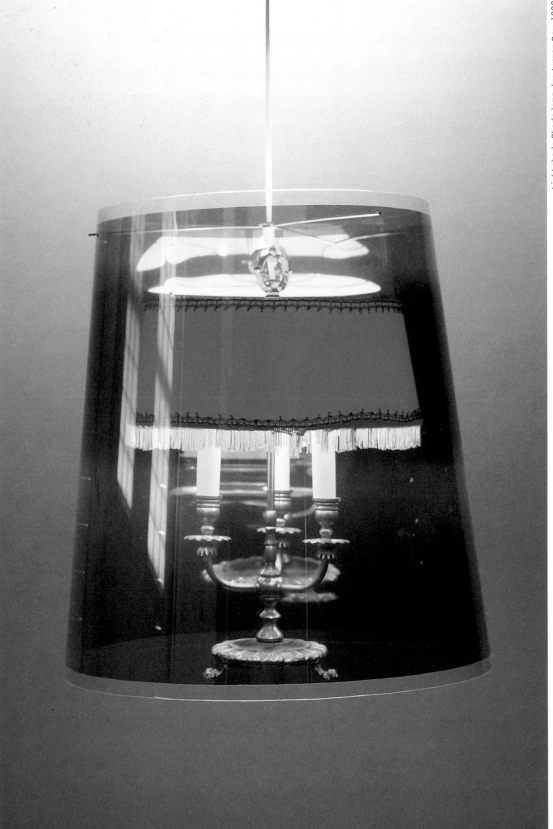

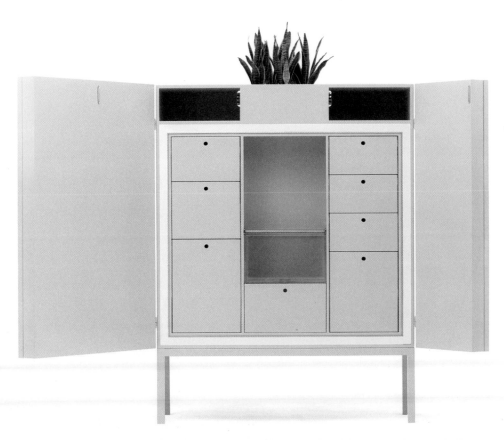

"Zeezicht, an airy apartment for a single," Eindhoven, featuring a bathtub and kitchen integrated into one unit, by Urban Affairs, 2(

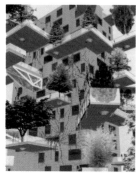
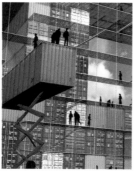
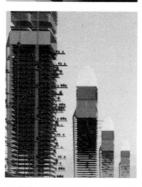

Het vormalfabet

Gemeente Amsterdam

Gemeente Amsterdam
Waterleidingbedr

ULTUUR
S CONFRONTATIE

Bureau MVRDV met Thomas Weldershoven en Niki Gonnissen.

Een schoenendoos
nogal in het oog spr

® Richard Hutten

BAR Architects — For the instrumental role that Joost Glissenaar played in realizing projects like the Villa VPRO and the Silodam residential building in Amsterdam, the venerable architecture Web site Archined jokingly referred to him as the G in MVRDV. In 1999 he went independent and founded BAR Architects with Klaas van der Molen, after winning first prize in Europan 5, a pan-European competition for emerging architects. Their "Sandwich City" proposal for the redevelopment of an urban wasteland in Amsterdam was never realized, but it did result in a string of commissions, enough for them to make the jump to private practice. A recently finished project of theirs is the Junkie Hotel, located in a monumental building in the old center of Utrecht. Taking their cues from data-intense research, the architects created a permanent shelter where the homeless enter through a long hallway completely wallpapered with photographs of Hedera Helix, or British ivy. Similarly—to ease the transition from outside to inside—the units, designed to house twenty-two people, are covered prominently with prints of the unwavering evergreen leaves.

Expo 2000 — The economic boom of the late '90s culminated in a sumptuous display of Dutch design at the World Expo 2000 in Hanover, Germany. Presented under the motto "Holland creates space," the Dutch entry was MVRDV's thirty-five-meter-high self-sustaining tower containing eight plateaus, each holding its own ecological environment, from sand dunes to forest, from a lake on the roof to an ice rink flanked by the chairs of Marcel Wanders. Like infrastructure and urbanism, nature is, in the view of the Dutch, something that can be planned for, designed, and constructed. The second contribution to Expo 2000 was **Remaking.NL**, an exhibition on projects that reconceive the Dutch city and land in ten regions of the country, providing an extensive overview of changes influencing the future of The Netherlands. Each region created its own exhibition in a shipping container that was airlifted by helicopter to a floating island in Hanover's Maschsee.

MVRDV — The need for decision makers to read a certain postindustrial numerology in statistical data is uniquely exploited by the Rotterdam-based architectural firm MRVDV. In the slipstream of Rem Koolhaas, the three MVRDV principals—Winy Maas, Jacob van Rijs, and Nathalie de Vries—have perfected the creation of "datascapes," a method of shaping space through complex amounts of data that usually accompany contemporary building and design processes. The information can supply scenarios the world is not ready for, as was the case with their Pig City proposal, another step in MVRDV's research into how a small country like The Netherlands will be able to tackle the problem of space in the face of its continuing population growth. In a country with almost as many pigs as people, the Ministry of Agriculture, Nature and Fisheries asked MVRDV to study the pig industry with regards to the space it occupies, the pollution it creates, and the diseases it unleashes. Their study of the data resulted in a proposal comprising seventy-six towers, each 622 meters high, that would house all pigs. With elevators regulating the flow from piglet to bacon from one floor to the next, these towers would optimize the production process of this resource-intensive sector. MVRDV was actually not joking when they stated the plan—presented as "just a concept"—could be realized. Architecture critic Hans Ibelings praised the courage of the proposal: "Pig City is a combination of creative imagination and a bookkeeper's realism. If the pig flat is a utopia, then it is a utopia without ideals."

Thonik Studio — Graphic designers Thonik work in a controversially fluorescent orange "shoe box" created by MVRDV, featuring a baby blue interior design by Richard Hutten. It is a "collaboration of kindred spirits," of people who share similar attitudes in their respective fields of graphic design, architecture, and industrial design. They are all designers with a love for restrictions, working from one clear concept, drawing their public into a world of ideas, presented with an iron logic. Design critic Ineke Schwartz captures Thonik on the cover of a book on their work by saying: "From the start thonik® have been at the forefront of a new generation of graphic designers. The designer as director, as conceptual artist, as strategist, as media expert and as obstinate busybody—thonik® cover all these roles with gusto. And with results."

Richard Hutten — The Centraal Museum in Utrecht asked industrial designer Richard Hutten to design outdoor seating for its restaurant's courtyard. Hutten observed his own son playing on an orange Skippyball, and thus the Zzzidt Object was born. Hutten calls himself not a form giver but rather a form taker. All form, he claims, is given, set in age-old archetypal shapes whose function is clear and proven. No new forms need to be sought; they are already available, ready to be reinterpreted, recombined, and reused. Hutten's work is finding a global appeal: a Richard Hutten Design Academy is being built by MVRDV in Seoul, South Korea, offering a curriculum devised by him in collaboration with the Design Academy in Eindhoven, whose unusual academic approach values both the highly conceptual and the eminently practical.

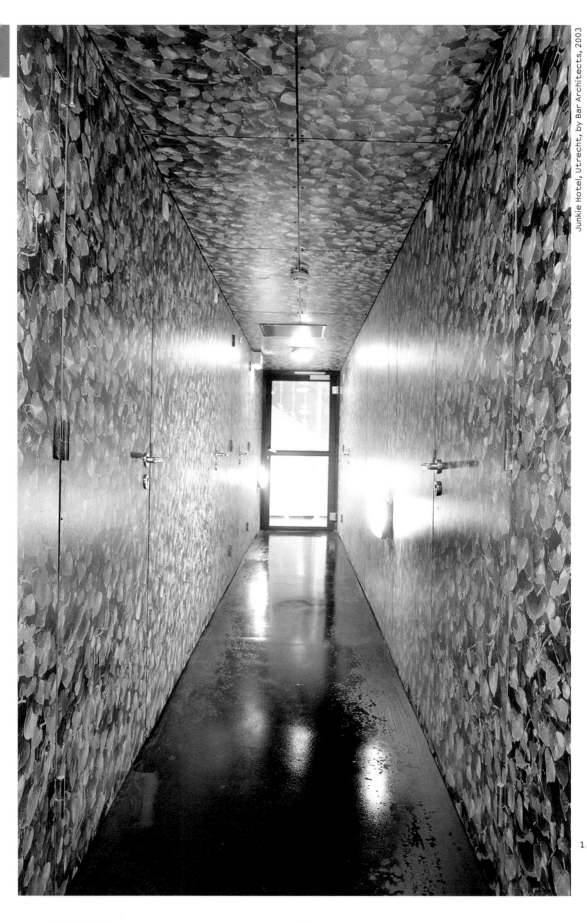

RE MAKING .NL

Cityscape | Landscape | Infrastructure

Exhibition catalog **Remaking NL**, by Vanessa van Dam, 2000

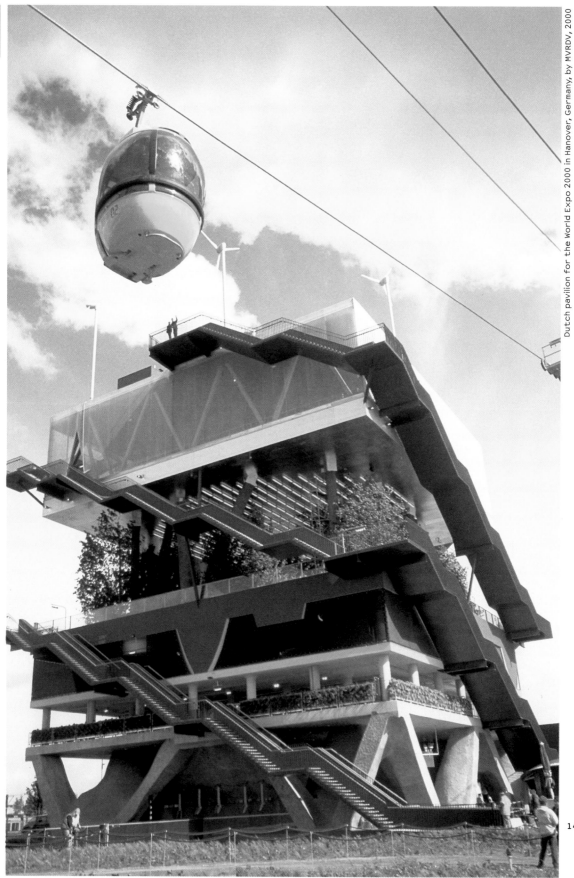

Dutch pavilion for the World Expo 2000 in Hanover, Germany, by MVRDV, 2000

Thonik Studio, Amsterdam, by MVRDV, 2002

Seeing Is Knowing Is Making

In 1995, the president of the trading company SHV, Paul Fentener van Vlissingen, asked graphic designer Irma Boom and art historian Johan Pijnappel to create a book that would celebrate the company's centennial. In a way this was a strange request, as SHV, like many other Dutch companies, has been very careful not to put itself too much in the limelight. The serious work of making money was something that happened in the background. Products could appear and were subject to advertising, of course, but the organization that put them on the shelves remained—along with its directors and shareholders—out of sight. SHV was also one of those strange Dutch companies that did not seem to have an identity. It had started as a trading company and grew rich by moving vast amounts of ore, wheat, and other staples through the Dutch harbors. Investments in other industries followed as the money that was gained not from making things but by abstracting value from them disappeared into an ever-growing portfolio of other companies. The directors and owners of the firm, most of them members of one family, built proper homes and collected art but did not go jetting around the world. They remained relatively anonymous. Theirs was a slightly mysterious company.

Fentener van Vlissingen is a little more eccentric. He lives in Africa, is highly involved in nature conservation, and organizes multi-disciplinary conferences on the future of the planet. When Boom accepted the job, she asked and received permission to delve into the company's archives. She spent almost two years going through annual reports, snapshots of company meetings, correspondence, accounting analyses, and files on investments. She culled this mass of material down to a stack of images that she organized into a book 2,136 pages long. Published in 1996, it did not so much tell the history of SHV in words as it showed the emergence and development of the holding company in images. Boom offered no moral, nor did she pass judgement on SHV's activities. She collected and researched, and in her act of selecting, sequencing, framing, choosing paper and binding, and engaging in all the other aspects of the graphic designer's craft, she not only made an art object, but also authored the book. Reading it, one could obtain a clear and almost encyclopedic sense of the company. SHV's existence as a fact, as opposed to a financial abstraction, was suddenly real.

Boom was working in a long Dutch tradition that started with the making of paintings, mirrors, and maps and continues to this day in the field of graphic design. It is a tradition of representing as accurately as possible all the artifacts of everyday life. The artist's work consists of organizing, crafting, and framing the information in such a way that it gives back to the viewer or reader reality in an altered form. This art does not tell a story or pretend to have a meaning. It just presents the facts, and in so doing it changes our perception of the relation between these building blocks of knowable reality. One might say that it reveals the true nature of things by exhibiting the relationship between things. This type of work has largely died out in Dutch art (though it is coming back in photography) but lives on strongly among graphic designers and some architects who have made the collecting, organizing, framing, and constructing of data their central focus.

The nature of the "realist" tradition has been most clearly defined—though somewhat controversially—by art historian Svetlana Alpers. Her writings on Dutch art seem particularly relevant here. "Seeing," says Alpers, "is knowing is making." What she means is that in Dutch art, what can be seen or experienced can indeed be known, for there is always a clear body of information on the subject matter at hand. What is known can, in turn, be made by using this information to reconstitute, recombine, and perfect the things one has seen. Creation produces a new order that is then again clearly visible, and thus the whole cycle can start anew. It is a world in which there are no hidden meanings or unseen places. If you look hard enough—perhaps with the help of a microscope o a telescope, or a camera obscura—you can see everything. If you look closely enough at a thing, you can figure out how to make it, or how to fashion something just like it, or how to create something better. The circle is complete and the world is self-enclosed; reality has reproduced itself through the catalyst of human perception and manipulation, returning to itself in a reorganized, perfected manner.

Thus art in The Netherlands does not refer to an outside context. It might draw on the outside world but seeks to either keep it out (like the sea) or use it (again, like the sea) to bring elements under control. The outside world remains blocked behind dikes and enters only as bits and pieces that can be consumed or, even better, converted into value. The Dutch world is essentially interior. It mirrors, maps, and paints reality as it is, so it makes sense to the observer who is already in that reality.

Spreads from the "Buffalo Book," commissioned by Paul Fentener van Vlissingen, by Irma Boom, 2001

Alpers compares this "pictorial mode" with the "southern mode" (by which she means paintings made and interpreted south of the Alps). According to theoreticians of Italian paintir such as the Renaissance artist and biographer Leon Battista Alberti, painting is a window onto another space that exists beyond the picture plane. We cannot actually inhabit it, but th painter can imagine it for us, summon it forth out of the depth of his soul. Our mind's eye finds a place on the canvas. This implies that there is another reality out there, beyond our view. To Alberti, following Plato (as well as a long tradition of Christian philosophy), this is the truly meaningful universe, the one that signifies something—literally. All *we* see are signs of meanings we cannot apprehend; language, painting, and every other form of art are just systems that etch the truth onto our senses. What connects these signs to one another is the story, or *istoria*: the meaningful narrative that relates all action. and appearances to a meaning one can gain only by perusing the whole picture or reading the whole story.

In Dutch and Flemish art, or "northern pictorial modes," Alpers claims, the reality is all there. There is no hidden message. She uses the distinction Hannah Arendt makes between "knowing and "understanding" to explain the difference. There are two ways in which we come to some sense of who we are in the world, Arendt claimed. One is to observe the world around us, to try to comprehend it as intensely as possible, and so to place ourselves in that world. The other is to deduce meaning from what we see and to make sense of what appear to be random occurrences by inventing a higher truth that aligns them in a logical manner. The latter uses the "southern mode," Alpers would claim, while the former is the goal of Dutch art. Instead of a window, a painting is a map or a mirror. It gives the world back to us in an altered form: either framed and reoriented or miniaturized, abstracted, and converted into data.

6000 Namen Spiegel (6000 Names Mirror), by Milou van Ham, 1996

Alpers proves her point through an analysis of perspective techniques and treatises on painting, and observation of the ways in which the Dutch used paintings, mirrors, and maps as interchangeable elements in their interiors Critics have since pointed out that the Dutch expected to receive morals, anecdotes, and other stories from their paintings and that there was a strong desire among many painters and clients to come close to the Italian ideals of painting. Yet the argument for a Dutch mode of representation helps to explain the power that the simple paintings of middle-class interiors, street scenes, and still lifes possess. Of course, there is the sheer skill evident in their craft to delight us, but there is also something that goes beyond their meticulous presentation. There is something about their certainty and their enclosure that still matters.

In Vermeer's interior scenes, there are no views of the outside world. The eye follows grids of floor tiles and wanders from figure to figure, each revealed by soft light. When you try to find the source of that light, your eye bounces off closed shutters. The vista down the hallway never leads to a world beyond the domestic scene. Similarly, when De Hooch doe give you a glimpse of the street outside, the wall of buildings on the other side of the canal closes off the vista. Saenredam never shows anything but sky through the windows or other openings in his paintings. His are interiors in which the eye can wander from object to object without ever escaping. Only maps and exotic objects such as carpets or tropical flowers bring the outside world in, and then only in a manner that the painter controls completely. They have been domesticated and are known.

The Dutch didn't just paint their world in this way. They built it as a set of interiors as well: the landscape sheltered behind dikes, and cities turned inward. The most extreme example of this inward turn is the central part of Amsterdam. What began as a simple collection of houses and ware-houses around a dam was enlarged according to a plan first devised in 1585 that had no clear precedent and has not been imitated outside of The Nether lands. Four concentric canals form nested half octagons around the original city center. The canals bring small ships right into the heart of the city, allowing them to pass through. Houses of a standard size, about eight by twenty-five meters (except in a few cases where inhabitants bought up several lots), line the canals. The houses were all built more or less the same and are dominated by large windows that bring light into the deepest recesses of the narrow lots. Behind the houses are gardens, which form sheltered and protected private worlds behind the near-uniform facades.

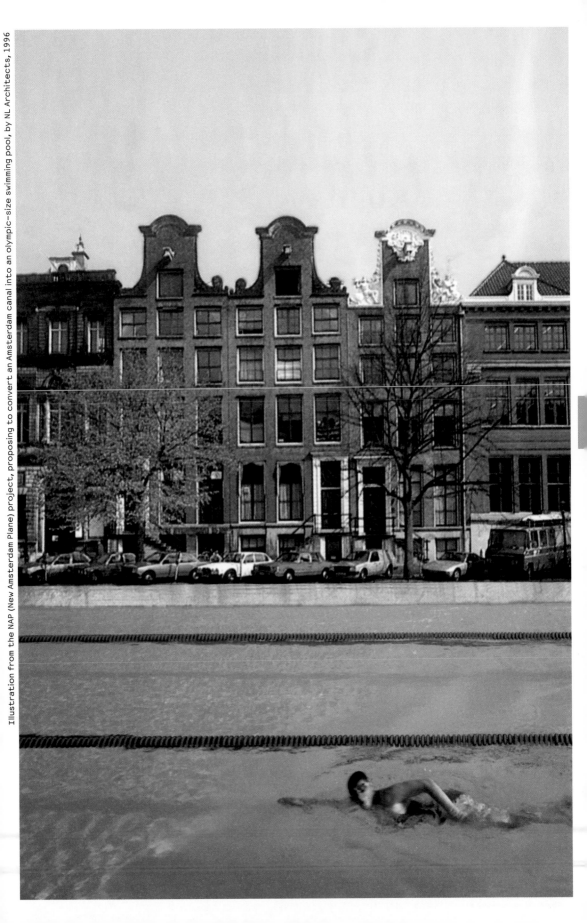

Illustration from the NAP (New Amsterdam Plane) project, proposing to convert an Amsterdam canal into an olympic-size swimming pool, by NL Architects, 1996

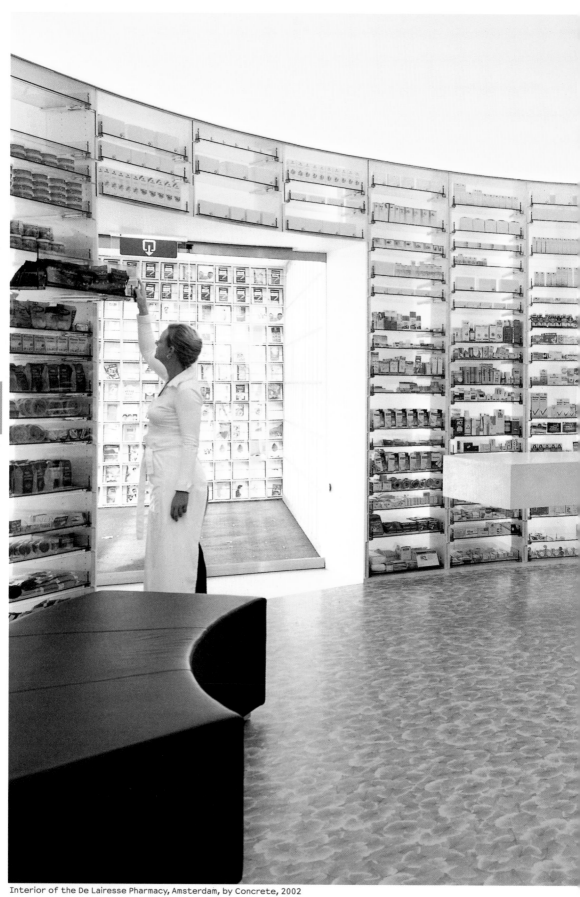

Interior of the De Lairesse Pharmacy, Amsterdam, by Concrete, 2002

This collection of standard objects and, more important, similar interiors forms a collective shape that always turned in on itself. What is remarkable about Amsterdam, Henry James observed in 1900, is that "it presents no vistas that lead elsewhere." Always there is another turn, always another row of houses. The collective urban landscape becomes a labyrinth made up of more interiors. Within this world, everything can be seen and known, as the painter Jan van der Heyden proved with his magnificent cityscapes. He was one of the most successful painters in Europe, famous for being able to paint every brick of a facade, and also the inventor of the modern fire brigade. In 1690 he published a volume of prints (the *Fire Brigade Book*) that showed views of canal houses before a fire, after the conflagration (but before his brigade came into action and the fires were still put out by neighbors or other haphazard groups without proper equipment), and then once the city had adopted his suggestions. If the fire in the first case produced complete devastation, opening a void in the city, after Van der Heyden was done inventing and drawing, fires could create only a small interruption in the city's fabric. Man's craft and invention could contain the unknowable, the unpredictable, and the destructive.

Although Amsterdam is the most extreme example of such self-reflective city planning, Delft, Haarlem, and other cities share many of its characteristics. They are all complete worlds that lack grand boulevards and the vistas these offer. They have few monuments or big squares, and when the latter do exist, they are usually filled with markets. When Amsterdam finally got so rich and powerful that it could build a giant town hall out of stone, completely out of scale and character with everything around it, the burghers could not bring themselves to finish it off in the usual manner by putting a big front door right in the middle. Instead, the central axis to the building is blocked. Visitors enter the stone structure from the side; in the building's center, one finds a very narrow, high-ceilinged room where judges once sat to weigh serious crimes. This spatial arrangement conveys the sense that judgment, knowing the truth and suffering the consequences, was central.

To this day, the town hall towers over the city as a reminder of the brief moment when The Netherlands, with Amsterdam at its core, was a world power. This building is an exception. In The Netherlands, any city is still largely made up of bricks, each the same, that together create row after row of houses. These form a collective wall and make up the bulk of the urban fabric. The brick as a building module is not very conducive to making monuments and for that reason is usually plastered over in other countries. It is too particular and too small. While brick is flexible, it is not very expressive in itself. It tends to create a sense of sameness from one facade to another, while exposing the method of construction in its orderly rows. It is also a small geometrical object made out of muck left behind by the river, thus showing, in yet another way, how order can be made out of nature.

The architect H. P. Berlage understood this when he expanded Amsterdam in 1915. He used brick. Berlage made neither picturesque neighborhoods nor grand axes, but a succession of short streets that turn at a point where the walls of housing become slightly taller or where a public space enlarges into something that is often not quite a square. The mass of the houses breaks apart into planes and volumes that slide by each other, build on each other, and twist and turn to create a plastic but completely coherent and self-sufficient cityscape. Still, there were no vistas that led elsewhere. Berlage's pupils and followers extended the same principles to The Hague, Utrecht, Rotterdam, and countless other cities. It turns out that the grand compromise between modernists and traditionalists had a solid foundation: the making of orderly, rational, and abstract compositions.

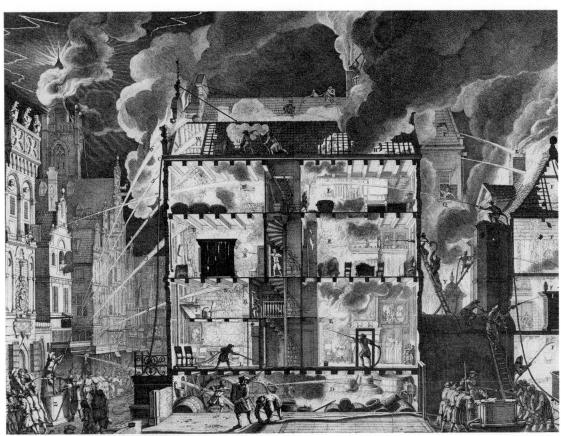

Spread from the **Fire Brigade Book,** by Jan van der Heyden, 1690
Dutchtub, by Floris Schoonderbeek, 2002

There is an essential sense of smallness in the Dutch urban environment, and one that makes a direct link to the interior. Everything is known, seen, and controlled, so everything is, in a sense, interior. It is also artificial and focused on the artifacts by which one knows, sees, and organizes one's daily life. This is not so strange, as one could also say that the "northern mode" is the characteristic art form of the middle class. This particular social group does not define itself by its history or by a mandate from some unseen force, nor is it tied to the land. It is instead an in-between group that exists by making something abstract—value—from concrete goods. Its members inhabit a world, the city, dissociated from the land and the factory alike. They mirror themselves in their possessions. The Netherlands, one of the cradles of capitalism, is the essential middle-class country, and its art and design reflect this. The middle class has always accepted the exposed artifice of their landscape (whether urban, rural, or domestic) and expect it to be integrated into their lives. For this reason, the Dutch are also some of the few people who accept abstraction as a proper form of art, and one they expect to see in their buildings and their furnishings, their magazines and their books, and not just in paintings on the wall.

The notion that one creates a world by reorganizing and perfecting what is already there is central to the way the Dutch have made space and how they have thought about their environment. They do not import the new as an alien object to be placed in their landscape, nor do they merely try to preserve the crumbling ruins of the past. The aesthetic is one of utilizing and transforming reality. If anyone proved that in form, it was Gerrit Rietveld when he built a small house for Truus Schröder, the wife of a jeweler. Located on the edge of Utrecht, it is the very emblem of modernism in its clean, abstract planes. It is also how I first came to love architecture. When I was about fourteen, a high school teacher arranged for me to have tea with Mrs. Schröder. I had known about the house as the "three-dimensional Mondrian," but now I had a chance to see the whole structure.

Like most Dutch cities, Utrecht consists mainly of rows of two- and three-story brick houses. Where one row ended and the grid of meadows took over, Rietveld, who was trained as a furniture designer, constructed a house that seemed to take the underlying geometry and hidden structure of that row and expose it. He then realigned the planes so that they took on the character of the grid of agricultural fields to the east of the lot. The house, at the time, literally existed between the services of the city and the openness of the country. This was true inside as well, where the piano nobile, or main living floor of the tiny little cube, was one large space that the inhabitants could, with the help of sliding walls, divide into as many as five separate compartments. Mrs. Schröder and I spent some time trying out all the different possible combinations and then sat down for a cup of tea at the little dining-room (or kitchen) table. She reached over to the corner and opened up the two windows that met there. As the corner was not fitted with a post, which would usually contain the space even after the window had been opened, this simple act made one of the traditional borders of a structure disappear with a single movement. Space flowed, and yet everything was clear.

1

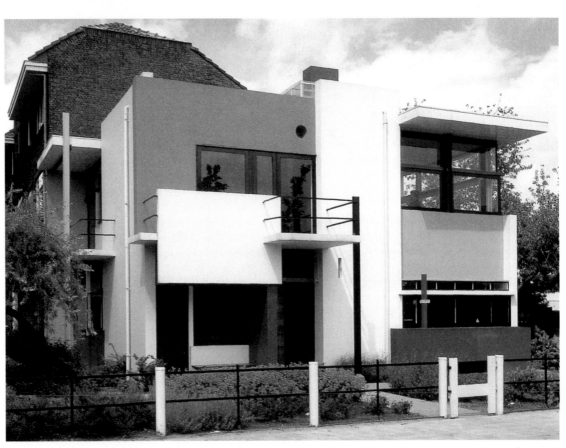

Exterior and interior of the Schröder House, Utrecht, by Gerrit Rietveld, 1924

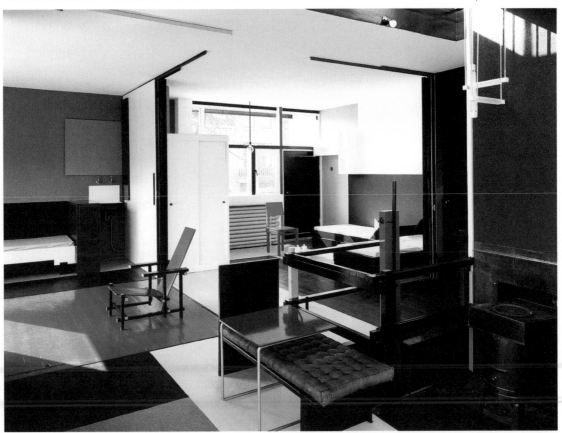

That sense of <u>open clarity</u>, in which every aspect of the building is in its place but where each room has many functions, may not be particular to The Netherlands. Yet there is a peculiar way in which residential buildings here exist at the junction of furniture and the city . Most house have to fit into an urban fabric and thus have a similar configuration. Within that standardization, each inhabitant is free to arrange pieces, but the house also has to become a clever machine for living. Windows are large to let light into narrow spaces in this often gloomy climat (and perhaps to bring those amazing skies into view). Windows, shutters, and even doors open in ingenious ways. Hooks and pulleys bring furniture up past stairs to narrow to maneuver.

In the house, mirrors, maps, and paintings no longer stan out, but there are still objects that show you how and of what they are made. For the last decade, The Netherlands has produced some of the most interesting furniture in th world. This is a very recent development. In the early twentieth century, while the British were making sensibl seats, the French were perfecting different styles, and the Americans were being inventive, the Dutch were just copying and mixing. Architects such as Berlage and K. P. (de Bazel designed the first high-quality pieces of Dutch furniture in the late nineteenth century, but mostly just carried the themes of their architecture into the interior. In general, furniture was something to be imported. It was an element of that vast outside world that the Dutch could know and reorder by bringing it into the controlled domain where they lived.

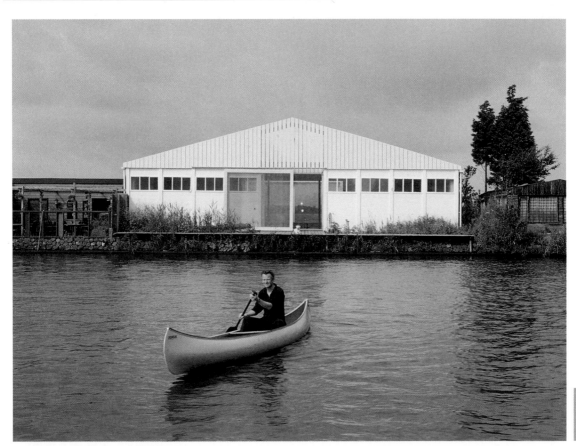

Exterior and interior of De Schieschuur, the house of Wim Kloosterboer and Jennifer Sigler, by Made Architects, 2002

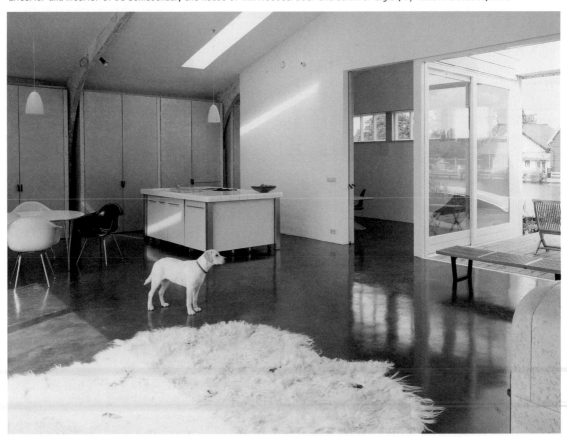

Rietveld changed this by making furniture that was an extension of the dissolution of that domain into a play of pure geometry. His furniture existed as structural grids that caught planes of use in a logical composition, as in his famous Red and Blue chair of 1918. His pieces also represented the intersection of a larger geometry at a point where one might sit or place an object, as in the side table he designed the following year. Space and form coalesced.

Rietveld did not have much use for bending new materia in surprising ways, unlike his German contemporaries. He was also less interested in the pseudoscience of posture and comfort. He merely used basic building blocks of furniture—wood and plywood—to create new combinations of forms. The new consisted of a re-organization, not necessarily an invention from nothing

The same is true for many of Rietveld's colleagues in the de Stijl movement, named after an influential art magazine. Though there are many possible interpreta-tions of what the various painters, architects, and designers loosely aligned with the publication intended what is most interesting is their adaptation of what already existed. J. J. P. Oud's startlingly white rows of worker housing, for instance, were just a whitewash of the traditional row of houses. His design for De Unie was a reordering of a simple facade by pushing and pulling at its various parts, such as lintels, windows, and doors, to create a composition that, like the Schröder House, abstracted and reorganized the storefronts to either side.

Seven Chairs in Seven Days, by Ineke Hans, 1993–95

The de Stijl movement presented a purely visual clarification of the knowable world by artists who wanted to reveal underlying forms and open them up to inspection. Even its architects, who came to be known for their "new businesslike attitude" (*nieuwe zakelijkheid*, a term used to describe the pragmatic, modernist work of architects such as Oud and Brinkman and Van der Vlugt), were doing nothing more than revealing the industrial forces that shaped their building materials and demanded a novel arrangement of functional pieces. In graphic design, Piet Zwart and Paul Schuitema, in their work for such companies as NKF (Dutch Cable Factory) and the coffee, tea, and tobacco distributor Van Nelle, rearranged the page so that information could be more clearly visible.

There were particular qualities to the Dutch variant of modernist design that caused its success on an international stage. These were its insistence on the revelation of structure, its emphasis on a clear and clean visual organization, and its attempt to efficiently mirror and reorder the world around it. These qualities contrast with the expressive and experimental tendencies in countries such as Italy, with its protofascist Futurism, and Russia, with its revolutionary Constructivism. There was no need to defy gravity or avoid revolution here, only the desire to create an efficient mirror of a new society. The new could be seen, known, and thus made. These tendencies continued throughout the period after the Second World War, becoming embedded not only in the production of houses but also in the worlds of interior and furniture design. In graphic design, the Dutch developed a particular variety of Swiss minimalism. To them, the actual letters were more important than the underlying grid system; it was the typography that made the principles of organization on the page, as well as the message, visible. Seeing was again knowing and making. For more than a century Dutch typographers experimented with type, making the country into a center for that craft.

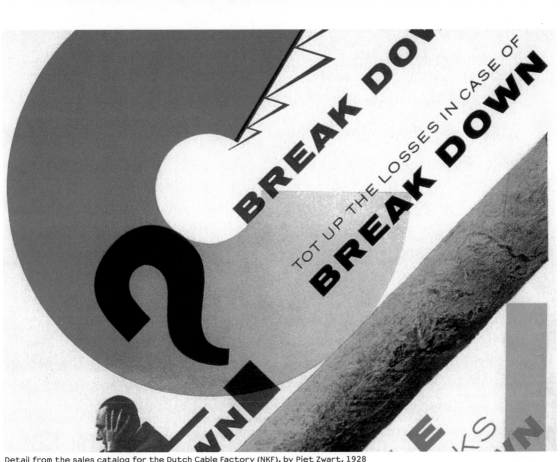

Detail from the sales catalog for the Dutch Cable Factory (NKF), by Piet Zwart, 1928
Modular Militant Modernism T-shirt, by Experimental Jetset, 2000

Dutch graphic designers found themselves working not just to produce propaganda and advertising but also to create daily icons, such as the packaging for Van Nelle tea and coffee, presented in abstract, brightly colored boxes. One of the most remarkable aspects of Dutch culture is how many of the objects, images, and spaces one encounters every day have been designed. Spaces had been designed—both on a large scale in the sense of polders, and on a small scale in the sense of cleverly arranged interiors for specific functions—as early as the Middle Ages, but in the twentieth century more and more objects were redesigned so that their principles and interrelations would become clear and visible. Under the leadership of J. F. van Royen, the Post, Telephone, and Telegraph company (PTT) became a leading commissioner of graphic designers. Later, the Dutch railroad company, NS, asked graphic designers to rethink every-thing from the company's logo to the trains themselves. The result, designed by Tel Design, was the distinctive yellow color of these streamlined forms. They stood in clear contrast to both the green of the meadows and the red of the cities, making fleeting compositions in the landscape. Graphic designers even created the country's tax forms and its currency, whose distinctive mixture of geometry and simple shapes won awards for designers such as Ootje Oxenaar.

Designers learned how to organize large amounts of information into easily comprehensible forms. They did not have the luxury of making coffee-table books with a great deal of white space, nor did they need to sell something with flashy advertising posters. They simply had to perform the service of making legible designs. Of course, this was not the only thing they did. Designer and museum director Willem Sandberg led a group of designers who used state-supported museums as their base of patronage, allowing them to try out wilder and more expressive ideas.

Starting in the 1960s, designers here as elsewhere began to rebel against what they saw as restrictive rules. They wanted to open up the possi-bilities of new forms of communication. Yet even when their designs became wild, even pornographic, they remained disciplined. George Noordanus's famous 1971 poster for the left-wing party PSP, for instance, shows a naked woman who stands, arms stretched out, in front of a cow in a meadow, in a pure, symmetrical composition. The act of rebellion is presented in a completely classical and therefore powerful manner.[1] Total self-control allowed expressions of the newfound freedom to be even more effective.

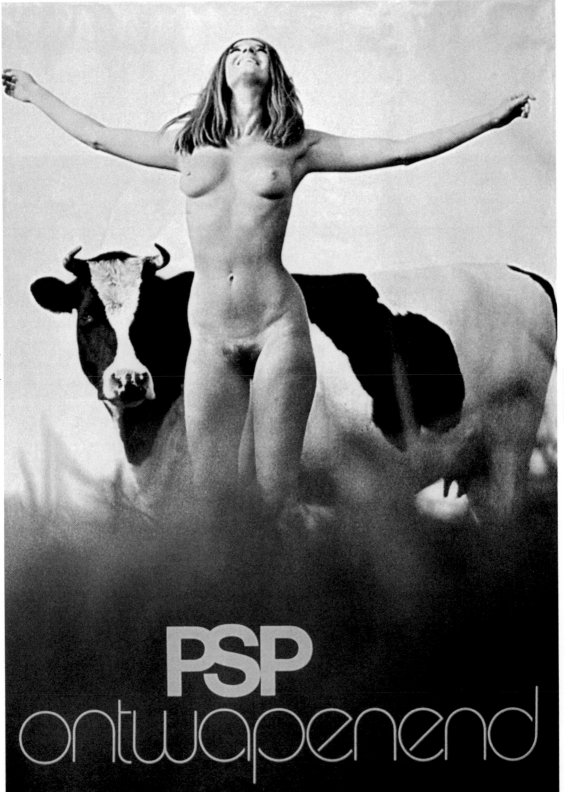

Joseph Plateau, 1994

Joseph Plateau, 1994

Joseph Plateau, 1994

Irma Boom, 1997

Irma Boom, 1993

Irma Boom, 1993

Irma Boom, 1993

Irma Boom, 1993

Mevis & Van Deursen, 1995

Mevis & Van Deursen, 2001

Julius Vermeulen, 1995

Mieke Gerritzen, 2001

Dept, 1997

Dept, 1997

De Designpolitie, 1999

De Designpolitie, 1999

Experimental Jetset, 1999

Experimental Jetset, 1999

Joseph Plateau, 2000

Catherine van der Eerden, 1998

Gerard Hadders, 1996

Gerard Hadders, 1996

Gerard Hadders, 1996

Joseph Plateau, 1997

Felix Janssens, 1998

Felix Janssens, 1998

Felix Janssens, 1998

Peret, 1992

Harmine Louwé, 1998

Harmine Louwé, 1998

Harmine Louwé, 1998

Harmine Louwé, 1998

Ben Laloua, 2001

Ben Laloua, 2001

Ben Laloua, 2001

Ben Laloua, 2001

Vanessa van Dam, 1999

Vanessa van Dam, 1999

Anthon Beeke, 2003

Anthon Beeke, 2003

Mevis & Van Deursen, 1998

Peter Struijcken, 1981

Joseph Plateau, 2004

Mevis & Van Deursen, 2002

Jan Bons, 2002

Jan Bons, 2002

Walter Nikkels, 1994

Expeimental Jetset, 2002

Jan Bons, 2002

Jan Bons, 2002

Golden Masters, 2001

Golden Masters, 2001

Traast & Gruson, 2000

Traast & Gruson, 2000

Roelof Mulder, 2000

Roelof Mulder, 2000

Irma Boom, 2003

Irma Boom, 2003

Lex Reitsma, 2001

Lex Reitsma, 2001

Mart Warmerdam, 2002

Mart Warmerdam, 2002

Mart Warmerdam, 2002

Mart Warmerdam, 2002

The balance between rebellion and discipline was struck throughout the 1970s and 1980s. Amsterdam gave rise to the group Wild Plakken (wildly plastering political posters around town), which tried to bring the energy of revolution into the staid world of art commissions. Yet somehow they managed to make the power of cheapness look carefully studied. The Rotterdam group Hard Werken (Working Hard) brought back a sense that graphic design should break rules not to be weird and wild but to communicate more effectively. Both groups developed a form of collage that was related to the postmodern reuse of the period but also had deep roots in the Dutch traditions of redefinition and reorganization. Karel Martens, who trained several generations of designers, and several of his colleagues synthesized all these rebellions into a tightly woven yet completely free approach to information that now rules much of the Dutch graphic-design world. "Calvinist expressionism," one observer called it.

Modernism in The Netherlands has, in other words, progressed in keeping with the country's roots. It has moved from a basic belief in the knowability, visibility, and perfectibility of the world to a no-nonsense documentation and reorganization of that world, channeling foreign impulses—whether styles, new materials, or new production techniques—to comprehensible forms. It is also a movement that has not seen its best examples in painting or sculpture, except when Mondrian, Van Doesburg, and a few others were active in de Stijl (and before they all moved to other countries). Dutch modernism is a design movement because it involves itself in the reorganization of the things of everyday life.

If one looks back at this tradition, one notices not just the emphasis on "realism," or the reflection of what exists, the modesty of expressive means, and the ability to domesticate foreign forms and new impulses into familiar shapes but also a sense that what the artist, architect, or designer does is reuse and reorganize. While in most other countries the notions both of art and of modernity are tied to invention, the Dutch have seen art more as an iterative process. Now that we live in an era where our faith in the ever new is lessening along with the supply of uncharted terrain and natural resources, this tradition has assumed new relevance.

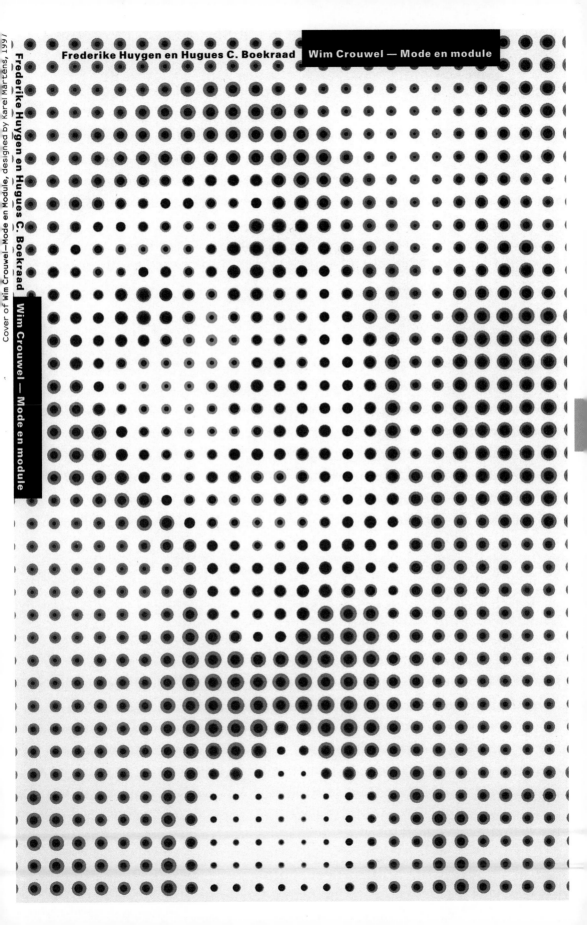

Frederike Huygen en Hugues C. Boekraad Wim Crouwel — Mode en module

Frederike Huygen en Hugues C. Boekraad

Wim Crouwel — Mode en module

A theory for how this tradition could be continued into the twenty-first century came out of the world of furniture design at the close of the last century. It was promulgated by an ad hoc group of loosely related young designers assembled by the critic Renny Ramakers and the designer and educator Gijs Bakker in 1993. Ramakers had noticed that many of the students she saw at design academies were interested in similar ideas. Together, she and Bakker founded a cooperative, Droog Design, to help those students develop and market their products. It was meant to be not a production company or a store but a seal of approval: the duo would decide that some specific design was "Droog"—dry—and then ask the designer to let them include it in a series of shows they organized around the world. The idea was an instant success and helped bring innovations in Dutch design to a worldwide audience.

Ramakers and Bakker had a clear idea of the importance and character of the products they chose. They were interested not in radical novelty or warm fuzziness but in a dry, rational, and perhaps slightly ironic representation of reality. What interested them was the designers' lack of concern with the propriety of the final form, their disregard for the idea of invention and the expression of a style. They were attracted to objects that were specific, though sometimes idiosyncratic, responses to a given situation. One classic from Droog's first collection, for instance, was the chest of drawers (1991) by Tejo Remy. It was a pile of drawers Remy found at a dump, which he tied together with a nylon strap to make a jumbled stack. The result looks happenstance, and may not be the most logical chest of drawers, but it becomes a microcosm of all chests one has seen, stripped of the constraint the designer usually puts on such a piece of furniture by choosing one style for a frame. In another work, Remy stacked cast-off clothing into a pile to make a supremely comfortable chair.

Not all Droog products and projects were or are this rough. Former Droog designers such as Marcel Wanders and Richard Hutten delight in making highly finished products that are either the outcome of a particular manu-facturing process (as in Wanders's Knotted Chair, made out of rope tied together and dipped in polyurethane) or a train of thought that is specific to a function (such as the children's chair built into Hutten's dining-room table to make the tot the "real center of attention"). What ties all of this work together is its ability to free the object from its need to be either a slave of function or of design. This work does not stand for something, has no particular style, and it does not solve functions in the simplest fashion. Instead, Droog's work brings a host of other issues into the home and domesticates them, making them visible and usable.

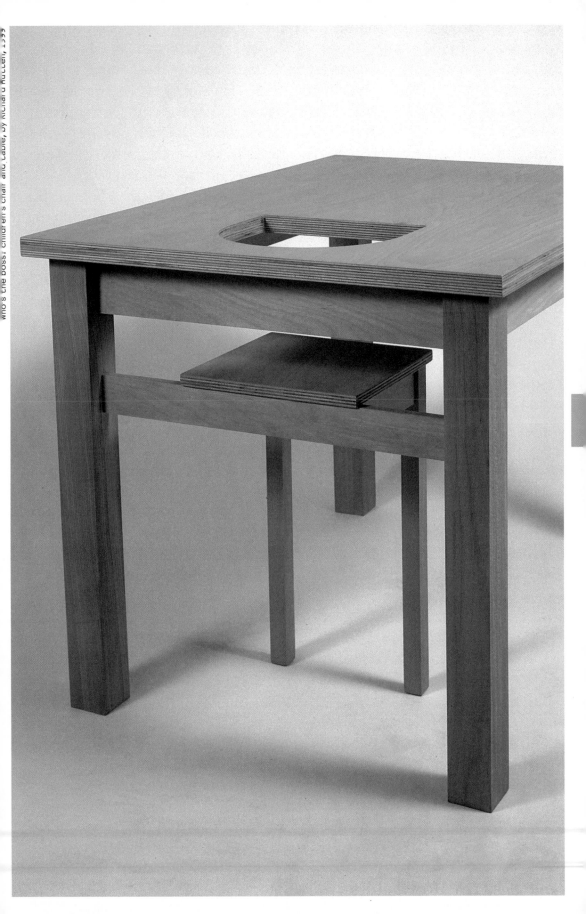

Sometimes these are global political issues, as in Arnout Visser's project for packaging made out of gourds, which seeks to reduce the need for extra containers and help third-world farmers create a more marketable product. Sometimes the topic at hand is history, as in Piet Hein Eek's furniture made out of wood scraps that contain within them the memory of former lives. Whatever the issue, it is embodied in the material, the form, or the composition, rather than being present as a reference. You might think this is all very ponderous, but the work also has to have a dry humor about it to pass Ramakers's and Bakker's "Droog test." There must be a sense that the designer is making fun of both the user and him- or herself. He or she is looking in the mirror and seeing something that we might not have noticed.

A classic Droog moment was the installation for the 2000 Salone del Mobile, the Milan furniture fair. They had been asked by a German cultural foundation to think of ways to revitalize the village and estate of Oranienbaum. Built by a German aristocrat who had married a Dutch princess, the castle and its grounds were once famous for greenhouses filled with orange trees—not only a remembrance of sunnier places, but also a redolent reminder of the Dutch royal house. Droog responded not only with do-it-yourself bird feeders and orange tree planters but also with an attachment they envisioned for a grain sifter. After harvest time, this agricultural implement would go through the forests and fields suck up all the fallen leaves and dead grass. These would be compacted by the machine and extruded through the attachment that would turn the congealed mass into a bench. The machine would plop the organic seating out the back as it wended through the forest, leaving benches as ways to promote the leisurely enjoyment of the park until the spring rains would dissolve them into the ground. The world as found was rearranged, reconceptualized, and reused.

There would seem to be a great distance between the carefully wrought work of the Dutch seventeenth-century painters, the book Irma Boom produced to celebrate an obscure trading company, and Droog's bench-making machine. Yet all of them have the quality of rearrangement and re-presentation. The enduring power of Dutch art remains exactly that capacity to give our world back to us in a way we did not know it before. It makes the world all the more real for us by the act of the designer or artist—no more and no less. If many Dutch artists have forgotten the worth of such an endeavor, the country's designers have not. They to continue make material and real what is otherwise only vaguely present, to map the world around us so we can navigate through it, and to mirror the rich materiality of reality in the craft of arrangement. Through them, we see the world in new ways so that we can know it and make it a better place.

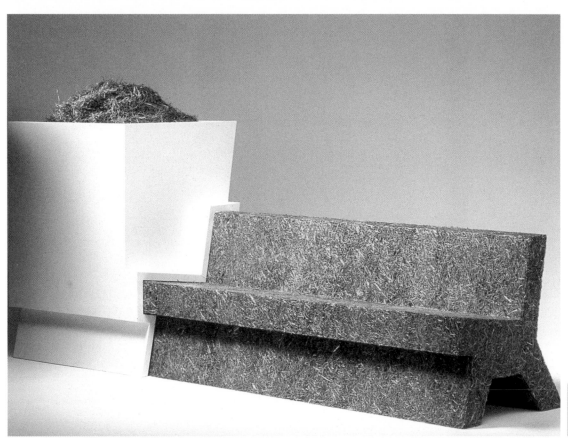

Garden Bench for Droog Design, by Jurgen Bey, 1999
Tree Trunk Bench for Droog Design, by Jurgen Bey, 2002

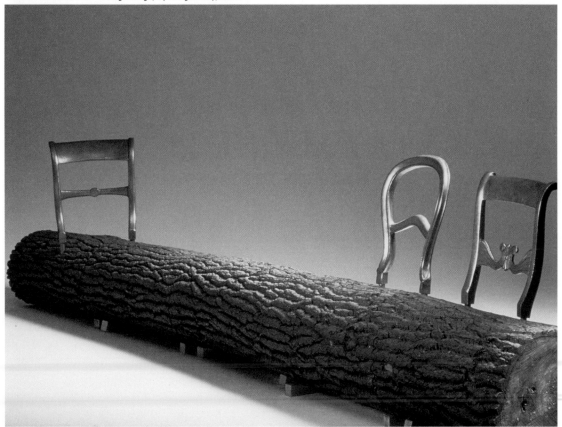

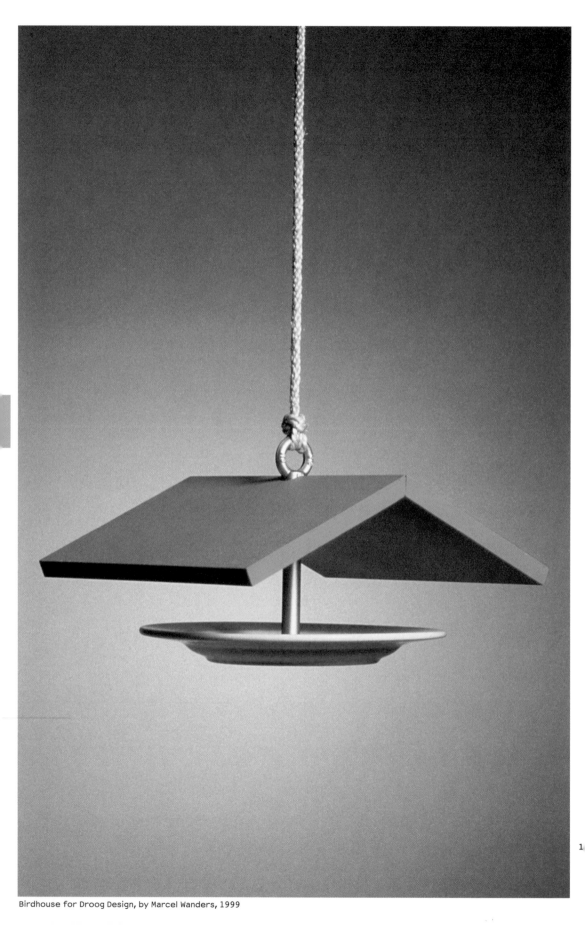

Birdhouse for Droog Design, by Marcel Wanders, 1999

DO NORMAL

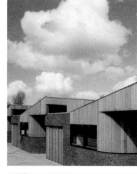
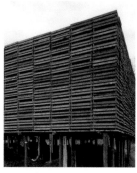
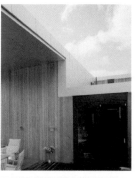

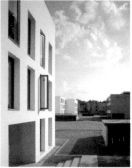

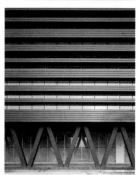

AT WORK

NEUTELINGS RIEDIJK ARCHITECTS

010 PUBLISHERS

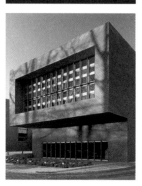

OASE 59 2002
Tijdschrift voor architectuur / Architectural journal

T E R R A

Galeriile U.
Grafic design din Olanda
Str. Iuliu Maniu 2–4
Cluj–Napoca
aprilie–mai 1996

Onix — One of the few emerging architectural firms based not in the western part of the country but in the northern town of Groningen, Onix differs slightly but distinctly from their colleagues in the Delta Metropolis (Rotterdam, Utrecht, and Amsterdam). Their design attitude is a "continuing quest between old and new, between change and improvement, between self-evident and alien, and between generic and signature...A continuing work in process that turns down any bent to the past or future. The architecture becomes a product of the **now**." They build often, but not exclusively, for a rural scale with an organic and highly modern approach, exploring refreshing and skilful (re)uses of wood. The Web site Architectenweb—which each year compiles a Top 40 chart of the most talked about architects—reports a meteoric rise in attention for Onix in 2003, jumping straight to the number-one spot (shared with MVRDV) after not even being listed in 2002.

Claus en Kaan — Architect David Chipperfield says of Claus en Kaan that they have "worked their way toward architectural solutions by way of their 'skill,' as opposed to starting with conceptual ideas and learning how to build them." Since the founding of their firm in 1988, Kees Kaan and Felix Claus have made a name for themselves not by redefining the trade but rather by embracing a highly functional architecture with a severe, modernist, no-frills aesthetic. Although often seemingly banal and unabashedly catering to the immediate needs and visions of the reigning Dutch middle class, Claus en Kaan's buildings are pure in form and immaculate in composition. As they put it, "Acceptance of the banal conditions of construction enables a good concept to become fit for building." On their Web site they quote, fittingly, the master Mies van der Rohe: "Thinking up a new architectural style every morning is not for me. I don't want to be interesting, I want to be good."

Joost Grootens — The prevailing reality in The Netherlands is one that can be dubbed "normalism." It reflects a pragmatic culture of common interests in which good citizens depend on a just system that operates within the limits of laws, rules, rights, and agreements. The work of Amsterdam-based graphic and environmental designer Joost Grootens epitomizes the idea of normalism. Grootens's minimalist designs—be they for a prison recreation yard, a doorknob for the blind, or a book on Neutelings Riedijk—are almost invisible interventions, tinkering away at details, adding a tiny yet fundamental upgrade to the makeup of everyday life. The introverted work always contains a shy, barely audible commentary on the nature of our times, that when amplified resonates with the strength of distilled wisdom and beauty, upholding and reinforcing the ideal that one designs for a better world.

Neutelings Riedijk — **At Work** is the seemingly surprising title of a book on the architecture firm Neutelings Riedijk. Surprising because the studio notoriously insists on a (highly-efficient) four-day workweek in a profession known for weekend shifts and brutal deadlines. Calling their work process the "methodology of sculptural science," they translate and organize their briefs with a simple mathematical concept, fitting the agenda of each client to a T. Then they sculpt, appropriately clothing the naked volumes to evoke powerful, steadfast forms, producing blunt, expressive buildings that harmoniously take their place in the landscape. When, at the opening of their exhibition **Behind Curtains** at the Netherlands Architecture Institute, their work was described as "bourgeois monumentalism," the duo was reportedly not too pleased. But while this doesn't sound too flattering, it is exactly what they have succeeded in achieving, an admirable feat in itself.

Karel Martens — A much-revered mentor and nestor of Dutch graphic design, Karel Martens single-handedly connects several generations of graphic designers with the lessons, insights, and ideals of the modernist practitioners of the 1920s. He has infused his design disciples with the urge and the sense of duty to have a clear standpoint, to take responsibility, and to use this to add a system of meaning and authenticity to all output, serving the public intelligently and with integrity. Martens's own body of work over the past forty years is the best example: having worked for a remarkable number of companies, institutions, and publications, he has been a defining factor in the look and feel of the country. He is also the founder of Werkplaats Typografie, a two-year typography workshop that he oversees with fellow designer Armand Mevis.

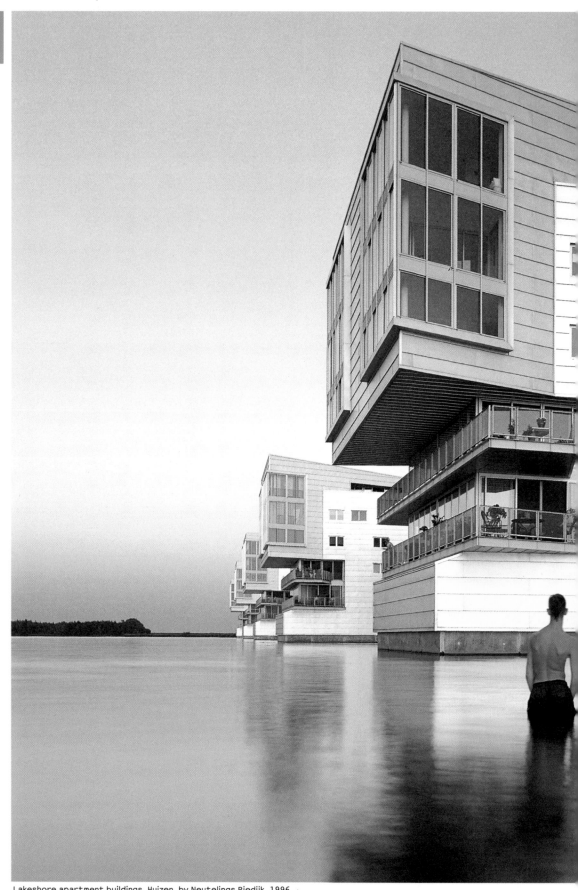

Lakeshore apartment buildings, Huizen, by Neutelings Riedijk, 1996

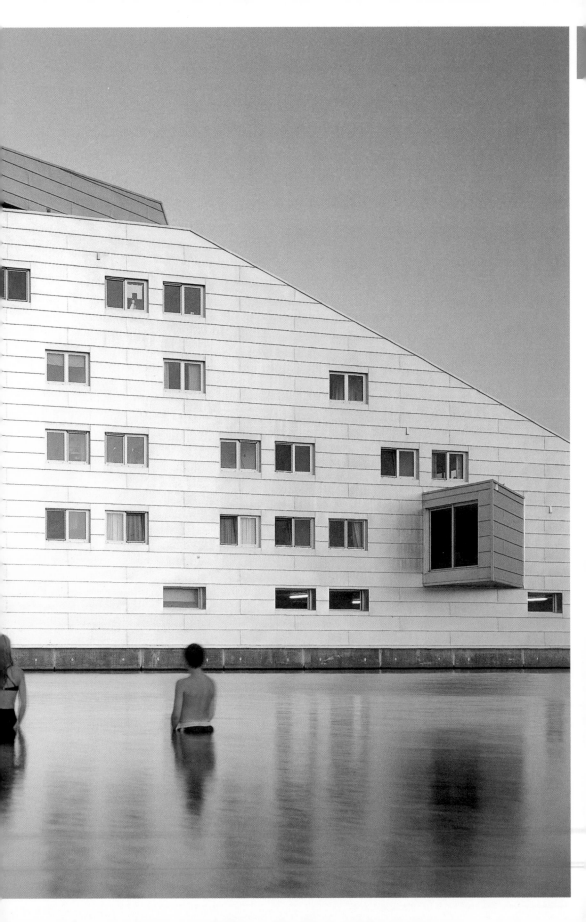

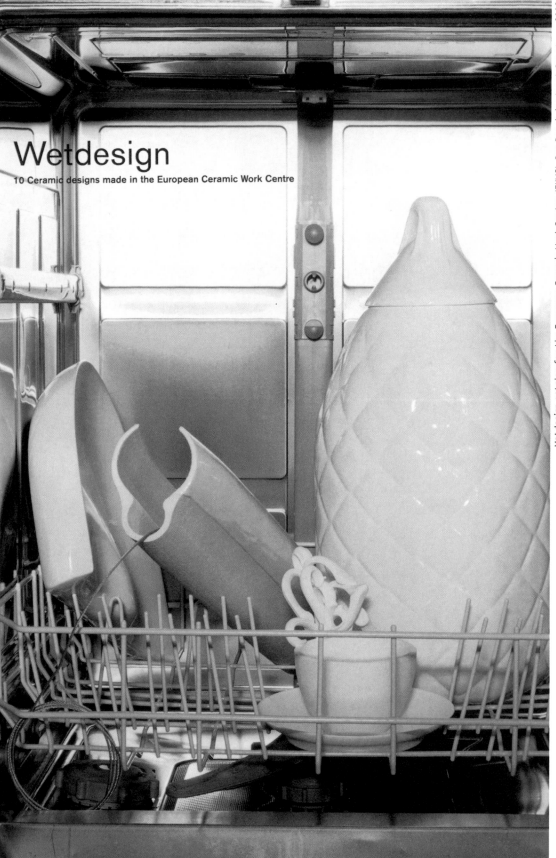

Wetdesign

10 Ceramic designs made in the European Ceramic Work Centre

Wetdesign catalog for the European Ceramic Work Centre (EKWC), Den Bosch, by Joost Grootens, 2002

OASE N=43 / Zwischenraumgespenster

Tijdschrift voor architectuur / 1995

Ratio en een wil tot orde stonden centraal in het denken van de moderne stedebouw en architectuur. Tegenover een eigentijdse, chaotische situatie werd een ruimte van bevrijding geplaatst, een ruimte waar veiligheid, rust en hygiëne zouden heersen. Het ding om een ruimte die voor iedereen geldig was en waaraan iedereen deel zou hebben, een ruimte die ordelijk en overzichtelijk zou zijn, kenbaar en begrijpelijk. Dit denken liet zich leiden door een paradoxaal verlangen. Enerzijds behelsde dit verlangen een streven naar bevrijding en verlossing uit de eigen als onderdrukkend en bedreigend ervaren situatie, anderzijds zou dit streven middels controle over en beheersing van deze situatie gerealiseerd moeten worden. / Een programma voor de emancipatie van de anonieme massa's in de moderne metropolen was het concrete resultaat van dit denken. Architectuur en stedebouw vormden slechts twee van de instrumenten om tot een menswaardig bestaan voor deze massa's te komen. Het nationale staatsapparaat en zijn bureaucratie, ideologisch onpartijdig en niet-religieus, werden ervoor uitgevonden om dit programma te realiseren. / Maar, zo kun je je afvragen, wat gebeurt er, als de ratio zich laat overmannen door haar eigen verlangen naar bevrijding en controle? Is het niet zo dat deze drijfveer van de ratio zelf eenvoudig tot een obsessie kan worden, waardoor wat kenbaar en begrijpelijk gedacht werd, zich omkeert tot een niet-kenbare en volstrekt onbegrijpelijke chaos? De ruimte van de ratio wordt dan een paranoïde ruimte. In deze ruimte lijkt een kwaad te heersen dat onverwachts en te allen tijde op elke straathoek en in iedere kamer kan verschijnen. En welke muren men ook bouwt, hoeveel sloten men ook op zijn deur plaatst, het spook weet toch binnen te dringen. Sterker nog: iedere nieuwe strategie lijkt direct nieuwe spoken op te roepen. De veilige ruimte lost op in een droom, het ontwaken is nu de echte nachtmerrie.

Mikel van Gelderen / Christoph Grafe / Dirk van den Heuvel

VEENMAN DRUKKERS
Maxwellstraat 12

Vd bezoekers →

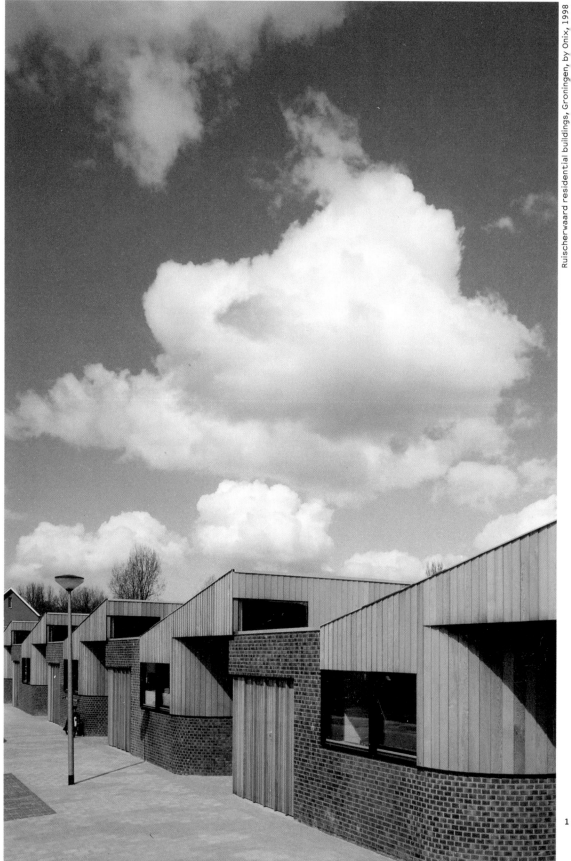

Ruischerwaard residential buildings, Groningen, by Onix, 1998

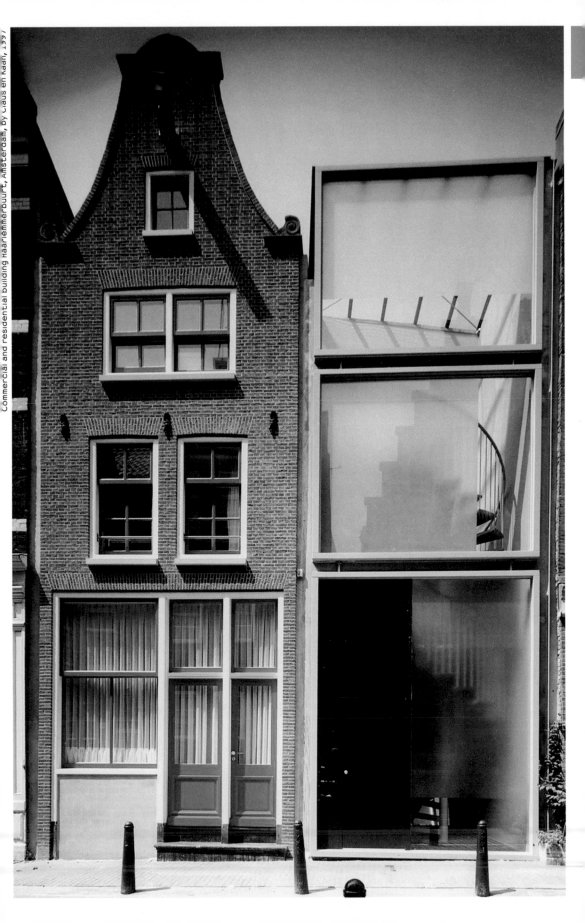

Willem Henri Lucas — In a lecture at UCLA, graphic designer Willem Henri Lucas, a student of Karel Martens and apprentice for Max Kisman, once proclaimed of himself: "WHL loves words more than images, painters even more than photographers, magazines even more than books…WHL thinks design should be about communication, like a personal one-on-one conversation! WHL thinks designers should be very responsible! WHL thinks design should move and touch people! WHL thinks loads more…" These beliefs and characteristics are omnipresent in his designs, which are sober and direct, intimate and thoughtful, language-driven and intriguingly human. Yet, as UCLA design professor Rebeca Mendez states, "the significance in every one of [his pieces] lies in the deliberate violation of aesthetic conventions—the authorship, composition, hanging—and much of the humor of the work arises from Lucas's willful transgression of the norm." From 1990 to 2002 Lucas served as professor and chair of the Utrecht School of the Arts' graphic-design department, teaching and influencing an entire generation of young designers.

Herman van Bostelen — When Henri Willem Lucas left the Utrecht School of the Arts in 2002, a farewell symposium was organized. Herman van Bostelen designed a striking poster and invitation, and designers who had graduated during Lucas's tenure contributed their work to a catalog exploring the question of whether his time and influence had resulted in a specific Utrecht School style. Lucas carefully analyzes in his introduction: "The clear and single-minded use of the image, the preference for a sans serif letter, a 'knack' for systems within design, the sometimes cold, distant atmosphere, or the urge to design and communicate with as little means as possible" is dominant in most of the works. The work of Herman van Bostelen, a 1996 graduate, certainly possesses these qualities. His typographic solutions simmer solemnly, reverberating like frozen moments of poetry. His meticulous placement and refined approach turn every design he touches into an "intimate, yet monumental gem" (as described in the 2001 design yearbook **Apples and Oranges**). Now himself a teacher at the Utrecht School of the Arts, he continues in the vein of Karel Martens and Willem Henri Lucas, instilling in his students traditional modernist principles to be applied toward honest, integral design.

Martijn Engelbregt — A 1996 graduate from the Utrecht School of the Arts, Martijn Engelbregt had telemarketers threatening to sue him for "stealing their bread" when he released his "counterscript." Engelbregt had designed and published a one-sheet manual that mapped, with words, colors, and arrows, a method to sabotage the intrusive questionnaires used by telemarketers, allowing one to take control of the flow of questions and answers. For another project, supported by the cultural and political center De Balie, Engelbregt sent out 200,608 very official-looking questionnaires to the residents of Amsterdam, asking people if they knew and would be willing to report illegal aliens. Of the recipients, 199,713 didn't reply. Those who did expressed their dismay, and the national press was on Engelbregt's doorstep. Three people, however, were disappointed it was just an art project and that they couldn't really notify the authorities! Engelbregt excels at taking the data-mining tools of the omnipresent Dutch bureaucracy and creating work that holds up a mirror, confronting and forcing people to take a stand on societal issues.

Dietwee — Dietwee is Dutch for "those two": Tirso Francés and Ron Faas, two designers from diverse backgrounds, together synthesized into a successful design studio at the core of the thriving local design community in Utrecht. Never hindered by the outdated anticapitalist principles paralyzing so many Dutch design academies in the late '80s, they traveled between commercial and cultural work, effortlessly adapting the discourse for each client. To truly grasp the message their clients want to communicate, they first demand to speak about the firm or institution's strategy at the highest level. These findings are then translated, not with the approach of a closed design studio, but more with that of an advertising or talent agency: Dietwee collaborates with a network of specialists from all walks of life, always remaining close to their alma mater, becoming the unofficial finishing school for the best design graduates from the Utrecht School of the Arts.

SYB — Starting a new term as professor at UCLA, Willem Henri Lucas asked his students to fill out the Riso-Hudson Enneagram personality-type test, seventy-five questions that determine which of nine archetypal personality types one embodies. Herman van Bostelen would be type 4, the individualist romantic, Martijn Engelbregt would fall more into type 5, the investigator or thinker, while Dietwee would score high as type 8, the challenger or leader. A towering presence at Dietwee, Sybren Kuiper works for them as art director, and his moniker—SYB—shares prominent credit on some of the studio's signature work. Sharing Dietwee's tendency to use bold images and clear typography, Kuiper communicates concepts in direct, forceful, no-nonsense graphics. In Riso-Hudson Enneagram terms, Kuiper would probably be a type 6, a skeptical loyalist, committed to his style, reliable, and hardworking.

Faith

FLoss

Flux
de nieuwe versie

no.
4.50

U
topia

Xes

lente 1992

Heerlijk, een nieuwe we-
reld Van Witte Zanden, vre-
dig en stil Levensmiddelen
T.L. Hype Berichten van het
Front De gedachte grens
Eddie Woods - Een sample
van de gangsterpoet De
terreur van de willekeur

n
o

feel-
ings

Het meest succes gewenste blad van de jaren negentig

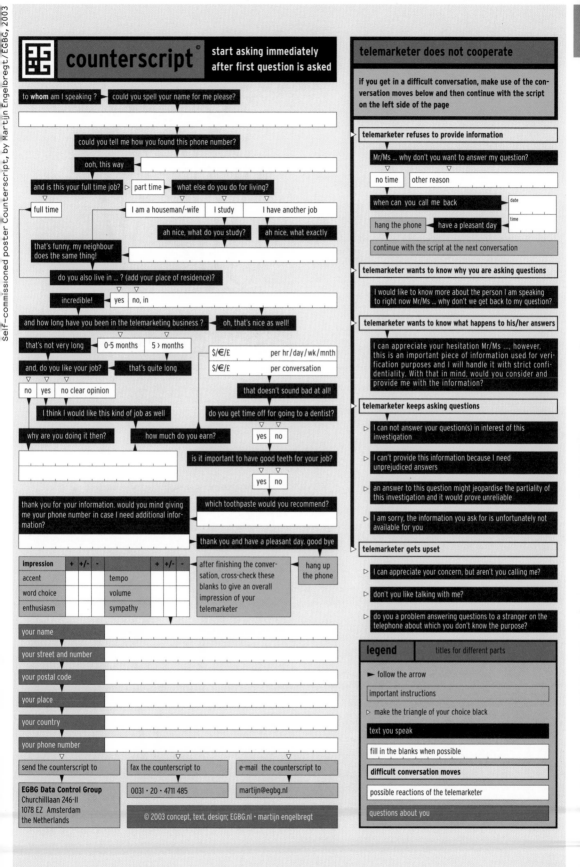

Missie

De missie van ONVZ luidt als volgt: Het optimaal behartigen van de belangen van de verzekerden op het gebied van zorgverlening. De belangenbehartiging van verzekerden vormt de leidraad in het denken en doen van ONVZ en krijgt behandeling op twee gebieden. In de eerste plaats komt deze tot uitdrukking in optimale ondersteuning bij ziekte, door onder meer het verzorgen van zekerheden, en in de vorm van begeleiding en advisering van onze verzekerden.

Daarnaast wordt de behartiging van belangen mogelijk door verzekerden zo gezondmogelijk te helpen bij het streven om gezond te blijven.

Bij de concrete invulling van de missie speelt het ONVZ ZorgServicebureau een belangrijke rol. Hier kunnen verzekerden onder andere terecht voor zorgbemiddeling, het verkrijgen van zorg in natura en voor informatie over ziekte en preventie. Via het gezondheidsbulletin krijgen verzekerden informatie over zorg en preventie.

Nieuwe producten

De markt is continu in beweging. In zichzelf, wensen en behoeften veranderen voortdurend. ONVZ is er van overtuigd dat regelden uit de markt bepalend moeten zijn voor de wijze van handelen. VanGaar dat ONVZ haar agenda van verzekerden op de producten afstemd op wat er in de markt leeft. Alleen een zorgspecialist kan door voldoende snel en flexibel op reageren.

De in september 1997 geïntroduceerde ONVZ Supto Polio heeft dit in 1998 ten volle bewezen. De sterke groei van het aantal nieuwe verzekerden is in belangrijke mate aan dit innovatieve product te danken. In november 1998 introduceerde de ONVZ een polio waar alleen zorgarbeidsongevooremsen en hun persoonlijken op verzekerd kunnen worden.

Ondanks de korte periode is nu al zeker en vastgesteld dat dit product enthousiast is ontvangen.

waar zitten uw uitstekende punten?

kruis al uw uitstekende punten aan

Collectieve markt

De collectieve markt van de particuliere ziektekostenverzekeringen groeit nog steeds ten koste van de individuele markt. Deze ontwikkeling beïnvloedt het maatschappelijk risicomodel in negatieve zin. De toenemende concurrentie en de veranderende rol van de vroegere ziekenfondsen zorgen ervoor dat het premievolume te laag blijft, minder dat hun uitdrukende verzekeringsaangrijpingspunten staan.

Een vorm selectieve benadering is voor ONVZ dan ook de enige mogelijkheid om ons ledental in dit deel van de markt te spreiden. Er is een sterke individualisering wordt waarneerbaar naar individualisering tussen collectieve afspraken, waarbij ieder individu producten kiest die passen bij zijn of haar eigen omstandigheden. Werkgevers daarentegen willen graag op basis eenvoudige afspraken maken over prijs en dekking. Op de collectieve ziektekostenmarkt was het tot nu toe niet mogelijk om de wensen van zowel op het wensen van de verzekerde te combineren met collectieve afspraken op bedrijfsniveau. De ONVZ Flexibel Polio stelt ons in staat in te staat deze brief een dekking te bieden.

Tot op heden was dit bij geen enkele andere collectieve ziektekostenverzekering mogelijk.

Ook ziektekostenverzekeraar kunnen, via de ONVZ Flexibel Polio, deelnemen aan een collectief ziektekostencontract. Ze kunnen individueel kiezen voor aanvullende modules. De dekking komt hiermee op zorgniveau hetzelfde niveau als voor particulier verzekerden. Het marktaanbod van ONVZ neemt thee op dit productconcept elk jaar toe.

hoe stijf bent u?

ga met beide benen naast elkaar staan, houd de knieën recht en buig voorover

kruis het punt aan tot waar u met uw vingertoppen kunt komen

De Designpolitie — De Designpolitie (literally, "the design police") are sure to be design heavyweights in the years to come. Already the partners Richard van der Laken and Pepijn Zurburg have authored a body of work that astonishes with its straightforward graphics, fueled by deadly accurate concepts, devoid of any attempt to glorify the message communicated, and yet crystal clear in their delivery. Their billboards and commercials for the Amsterdam zoo Artis artfully translate the name into "ART=," with icons of everyday objects evoking animal forms. Their one-page visual editorial in the newspaper **De Volkskrant** features an oil-devouring Pac-Man clad in the American flag, leaving crosses in its wake. At times intimidating and ruthless in their design solutions, De Designpolitie are devoted humanists, and when depicting the body, nudity, or sex in their work, they do so passionately and sensitively. Though they are seemingly idealistic, don't ever tell them that design is able to change the world. It has no power to enforce. But isn't that what the police are for?

Coup — Fluent and original like few others in The Netherlands in the properties of dynamic typography, Peter van den Hoogen and his wife, Erica Terpstra, make up the design studio Coup. They do not distinguish between the RGB and the CMYK domain, designing everything from Web sites to Stedelijk Museum catalogs to postage stamps to television bumpers. During an internship at **Mediamatic Magazine** in the mid-'90s, Van den Hoogen discovered the Web and immediately became fascinated with pushing the limitations of HTML. All the new technological design tools fell under his scrutiny: he tortured his Illustrator software into producing near-impossible vector infographics, painted his daughter in MacPaint on a poster for the Springdance Festival, and created Dynamic HTML animations no TV could properly display. His intimate knowledge of technology, combined with the rigid graphic-design lessons of his education, allowed him to turn computer language into design vernacular, wrestling it away from the programmer's logic and into the hands of the creative mind.

Annelys de Vet — If one were to characterize designer Annelys de Vet in terms of the Riso-Hudson Enneagram personality-types, she would be the motivator and achiever: "effective, competent, adaptable, goal-oriented, ambitious, organized, diplomatic, charming, image conscious, and into performance." In front of a sold-out club full of Dutch designers, she held a presentation at the multimedia event "The Biggest Visual Power Show"…fully nude in body paint. The original cover she designed for **Deep Sites**, a book by Max Bruinsma, had her and Marijke Cobbenhagen on the cover, both diving backward from a rowboat into a lake. Except they were topless! Fearing controversy, the publisher had her reshoot the cover. A prolific and confident lecturer, De Vet now also teaches at the Design Academy in Eindhoven. Once, as an exercise, she had her students create a new political party, complete with program and identity. One party program proposes to sell The Netherlands. Since due to global warming the country will someday disappear into the waves again, it proposes that it would be best to move the Rijksmuseum stone for stone to Hamburg, ship the Erasmus Bridge off to New York, the Van Gogh Museum to Japan. The proceeds of this "clearance sale" would be divided evenly among all citizens, who would then have the capital to go and build a life elsewhere.

178 Aardige Ontwerpers — Literally translated, **Aardige Ontwerpers** refers to "nice" or "pretty good" designers. Their work embraces every assignment, cause, and subculture with energy and enthusiasm. Assigned to classroom 178 when the Utrecht School of the Arts embraced the "atelier model," the five designers who would form this collective were together, glued to their screens, twelve hours a day. They never broke the bond of camaraderie and collaboration, and have had a studio together in Amsterdam since 1999. They define the character and the role each of them plays for the larger good as follows: Joost Hoekstra is the Infonaut, "someone who moves in the twilight of information and meaning"; Mark Veldhuijzen van Santen is the Chaotician, "with the ability to see chaos in order"; Jos Kluwen is the Formologist, "who has elevated the fabrication of forms into an art"; Merel Sas is the E-motionist, "a person who can make emotion, rhythm, and movement flow together naturally"; and Erik Hoogendorp is the Transformator, who "has the task of transforming currently existing images and concepts into new matter."

Nynke Meijer — Jan Palach was a Czech student who was internationally immortalized when, in 1969, after the Prague Spring of '68, he was captured on camera igniting himself in protest against Soviet oppression. He died three days later, becoming one of the twentieth century's great tragic heroes. Though born many years after him in a different country, Nynke Meijer painstakingly researched and meticulously charted the life and times of Jan Palach in the book **Jan Palach, Tomorrow You Will Be Born Awake.** Only fifteen copies of the lovingly crafted and hand-bound publication—Meijer's visual-arts graduation project at the Utrecht School of the Arts—were made. One caught the attention of the international jury of Die Schönsten Bücher aus der Welt 2002 ("the world's most beautiful books") competition in Leipzig, Germany, and was awarded the most prestigious prize, the Golden Letter.

Catalog illustration for the Springdance art and dance festival in Utrecht, by Coup. 2000

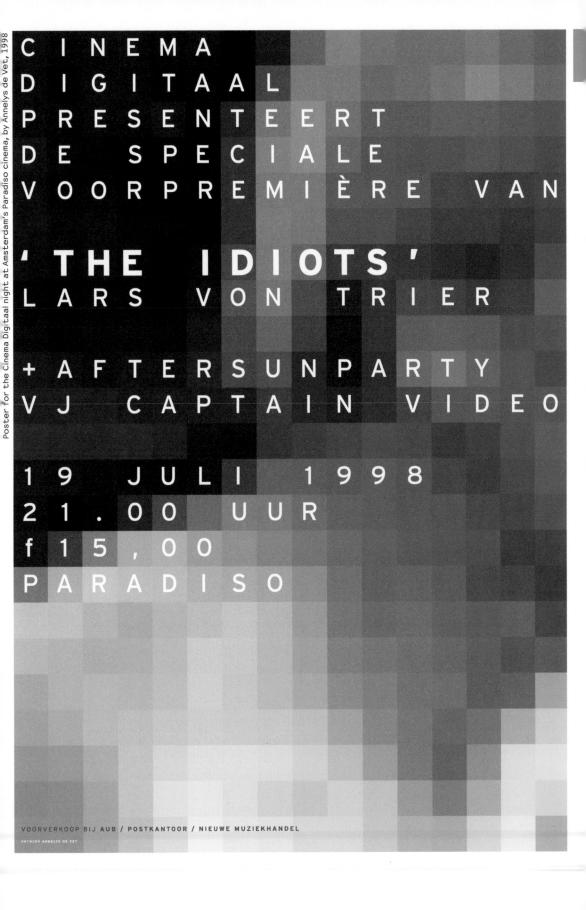

CINEMA
DIGITAAL
PRESENTEERT
DE SPECIALE
VOORPREMIÈRE VAN

'THE IDIOTS'
LARS VON TRIER

+AFTERSUNPARTY
VJ CAPTAIN VIDEO

19 JULI 1998
21.00 UUR
f 15,00
PARADISO

VOORVERKOOP BIJ AUB / POSTKANTOOR / NIEUWE MUZIEKHANDEL
ONTWERP ANNELYS DE VET

Illustration for **Squeeze Magazine**, by 178 Aardige Ontwerpers, 2001

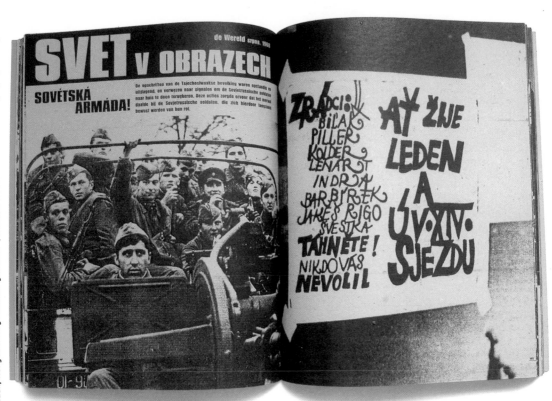

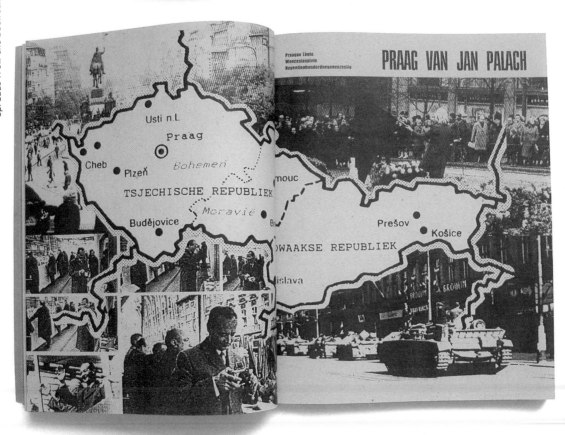

kaarten:17,50 (try out:10,-) telefonisch reserveren vanaf 24 mei t/m 9 juni (maandag t/m donderdag tussen 10.00 uur en 12.00 uur) tel. 030-520334

Poster for a fashion show at the Utrecht School of Arts (HKU), by De Designpolitie, 1994

The Fields of Babel

From the outside, the Media Park in Hilversum, a town about half an hour southeast of Amsterdam, appears to be a normal research-and-development or office campus. The structures are all about four stories tall, and each block has its own bit of color or distinctive shape, while the whole is carefully orchestrated and contained behind a guarded gate. But drive along the ring road or walk around a little, and you will see that these are pretty strange structures. They bristle with antennas, and each form is slightly odd for an office building. They are closed blocks, hermetic and slightly mysterious, but each has its own identity: one hides behind colored glass, another lets trees grow through its cantilevered roof, another seems to sprawl over its lot with brick appendages.

The weirdest of them all is the Villa VPRO. Here the parking garage in front of the building turns into the lobby of the main entrance. The gray ground flows under the glass doors, past a tiny "sin lounge" done up like a bordello, where people can smoke facing a cigarette vending machine, and into a lobby where an ornate desk, an oriental carpet, and a chandelier float in a sea of undulating concrete. The building does have a central core, and you could turn around and take the stairs there, but it is easier to scramble up the concrete mound on the right, aiming for a high-backed chair perched at the top of the rise. From this platform you can then wander into the rest of the building. A continually shifting array of office pods appears as the building unfolds into a strange hybrid between a traditional office and an "open office." Changes in level, shifts in plan, and partitions made of incongruous materials such as rubber delineate different work areas. Elsewhere, what should be a simple set of stairs turns into a broad flight where workers gather at lunch or for special announcements. One of the floors curves up, becomes an enclosure for rooms packed with recording equipment, and then turns into the next floor. Toward the top of the building, this seemingly messy spiral of different levels filled with office furniture turns into a climbing, terraced cafeteria.

Or you can bypass all this madness, get right into the elevator, and ascend to the top floor. The door opens and suddenly you are back outside, on a grass field completely covering the villa's roof. Bits and pieces of the office building peek up above the field, which otherwise looks like a Dutch meadow floating in the air. To one side, the field plunges back into the building, running alongside and eventually merging with the cafeteria. And what does this whole building look like? At first glance, it is a simple box, concrete and steel, nothing special. Then you start tracing those concrete floors that loop back on themselves and begin to notice the different shades of glass that define different uses and sun orientations.

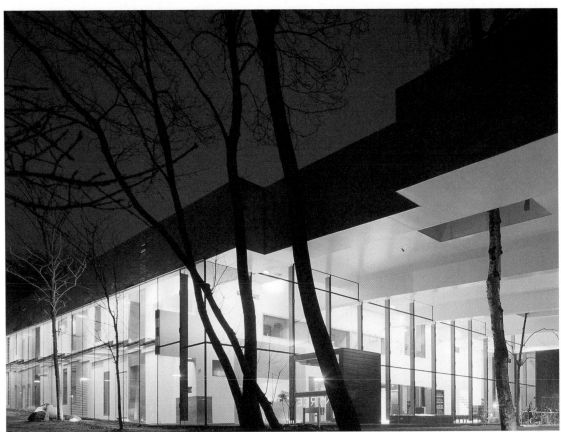

Entrance of the Media Authority Building, Hilversum, by Koen van Velzen, 2001
Entrance of the Villa VPRO, Hilversum, by MVRDV, 1997

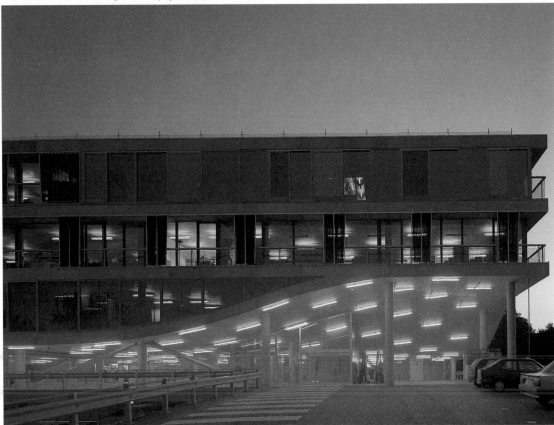

The Villa VPRO, designed by the Rotterdam-based firm MVRDV, is the headquarters of a broadcasting company. When I went for a tour, I had to listen for an hour as a guide, hired by the company, carefully explained everything that was wrong and bad about the building. This structure is convoluted not just in its appearance but also in its social construction. Commissioned by the most creative and tumultuous of the country's media companies, which is run as a near collective, the building unified many different departments and programs that until then were housed in little villas around town—hence the half-nostalgic, half-ironic name of the new headquarters. The company didn't want a normal office building but something that would be open and flexible and reminiscent of their quirky previous homes. They got exactly that and instantly set about fighting with each other, complaining about noise, openness, and quirkiness and, this being The Netherlands, airing all their disagreements in public. The Villa VPRO became a mirror or portrait of the company, with its audience participating in a series of documentaries and discussions about the building that were then [2] broadcast by the company itself.

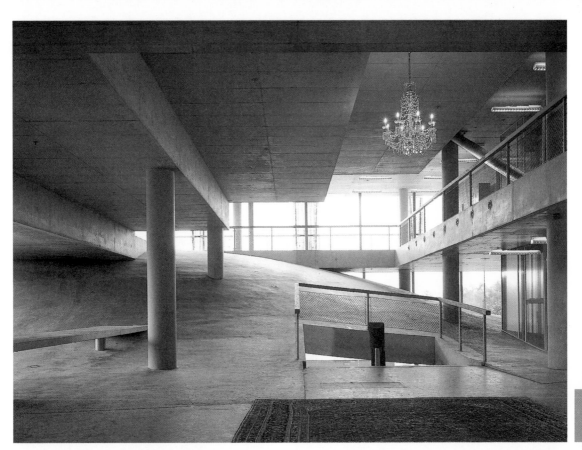

Interior views of the Villa VPRO, by MVRDV, 1997

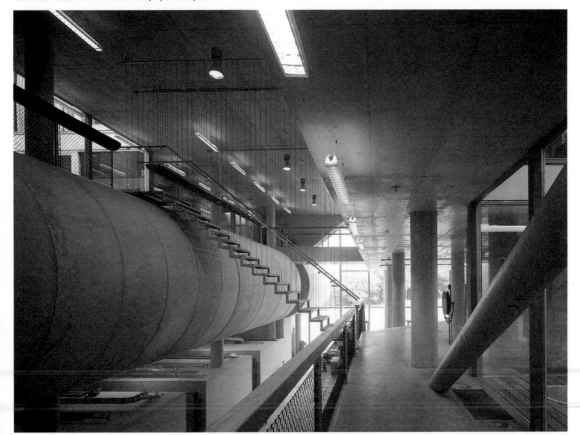

This quality of complexity that results in, and sometimes even results from, self-criticism, is perhaps the final inward turn the Dutch have taken. It is manifest in the very physical structures that make up Dutch culture—such as massive polders, infrastructure, and new towns, or even books and chairs. Creating a world in which "seeing is knowing is making" might start out as a rational project but often turns into something so complex, so labyrinthine, and so obtuse that nobody, including the maker, can figure out exactly what is going on. That makes for a peculiar kind of beauty.

The art, architecture, and design of The Netherlands exhibit an aspect that presents the exact reverse of the sparse, controlled, and rational aesthetics one expects after seeing the canonical forms and images the country produced during its golden age. To some extent, this kind of design answers to the baroque as a particular style that developed in the sixteenth century in Italy, and then in France and England. That style, unlike the mirroring and mapping of what Alpers calls "northern modes of representation," was a way of deriving more space and decorative elements out of the rigors of classical form, not merely the expression of state power. Spaces became more differentiated into chambers, antechambers, apses and semi-apses; columns sprouted a vast array of doubles, capitals, and connective tissue; and walls and ceilings soared away from what was strictly necessary to enclose space. Baroque, in its conventional definition, is evident in an increase in scale, ornamentation, and the transformation of well-mannered classical forms into dramatically expressive elements. It stretches columns, billows out drapery, and decorates walls with stories of war and conquest. It tends to dissolve structural boundaries, replacing them with flowing lines that move across space and tend toward dissolution in light. These elements exist in painted and sculpted images but become integrated ensembles in the churches and palaces of the period. The baroque period also produced heroic figures such as Bernini, who represented the type of "genius" who not only invented radically new forms but also unearthed, in some mystical sense, art and architecture's ability to represent the ineffable.

03
8 710966 000359

Master Forever

The baroque is also a natural development of the established, classical order. It is a collapse of structure, and a dissolution. It is as if form were being brought to its melting point. Several philosophers have argued that the baroque marks a point of transformation both of an aesthetic and of commissioning (and thus a political and economic structure), when the sureties of the former order are experienced as artifice that can be toyed with or must dissolve in favor of something new or other. The baroque becomes a name for the complexity inherent in a system as it comes to a point of transition.

The notion of sucking the outside into the interior, of dissolving form into ever more complex subsets and filling the empty spaces with ever more pliable folds of drapery, was as much part of seventeenth-century Dutch painting as were the grids and serenity we now associate with it. Underneath the calm surface, at the edge of the picture, in the glances between the depicted lovers, and in the luxurious embrace of the surface of things, lies a baroque sensibility. The scientific project of representing things as they were quickly blended into a fetishistic adoration of a simple oyster, lemon, or flower. The very attempt to contain such luxury within Calvinist constraints, within the frame and within the surface of things, gave force to the image. In the work of Rembrandt, that force famously exploded to the surface.

It takes a genius such as Rembrandt to make baroque works of art, and there have been very few such figures in Dutch culture. "Don't stick your head above the grain before they start mowing," a popular Dutch expression goes; indeed, it may be lopped off by the leveling scythe of commonsense culture. When aberrant or merely large forms appear, they are usually seen as part of "southern," or more particularly Catholic, influences. Such is true of the work of the neo-Gothic architect P. J. H. Cuypers, even though his Rijksmuseum and central train station, both in Amsterdam, were part of a broadly accepted government commission.

The Dutch baroque lurks in the shadows, almost hidden. It appears only fleetingly, just out of sight, and in general plays hide-and-seek with the veneer of a rational order that the Dutch like to think covers their country. Take the work of Michel de Klerk, the genius architect of the Amsterdam School, which, after the passage of the Social Housing Law in 1901, produced some of the most striking housing projects in the world. The most famous housing block he designed was De Dageraad, centered around a small tower at the inward bend of a kidney-shaped courtyard. De Klerk did not abandon the brick row houses that make up the Dutch urban vernacular but instead folded and then unfolded their basic pieces in line after line of angled brick courses, white-framed windows, and steeply sloped tile roofs. Walls turned from orthogonal elements into fluid, clothlike red arcs the architect curved, swept up, and then folded together around bands of openings and doors. The windows act as interruptions in this fabric and are themselves part of complex parallel lines of motion. The influence of art nouveau or *Jugendstil* is obvious here. Yet these buildings did not dissolve into wavelike forms that to critics such as Baudelaire reflected the oceanic currents of an unstable and quickly changing new age. Instead, they seemed to drink all that energy into their solid forms. The result was not a mirror to a world of trains and train stations, power turbines and department stores but a form that could stand strong against the eviscerating effects of technology.

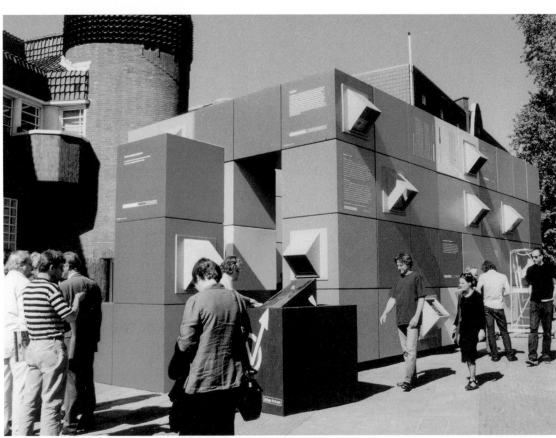

Urban Tetris, a mobile installation commemorating the centennial of the Social Housing Law, by Maurer United Architects, 2001
5 Urban Living Solutions, animations shown on screens built into the Urban Tetris installation, by Arno Coenen, 2001

My favorite de Klerk work is a small house he designed for a suburb about half an hour outside of Amsterdam. It is a compact affair whose plan is based on one unique act of rotation—setting the living room at a 45-degree angle to the entrance—that introduces a whole dynamic of complexities within the arrangement of spaces. The outside is a version of a traditional farm building in which the roof has grown taller and comes down farther than normal, enveloping the whole house in its swerving forms. The simple form of a house has become complex on the interior, while the exterior has the appearance of a small country cottage exaggerated in scale. It becomes both a more compact and a more graphic image of a house.

The strangest example of this kind of enlargement that melds familiar forms into something strange, more abstract, and yet much more familiar is the St. Hubertus Lodge, designed by H. P. Berlage and completed in 1920 for the Kröller-Müller family. The wife in this case was the heir to a large shipping fortune; her German-born husband had worked his way up through the company's ranks. When he tried to woo her, she demanded that he come to share her love of art. Their compromise was the estate where a hunting lodge and a museum for her art collection were built. The couple used the legend of St. Hubert, who was converted to Christianity when he saw a burning cross between the antlers of a deer he was about to shoot, as a metaphor for their own situation: art was the cross, Mrs. Kröller-Müller the deer. Berlage's design appears to be a version of one of de Klerk's social housing projects stranded in the forest. It is, however, a private home, in the shape of the antlers of a deer, with a nearly fifty-meter tower whose bricks form the outline of a cross in the middle.

Such large and explicit statements are the exception in Dutch culture. The baroque often remains hidden in the manipulation of the surface, as Berlage ably showed in his designs for the new neighborhood of Amsterdam South, which was an enlargement and outgrowth of the original canal zone. He did not set his blocks against the semi-octagonal order he was expanding, nor did he try to create an orthogonal repetition of its inward-turned geometry. Instead, he designed a formal order that carried forward the parallel lines of the canal zone into housing blocks with communal rather than private gardens between them, which focused on small squares. The angled streets are caught by towers or sometimes just higher building blocks that are themselves just more housing. The inherent order of the canal zone has been expanded, regularized, and emphasized.

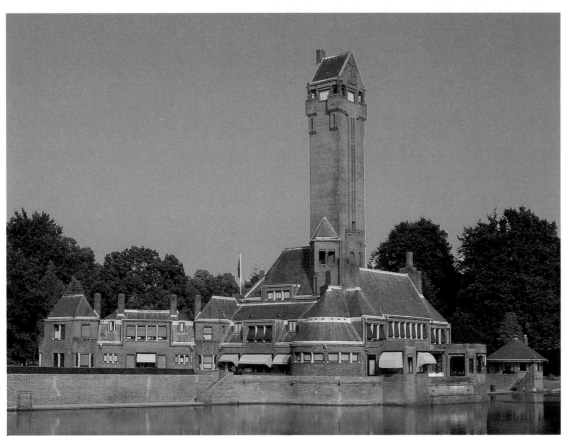

St. Hubertus Lodge in the Hoge Veluwe National Park, once the private estate of the Kröller–Mülller family, by H. P. Berlage, 1920
Posbank Pavilion in Veluwezoom, part of the Hoge Veluwe National Park, by Bjarne Mastenbroek/De Architectengroep, 2002

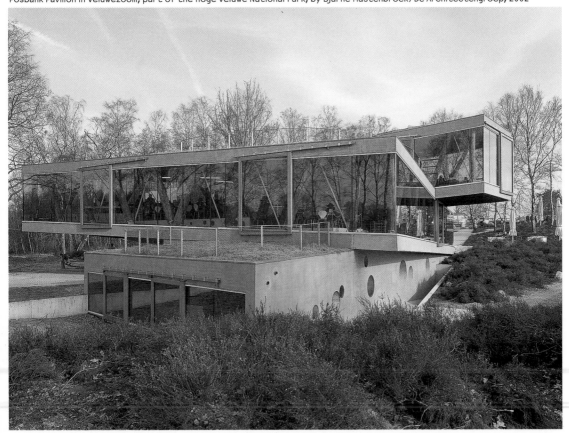

Architects and urban planners still work with the basic building blocks of the Dutch city, which are defined by the underlying order of the irrigation ditches, meadows, dams, and connecting roads. They populate this order with expanded and distorted versions of the red-brick house with a sloping tile roof, curving, curling, unfolding, and refolding it to enlarge its scale, let its rigid forms dissolve, and make it look more like a child's drawing of a strong, sheltering structure. A good example is the rows the architect Dick van Gameren designed in the new neighborhood of Ypenburg. There the roofs become geometric planes that cut into the row's volume; the corners rise up, and the whole structure, seemingly escaping from the rigid grid in which it sits, gives the impression that some large force has molded it. These houses are folding in on themselves, hunkering down on their sites to fix them with more certainty, while their roofs point to the landscape of new neighborhoods and highways around them.

These formal gestures imply the work of a powerful architect who can actually shape such large forms. Such a figure must, in the mythology of architecture, fight against the forces of nature but also against established norms. He, never she, must be somewhere between slightly and very eccentric and must employ a well-developed ideology while working intuitively. He must also work well with the establishment, producing monuments for them. This syndrome, in which the architect becomes the grand maker of exuberant form in the manner of Bernini, is not prevalent in Dutch culture, but it does show up now and then. What is interesting is that it rarely leads to the making of isolated monuments, and when it does, those objects wind up being flawed. Sybold van Ravenstyn, who for several decades before and after the Second World War fought what he saw as an oppressive modernist establishment, might count as one such figure, but his work is more rococo than baroque. He did a great deal of design for the national railroad, including major stations in Utrecht and Rotterdam, as well as drawing up the railroad's standard signal box. When he tried to elaborate on basic modernist structural forms implied by the need to rationally and efficiently accommodate the technology and the public, the results were thin lines and curves that, rather than penetrating or warping, danced on the surface of the concrete and glass structures. Van Ravenstyn was decorative rather than baroque.

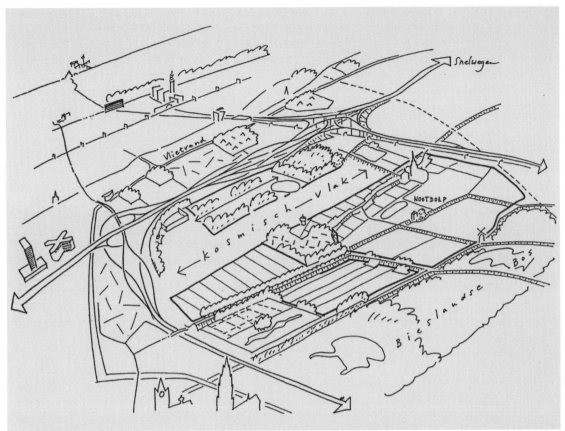

Site analysis for the masterplan of the new residential neighborhood Ypenburg, by Frits Palmboom, 1994
Housing project Singels Deelplan II, Ypenburg, by Dick van Gameren/De Architectengroep, 2002

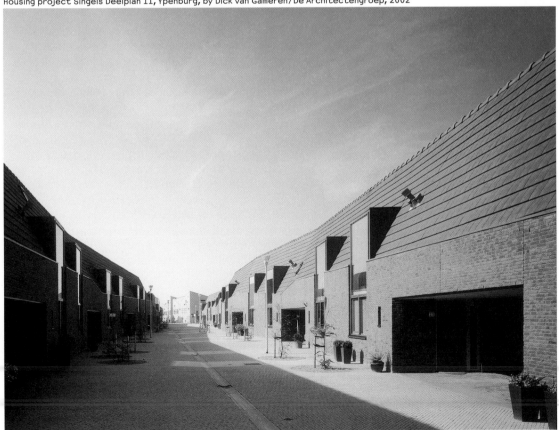

In fact, one finds failed baroque buildings all over The Netherlands. The Palace on the Dam (as the grand town hall came to be known after it was taken over first by Napoléon's brother when he ruled the country and then by the royal family) was the first of such structures, failing to adapt its palace logic to the needs of a collective civic government or to a small-scale, brick context. In the twentieth century, architect A. J. Kropholler proved how silly monumental gestures look on brick boxes when he placed towers on top of museums in Rotterdam and Eindhoven and streamlined their walls into closed brick facades. When K. P. C. de Bazel designed a new headquarters for the Dutch Bank, he clad the large structure with alternating bands of light and dark stone. Placed on a connecting street between two canals, it is invisible from afar, and its monumental nature dissipates. It is neither convincing as a grand palace of capitalism nor really well integrated into its narrow site.

An egregious twentieth-century example of a failure at baroque form is J. J. P. Oud's headquarters for what is now Shell Oil. Oud was a grand master in the tradition of some of the Italian and French models: self-taught, mercurial, sure of himself, but prone to depression and breakdowns. He was one of the heroes of Dutch modernism, producing highly refined blocks of housing for Rotterdam (where his brother was the mayor). Working for a rich and powerful oil company, Oud inflated his modernist idiom, subjected it to the compositional logic of classicism, and then treated that order as a thin and pliable skin to be wrapped around what is essentially a big box. The building never seems to be quite sure of its scale, and one gets little sense of whether this is just an office building or a monument to corporate culture. It is too grand to be the former, and too reserved to succeed at being the latter. The clumsy result effectively ruined the architect's career, leaving him without commissions or critical acclaim for many years.

Hugh Maaskant was one of the more effective modernist baroque masters. Consciously adopting American sensibilities, he sought to break open the scale and sensibility of the Dutch city in the heady years of the late 1950s and 1960s. The huge bulk of his Groothandelsgebouw, meant to house small businesses whose buildings had been wiped out during the Second World War, overwhelms Van Ravenstyn's adjacent Rotterdam Central Station. It is a massive concrete rectangle the architect folded in at the middle, with a skin that is a complex play of concrete frames not really justified by structural demands. Cars and trucks, and with them the life and scale of the postwar city, enter the building through access ramps running right into the central courtyard. A cinema originally drew visitors to the roof, where they could look back out over the city. Maaskant also designed the pier at Scheveningen, which celebrated pure consumerist delight floating away from the gridded landscape behind the dunes into the water of the North Sea, and the provincial headquarters of Brabant, which celebrated the power of bureaucracy in the years when the welfare state was vanquishing all.

Maaskant's buildings are exceptions and stand out all the more because of it. They are not always beautiful, exactly because they are so alien, but also because their convolutions and involutions do not have the staid certainty that emanates from much of the rest of Dutch culture. Yet it is this discomfort that makes them so powerful. When the Dutch go baroque, they don't just make something big and glorious, they design something that seems wrought with insecurities and self-inspection, as if one could try to understand the forces at work in making something so large. Perhaps it is no accident that the most popular painting in Rotterdam, where Maaskant was based, is Pieter Brueghel the Elder's _Tower of Babel_.

Maaskant's Rotterdam-based heir and builder of Babels is Rem Koolhaas, the founder of the Office for Metropolitan Architecture (OMA). Koolhaas has all the attributes of a baroque master, including physical height (though he is not as tall as the two-meter Maaskant) and the manipulative personality of a diva. OMA works with some of the richest corporations in the world, yet Koolhaas maintains a continual stream of criticism and self-criticism about his firm's work. OMA has built massive structures—including Euralille and, more recently, the Seattle Public Library—and yet he sees himself as a misunderstood genius in his own country. Above all else, Koolhaas is, as the critic Ole Bouman has put it, the "silver surfer": he delights in riding the flows of late capitalism, tracing its contours and its complexities in his work. His work is not so much alien as it is an intensification and reformation of a modern vernacular.

Computer rendering of the Chinese Central Television (CCTV) headquarters, Beijing, by Rem Koolhaas/OMA, to be completed in 2008

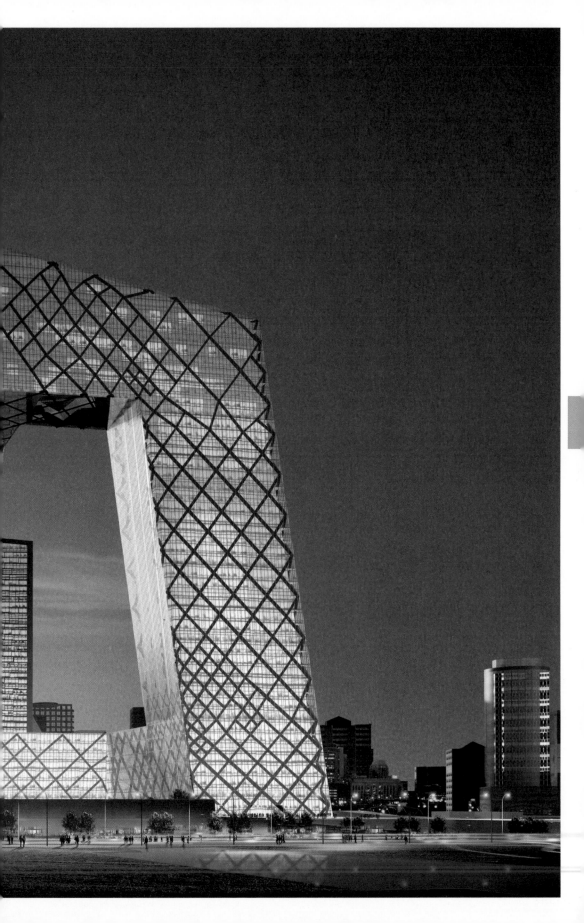

I first met Koolhaas in the German town of Mönchengladbach. We were to visit the new museum there, designed by Hans Hollein. Koolhaas came storming in an hour late, looked around, pronounced the building "bourgeois bullshit," and bundled me in his car for a high-speed run back to Rotterdam. Along the way, he kept up a constant stream of criticism of Dutch architecture, while explaining his own grand plans. He was at a point where he was about to turn the theories he had developed into major buildings, and he was filled with both self-confidence and doubt. I was in awe, as one should be before such a genius.

Koolhaas's first book was _Delirious New York_. Published in 1977, it was an impassioned plea for "Manhattanism." He argued that this was a quality that not just came from the making of tall buildings but also was the result of the embedding of complete fantasy worlds within the grids that made those spires possible. Koolhaas did not so much add to the mythology of New York as a skyscraper Mecca as show that it was a giant tower of Babel, filled with competing fantasies whose sensuality and exoticism were the driving force. This Manhattan became the model Koolhaas/OMA then tried to build in fragments and insert in other cities. The firm's proposals for the Dutch Houses of Parliament in The Hague, which won a competition in the same year that his book was published, expanded, intensified, and embellished the medieval and nineteenth-century complex into a modernist collage. Its renovation of the Dome Prison of Haarlem the following year laid bare, through excavation and addition, the ordering principle of this house of confinement and, in drawings that separated the various elements of the structure into floating islands that seemed to want to fly off the page, enlarged it substantially.

Over the years, Koolhaas/OMA's work became more introverted and solid— though this might also be the result of the departure of such key (and non-Dutch) collaborators as Elia Zenghelis and Zaha Hadid. The firm tried its ideas out on a housing block in the northern part of Amsterdam and on a police station in the new town of Almere. It finally reached a point, in 1994, where it could produce a building that fully embodied Koolhaas and his collaborators' thinking. The Kunsthal in Rotterdam is a compact box sitting on the side of the main dike that protects the city against inundation from the river Maas. Like the traditional dike house, it has two fronts and two scales: one on the main thoroughfare atop the dike, the other toward the rural scene behind it, which in this case is a municipal park. On both sides, the building looks like a solid box, but that seeming solidity is somehow undercut as the building seems to float on a ground floor of glass. The front or dike side has a porch that appears as a vestige of a monumental arcade, while the rear is a more abstract object levitating over the green.

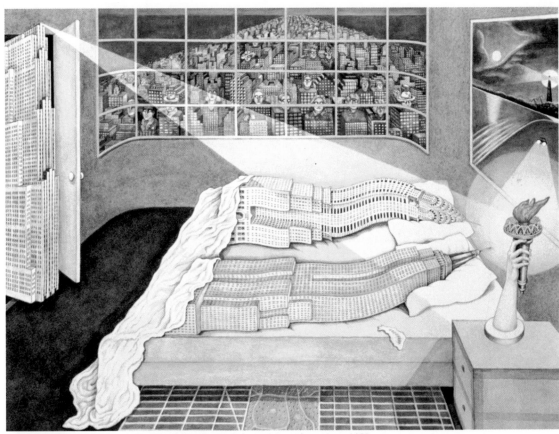

Cover illustration of Rem Koolhaas's **Delirious New York,** by Madelon Vriesendorp, 1975
Kunsthal, Rotterdam, by Rem Koolhaas/OMA, 1993

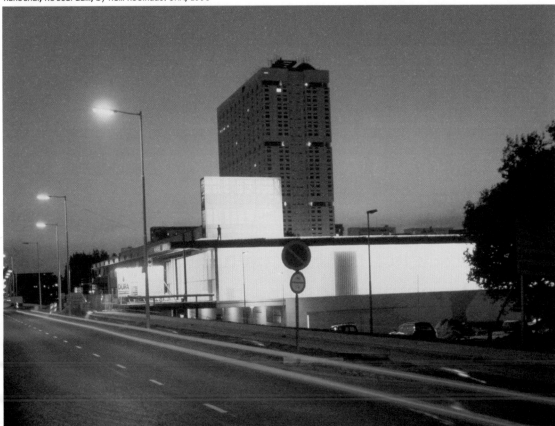

There is no main entrance in the facade. It is as if Koolhaas could no more make himself follow the rules of classical monuments than the designer of the Palace on the Dam could make a front entrance. Instead, the building is cut open two-thirds of the way down its facade, creating a path that leads into the park. Halfway down the slope of the dike, you enter the building, only to find yourself in an auditorium that slopes in the other direction. The dike and its slope, but also the expanse of park on the other side and the pathway that connects the two, seamlessly turn into interior spaces and devolve into the other, cultural world of the galleries.

The galleries themselves, though fairly convent-ional, are interrupted by such alien features as oddly placed structural elements and tree trunks that seem to hold up the roof. The ceiling reveals not the major structural forms that span the space but the diago-nals that strengthen them, just as one beam, painted orange, peeks over the roof from the outside as a sign of the structure. Everywhere, inside and out, major and minor elements, surface, and shape criss-cross and confuse the viewer; the elevators, which are barely ever used, become the building's sign and turret, and the auditorium's slope becomes the roof of a café tucked in underneath.

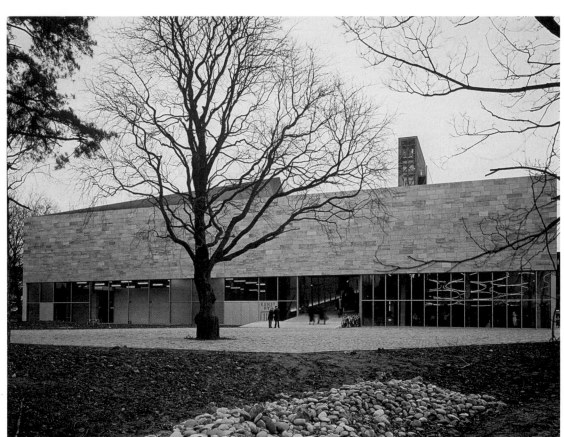

Exterior of the Kunsthal as seen from below the dike, Rotterdam, by Rem Koolhaas/OMA, 1993
Kunsthal auditorium, Rotterdam, by Rem Koolhaas/OMA, 1993

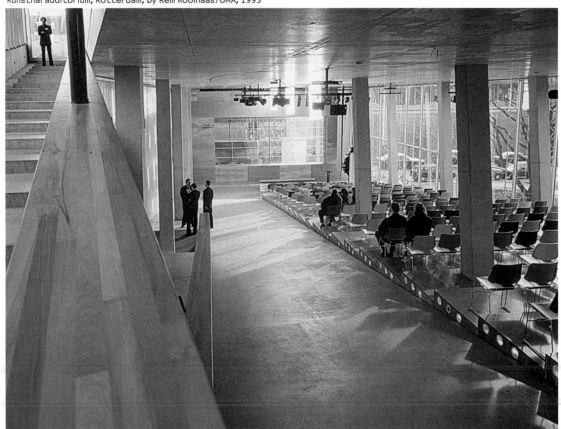

Since finishing the Kunsthal, Koolhaas/OMA have attained this level of complexity only in private homes, though several current projects promise even greater treats (both in size and in complexity). Partially, this is because Koolhaas is continually concerned with mining the realities of the modern city rather than making isolated monuments. To him, architecture is a node of intensity that comes out of a great deal of research and leads to a reorientation of the institutions he houses. As such, the forms he designs have to extend, warp, and intensify what is already there rather than establish a new paradigm.

Though Koolhaas is loath to admit it, the lessons of his architecture now permeate the work of his students, former employees, collaborators, and almost everybody else who comes into contact with him. He has reshaped Dutch architecture just through his heroic presence. He has enabled designers such as Ben van Berkel and Caroline Bos to make the Erasmus Bridge but also to make quasi-monumental forms out of switching stations and to turn the Valkhof Museum into a further elaboration and abstraction of the formal spatial sequences evident in the Kunsthal. Van Berkel and Bos's Möbius House, completed in 1998 (and which they claim inspired some of Koolhaas/OMA's own recent work), is the very paradigm of Koolhaasian involution: a concrete plane that folds continually back on itself, making a complex yet smooth structure around and along which the activities of everyday life can flourish.

If Van Berkel and Bos represent the heroic and infrastructural side of Koolhaas's influence (at least in their early work), Willem-Jan Neutelings and Michiel Riedijk represent that part of his work that one might call no-nonsense baroque. Their most accomplished building, the Minnaert outside of Utrecht, is a box stretched beyond the bounds of good proportions, and the marks of that distortion are present on its spray-on skin. It is not a pretty building: the frozen red foam has the appearance of the wrinkles of some monster of ancient modernism affixed to this semirural campus. Neutelings and Riedijk have accepted the bulk that comes with such institutional buildings but dissolved it into drapery. Inside, the building contains a large courtyard in which rainwater, draining from the roof, collects in a shallow pool; beside it, students sit on red benches behind keyhole-shaped openings. There is a strange sensuality about this space, and also a sense of uncertainty, whether one is inside or out. Nor is this Neutelings and Riedijk's only trick. They also plaster buildings with letters, adapt them to fit fire trucks, and engage in other complex moves. In the end, however, there is an essential strangeness about their work that belies the rigid translation of the function, technology, and site they espouse.

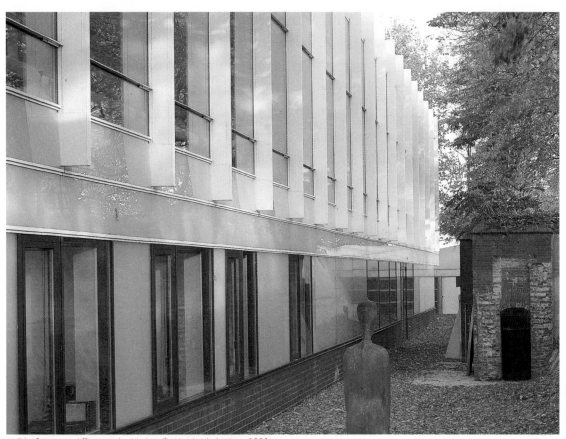

Valkhof Museum, Nijmegen, by UN Studio Van Berkel & Bos, 1999
Minnaert Building, University of Utrecht, by Neutelings Riedijk, 1997

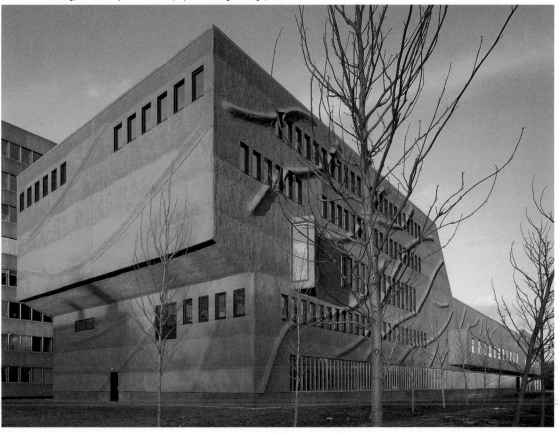

Neutelings used to explain their work as "lazy," by which he meant it was a semiautomatic response to the situation. Now he talks about it as a balancing of "good taste and cliché bravura." They want to make something bigger and more significant out of their commissions but continually doubt their right to do so or the appropriateness of the result. They mock their own heroic forms, undercut them, and make them seem weightless. A fire station they designed for the town of Breda is clad in red brick but has an amorphous shape that makes the humble form seem like wallpaper. The main garage and the administrative areas rise up out of this red miasma into a cantilevered nose whose glass window seems to be standing watch over the city, but it is too abstract and too caught within its own cladding to be truly heroic or expressive. References are stated and buried, large forms appear and dissolve, normal and logical results or responses to site, material, and program create strange deformities.

It is in this almost intuitive and yet thoroughly logical response that the strangeness of the forms appears. The attitude is also a counterpoint to something Ben van Berkel and Caroline Bos said about the same time the fire station was erected: a building is no more than the translation of accumulated data into form. Both of these approaches make the work of the architect paradoxically more heroic. Only the great makers know how to mold these shapes into a given form, the strangeness of which gives the resulting structures a recognizable character and an identity that clearly relates them to their creators. They escape from the boundaries of order, as well as from the systems one might use to evaluate them, precisely by eschewing imposed style in favor of developing form. Van Berkel and Bos's Möbius House is an example. It gives its clients the sort of rooms out of which a freestanding home is usually made, but then captures them within a concrete framework where walls become ceilings, ceilings become floors, and floors become walls again in a seamless flow of concrete. From the outside, the villa is an expansion of its slightly sloping site, while from the inside all the proper functions of a house start to flow into each other and pile up so that one gets lost in this domestic labyrinth. It is that haunting sense of the familiar turned somehow other that makes the Dutch baroque so powerful.

Fire station, Breda, by Neutelings Riedijk, 1999
Möbius House, Het Gooi, by UN Studio Van Berkel & Bos, 1998

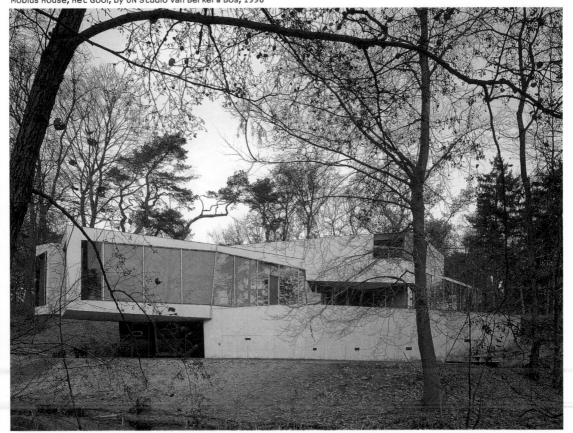

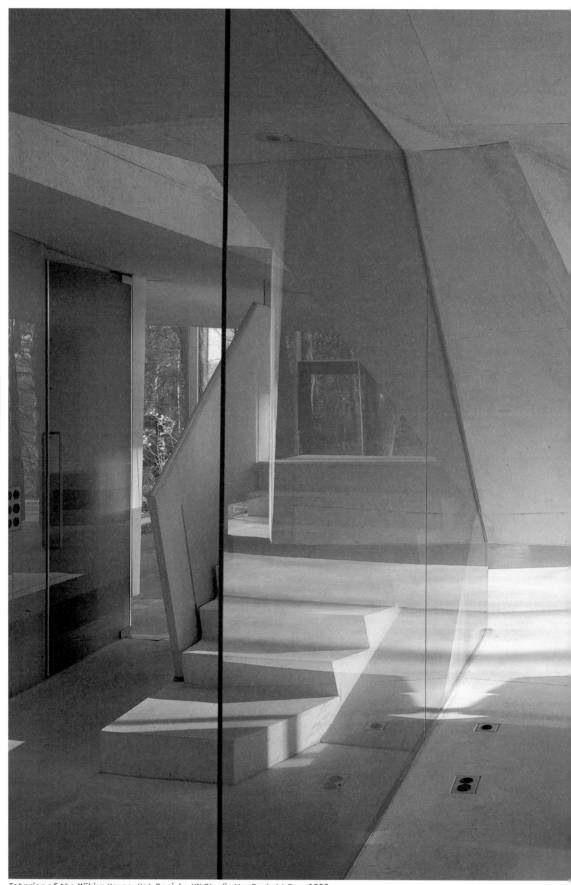

Interior of the Möbius House, Het Gooi, by UN Studio Van Berkel & Bos, 1998

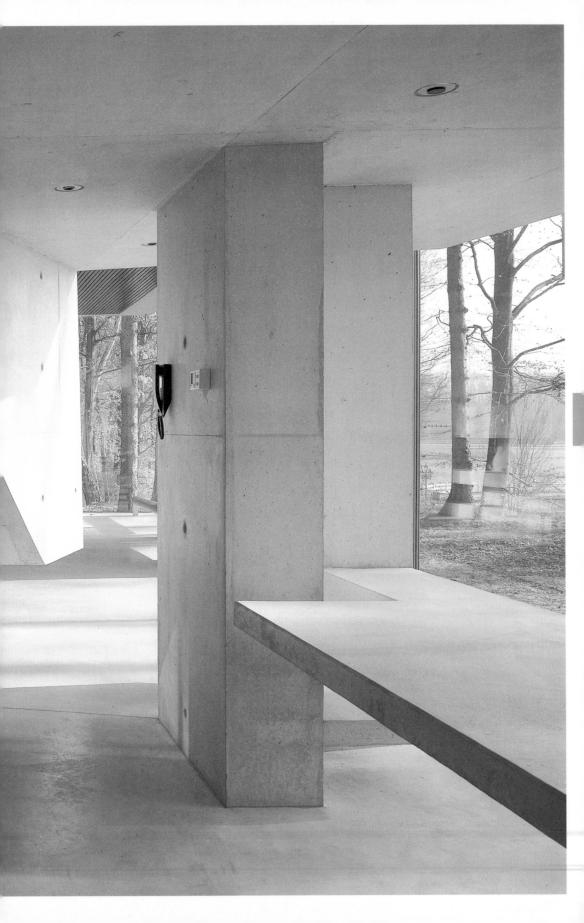

The most direct translation of Koolhaas/OMA's work is found in the architecture of MVRDV. Their Villa VPRO uses many of the forms one of the principals, Winy Maas, developed while working on the Educatorium, a classroom building that sits opposite the Minnaert. The firm took the idea of research and data collection a step further, designing "datascapes" that project form directly out of numbers. The exponential growth of Dutch society, for instance, is turned into grand mountain ranges of garbage and towers housing pig slaughterhouses. In real life, MVRDV produces housing that is "supermodern": so clean, so abstract, and so seemingly arbitrary that it is almost like a sci-fi creature in its effect. MVRDV can do this even though these monsters' building blocks are the mass-produced elements that also make up the skin and bones of other housing projects or office buildings. MVRDV cantilevered apartments off assisted-housing projects and made collages of different housing units in one single slab at the edge of the Amsterdam harbor. There is a system to everything they do, and yet there is always a touch of the absurd.

A remarkable MVRDV design is a proposal for sixty-four houses in the VINEX neighborhood of Ypenburg. The buildings are like a classical lexicon of variations in shape. There is a courtyard house, a house made up of two parallel bars, a house that is cross-shaped. The architects have worked through every geometric permutation a basic house plan can have, abstracted it, and clarified its shape. Then they made one simple decision: they left out all the windows. The houses become completely interior worlds whose only view is of that endlessly changing Dutch sky. They have taken the lessons of Vermeer—but also of Koolhaas—to just about the furthest extreme imaginable.

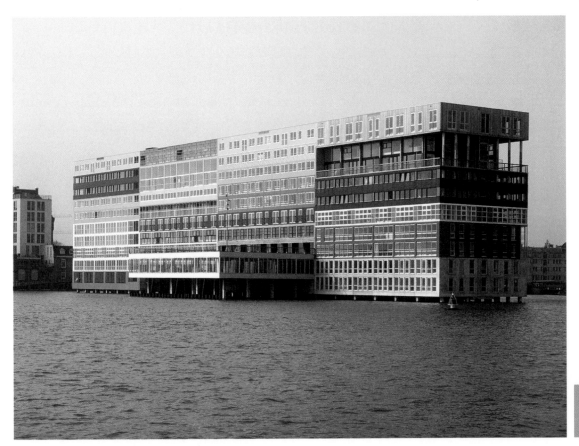

Silodam residential building, Amsterdam, by MVRDV, 2001

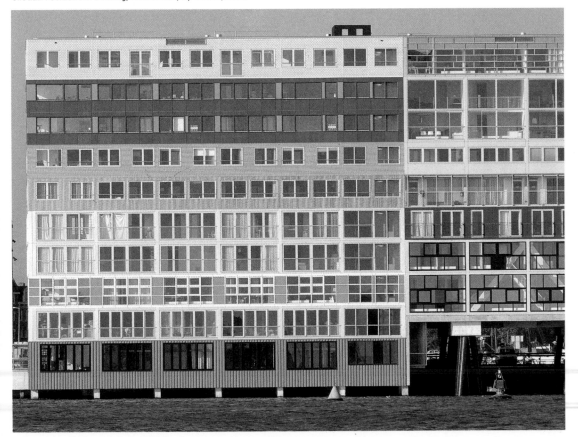

One can find examples of the peculiarly Dutch brand of the baroque in other design fields as well. The industrial designer Marc Wanders, who is assuming the characteristics of a baroque master, delights in such tricks as using condoms as molds for his Egg Vases and making nearly two-meter-tall lamps that are abstracted versions of the standard table model. His shower is a single tube arching out of the ground, a piece of hidden plumbing become monumental. He has even made a chromed version of his Knotted Chair. This delight in absurd excess coming out of such practices as enlarging common household goods is the product of a workshop he calls, appropriately enough, Wanders Wonders. His product line's brand name is Moooi, the Dutch word for "pretty" or "beautiful" with an extra consonant added. Come watch the miracle of the transubstantiation of plastic into precious metal, of the dirty into the artful, the useful into the abstract, he seems to be saying.

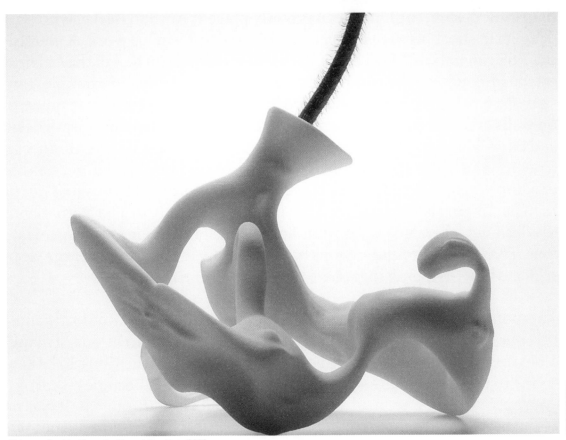

Airborne Snotty Vase, by Marcel Wanders, 2001
Knotted Chair, by Marcel Wanders, 1996

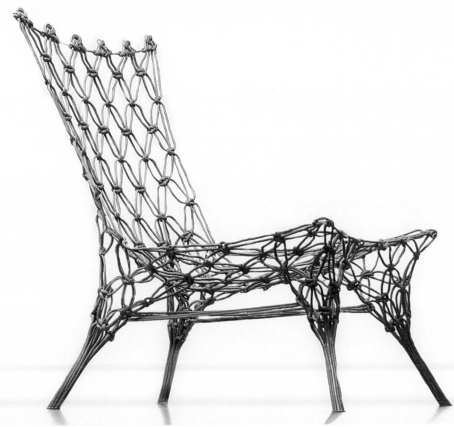

In graphic design, the Dutch can proudly present Anthon Beeke, who delights in shocking viewers by using pornography in his work. A member of the "'68 generation," Beeke sees his work as direct criticism of the Calvinist establishment. A poster for the play *Troilus and Cressida*, for example, consists of a woman's vagina made up to look like a horse's behind. It appeared on walls everywhere in Amsterdam. "You have to understand," says designer and critic Dingeman Kuilman, "the Protestant tradition always produces its reverse, which uses the knowledge and the discipline it gained, such as how to compose and how to choose type, against the very traditions that nurture it." That might also be true in other countries, but only in The Netherlands do the designers then receive commissions from state-funded arts organizations. The Dutch baroque swoops back into daily life, gliding over the clean surfaces before ripping them bare to shock and appall.

This points out the importance of the bits and pieces of the Koolhaasian baroque that purposefully don't work. My mother used to be one of many older people who complained about the steep ramps at the Kunsthal. I kept trying to explain to her that it was the point; you had to become aware of your surroundings, get mad at the architect, and work through it. It was not a kind of therapy, as the architect Bernard Tschumi has proposed, but a way of heightening your irritation at the world. Once irritated, you will also be open to the world's sensuality; Koolhaas wants us all to feel his delight, his power, and his unease.

The Koolhaasian baroque extends beyond buildings into town planning, landscape architecture, interiors, and even art. For years, Koolhaas has collaborated with Petra Blaisse, who designs both interiors and gardens but not the buildings in between. Instead of the hard divisions a building makes she is interested in introducing screens and scrims; curtains are the major design element in her interiors. They are theatrical—sometimes literally so, as in the stage curtain for the OMA-designed Netherlands Dance Theater— and they often invade the rooms they are meant to close off from the outside world. They become objects unto themselves, and then Blaisse cuts circles, ovals, and gaps into them, leaving a vermiculated surface. Mirrors and appliqués sometimes replace what is lost. In the process of turning the curtains into objects, Blaisse uses them to reflect the full force of the mapping and mirroring impulses of Dutch art. She employs similar techniques in her garden designs, using the complex geometries architects like to set out with their buildings as a pattern for the soft fabric of planting that she can pleat, [2] distort, and turn back on itself at will. Modernism in the hands of Blaisse becomes a pliable cloak to be worn against the chill of functionality.

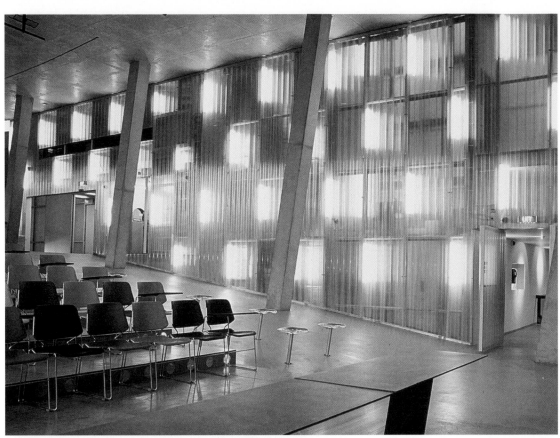

Kunsthal auditorium, Rotterdam, by Rem Koolhaas/OMA, 1993
Sound Curtain, Kunsthal auditorium, Rotterdam, by Petra Blaisse, 1993

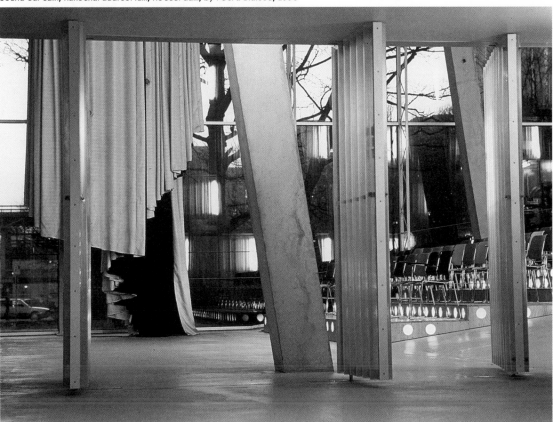

GLOBE SPEELT SHAKESPEARE

TROILVS EN CRESSIDA

Poster for William Shakespeare's Troilus en Cressida, by Anthon Beeke, 1981

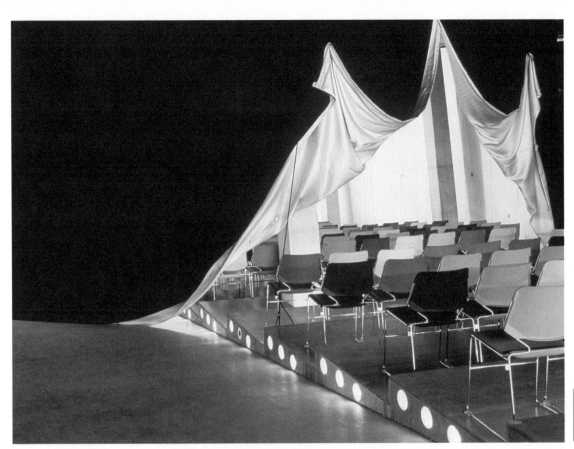

Sound Curtain, Kunsthal auditorium, Rotterdam, by Petra Blaisse, 1993

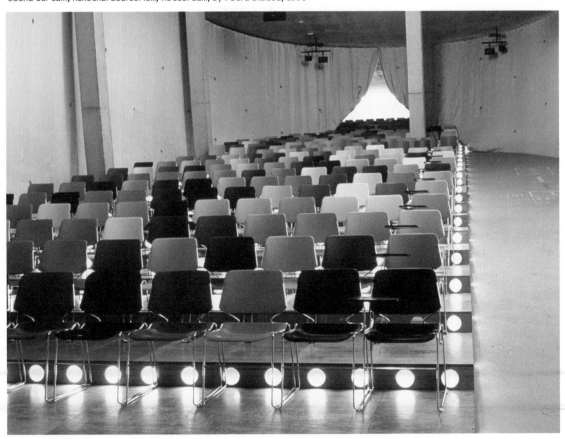

West 8, a Rotterdam-based multidisciplinary design firm, has taken the implications of Koolhaas's baroque visions even further. They see the city as a collection of planes and volumes that the landscape architect can heighten and intensify. When faced with building a new plaza on top of an underground parking garage, they did little to hide the expanse's bareness. Instead, they laid down a variety of industrial materials and put all the street furniture to the side. A line of giant cranes looms over the square from between the benches. At the end of each of these red-painted mechanisms is a single light that occupants can manipulate to spotlight the various activities in the square.

More recently, West 8's principal designer, Adriaan Geuze, has become interested in landscapes so dense and vertically stacked that they turn into something like buildings, becoming heroic counterpoints to the business blocks of the modern metropolis. He has proposed stacking conifers into towers surmounted by a gold "blob" and focused around a Zenlike pool. He has lifted a section of the Swedish countryside up on a jumbled woodpile and has proposed taking Koolhaas's hidden pleasure points out of the skyscrapers and suspending them in midair in Manhattan. Geuze and his gang are also urban designers, laying out neighborhoods such as Borneo Sporenburg in Amsterdam as if it were a warped version of the hedgerow gardens that provided such erotic delight to eighteenth-century aristocrats. The compact rows, with the diagonal cuts that result, are also an intensification of the traditional Dutch row houses, with each house on the block designed by a different architect. Dutch modernism here comes close to a boiling point.

Koolhaas's strangest collaborator is the artist Joep van Lieshout. Van Lieshout's art consists of everything from retro-fitting 1970s RVs into molded-plastic space capsules to making sausages. He feeds on the seediest pieces of 1970s culture, from all the forms of plastic that permeated the era's clothes, cars, and homes to the sexism and vulgarity coating those slick surfaces. He then reverses our associations with that aesthetic by using these forms to make composting toilets, self-help gardens, and other eco-friendly elements. He makes sculptures of giant genitalia you can sit on. He takes beer crates and paving stones and stacks them up to make something that could be either a bench or a table or a work of art.

In 2001 van Lieshout set up AVL-Ville (Atelier van Lieshout Ville) in the harbor of Rotterdam. This self-proclaimed Free State (modeled on the original Dutch secession from the Spanish, which was called the Orange Free State) had its own garden, restaurant (the Room of Earthly Delights), and a workshop to make limited-edition art objects and installations. Van Lieshout fought a running battle with the police over permits, and finally decided to call it a day in January 2002. At the closing ceremony, we gathered in a freezing warehouse to spend, in good Dutch fashion, six hours debating the meaning of all of this. We ate AVL-Ville's last pigs, which had been slaughtered that week, and drank heavily. Museum director Chris Dercon gave the ultimate valediction, citing critic Wouter Vanstipthout's pronouncement what The Netherlands needed was an architecture that was "dirty, delicious, and offensive." That was too easy, Dercon added, pointing out that to merely offend the norms would just brand the work as more "art." Instead he claimed that Van Lieshout was following Koolhaas's lead in integrating his weirdness into the fabric of everyday life—negotiating with authorities, playing on the sensibilities of his audience, and making something that invaded and evaded one's perception.

Van Lieshout is not the only artist trying to turn the Silver Surfer's wry exposition of modernity into a warped representation of the true driving forces of our modern world. Photographers such as Ineke van Zwammerdam, Viviane Sassen, Juul Hondius, and Frans van der Salm use Photoshop, elaborate staging, miniature models, and other digital tools to make similar assaults on modern reality by warping, exposing, and reformulating it. If Koolhaas remains essentially an architect, and thus someone whose heroic stance always houses and represents his clients, these artists are taking his research and development to the next stage. They are baroque master pornographers of the real, forcing us to confront the fact that technology does not so much destroy humanity as let our appetites and prejudices float in and out of the ordering structures—from houses to whorehouses, and churches to museums—that used to contain them. After all, the television show *Big Brother*, a spectacle of twenty-four-hour surveillance, was invented in The Netherlands. The sleep of Calvinism produces baroque nightmares.

Bathrooms in Rem Koolhaas/OMA's Euralille building, Lille, France, by Atelier van Lieshout, 1994
Untitled, by Joep van Lieshout, 1985

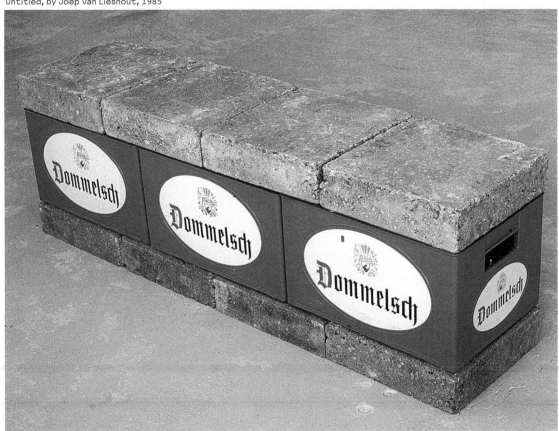

Young swimmer drying himself on bridge in the harbor neighborhood Borneo Sporenburg, Amsterdam, by West 8, 2000

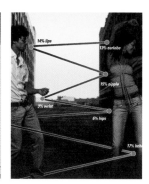

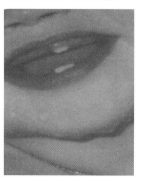

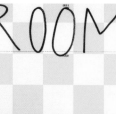

KesselsKramer — Founded by Erik Kessels and Johan Kramer, KesselsKramer is a "group of brains activated in the creation of ideas and solutions for brands and communications."

Fearless, provocative, and cutting-edge, their advertising campaigns expose unsuspecting audiences to fashion models posing as anarchist rioters, amputees modeling shoes for a shoe store, and little flags stuck in dog poop advertising an Amsterdam budget hotel. But with KesselsKramer's expertise in design, short films, documentaries, product development, and editorial work, their projects extend far beyond advertising. **The Other Final**—a film the agency wrote, directed, and produced—documents a football match played on the same day as the World Cup Final in 2002, between the two lowest-ranking teams in the world, the Caribbean island of Montserrat and Himalayan kingdom of Bhutan. "Do" is KesselKramer's brand of products, services, and ideas that only exist based on the involvement and interaction of the consumer with the product. In collaboration with Droog Design, "Do" was introduced to the world in 2001.

Ben — In Dutch, "Ben" has a double meaning: it is both the name of a person and the first-person form of the verb "to be." For mobile-telephone network Ben, KesselsKramer coined the tag line "Ik ben Ben" ("I am Ben") and famously introduced the brand as a person. Felix de Rooy describes the campaign and its influence in the monograph **KesselsKramer 96-01**: "Multicultural faces representing a panorama of race, color, age and lifestyle confront the consumer on billboards and on full-page newspaper ads, proclaiming 'I am Ben.'...The multi-cultural harvest of colonial history manifests itself proudly on national TV screens: I am seen therefore I am. Ben becomes part of an advertising iconography liberated from xenophobia and intellectual paternalism." De Rooy concludes with calling the agency "postmodern urban anthropologists in the jungle of the advertising industry" who introduced a twenty-first-

century existential update to Descartes's "I think therefore I am." Three years after the brand's introduction, it was swallowed by T-Mobile, who put an untimely end to this campaign, replacing everyman Ben with the one and only Catherine Zeta-Jones.

Harmine Louwé — Traveling through The Netherlands amounts to a journey through the portfolio of Studio Dumbar. Creators of logos for the railroads (KPN), the post office (PTT/TPG), the largest social and public insurance companies (GAK and Aegon), and even the striped identity of the police cars, fire engines, and ambulances, Studio Dumbar has put an indelible mark on the public sector. After working at Studio Dumbar for five years, Harmine Louwé embarked on an independent career in 1993. She has emerged as a favorite among creative directors at Wieden & Kennedy and KesselsKramer, who love her eye for detail and refinement on jobs for wide-ranging clients such as Microsoft, Nike, and Ben. Reviewing her Four Seasons stamps (1998) for the PTT, which are adorned with luscious fruit, journalist Ewan Lentjes writes an all-inspired response in the magazine **Items**: "One starts to comprehend how Snow White, or so much earlier Eve, could not resist temptation." Indeed, in Harmine Louwé's designs there is an undercurrent at work that is explicitly and deliciously unrestrained and seductive, adding her own mark of excellence to the landscape of Dutch design.

Fanclub — From 1998 to 2003, the Fanclub network was a European base of strategic/conceptual thinkers from many different cultural scenes and media, whose vision statement read: "In today's saturated media market, brands should be extremely mindful with their communication. Shouting louder than the competition or invading people's private space with over-branded experiences may result in a boomerang effect of numbness, irritation and aversion in the long run. Consumers rely most on information they discover themselves, based on their own experience or coming from sources they trust. Let's be honest: how credible are brands as a source of information about themselves? Word-of-mouth is becoming an increasingly important communication tool for brands. Brands should try to create true fans. People that really love a brand are the most powerful and effective spokespersons the brand can have." Artfully applying the skills of designers like Rob Meerman, Goodwill, and the duo Maureen Mooren and Daniel van der Velden, Fanclub represented an ecosystem of interconnected creatives, offering eager brands access to the fountain of youth. These brands, in turn, provided the substantial subsidy that made Fanclub's culture-creating experiments possible.

Maureen Mooren and Daniel van der Velden — When Fanclub was asked by the beer brand Dommelsch to come up with their promotional campaign for the three-day music festival Lowlands, the medium for the message was one and a half million plastic beer cups. These so-called InfoCups were decked out in transparent primary colors and bore eighteen different announcements for events. On some of the cups, questions were posed and space was allotted for the customer's reply. While most cups ended up ignored and crushed in a postfestival psychedelic carpet of biodegradable plastic, some may have ended up priceless vessels of memories. Designed by Maureen Mooren and Daniel van der Velden, this project, like much of the duo's work, encourages their audience to participate—to customize their experience of information and imbue it with their own value. To the designers this dynamic allows both audience and designer to break away from generic and passive channels of communication, giving them the freedom to search for new meaning in an age when, in Mooren and Van der Velden's view, "the status of information, and therewith the information object, has degraded to something close to trash."

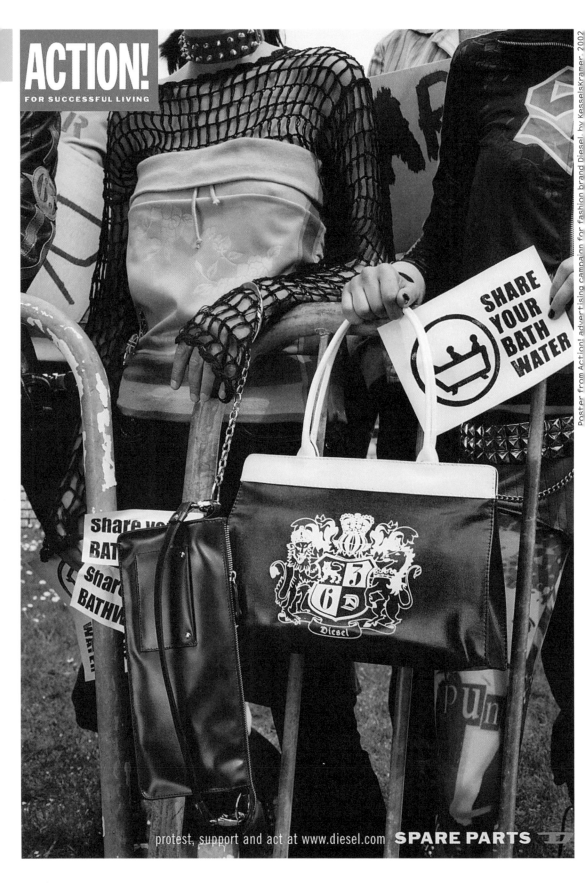

ACTION!
FOR SUCCESSFUL LIVING

SHARE YOUR BATH WATER

protest, support and act at www.diesel.com **SPARE PARTS**

Telephone books for the mobile telephone company Ben, by Harmine Louwé, 1998

SIDE 1

• SHORT EXPLANATION TO A FUTURE ARCHAEOLOGIST •

You are discovering this letter in the faraway future and you realize it has
been written, designed and conceived in September, 2001. What was so special
about September, 2001? Once a brand new, mint condition exhibition invitation
letter, this now-dated piece of information is no longer of any relevance to
anyone. But it still is more interesting than it seems. It was so typical of
its time. Why? The visual impression of this recycled letter offers interesting
information about the specific historic period in which it was written.
The abstract image underneath the text at first sight recalls nothing in
particular; two slender rectangles, one taller than the other; a distant light
between them. This image, honestly, is not even an image.
To the contemporaries of this invitation letter, these rectangles had a
striking meaning. They weren't just rectangles, but the ghostly silhouette of
the World Trade Center in New York City. Both towers of this building were
destroyed by hijacked commercial passenger airplanes on September 11, 2001.
They collapsed shortly afterwards. There was - remarkably - no apparent
connection between the World Trade Center attacks and the events promoted by
the invitation:

FRIDAY 5 OCTOBER, 2001, 8 PM
OPENING EXHIBITION
ANTHEA BUSH & APRÉ WIEHAGEN
BENTHUIZERSTRAAT 96, ROTTERDAM
6 OCTOBER UNTIL 20 OCTOBER, 2001

Perhaps contemporary readers were so preoccupied by these most unusual strikes
in New York that the WTC's vanished image became a suitable projection into any
context. So, the abstract image underneath the text wasn't really meant to be a
building, but just what it was: a computer drawing of two slender rectangles,
one taller than the other.

ROOM invite 210×297 mm
recycled letter

Benthuizerstraat 96 – B
NL 3035 CR Rotterdam
tram 8 from Central Station > Oostplein
T 06 17496916 / 06 20628633 / 06 24908693
E roombase@luna.nl W www.luna.nl/-room

friday / saturday
1 – 5 PM

ROOM organized by
karin de jong / ewoud van rijn /
roos campman / ann pettersson
☺☺ thanks to RKS, Mondriaan Stichting,
Prins Bernhardfonds, Erasmusstichting,VSB Fonds

Dear,

This letter is to say that it is over between
you and me. I'm so sorry I have to tell
you this now. But don't take it personal.
I hope we will stay friends.
For some time I have believed, like you, that
we would stay together forever. This is over
now. Some things you shouldn't try to push.
but just leave as they are...
As I find writing this letter very & painful I
won't make it too long. I don't have so
much time either, because tonight (friday 25
february 2000) I'm going to the preview of
a new show by mattijs van den Bosch,
Ronald Cornelissen, Gerrit-Jan Fukkink, Connie
Groenewegen, Yvonne van der Griendt,
hine kramer, Marc Nagtzaam, Désirée palmen,
Wouter van Riessen, Ben Schot and Thom Vink,
8 PM. I think it is at 1e pijnackerstraat 100;
I forgot the exact address, but I'll see.
mattijs, Ronald, Gerrit-Jan, Connie, Yvonne, hine,
marc, Désirée, Wouter, Ben and Thom are all great frie
of mine. We will probably go out afterwards.
But this doesn't mean that I don't care about y
I have to go. I'm already late.

goodbye

ROOM invite 210×297 mm
recycled letter

1e Pijnackerstraat 100
NL 3035 GV Rotterdam
T/F 010 2651859
T/F 010 4773880
E roombase@luna.nl

friday / saturday / sunday
1 – 5 PM

ROOM organized by
roos campman / eric campman /
karin de jong / ewoud van rijn
ROEM thanks to PWS Woningstichting

SIDE 1

Last week my rapidly growing creative marketing agency got a phone call from
Jos Verstappen, saying he wanted to drop by for an urgent meeting.
My secretary agreed right away, creating an emergency timehole in my schedule.
Meanwhile, we were baffled. We had been considering the Formula One racing
world uninteresting and conservative, but suddenly, I could see sparks in the
eyes of my co-workers. And I, admittedly, was getting a little nervous too as I
was facing the very real possibility that the renowned racing driver would
enter in person, asking us to develop a new visual marketing strategy for him,
and, very probably, with him.
I do admire his racing skills, yet I have some second thoughts about the rest.
Jos Verstappen: the problem, frankly, starts with the name. Verstappen may be a
good racing driver but his name sounds poor in comparison to some of his
Formula One competitors, like Rubens Barrichello, Giancarlo Fisichella,
Mika Hakkinen and David Coulthard. Names recalling worlds, heroic, poetic, like
the very first airplane pilots. But to develop a new face, perhaps even a new
name, for that exceptional driver from the Arrows team named Jos, would be a
challenge no one, not even me, would be able to resist.
We all sat down in the boardroom waiting for Verstappen.

After half an hour he entered. A shock. The man who stumbled in was in a bad
state and clearly not Jos Verstappen. He looked as if he had been beaten up
badly. His clothes were ripped. I dryly marked: 'IF YOUR NAME IS NOT JOS
VERSTAPPEN, WHO ARE YOU?' He collapsed. I rushed towards the unknown individual
as someone else started making an emergency dial for medical care.
The man whispered:'I KNOW I HAVE A LOT TO EXPLAIN TO YOU. BUT I KNEW THERE
WOULD BE NO OTHER WAY TO GET YOU ALL TOGETHER IN THIS BOARDROOM. YOU NEED TO
KNOW THAT...' 'WHAT?' I asked. 'TELL ME BEFORE IT IS TOO LATE!'
'ON FRIDAY, JUNE 14 AT 8 PM', he said, 'A PROJECT WILL BE ON SHOW ENTITLED
'DEMOLITION DERBY TRANSPORTED'. IT DEALS WITH CAR RACING... AT BENTHUIZERSTRAAT
96, ROTTERDAM... THE SHOW WILL BE ON FROM JUNE 15 UNTIL JUNE 24... THE OPENING
HOURS ARE FRIDAY UNTIL SUNDAY... 1 TO 5 PM.'
I screamed! 'I WANT TO KNOW THE NAMES! THE NAMES!'
'ATELIER VAN LIESHOUT... RON VAN DER ENDE... MAURICE BRASPENNING... BETSABEE
ROMERO (MEX)... SEAN DUFFY (USA)... OSKAR DE KIEFTE... VIDEO WORK BY KEES DE
GROOT (PLANET ART) AND JEROME SIEGELAER (VJ STALKER)... MUSIC BY 69 CHARGER...
AND... AND... A DIARY IN WORDS AND PICTURES BY SANDRA SMALLENBURG.'
'AND THE RACERS? ARE THERE ANY RACE DRIVERS INVOLVED?' He was almost passing out.
'IS JOS VERSTAPPEN INVOLVED??'
'NO... FOR THE NETHERLANDS: PAUL SEGERS... STAN WANNET... WJOSNA... INEKE
BROERSE... ALLARD ZOETMAN... MARTIJN SMULDERS... MARIEKE KLEINEE... ELISE VAN
DEN HEUVEL... FRANK J. VAN DER LAAN... FEDERICO D'ORAZIO. FOR THE USA: JENNIFER
BUEHN... LISA TAN... DAVID CANESO... MARK CANESO... LAURA HOSEA... JENNIFER
NOCON... JASON PYNE... RYAN CHORBAGIAN... JAMIE OCAMPO... PAUL FAIEMENT...
CONCEPT BY FEDERICO D'ORAZIO WITH PAUL PAIEMENT... DEMOLITION DERBY WAS
ORGANIZED BY THE ARTIS FOUNDATION... AND... AND... THERE IS SOMETHING ELSE...
SOMETHING VERY IMPORTANT I HAVE TO TELL YOU...'
'TELL ME!' I yelled; his eyes started rolling.

The man not Jos Verstappen passed out into unconsciousness.

OOM invite 210×297 mm
cycled letter

nthuizerstraat 96
3035 CR Rotterdam
m 8 from Central Station > Oostplein
06 17496916 / 06 20628633 / 06 24908693
roombase@luna.nl W www.luna.nl/-room

friday / saturday / sunday
1 – 5 PM

ROOM organized by karin de jong /
ewoud van rijn / roos campman /
eric campman / ann pettersson
☺☺ thanks to RKS, Mondriaan Stichting,
Prins Bernhardfonds and Erasmusstichting

SIDE 1

An urgent message from Ewoud van Rijn arrived on my desk this week. My desk, located on
the top floor of my highly succesful creative marketing office, oversees the pittoresque
banks of the Amstel River near the world-famous Carré Theatre. Ewoud, an old friend from
the business who I have worked with for years, asked me for help in a music project called
'Mel & Nell'. The question was to develop a strategy helping to market Mel & Nell into a duo
pack pop act aimed at kids from 8 to 16.

Mel (15) & Nell (15) are a pair of identical twins raised and schooled separately from their
friends in a commercial incubator near Bussum, under the guidance of Ewoud. Ewoud, who co-
founded Veronica in the seventies and who played symphonic disco before he became a
producer and manager of 'young talent', has never been wrong in predicting the success
of his acts.
Mel is blonde, innocent, pure. Nell is exactly the same but slightly more experienced and
seductive: think of Brooke Shields in Blue Lagoon. Their first hit is called 'My Little Lover'
with lead vocals by Mel, and a short rap by Nell. Ewoud, who commissioned the song, has
carefully monitored the family-filtered lyrics, and yet, there is a subliminal touch of
perversion to Mel & Nell.

My proposal for the marketing involves:
· Mel & Nell beachball available as a gift at Etos, Jamin and Bart Smit.
· Mel & Nell planner, notebook and calendar (including photography), for sale at AKO, Bruna,
V&D, Bart Smit.
· Mel & Nell fan site with pictures of Mel & Nell, stories about Mel & Nell (including bio) and
a chatbox.
· Free downloadable Mel & Nell build-your-website set of buttons, banners and separator
bars to help kids build their own site.

Is this true?

I admit that I was lying when I just told you my studio oversees the banks of the Amstel.
It doesn't. I don't have a highly succesful creative marketing office. Ewoud van Rijn has never
been involved with either Veronica or symphonic disco. Mel & Nell do exist, but they are not
identical twins aged 15, destined to become tools of commercial exploitation. Their full names
are: Mel O'Callaghon & Nell-Bunny. I have never developed a marketing plan for them, and if I
had, it would not have included beachballs, notebooks and a fan site. They are not from
Bussum, but from Sydney. Their two-day art show opens Friday June 29, 2001, at 8 PM, in
ROOM (the exhibition space Ewoud van Rijn co-founded), Benthuizerstraat 96, Rotterdam.
The show continues the next day, Saturday June 30. For more information, call
06 24908693.

ROOM invite 210×297 mm
recycled letter

Benthuizerstraat 96
NL 3035 CR Rotterdam
tram 8 from Central Station > Oostplein
T 06 17496916 / 06 20628633 / 06 24908693
E roombase@luna.nl W www.luna.nl/-room

friday / saturday / sunday
1 – 5 PM

ROOM organized by karin de jong /
ewoud van rijn / roos campman /
eric campman / ann pettersson
☺☺ thanks to RKS, Mondriaan Stichting,
Prins Bernhardfonds and Erasmusstichting

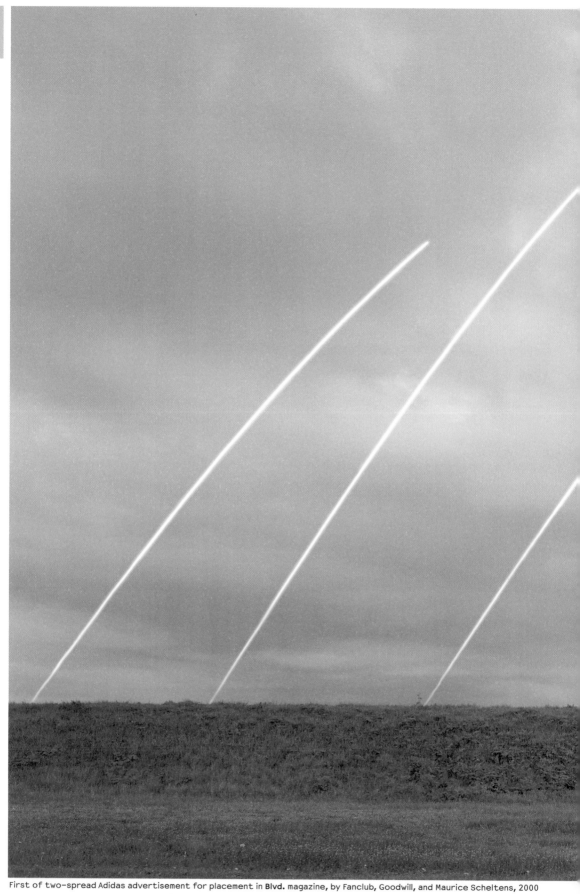

First of two-spread Adidas advertisement for placement in **Blvd.** magazine, by Fanclub, Goodwill, and Maurice Scheltens, 2000

Re-Magazine 10
Claudia

BUTT

so

ON A CLEAR DAY
CAN SEE FOREVER

lost-
found

(in Los Angeles)

Amsterdam

amsterdam

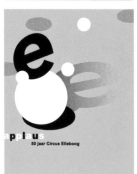

applaus
50 jaar Circus Elleboog

Jop van Bennekom — When Jop van Bennekom launched **RE-Magazine** in 1997, it was to be a personal communication, a "series of publications about daily life in the form of a magazine…It seems that we've become immune to our direct environment, to the common and the banal…the marginal, the details and the seemingly uninteresting. Maybe we can see our daily environment with a new outlook, break down the way we are conditioned, even if just for one brief moment…and never be bored again." A dozen issues later, this magazine about nothing is known and revered worldwide. Van Bennekom's **Butt**, a pink-papered gay magazine created with journalist Gert Jonkers, enjoys a similarly unexpected celebrity. **Butt**'s initial print run of 1,500 has grown to 6,000, counting fashion maven Tom Ford and Elton John among its adoring fans. Van Bennekom acts as his own writer, editor, strategist, publisher, and art director, using his magazines as a personal platform to showcase his many talents. Through graphic design and the medium of magazines, Van Bennekom creates an art that slows down the cultural assault of information, adding a moment of silence to communication.

Jan Rothuizen — Lost & Found is a forum for artists, designers, filmmakers, and poets to present projects in progress or long forgotten. Organizer Jan Rothuizen created the event as a successor to TimeFuckers, a similarly themed evening he hosted previously at Amsterdam's Paradiso. Rothuizen's initiatives and artwork concern the larger realm of social cohesion in cities and public spaces, reflecting a "desire to record what is present in absence, in what cannot be named or found." For one project, he collected flyers of missing pets and people and posted them along a tree-lined avenue in a park, the handmade heartfelt cries creating a "monument to the lost." In the Portuguese city Porto, he turned an anonymous concrete pillar under a freeway into a "monument to the unknown immigrant" and his poem on one book cover reads: "The other day I felt so lonely, I decided to eliminate the word 'lonely' from my vocabulary and replace it with the word 'ordinary.'"

Roosje Klap — Discouraged with the process of shopping his work to galleries in New York, Jan Rothuizen wandered the streets of Manhattan. The notes and illustrations of his meanderings led to the sublime **On a Clear Day You Can See Forever** (1999, published by Artimo, designed by Armand Mevis). The book features a remarkable map of Manhattan (designed by Roosje Klap), with each street turned into a line of text from his book. A graphic artist and image editor for several publications and catalogs (including **Woman by** for the Centraal Museum), Klap is also an integral part in making underfunded, autonomous projects happen. She was involved in the event Happy Chaos, the experimental platform **Sec Magazine** (for young visual artists, 1998–2002), and the Immer Wieder Klebe Klub!, a group of artists, photographers, designers, and musicians gathering in Berlin, silk-screening posters throughout the day and pasting them on the city's walls at night.

Melle Hammer — This is Melle Hammer in his own words: "Typographer. Designer. Teacher. Lingering between art, design, and advertising. Easily seduced to design a table, a chair, or a stage set. Every now and then: a movie or a poem comes out. Always: questioning 'the spot.' On and on surprised, outraged, or in love. Lost? Found!" Fresh from the Rietveld Academy, Hammer went to work at Total Design in 1987 and, from there, enjoyed a wildly successful career in advertising. He currently devotes his time in complete autonomy to pursuing the soul of typography. He states: "I want to become the best designer in the world, and I am going to do that by making lots of work." At times, this perfectionism proves a liability. His book-jacket designs for a series on debuting poets were so stunning that the titles repeatedly sold out in the first week of publication—for the covers, not the content. Called a poet by critic Max Bruinsma, Hammer unanimously won the competition to devise a logo for "Amsterdam, City of Culture"—turning the three Andreas crosses of the city coat of arms into one, a design solution that was, in the designer's words, "dry as the plop of a suddenly bursting tire, simple as the signature of Charles the Great, as clear as the location of a treasure on a map; two strokes forming the cross of Amsterdam."

Harmen Liemburg/Richard Niessen — From 1999 to 2002 the Golden Masters—a collaboration between graphic designers Harmen Liemburg and Richard Niessen—held audiences captive with their idiosyncratic and refreshing additions to the Dutch design landscape. The designers created dense maps, combining updated '60s psychedelics with poppy Japanese illustrations and Arabic typography in layers and layers of luscious print work. In art school, Liemburg first studied cartography, then went on to fall in love with silk-screen printing under the auspices of teacher Kees Maas—a process he continues to master. Richard Niessen shares Liemburg's interest in the medium, as well as his additional curiosity for rhythm and music. Liemburg and Niessen's joint preoccupation with the creative process inspired them to organize the Jack event—an opportunity for musicians, visual artists, and writers to explore how artists develop ideas through varying media. The British Dutch designer Stuart Bailey (who did his graduate studies at Typografische Werkplaats in Arnhem) reviews the second Jack event on the Typotheque site: "Jack represents the best and worst of young Dutch art and design; healthy funding, enthusiasm and cross-disciplinary participation, with insubstantial—or at least unfiltered—output."

RE−

©

Re-Magazine #4
From Amsterdam NL
The Summer of year 2000
~~The Boring Issue~~ *sorry!*

9 789080 572911

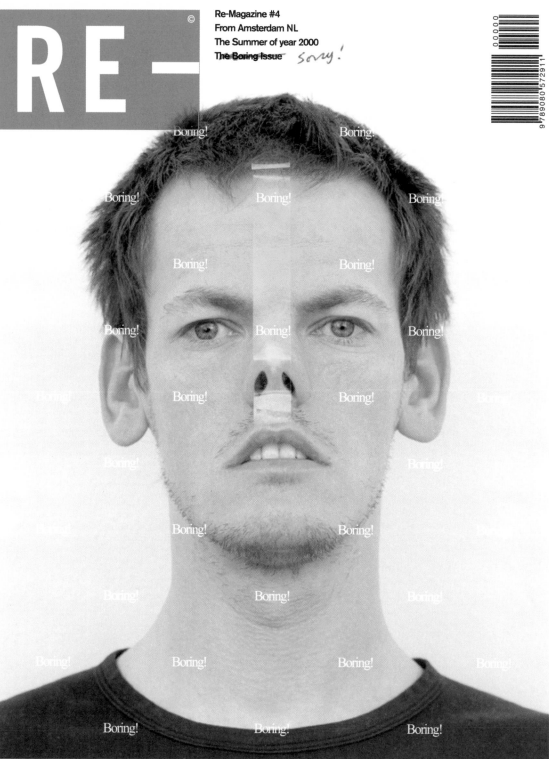

BUTT

Big Fagazine
Special New York Issue
Summer 2003
NL €9 / EU €11 / USA $12

Tokyo

Amsterdam

x Tokyo. The dwelling plane of the noises.

Tomoko plays Amsterdam

30 augustus t/m 14 oktober 2000

Amsterdam, Den Haag, Rotterdam, Utrecht, Groningen, Tokyo

Tomoko Mukaiyama

Digital PBX

piano

ruimtelijke installatie

In samenwerking met Muziekcentrum De IJsbreker

Informatie en reserveren: 020 - 693 90 93 of www.ysbreker.nl

Schitteren in afwezigheid, hoe voorbeeldig zou dat zijn, om steeds weer te schitteren in afwezigheid. Je ziet het voor je, hoe je niet binnenkomt op het feest. Geen mensen groet en alle blikken niet op jou gericht zijn. Je ziet hoe iemand je geen drankje aanbiedt en jij, geen gesprekjes begint met gezichten die je niet kent. Je ziet hoe je niet naar de nieuwe mensen kijkt die binnenkomen, zoals ze ook niet naar jou gekeken hebben. En je voelt hoe je geen onderdeel van dit feest aan het worden bent. Je ziet niet hoe grappig je bent, en drinkt terwijl je niet in vorm bent. Ook de grote klok zie je niet, met wijzers die draaien. Of de zon die ergens aan het opkomen is. Je hebt het niet in de gaten, want je bent er niet, en ziet niet dat de meeste mensen al thuis zijn als jij in de stemming komt. Schitteren in afwezigheid, hoe voorbeeldig zou dat zijn, om iedere keer weer te schitteren in afwezigheid.

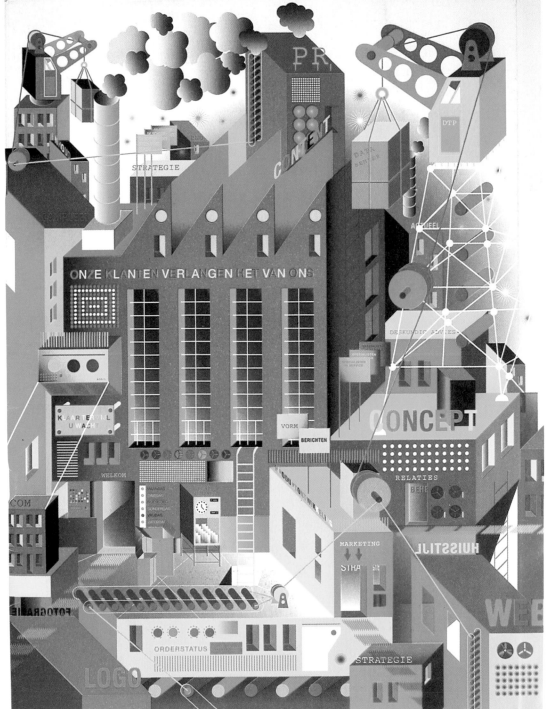

Cover illustration for Vormberichten magazine, by Golden Masters, 2000

Poster homage to Ada Stroeve, former curator at the Stedelijk Museum of Modern Art Amsterdam, by Melle Hammer, 2000

Vincent de Rijk — Vincent de Rijk's set of ceramic bowls is beautifully installed at the Vivid Gallery in Rotterdam, but it is on the outskirts of the city that the master can be found. De Rijk has a cacophonous studio full of tools and machines in a warehouse in the harbor of Rotterdam, a building he shares with, among others, Richard Hutten, Schie 2.0, Made Architects, and Sebastiaan Straatsma. Amid every variety of sawdust lie remnants of models for visionary buildings by the likes of MVRDV and Rem Koolhaas's OMA, as well as the custom-made molds for the polyester-cast walls of Koolhaas's New York Prada store. In its "society" pages the leading architecture Web site ArchiNed calls De Rijk, in respectful jest, the "polyester casting king of The Netherlands, a designer (of vases, plates, furniture) as well as a first aid for famous architects in presentation crunch."

Irma Boom — When asked in an interview in the "Made in Holland" issue of **Emigré** magazine, "What is Dutch about your design?" Irma Boom gave the best possible answer: "It is subsidized." But that was in 1992, and since then Boom has grown well beyond the government-subsidy level and gone on to conceiving monumental books for worldly clients, like SHV and Paul Fentener van Vlissingen, Ferrari, and Vitra; creating signature titles for major publishing houses; and giving the Prince Claus Fund its regal identity. Petra Blaisse and Rem Koolhaas/OMA have also come to rely on her talent, as she is a regular and influential contributor to their projects and presentation materials. Always working, Boom seldom limits her role to that of the traditional graphic designer: she is rather a coauthor, involved at all levels, using insight and intuition to shape both content and form. In 2001 she was awarded the Gutenberg Award of the city of Leipzig, the most prestigious book-design award. The jury wrote: "Irma Boom is one of the most outstanding and influential book designers of the present. Her extensive work is characterized by a rich fantasy, unusual sensibility and exceptional creative power as well as by a high aesthetic appeal. Irma Boom succeeded to open up new dimensions for the design of the book, which connect traditional heritage with modern forms of expression in a relaxed manner. The works of Irma Boom impress with a wealth of ideas and lightness of creative gesture."

Petra Blaisse — Irma Boom designed the book **Inside Outside** for the studio of the same name, the practice of interior and landscape architect Petra Blaisse. When you leaf through the pages from front to back, the exterior designs are shown. From back to front, the interiors are shown. In addition, every page is perforated, making both "in" and "out" visible simultaneously, showing how closely intertwined these spaces are in Blaisse's work. In a feature in **Metropolis** magazine, Melissa Milgrom describes Blaisse as someone with a "talent for turning nature into culture and culture into nature. She is in a sense architecture's experimental Earth Mother, convincing builders of glass, cement, and steel monuments to pay attention to—of all things—curtains and gardens…She has created opulent gardens and immense curtains (soft walls, really, that move and breathe) for OMA's high-profile private residences such as the Villa Floirac, in Bordeaux, and the Villa dall'Ava, in Paris, and for many of the firm's cultural halls throughout Europe." Indeed, Koolhaas would be the first to admit the indelible mark her contribution has left on his work.

Rem Koolhaas/OMA — René Daalder is a collaborator of architect Rem Koolhaas. Since they were sixteen, the two have been best friends, as have their wives Bianca Daalder and Madelon Vriesendorp. Daalder seldom talks about his friend, and when he does it is usually in the context of some current project. But when prodded with the question "Is Rem a genius?" he answers: "Genius is such a nineteenth-century type of phenomenon. In my opinion the genius in our time resides in the collective, but that is not to say that Rem isn't great; he's definitely as good as it gets. He's probably the single most successful creative Dutch person of the last half century. Unfortunately that doesn't buy you much in the old country. Last year they showed a documentary following Rem through Lagos on Dutch television, and on a talk show afterward people were saying things like: 'Who does this man think he is, he uses toilet paper just like the rest of us, doesn't he?' The aggression in that country toward people who have attained Rem's kind of stature can be very painful. When we were young Rem saw himself much more informed by his early years in Indonesia than by Holland, and he has been circling the globe ever since, which perhaps is a very Dutch trait in itself. Still, when he was offered a Dutch prize for his entire oeuvre (after he had already won every existing international prize), he was hardly able to say 'thank you,' which was a very meaningful moment. Being a Dutch creative genius is like having to live forever with the pain of a marriage that has gone wrong."

Joep van Lieshout — Joep van Lieshout's largest work to date is AVL-Ville, a sprawling industrial compound at the Rotterdam harbor where he and the thirty employees of his Atelier became a civic artwork and social experiment in progress— complete with their own custom housing, education, hospital, sewage treatment, money, mobile city farm, and slaughter-house. Revolving around the pursuit of pleasure, justice, and survival, AVL refurbished shipping containers as laboratories for firearms, bombs, medicine, alcohol, sex, and abortions. A customized Mercedes was outfitted with a homemade 57 mm machine gun. AVL-Ville was a self-proclaimed free state where the limitations of laws, permits, and permissions of the over-regulated Dutch society were unilaterally suspended to afford an honest, uncompromised existence where artistic expression was given the free rein to indulge in primary needs. Rather than offer a model for world domination, this autonomous free zone encouraged small creative communities to translate this liberty into artworks that could then be exported to those who adhere to the rules of everyday life.

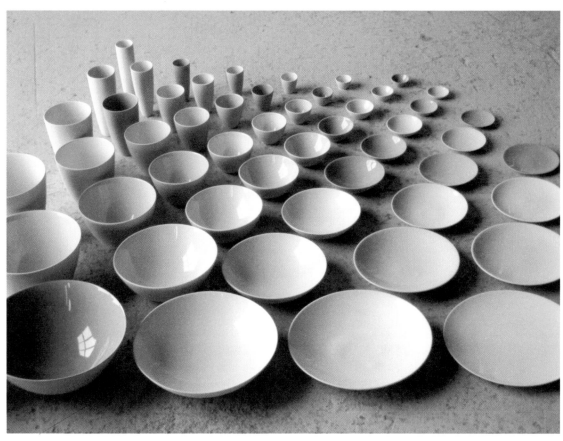

Set of ceramic bowls, by Vincent de Rijk, 2002

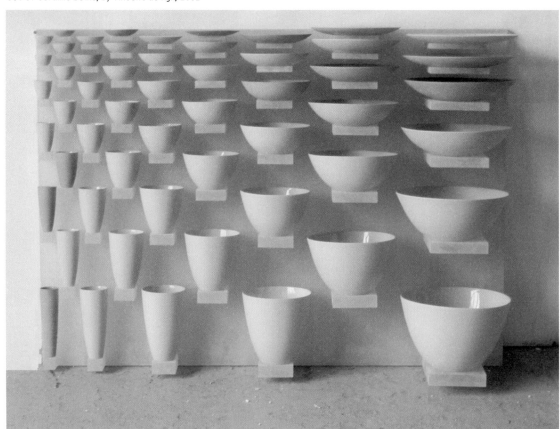

EXPERIENCING EUROPE

EUROPEAN CENTRE FOR WORK AND SOCIETY

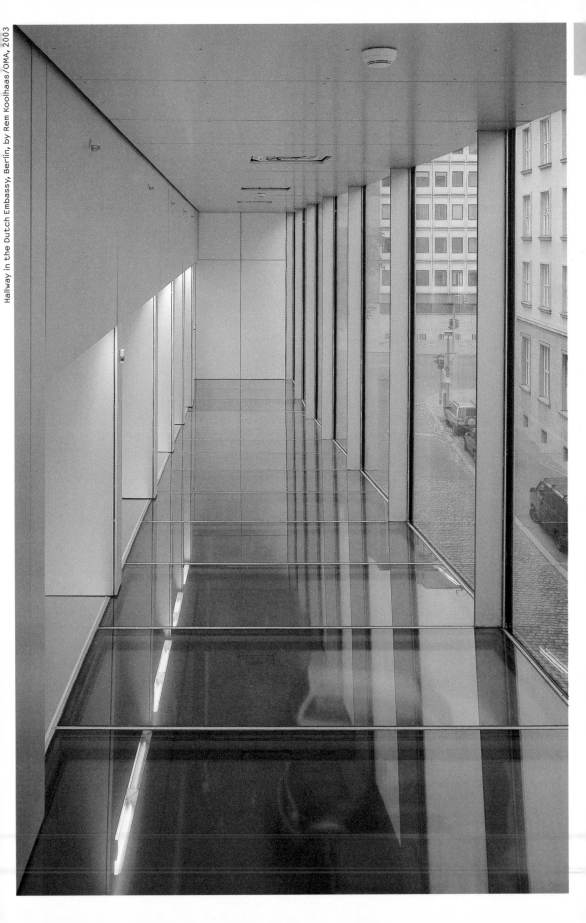

The McCormick Tribune Student Center at the Illinois Institute of Technology, by Rem Koolhaas/OMA, 2004

The Solace of Subsidies

Whenever I return to The Netherlands by airplane, I delight in seeing the narrow grid of meadows and irrigation ditches come into view as the plane descends through the inevitable layer of clouds (their density, of course, being always changeable). Below me lies a country in which there is <u>complete order</u>—where the relationship between water and land, house and country, road and city, and open and enclosed space is etched into the precise lines of the irrigation ditches, the meadows, the rows of houses, and the patches of green captured between them. It is a place in which every space has been negotiated and thus everything has its place.

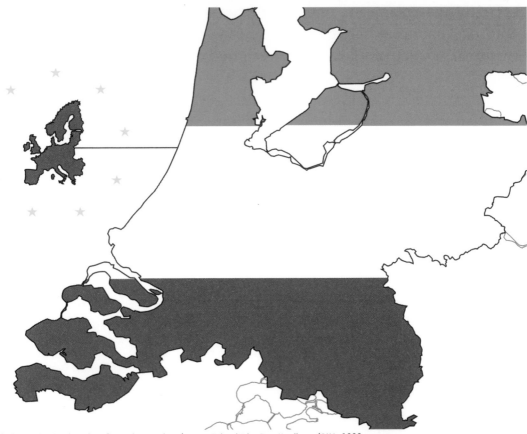

Map of The Netherlands taken from the study "Airport Island," by Rem Koolhaas/OMA, 1999
Aerial view of a typically Dutch agricultural landscape, 1996

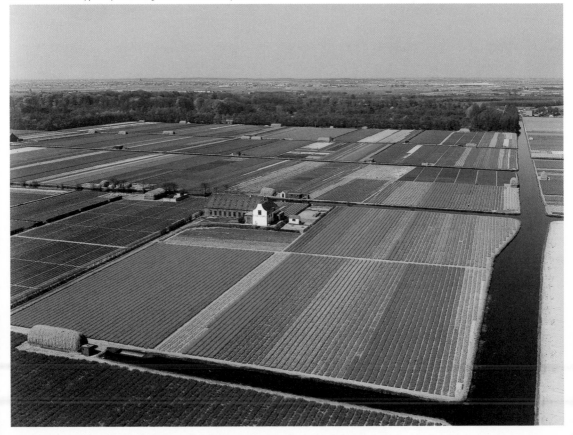

As I exit the airplane and walk into what seems to be just another terminal building, that order becomes even more evident. The terminals at Amsterdam's Schiphol Airport, designed originally in 1962 by M. F. Duinjer and F. C. de Weger, with interiors by Kho Liang Ie, are not great buildings. The original structures were glass-and-steel boxes that extended out into ungainly fingers. Their strongest feature was their openness, which included a dramatic moment when arriving passengers emerged from customs to stand on a raised platform, in full view of families and friends waiting to greet them behind a floor-to-ceiling glass wall about fifty meters past the baggage claim. The new additions, designed mainly by the firm Benthem Crouwel, are rougher, eschewing the finished appearance of glass and polished surfaces for an industrial aesthetic of white-painted metal tubes and plates. Nevertheless, these are buildings in which the eye can follow every structural element and understand exactly how the whole was made. Steel struts, glass walls, and dropped ceilings all expose their nature.

What isn't clear from such elements, though, is the terminal's overall shape. There are no soaring ceilings or grand axes. Instead, the long trudge to customs and baggage claim is a meandering path with many twists and turns, as if the designers were getting you ready for Amsterdam's labyrinth. Only the signage, scientifically designed by Bureau Mijksenaar for maximum legibility for peoples from different cultures, in various stages of jet lag, saves you. The signs are themselves worth looking at, their typography perfectly balanced and yet bold, their background a warm and slightly startling yellow. The mapping system is the most attractive thing about this place.

As you enter into the airport's main area, the pace picks up. This is not a "city airport," the public-relations people like to tell you, but an "airport city." When Benthem Crouwel started renovating Schiphol in the late 1980s, they not only added gates but also designed a range of office buildings and hotels floating over parking garages, meeting rooms, and shopping malls, creating a structure in which all the functions of a modern day airport have a place, a relationship, and an image. The train station sits at the juncture of arrival areas and shopping arcades. This is not just a place to catch a plane but a tangle of transportation systems, entertainment (including a casino), consumerism, and business. All of these uses have been carefully calibrated and crunched together, making for an efficient, if not particularly expressive or attractive, hub of activity.

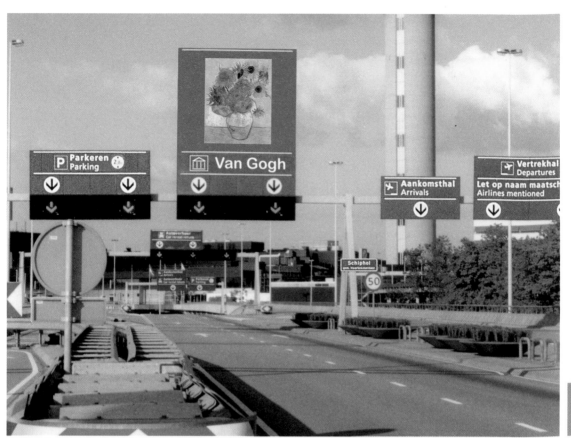

Illustration from the NAP (New Amsterdam Plane) project, proposing museum-oriented road signage, by NL Architects, 1996
Schiphol airport terminals designed by Benthem Crouwel, 1989–93, with signage by Bureau Mijksenaar, 2001–present

Several years ago, <u>Rem Koolhaas/OMA proposed moving Schiphol out to the ocean</u>. There it could continue to expand without creating noise pollution or traffic where people actually live. The plan was taken very seriously: the Dutch are fully capable of making sufficient land in the sea to support such a complex; and new high-speed transportation systems would allow it to be conveniently connected to the mainland. It might still happen, but strangely, the general reaction from the politicians and business-people concerned was that, though the Dutch love to polder, this airport city should remain in the heart of the country. That way, the ride from the center of Amsterdam to the airport would remain fifteen minutes, and there would continue to be a direct tunnel from the nearby tulip auction into the complex. When the planners and "stakeholders" had their say, though, it turned out that the careful negotiations about land use, noise levels, and infrastructure improvements linked to the proposal would not be avoided, but continued. That is, after all, what The Netherlands is all about.

They call it the "polder model," and it means nobody can leave the negotiating table until consensus has been reached. All participants might not be completely happy, but they can work with and under the result. The trick is often to apply the huge amounts of money the Dutch make off other countries (almost 40 percent of the economy is based on trade) toward subsidies that mitigate the pain of those who did not get everything they wanted. This money used to be distributed to support broad groups—the unemployed, the sick, or artists, for instance. But this eventually led the Dutch to face the same dilemma as the Scandinavian countries did during the 1970s and 1980s: a cradle-to-grave welfare state undermined incentives to work and productivity. The polder model was the Dutch answer to the resulting economic and social stagnation, combined with a complicated network of directed subsidies. The Netherlands is no longer a welfare state of mass transfers of wealth but an incredibly complex system of targeted and negotiated incentives and support mechanisms. These helped the Dutch become one of the most successful economies in Europe during the late 1980s and 1990s.

Illustrations taken from the study "Airport Island," by Rem Koolhaas/OMA, 1999

terdam Schiphol Airport the day after the 9/11 attacks in New York, by Marie–José Jongerius, 2001

Most of this economic system is invisible. It ensures that certain companies and publications survive, that the sick can continue to work part-time, and that cultural activities are supported in even the smallest town. The public face of such subsidies is design. Designers create the physical results of these negotiations, which take the form of subsidized housing developments, sound barriers around almost every new highway, libraries, cultural centers, and the signage and forms that let inhabitants find their way to all those riches. Designers themselves live off subsidies; they receive stipends as soon as they graduate, and every time they want to travel or learn. The support and central role of design, which are two strands of the same cloth draped over the rational order of the polders, cities, and infrastructure, form a crucial element in the success story of The Netherlands.

The Netherlands Architecture Institute, for instance, is almost fully funded by the state. That does not mean that the organization's management can just sit back and wait for the money to roll in. Even the lump sum it receives is based on four-year plans in which it explains its role in Dutch culture. These plans are then weighed against the requests of all the other cultural institutions, and an allocation is made. But that money is only barely enough to keep the doors open. For each specific undertaking, the institute must then make special requests to separate funds. These are small grants given not only by the Ministry of Culture but by semi-independent foundations, at the city or provincial level, or other ministries. My favorite is HGIS, pronounced like the Scottish dish, an acronym for the Homogenous Group for International Collaboration. It is a joint program of the Ministries of Culture and Foreign Affairs.

Though it might not seem like the most exciting adventure, the world of subsidies and commissioning in The Netherlands is worth exploring, because it has produced a new model for designing a better society. This is remarkable because until the middle of the nineteenth century, the Dutch had not been at all keen on public support for art or design. Private enterprise and collecting and public infrastructure intersected only on the facades of the canal houses, where the rules for how large a building could be, on plots laid out by the city government, created a common language within which only fine gradations could announce the wealth and taste of individual occupants.

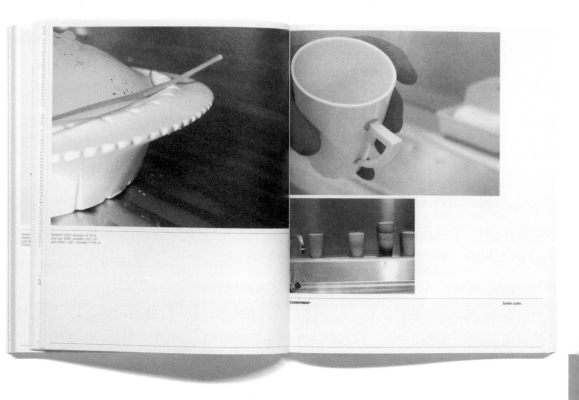

Spreads from exhibition catalog **Commitment,** an overview of artists who received grants from the Foundation for Visual Arts between 1999–2002, by Stout/Kramer, 2002

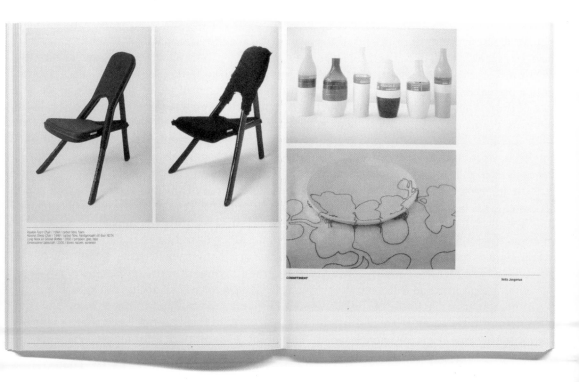

It was only when the Dutch government had to reinvent the country after the Napoleonic Wars that architecture and design became an affair of the state. The Netherlands had just regained its independence and, in an era of the discovery of national cultures, felt it needed to come up with an identity to distinguish its centralized kingdom from the newly rationalized nation-states of France and Germany. By the 1860s, politicians such as J. R. Thorbecke and J. A. Alberdinck Thijm were supporting the emergence of a "Dutch renaissance" style that would rekindle the achievements of the golden age. This desire intersected with the new political power of the Dutch Catholics to produce a government policy of commissioning a hybrid of neo-Gothic and neo-Renaissance styles for major state-funded buildings. The awkward work of P. J. H. Cuypers for such buildings as the Rijksmuseum in Amsterdam was the result. Here the vaulted arches, richly elaborated details, and layered rows of walls so typical of neo-Gothicism in England and France faded into uniform brick boxes whose interior organization has little of the dramatic scenography, tied to both religious prototypes and the picturesque, that would give their recherché elements some force.

At the same time, Thorbecke promulgated the principle that it was the government's role to support culture, which was an expression of the common heritage and consensus on which the Dutch state rested, but that the state should not set policy or standards for that culture. The result was a kind of commissioned freedom; the government would appoint architects and would support the arts but would not demand any say in the projects' execution. That was left to the so-called <u>pillars</u>, the combination of religious, social-welfare, political, and cultural entities dividing the country into Catholic, Protestant, free-thinking, and, later, Social-Democratic groups that together supported the edifice of the state. The result was a competition between, at first, three commissioning entities; later, as social groupings splintered during the twentieth century, there would be several more. In <u>broadcasting</u>, for instance, there was a Protestant, a Catholic, a free-thinking, a Social Democratic, and a free-thinking Protestant organization, each with its own building, each with its own programming, and each with its own style. All were propped up by government subsidies, but each developed a separate identity.

Some of the most important parts of the pillar system were the social-housing organizations, which collected money to build the actual homes and neighborhoods in which the members of their persuasion could live. Their role was strengthened by the Social Housing Law of 1901. By providing for streams of government revenue toward such cooperatives in the form of support for low prices and rents, this law helped support the emergence of an active architectural scene. Each of the cooperatives hired its own architect, and each wanted to develop an identity that fit their support group. Unlike developers, who tended to copy the architecture of the rich or the exotic forms of foreign countries in the cheapest forms possible, the housing organizations sought to express who they were as Protestants, or Social Democrats, or what have you, but also as a group that had a natural and historical tie to the land and its culture. A strong vernacular appeared: houses were built out of brick, in rows, with sloped roofs. The first two attributes came out of the tradition of work housing dating back to the almshouses of the Middle Ages, while the latter came from the farm buildings where many new city dwellers had previously lived. Windows were framed in wood, usually painted green. Apartments were clustered into small units around stairwells. The rear of the rows was kept as communal open space, a kind of collective version of the private gardens behind the Amsterdam canal houses. The whole neighborhood followed the turning, twisting geometries of the traditional Dutch cities but regularized it. Some of the housing blocks were manipulated to create more monumental entry gates, surroundings for squares, or other focal points. Even when some of the houses became larger and developers of homes for more affluent families picked up on what the building cooperatives were doing, many of the defining attributes of social housing remained visible in the semidetached villas these developers erected at the edges of The Netherlands' larger cities.

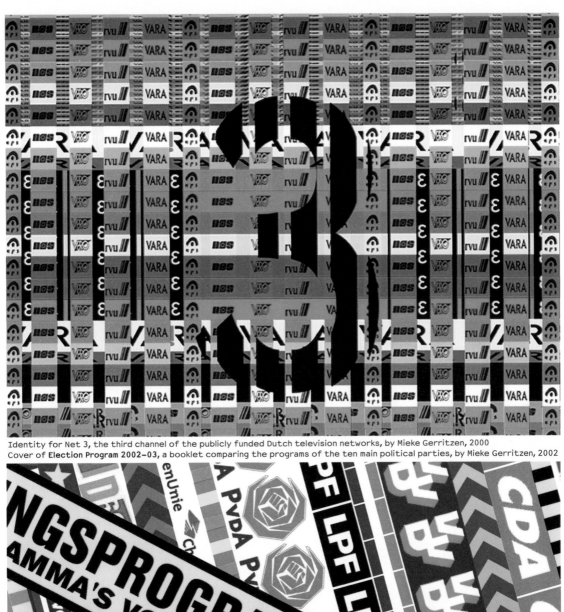

Identity for Net 3, the third channel of the publicly funded Dutch television networks, by Mieke Gerritzen, 2000
Cover of **Election Program 2002-03**, a booklet comparing the programs of the ten main political parties, by Mieke Gerritzen, 2002

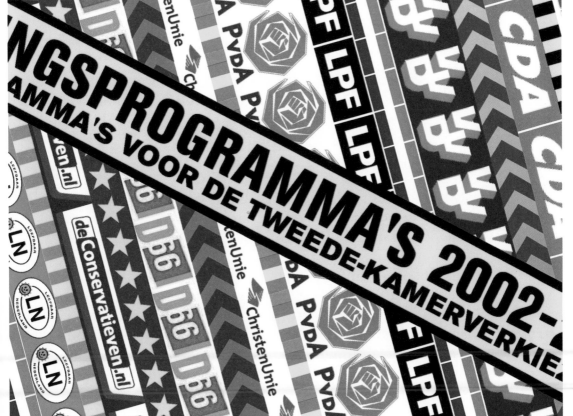

The Dutch housing vernacular might have emerged because of the logic of construction with brick and tile, the nature of the Dutch city grid, the romantic recollection of the golden age and agricultural forms, and because of formal traditions already present, but the housing cooperatives also helped set the style. They wanted to express a new way of creating community, and it mattered less what religion they espoused than that they each develop a variant on the forms of the golden age and the agricultural roots of their constituents. A rough consensus emerged, though it remained split between modern and traditional variants, that eventually cut across party and religious lines. The cooperatives' boards became more and more linked to local government, as the Social Democrats, especially, gained power at the beginning of the twentieth century. Cities such as Amsterdam and Rotterdam managed to build coherent landscapes of social housing through collaboration with the social-housing groups. The resulting landscape, then, was the remarkably homogenous product of government support, at both the state and local levels, for specific building initiatives.

It should be noted that there is an ideological tinge to almost everything having to do with design in The Netherlands. The making of innovative architecture and design has been built into the very fabric of the political system. The Social Democratic Party, which has been the largest or second-largest party in the country for the last three decades and in and out of power for most of the last century, has a strong stake in social housing. The web of pension funds and housing organizations that produce new neighborhoods and maintain the older ones is one of the pillars (together with the trade unions) on which the party rests, and the provision of adequate housing has been one of its major campaign platforms since the late nineteenth century. As a result, social-housing organizations, ministries, and supporting funds are woven together in a network of patronage. As one critic pointed out, Christian Democratic ministers become directors of hospitals when they retire, liberals (right-wingers) go back into private practice, and Social Democrats become heads of housing organizations. For historical reasons, the quality of the physical environment in The Netherlands, from housing to open space, has become a central issue for one of the largest parties. It happens to be the party that also believes, however faintly, in the necessity of building a better world in the here and now for all equally and thus has a logical interest in making the physical world better by design.

The main instrument of this improvement in the last decade has been a series of three Government Policy Papers on Architecture. The series was set up to parallel the Policy Papers on Spatial Organization, which had previously attempted to establish guidelines for the development of the country on a super-regional level. Here, the government had tried to bundle its various initiatives for improving infrastructure with zoning and planning regulations and incentives for private development, so that they could actually control the future uses and appearance of the land.

It turned out that this was a very difficult and ambitious task; the Papers on Spatial Organization were often disregarded and they certainly did not guarantee the quality of what was actually built. Consequently, the then–minister of culture drafted the first Paper on Architecture. Published in 1992 and accepted by Parliament that same year, it had the simple goal of improving the quality of buildings in The Netherlands. The paper set some vague goals for increasing public awareness but also proposed changing the approval process for new construction so that experts in the areas of architecture, public space, and urban planning could offer criticism and support. The paper also set up funds that let city council members, aldermen, and other politicians learn more about architecture through trips, classes, and conferences. In general, the government committed itself to the cause of good architecture, and small grants materialized to support debate and exhibition.

The paper did raise the public's awareness of architecture, and a second paper appeared five years later. This time, the government added concerns about landscape and planning issues to the initiatives. The Culture Ministry, which had pioneered the effort, also involved the Ministry of Spatial Planning, Housing and the Environment (VROM). Out of this paper and rising concerns about the disappearing rural landscape came a separate paper, called "Belvedere." Published in 2000, it is a remarkable document stating that what the public sees in their landscape is as important as the quality of buildings or underlying social issues that might be inherent in that space. The Belvedere Paper argued that the Dutch landscape is a "cultural legacy" that must be preserved, and new construction should extend, rather than bury, the specific characteristics of the land the Dutch have made for themselves. Research projects and design proposals received generous funding to accomplish this goal.

In 2001, the government published its third and most ambitious Policy Paper on Architecture. Entitled "Designing The Netherlands," it pulled three other ministries (Economic Affairs, Agriculture, and Transportation and Water Management) into the mix of policies and proposals. The authors of the paper asked: What is it the government can do in a situation where more and more of its functions are becoming privatized? Their simple answer was that they could set a good example through the public works and zoning policies they controlled. The paper picked ten "Big Projects" as exemplary fields of architectural action. These ranged from more or less traditional building projects, such as the renovation of the Rijksmuseum and the construction of a new building in the town of Amersfoort to house the State Historic Preservation Service and Archaeological Institute, to vague ideas such as beautifying the country's main east-west highway. One task is central in all of these projects: how to use state infrastructure and services to make public space (whether indoors or out) that is functional and beautiful. The paper's authors argue that construction and landscaping make for visual coherence and thus give collective identity to the country's physical reality.

The paper's scope is extremely large. One of the projects, the reuse of the sandy loam areas where intensive pig farming now takes place, for example, encompasses almost a quarter of the country's land. It is not clear what the paper really wants to do with this area, other than prevent the kind of makeshift development that local authorities and private developers will propose. This is perhaps the chief aim of the paper: to make people aware of the problems and opportunities by stating them as problems of spatial arrangement. I am not sure that I can sit through another debate on "public space" (improvement of which is another Big Project), but it certainly is important that planners and officials actually think about the squares and streets they leave behind when they build their office towers or housing developments.

Niet Storen (Do Not Disturb) public installation, by Martijn Engelbregt, 2001

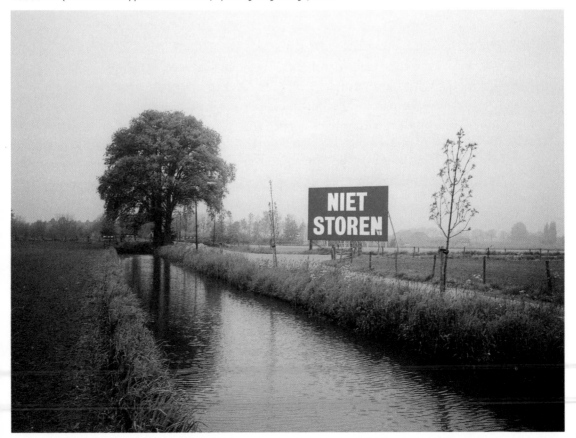

The next paper, which is being prepared at the Ministry of Culture for release in late 2004 or early 2005, will combine "Belvedere" with a further look at the urban and suburban landscape as public space with a particular heritage and with a future or futures that can be designed. By the time the discussion about this fourth paper starts, most of the projects in the third will still be underway. The discussions, funded by numerous studies, workshops, exhibits, and publications, will be an active part of Dutch life. Their issues have already been debated in Parliament, exhibitions about the projects have appeared, and the discussions are now part of party politics. Space and architecture have become a permanent part of The Netherlands's political scene.

Although the government supports the appearance of good architecture, one of the main reasons the actual results have been so good is that young designers have a remarkable say in their execution. Young Dutch architects receive start-up subsidies that help them set up their offices. Like artists, they can compete for the state-funded Rome Prize, which gives them a chance to live and work for a year in Italy upon graduation. They have an incentive fund that subsidizes travel for study and the publication of their work. They are eligible for the prestigious interdisciplinary Rotterdam Design Prize (which awards a small amount of money but a great deal of publicity). There is also the Maaskant Award, which goes every year to a promising young architect. Archiprix, a prize given to the best senior-thesis project, is turning into an international event. The award monies are rarely more than ten thousand euros, but the honors themselves open doors to potential clients by giving the winners prestige and fame.

Europan, the prize that has the most effect in this country, is not actually Dutch. It was originally set up in France to help young architects receive commissions. The Europan organization works with local municipalities throughout Europe that need social housing; it assists in writing the housing blocks' programs and organizes a competition open to architects who have graduated within the previous five years. The intention is that the winners work with the municipalities to build the chosen design. This remains an ideal in most countries, but in The Netherlands it almost always results in construction. The program has helped launch the careers of several young designers, including MVRDV and the firm VMX, and has resulted in several innovative housing projects in small provincial towns.

Beyond specific subsidies and awards, what helps young architects in The Netherlands more than anything else is that they actually receive commissions. This has partially been the result of a good economic climate and the continual demands for more and larger housing, which have created a plethora of opportunities for designers of any age. Though the economy has slowed down somewhat and expensive houses sell for slightly lower prices, there is a seemingly insatiable demand for smaller houses. This is the result of both what the Dutch call "social thinning" (smaller and looser family structures in which each member wants more space) and immigration from other countries.

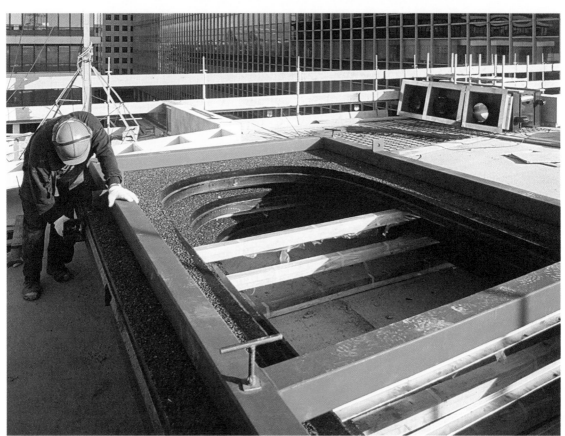

Construction of the Sarphatistraat residential building, Amsterdam, by VMX Architects, 2002
Stedelijk High School, Den Bosch, by VMX Architects, 2002

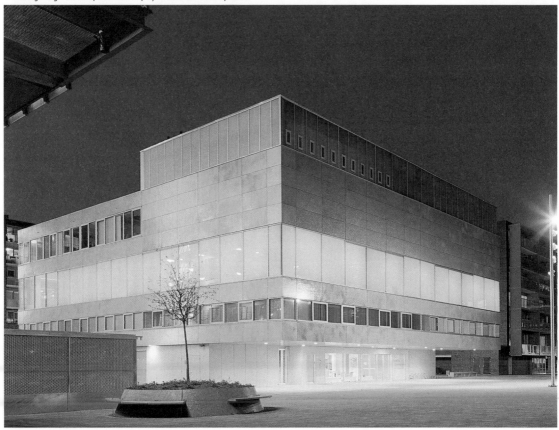

Bicycle parking garage, Amsterdam Central Station, by VMX Architects, 2001

In contrast to other countries, where such a demand is usually met by the production of generic, mass-produced housing, in The Netherlands young designers are often given a chance to design housing units almost as soon as they leave school. This is at least partially because Dutch designers are trained to go to work immediately; the main school of architecture, the Delft University of Technology, puts a strong emphasis on technical knowledge, while the half-dozen academies of building arts that train most of the architects require lengthy internships during study. Dutch architects know how to build at the beginning of their career.

The reasons for their success, however, go beyond the quantity of work and their training. It is also the result of a situation in which construction of housing has become so systematized that it has created a well-oiled machine to support the experimentation young designers embrace. Concrete shells and standard window assemblies can be deconstructed and reassembled in new ways, and even the gridded landscape in which new housing estates appear gives the architects a field within which they can experiment. In a sense, the whole Dutch building trade subsidizes experimentation by collectivizing individual homes into large-scale systems within which architects can create innovative form.

Finally, there is little of the professional hierarchy of age and social standing that stymies the development of young generations in many other countries. Architects in The Netherlands are not revered with grand academic titles, as they are in Spain and Italy, and are not seen as pseudoscientists, as they are in Germany. On the other hand, they are not just weird geniuses out to prove themselves, and only later given artistic freedom, as they are in the Anglo-Saxon countries. Instead, the Dutch architect is seen as part of a team. His (still rarely her) role is to provide that certain quality of organization and appearance that distinguishes each project. Young architects are often valuable because they let the developers of housing estates distinguish their product with new ideas and images.

A good example of this is the new housing estate called Hageneiland, just east of The Hague. Designed by MVRDV and completed in 2001, it consists of 119 mainly rental units. The architects started with an arrangement standard in such housing developments: a row of houses of poured-in-place concrete frames alongside the road, with small front- and backyards. But then MVRDV broke the traditional line of homes apart. They left two units standing on the road, moved the next one back, then brought another few forward, then moved a few back. By doing this from both sides of two parallel roads, they created a situation in which groups of one, two, or three houses stand next to the backyards of the front houses. Instead of presenting a closed front, the row has turned into a village of separate structures standing in space. As occupants move to and from their houses they pass the yards of their neighbors, while kids play in between. MVRDV clad each unit or group of units in one material: red tile for one, blue metal for another, concrete panels for a third. This further abstracted the generic forms that are the direct translation of the standardized construction method while making each structure identifiable. The result is something that looks like a modern version of a small village. A new world is arising in which Social-Democratic ideals transform recognizable housing archetypes.

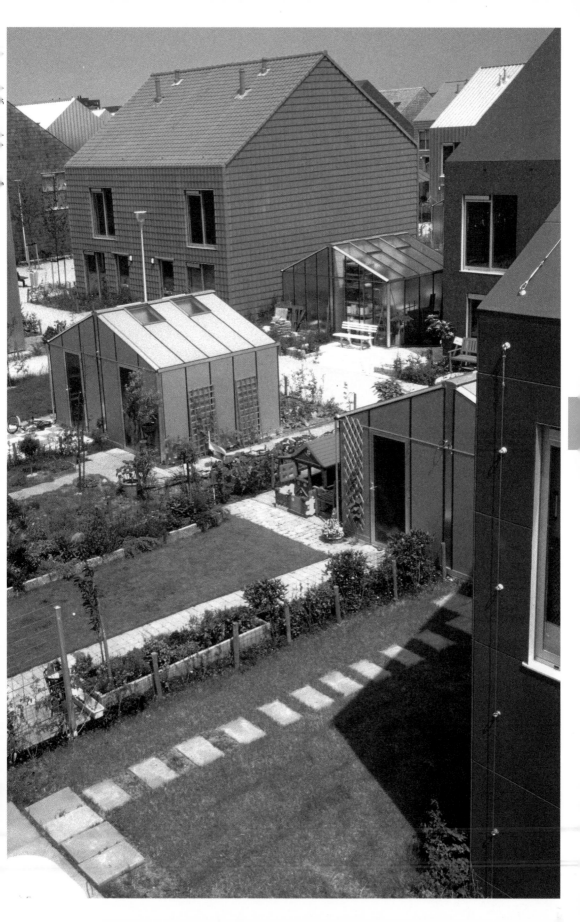

Hageneiland, Ypenburg, by MVRDV, 2001

The same push and pull between government support and experimentation by designers also takes place in the other design disciplines. Just as the government indirectly supported the housing corporations in their creation of innovative estates starting in the early twentieth century, it also founded a series of semi-independent agencies, originally completely owned by the state but over time becoming more independent, that became great patrons of design. The most significant of these was the Post Office, or PTT. When J. F. van Royen became president of the postal agency in 1913, he began commissioning notable graphic designers and architects to create a coherent house style. Indeed, many of the early graphic designers who made a mark on the Dutch scene were architects, such as H.P. Berlage or J. L. M. Lauweriks, or artists, such as Jan Toorop or R. N. Roland Holst, who brought their structural and expressive tendencies to work for the Post Office.

The Dutch did not have the French tradition of making advertising posters and were closer in style to the English book illustrators that came out of the Arts & Crafts movement. Graphic design to the Dutch was not an illustration or an abstract formation of space, as it was to the English or the Germans, but an addition to a text, something that made the message clearer by the way composition and typography emphasized the actual language. In a country with one of the oldest traditions of book design (it had been a haven for independent authors since the seventeenth century), the Dutch could be expected to have a strongly developed sense of the beauty of published work. Though there were excellent typesetters around in the nineteenth century, however, it was not until the mechanization of the twentieth century that the discipline took off.

Exterior signage for the Dutch Post Office (PTT), by Gerard Hadders, 1991

The Post Office's stamps quickly became sites for experimentation even for increasingly young designers. The designing spirit continued into the post offices themselves. Once the province of state architects, they became laboratories for architects such as J. Crouwel in Utrecht, who developed something that was not quite a house style but that blended elements of the Amsterdam School with altogether more monumental impulses. After the Second World War, mailboxes became commissions for industrial designers, and even postal uniforms were created by a succession of young fashion designers. The latest innovation to come out of the Post Office is the Roodrunner (*rood* being the Dutch word for red, the post's house color, pronounced "road"). This bicycle with a streamlined box on its front, designed by Springtime in Amsterdam, turns the saddle bags the delivery people used to hang on their bicycles into more voluminous objects, and in so doing gives the Post Office a new icon.

An iconic quality has always been important to the Post Office. Long before companies worried about branding, the Dutch Post Office understood that the customer experience, from licking a stamp, to mailing a letter, and finally receiving a reply, had to be both seamless and varied enough to respond to different circumstances. The Post Office had to have a completely coherent, disciplined, and yet flexible visual identity. Under design directors such as R. D. E. ("Ootje") Oxenaar, it maintained that control, and today it is attempting to extend it into its life as a private company. (The state sold the PTT in 1996. The Dutch telephone company, once considered the more valuable part of what had, by the early 1990s, become an unwieldy conglomerate, went its own way two years later, and has since foundered. It is struggling to maintain a coherent image, and has lost its competitive edge to many foreign competitors. The postal service, now called TPG, continues to commission good design, although its design department is much smaller than it used to be.)

PTT–TPG stamp for the Dutch Post Office (TPG), by Joseph Plateau, 2002
Roodrunner bicycle for the Dutch Post Office (TPG), by Springtime, 2000

Another place where the Dutch have historically encountered good design is the train system. The national railroads (NS, or Nederlandse Spoorwegen) came late to this interest in good design. It was not until 1968, when Tel Design clad a new generation of streamlined trains, with their distinctive bull-nosed locomotives, in bright yellow with blue stripes, that it gained a centerpiece for an identity. Between the bulletlike shape of the trains and the clear, confident house style, Dutch trains gave the impression of a system that was abstract and modern, turning the landscapes through which it ran into de Stijl–like compositions while maintaining a sense of solidity and clarity. The Dutch trains weren't just vehicles, they were pure color and form, completely distinctive and yet functional. They were a joy to ride. Here, too, uniforms and ancillary pieces such as train schedules reinforced the image set forth by the service's centerpiece.

Privatization has not been kind to the railroads. Truth be told, the rail system had already begun to lose a great deal of control over the passenger experience by not keeping up with technology and by a disastrous station-renovation program that was launched at the height of postmodernism. The result was the design of one confusing and strangely wrought station after the other. The government, which has been divesting in the service for several years, has split it up into real estate and construction, rail management, and passenger services. NS no longer controls construction of major new initiatives, such as the high-speed rail line to Paris, and has had to confront foreign competition in parts of the country. Additionally, they have let their equipment become so outmoded that they have had to import less-attractive secondhand trains from Belgium.

The NS's reliance on secondhand trains is symptomatic; as more and more state services are privatized, patronage of good design disappears. As organizations try to compete in a global marketplace, they feel the need to develop an image that is not Dutch, so they hire outside consultants to make them look more like companies based in the United States or the United Kingdom. The flagship air carrier, KLM, has for years been losing its Dutch identity; its pale blue color scheme, originally meant to remind passengers not only of the sky but also of Delft Blue ceramics, is now only a faint reflection of the strong sense of primary colors one can find at its home base. It used to be that there was something no-nonsense but thoroughly and thoughtfully designed about everything KLM did. Today, the carrier's Dutchness is communicated through references to tulips in their promotional materials and the little ceramic collectibles they give out in business class. KLM, like most Dutch companies, feels no need to export the good design that was once its birthright, and instead is trying to join the jumble of competing signs and symbols that make up the global marketplace. In 2003, Air France acquired a majority stake of the company.

The task of maintaining good design has now devolved to the government proper. It supports the trade through some commissioning, such as in the design of the new tax forms by Bureau Mijksenaar, but there it is also losing power. Since January 2002, the currency for which the country was known and loved by design aficionados around the world has disappeared in favor of the Austrian-designed euro. What has replaced the direct (and indirect, through the former state companies) commissioning of good design has been the support of design academies and institutes, designer's offices, and the even more indirect support of commissioning good work through cultural institutions. And here The Netherlands continues to do things a bit differently than most countries.

Illustration from the NAP (New Amsterdam Plane) project, proposing supermarkets in the trains, by NL Architects, 1996
NS train, by Tel Design, 1968

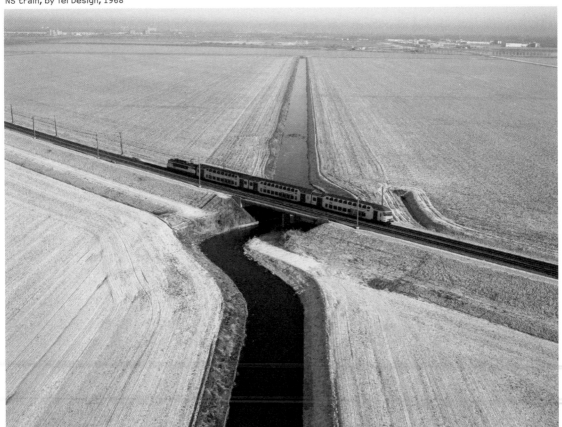

Most good Dutch graphic designers work for museums, theater companies, and other state-supported institutions, or they design heavily subsidized books. Only a few firms compete on a national and international level for the design of advertising, house styles, and logos. It seems that most companies believe that to sell themselves, they need to hire a foreigner. On the other hand, to continue the civilizing influence of culture, you need a Dutch designer. As such, design has shown itself to be part of what was once called the "civilizing offensive." According to the author Abraham Swaan, urban renewal, welfare reforms, the rationalization of the school system, and the support of cultural institutions were all measures taken by the bourgeoisie in the second half of the nineteenth century to accommodate and contain the rising working class. Keeping the city free of disease and dirt kept the ruling class safe. An ordered appearance to the environment made for more efficiency. Well-educated workers were more productive, and a shared culture created a sense of common purpose that could replace the family, the church, and class as a binding force. Seldom has a government set out to do all of this with more force and logic than in The Netherlands.

Over the years, education has become part of Dutch society's fabric, and the making of infrastructure has become a—perhaps even the— central task of government. What remains most controversial and yet highly effective is the complex web of cultural institutions the Dutch support. While other European states support highly centralized cultural bureaucracies, the Dutch have chosen to support their cultural institutions by encouraging as wide a variety of initiatives as possible. These institutions can apply for multiyear structural support, as well as any number of local funds for operating costs.

To promote their activities, arts institutions, theater companies, orches- tras, and other cultural groups invariably turn to graphic designers. This tradition was set in motion by Willem Sandberg when he was director of the Stedelijk Museum in Amsterdam in the 1960s. A designer himself (as was Wim Crouwel, longtime director of the Museum Boijmans Van Beuningen in Rotterdam), Sandberg invited artists and designers to make the Stedelijk into the country's heart of modern experimentation. Most large museums followed his lead and, later, smaller institutions in other fields followed suit. Today, the notion of good design is built into the way in which even the smallest theater company thinks, and decisions to pay designers what to foreigners appear like decent (though not exorbitant) fees are usually fully supported by the government.

2

Starting in the 1980s, the government took the further step of subsidizing specific designers and design initiatives. It created the Mondriaan Foundation, for instance, which specifically funds designers (as well as artists of all sorts) to present their work in other countries. It bought real estate in New York and Paris where designers and artists could stay while studying those cultures. It set up a stipend system for young designers that helped them set up their own offices. It arranged courses for government officials to learn from designers what good planning or architecture was. All of this took the place of the generic support system of the 1950s and 1960s that guaranteed artists, once they had been certified by the state, a fixed income (and obliged the government to buy their work, creating warehouses of unseen art). It also extended government support into the field of design.

One of the most obvious ways in which the Mondriaan Foundation and the Incentive Fund support architecture and design is to help fund books. Most common is the support for monographs on the work of individual firms, giving them the chance to present themselves both to the Dutch market and to potential clients abroad. In addition, funds are available to support the publication of even the most obscure research. One art historian, Wessel Reinink, published a beautifully produced volume on all the comings and goings, both of people and of animals, on the country estate Landgoed Linschoten, as a way of giving a full, multidimensional portrait of one particular slice of the Dutch landscape

In addition, designers vie for specific prizes. Since the 1950s there has been a prize for the best-designed book, as well as other awards for posters, typefaces, and other elements of the graphic designer's work. The Rotterdam Design Prize, given every other year, has become a national award for good design. Private companies have also chimed in, with the discount store chain HEMA employing young designers to create such simple items as kettles. Combined with a general rise of awareness among consumers about the importance of design and aided by several design critics at Dutch newspapers and magazines, there is now an atmosphere where design is taken much more seriously in the general culture than in most other countries. This system of specific support successfully replaced the ubiquity of good design in trains and at the Post Office.

Wessel Reinink's **Landgoed Linschoten,** designed by Irma Boom, 1994

Ironically, all of this occurred at the same time that Dutch culture was losing much of its specificity to foreign influences. In an environment dominated more and more by foreign retailers, telephone companies, and broadcasting conglomerates, the character of Dutch design became more and more difficult to find. ABN AMRO, the country's largest bank, had its logo redesigned by a British firm, and Philips, the maker of electronics, presented a new line of products designed by Italians. In response, most Dutch designers retreated into that safe haven where they could fruitfully engage in the making of posters and books for cultural institutions. It was here that the character of Dutch design was further developed. In catalogs for museum exhibitions, posters for theater productions, annual reports for cultural foundations, and cafeterias for all these institutions, designers made work that was highly disciplined, sober, and yet also witty.

A good example is the renovation of the Centraal Museum Utrecht. Its graphic image, designed by the Amsterdam firm Thonik, reduces the institution's name to the single letter *c*. Fat and assertive, it dances around the page as if trying to play with its own centrality. Walk into the museum and you find guards not in uniforms but wearing abstractions of the kind of sashes that used to indicate membership in an honorary order. Designed by Viktor & Rolf, they help indicate who visitors can turn to, while giving the wearer a certain amount of dignity without the pretentiousness of uniforms. The museum's core is a modern version of a medieval dining hall, designed by Rotterdam designer Richard Hutten. Long refectory tables sit under collections of lightbulbs dangling from exposed wires and grouped into candelabra. Stacks of wood make counters and children's seats. When the weather is good, you can sit on orange plastic "skippy balls" (plastic balls with handles for bouncing around) redesigned by Hutten. Here is Dutch design at its best, abstracting, reusing, and restating both the ancient and the recent past.

One problem that continually gives rise to design innovation in The Netherlands is the issue of translation. For a book published in Dutch to have an impact in the world, it has to appear in English. Only sixteen million people (twenty or so, if you count Flanders) speak Dutch. The costs of translation are almost always part of any subsidy request for an exhibition or a collection of a designer's work. And each time, the designer has to come up with a way of integrating the two texts so that different readers can find the information they need without creating competing fields of language. My favorite solution was the one the firm Thonik came up with for the 1997 catalog of the work of Wim T. Schippers. They printed the two texts in green and red and then supplied colored acetate sheets of the same tint. If you laid the green transparency on the page, only the red text would appear, and vice versa. Both texts were always present, but the reader could choose which to see.

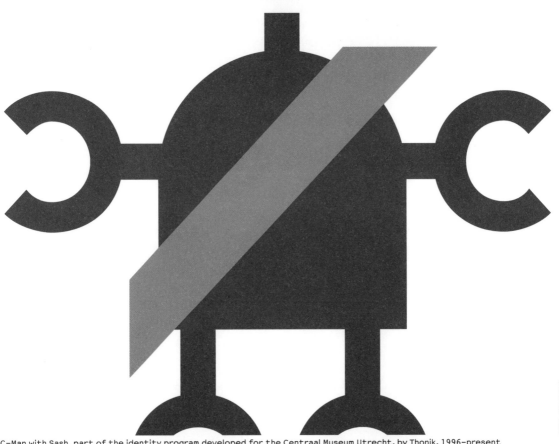

C–Man with Sash, part of the identity program developed for the Centraal Museum Utrecht, by Thonik, 1996–present
Zzzidt Object seating for the Centraal Museum Utrecht's cafeteria garden, by Richard Hutten, 2000

The problem of translation is absent for the makers of furniture, such as the members of Droog Design, and their work has become a staple of international design stores. Yet here, too, the Dutch government supported the export of Dutch design. Every year, half a dozen Dutch designers receive grants to present their work at the international furniture fair in Milan, as well as at fairs in Cologne and New York. Ironically, the work receives truly wide distribution only when it is picked up by foreign manufacturers such as Cappellini; Dutch design receives a running start from the government, but it is through corporate distribution networks that it becomes part of a global culture. To help things along, the Mondriaan Foundation subsidizes exhibitions of designers' work throughout Europe and in the United States. In the United States, the cultural consul, a position created in 1982 in all Dutch embassies, works tirelessly to promote Dutch design. The first consul, Rein van der Lugt, was especially effective in making Dutch design an integral part of the American design culture.

By now, Dutch design has become famous. Dutch architects such as MVRDV are exporting the lessons they learned designing social housing all over the world, and Dutch industrial, graphic, and furniture designers are picking up commissions in the United States, Europe, and Asia. In the recent competition for redesigning Ground Zero in New York, three of the seven teams included Dutch architects. Dutch designers work for Cappellini and for Vitra, for BMW, and for big American textile companies such as Maharem. Walk into the temple of high design in New York, a store called Moss, and Dutch design threatens to overwhelm the classics of high modernism hailing from Germany and France. For a small country, The Netherlands exerts amazing influence. That is the final result of the polder model: support that generates the ability to export one's achievements.

Viktor & Rolf, by Marie-José Jongerius, 1999

DOORS OF PERCEPTION

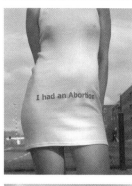
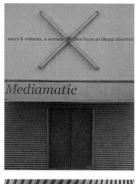

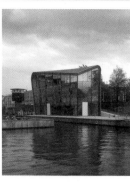

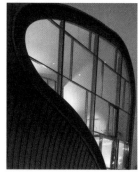
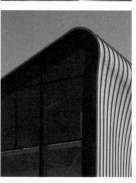

Doors of Perception — From 1993 to 2001, the Netherlands Design Institute was an integral part of the Dutch Cultural Council's plan to further the national agenda of promoting culture among its citizens. Led by the Briton John Thackara, the institute became an international think-and-do tank and cultural accelerator that put design on the agenda as a tool to create value for a sustainable world. It went beyond culture, becoming involved in economics, the environment, and social issues—crossing fields well before interdisciplinarity was a generally accepted cultural policy. One of its key initiatives was the founding of Doors of Perception, a "conference and website at the forefront of new thinking on design and innovation." After a brief hiatus the Netherlands Design Institute became the Premsela Foundation in 2002, but Thackara was granted the Doors of Perception name and legacy when he resigned in 1999. Doors of Perception remains a progressive and important voice on the Dutch cultural scene, but, remarkably, the council advises they would rather see the subsidies for the next four years spent on the Web site and newsletter, and no longer on the conference.

Mevis & Van Deursen — With a stable of cultural commissions and public-sector projects—from stamps to urban identities—the graphic designers Armand Mevis and Linda van Deursen exist in a symbiotic relationship with cultural funds and public money. Working together as Mevis & Van Deursen, they art-directed **IF/THEN**, a publication that was created for the fifth Doors of Perception conference and which earned the pair enduring acclaim from designers and new-media thinkers worldwide. Their **MetaTag** book for De Waag, the Society for Old and New Media, focuses on the designers' individual identities by offering two solutions to each problem, Mevis's in English and Van Deursen's in Dutch. For Mevis, design is "the need to seek the possibility to create space with each assignment to develop individual, autonomous, and critical ideas on how to respond to the production of mass-media communication."

For Van Deursen, design is "luckily a word we don't have a translation for in Dutch." Always exploring how form can become content and, in turn, tell a story through design, their work represents an open intellectual pursuit, not just a means for solving visual problems. The Design Museum in London correctly credits the duo with playing a "critical role in modernizing Dutch graphic design and redefining it as a dynamic medium."

Waag Society — De Waag is one of the oldest buildings in Amsterdam. Under one of its turrets lies the auditorium where at one time the guilds met to discuss their trade and where Rembrandt captured the then-controversial act of dissecting a body, in his **Anatomy Lesson of Dr. Tulp** (1632). Now the building houses Waag Society, dedicated to old and new media. "Holland is a lab land, as in a laboratory land," points out Doors of Perception codirector Kristi van Riet. "We don't really invent anything ourselves; we take the discoveries from elsewhere and experiment with new applications for them." Waag Society, founded in 1994, fits this bill perfectly. Their mission statement reads: "Waag Society is a knowledge institute operating on the cutting edge of culture and technology in relation to society, education, government and industry. With its knowledge Waag Society wishes to make a contribution to the design of the information society. In this it doesn't let itself be led by technology but instead looks at the possibilities of people, their creativity and culture. The interplay of technology and culture is the driving force of all Waag Society's activities." Under designers like Mieke Gerritzen and now Janine Huizinga, the Waag Society also succeeds in marrying a distinct graphical look to their interfaces, customizing and localizing the characterless screens devised by IT multinationals.

Women on Waves in Mediamatic Supermarkt — For more than twenty years the Mediamatic Foundation, led by charismatic principal Willem Velthoven, has made an invaluable contribution to the development of new media and e-culture in The Netherlands. One of the first to embrace the topic, it publishes its own magazine (**Mediamatic Magazine**), presents projects about the field (at their Mediamatic Supermarkt space and through the books **Multimedia Graphics** and **Website Graphics**), and reflects on the larger societal meaning of e-culture (contributing substantially to the Doors of Perception conference). In 2003 the entire Mediamatic Supermarkt building held the exhibition **Women on Waves** (WoW). Among other works, Velthoven designed the installation **I had an abortion**: body-hugging T-shirts with "I had an abortion" printed on them in a number of languages, hanging on clothes hangers, the predominant method of illegal abortion. On a scaffold in front of the gallery was placed Joep van Lieshout's "A-Portable," a shipping container housing an operational mobile abortion clinic. WoW activists use it to sail up to countries like Ireland and Poland (where abortion is illegal), offering to take women who are up to six-weeks pregnant to international waters, where the procedure can be performed in a medically safe manner. The Dutch health minister, Els Borst, has said that the decision to permit Women on Waves to sail under the Dutch flag and distribute the abortion pill is in line with government policy regarding the sexual independence of women.

Arcam and René van Zuuk — Arcam stands for Architecture Centre Amsterdam, an organization funded by a remarkable patchwork of public and private moneys to create a place where the architectural needs of Amsterdam and its surrounding regions are presented and discussed. Its new building, designed by René van Zuuk, is located on the edge of the River IJ, which divides the city into south and north, on the periphery between old and new. In the shadow of Renzo Piano's ship-bow–shaped New Metropolis–Science Museum (or NEMO), Van Zuuk designed a striking, supermodern sculptural bubble, at once voluptuous and rhythmic. Nominated as one of five for the NAi Architecture Prize, Van Zuuk calls himself, in the accompanying book, **Fresh Facts, The Best Buildings by Young Architects in The Netherlands**, a contextual designer; "a building," he says, "is at its best when it fits in with its surroundings."

DOORS OF PERCEPTION 3 ON MATTER

A MEETING BETWEEN INFO AND ECO COMMUNITIES

The third *Doors of Perception* will address a big question: how might information technology and design help us live more lightly on the planet? How can faster information help us *de*-materialise products and services and slow down our consumption of matter and energy? These are exciting questions, but eco-gloom is so *de*-motivating. The more think-tanks tell us about the dire condition of the planet, the more we sink into emotional entropy - pretending that things can't possibly be *that* bad, even when they can. By comparison, information technology seems to bring us non-stop good news. Computer power that doubles every 18 months; declining hardware prices; millions going online; and an 'information economy' that, we're told, will grow exponentially forever.

There's just one small problem with this rosy scenario: if the planet's systems crash, the Internet offers no escape. The eco-community has amassed solid evidence that a radical decrease in our consumption of matter and energy - by a factor of 10 to 20 - will be needed, within a generation, if we are to achieve a sustainable world. So where on earth do we start? The first two *Doors of Perceptions* put new information systems into a cultural, social and economic context; they basically asked: what is this stuff for? *Doors 3* poses an answer: the 'stuff' can help with the mental and material changes we have to make in order to achieve a sustainable future.

DOORS OF PERCEPTION 3 'ON MATTER', 6 -11 NOVEMBER 1995, NETHERLANDS DESIGN INSTITUTE, SOCIETY FOR OLD AND NEW MEDIA

Folder for the third Doors of Perception conference in Amsterdam, by Joseph Plateau, 1995

If/Then

design implications
of new media

0.1

play

1999

Netherlands
Design Institute

Dfl 69

US $29.95

IF/THEN PLAY

HET PROGRAMMERING GAST MUZIEKTHEATER

KASSA/ BOX-OFFICE 020 - 6 255 455 kaartverkoop vanaf heden bij
TOEGANG ƒ 55.- ƒ 42.50 ƒ 32.50 ƒ 22.50 Het Muziektheater, AUB-ticketshop en alle
CIP EN PAS 65 ƒ 42.50 ƒ 32.50 ƒ 22.50 ƒ 17.50 VVV-Theaterbespreekbureaus in het land.

BALLETT FRANKFURT

EEN CHOREOGRAFIE VAN WILLIAM FORSYTHE
OP MUZIEK VAN THOM WILLEMS

THE LOSS OF SMALL DETAIL

WO 5/ DO 6/ VR 7 JAN / 20.15 UUR

Poster for Ballet Frankfurt performance in the Amsterdam Muziektheater, by Mevis & van Deursen, 1994

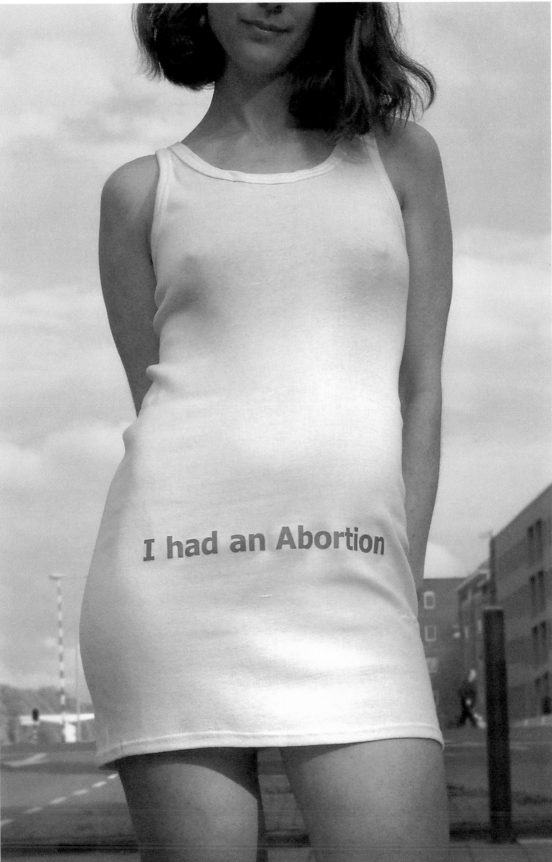

Dress design for the exhibition **Women on Waves** in the gallery Mediamatic Supermarket, by Mediamatic principal Willem Velthoven, 2003

I had an Abortion

Invitation for a Viktor & Rolf fashion show in Paris, by Mevis & Van Deursen, 2002

"Viktor&Rolf : because I'm worth it"

8587 Rue du Faubourg
Saint Martin
75010

pr_consulting
f: 212 228 877
t: 212 288 181

V&R

85-87 Rue du Faubourg
Saint Martin
75010

Saturday
October 5
at 1800
at BETC

Spring & Summer 2003

SATURDAY OCT. 5
AT 1800 H.
AT BETC.

Dress Europe:
Aurélie Otto
T: 01 42 61 57 36
F: 01 42 61 58 91

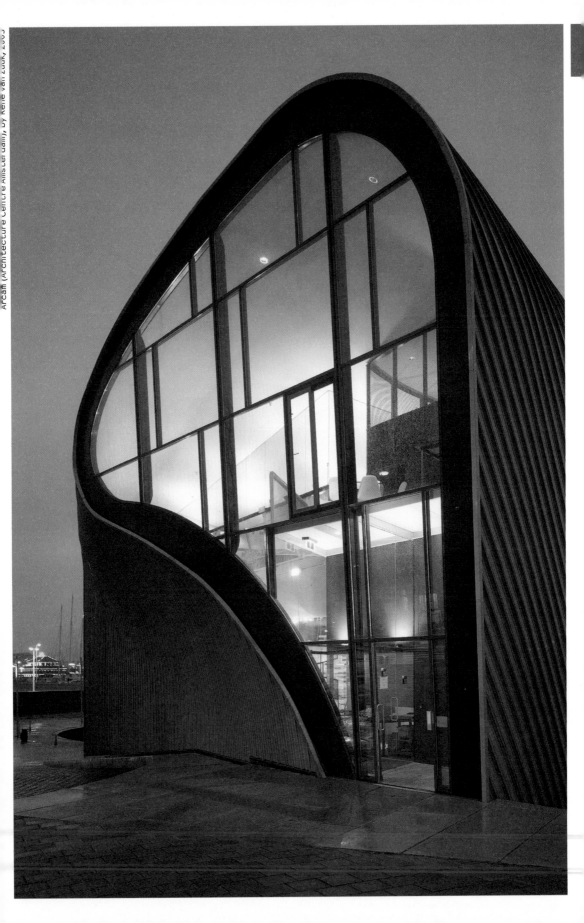

neo-
mania
Nº 24

MINDED

THE GOOD PEOPLE

INTER
SEX

HOW
TO TURN *YOUR*
CREATIVITY
INTO
MONEY

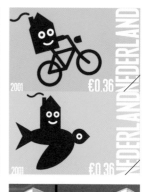

California, where he met type designer Zuzana Licko. A year later they started **Emigré**, a magazine about emigrant artists and about how being abroad fed their creativity—"a magazine that ignores boundaries." Licko's typefaces were used as headers, giving it a unique look. Coinciding with the birth of the Macintosh, **Emigré** was to become one of the first independent type foundries to establish itself around personal-computer technology. Today, it is a successful international enterprise supporting itself as a digital-type foundry and publisher of graphic design–related software and printed materials. Still based in northern California, the magazine continues to hold the imagination of a worldwide audience of graphic designers and has played a significant role in spreading the excitement about Dutch design by giving designers such as Armand Mevis, Experimental Jetset, and Mieke Gerritzen the opportunity to design their own issues.

Emigré — Rudy Vanderlans attended the Royal Academy of Fine Art in The Hague from 1974 to 1979, served as apprentice at Wim Crouwel's studio Total Design, and did corporate-identity work at Vorm Vijf and Tel Design. When he was admitted to the UC Berkeley graduate design program in 1981, he moved to

Mieke Gerritzen — Mieke Gerritzen is a designer-activist, always on the bandwagon to proclaim, with her iron logic and strong graphics, her stance on issues like globalization, corporatism, mobility, and the role of the designer. As journalist Jane Szita reports on the Doors of Perception Web site, Gerritzen views the "current, global design idiom" critically, "as one planet, one network, one style. She views today's position as a kind of domestication of the designer." Ever-questioning Gerritzen is certainly nobody's lapdog. After having played an integral role in groundbreaking projects like De Waag and VPRO-Digitaal, she currently heads the graduate design program at the Sandberg Institute while running her own studio, NL-Design, producing books like **Everyone Is a Designer, Mobile Minded**, and **A Catalogue of Strategies**, in collaboration with writers, philosophers, and

artists. Her pet project is the International Browser Day, a competition and call-up among design students from around the world to liberate the design of media interfaces from all-controlling corporate interests.

cool during the last decade: "The VPRO...served as the mouthpiece for the progressive intelligentsia and thus also for the majority of artists from the 1970s to the end of the 1990s. It was also the VPRO that chose MVRDV to design its new headquarters in 1995, the architectural firm's first big commission. And it is also the VPRO which has paid most attention to new Dutch design in all its guises in a relatively large proportion of its programs. But even more important was that from the 1970s to the late 1990s the VPRO itself set the standard for the way in which everyday reality might be regarded: always ironic, always putting things in perspective, always employing exaggeration or trivialization of phenomena, which always results in an alienating effect...They lay the groundwork for a particular way of looking, for an attitude to real life that is shared by practically all contemporary Dutch artists."

VPRO — In her insightful essay "From frugal to cool, the rise of Dutch design in the Nineties" for the catalog to NAi's **Reality Machines** exhibition, author Pauline Terreehorst (director of the Netherlands Fashion Institute) singles out the broadcasting company VPRO as one of three shared "contextual factors" contributing to Dutch design's reaching an apex of

Max Kisman — In 1993, Louis Rossetto, the founder of **Wired** magazine, attributed the distinct look of his publication to the teachings of Dutch graphic design. In particular he singled out Max Kisman and Willem Henri Lucas, the designers who were one of the first to design and produce a magazine digitally (**Wired**'s predecessor **Electric Word**). Over a career spanning many decades, designer and illustrator Kisman has been at the forefront of technological and popular-culture phenomena, imbuing posters for Paradiso, leaders and bumpers for VPRO television, intro spreads of **Wired,** and his newest venture, Holland Fonts, with his distinctive iconographic style. A wise and seasoned man, Kisman sees it as the duty of every creative professional to incite the emotions, to pick up what plays in culture and give it a form that penetrates the soul. The best way to do this? "I can't draw; still, I do it a lot. My handicap is my signature, my trademark. Imperfection is a quality in itself."

are also the role-model sweethearts of the new governmental e-culture policy. Though rejected for the period 2001–04, they are now fully recognized for their innovative force, receiving generous state funding to continue their "essential contribution to the e-Culture infrastructure in The Netherlands" with the "potential to become a valuable place of innovation and experimentation where new makers and a young and new audience meet each other." Next up on the channel is Han Hoogerbrugge's highly anticipated series "Hotel." Submarine has already moved on to larger things, getting the European Union to cofinance their online game, the Tulse Luper Journey, an interactive search for ninety-nine suitcases in twentieth-century European history, released in conjunction with a trilogy of films written, directed, and produced by Peter Greenaway.

Submarine — Submarine—"your periscope in unknown territories"—is an independent production studio and online network that produces and presents a range of interactive media formats on its Web destination, Submarine Channel. They

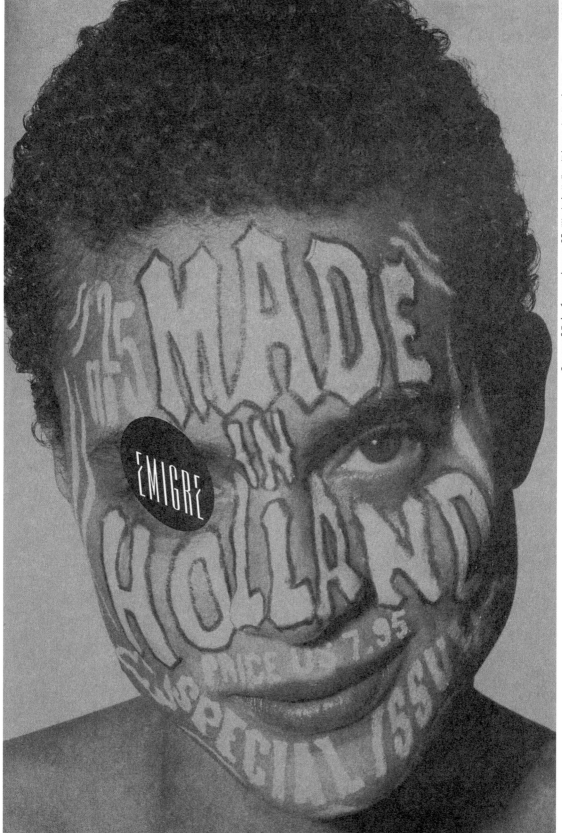

Cover of **Emigré** magazine no. 25, "Made in Holland" issue, by Mevis & Van Deursen, 1993

THE GOOD PEOPLE

THE GOOD PEOPLE

THE GOOD PEOPLE

THE GOOD PEOPLE

THE GOOD PEOPLE

THE GOOD PEOPLE

THE GOOD PEOPLE

THE GOOD PEOPLE

THE GOOD PEOPLE

The proBleM wIth cOMPutErs iS thAt theRe IS nOT eNouGh AfricA iN THeM

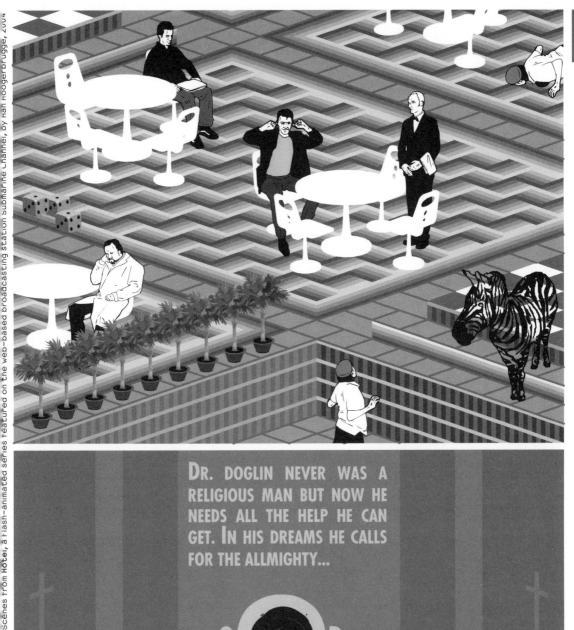

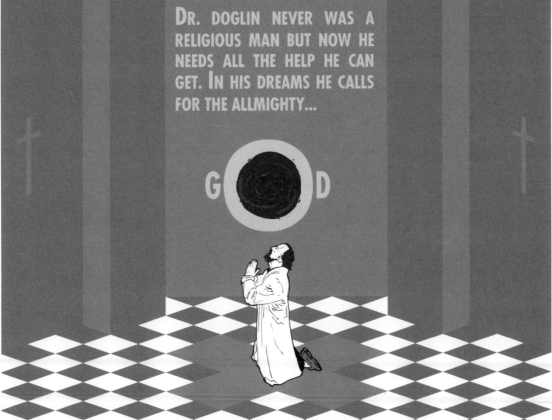

DR. DOGLIN NEVER WAS A RELIGIOUS MAN BUT NOW HE NEEDS ALL THE HELP HE CAN GET. IN HIS DREAMS HE CALLS FOR THE ALLMIGHTY...

G O D

West 8 — Founded in 1987, West 8 is an urban-design and landscape-architecture firm headed by Adriaan Geuze. Embracing and mastering a wide range of projects, from the acclaimed Amsterdam waterfront neighborhood Borneo Sporenburg to the landscaping of Schiphol Airport, the firm is largely responsible for putting landscape architecture back on the agenda of Dutch architectural discourse. Bart Lootsma's book **Super Dutch** provides a succinct summation of the essence of West 8: "In West 8's view, the landscape should be regarded no longer as the counterform of the city but as the entire configuration of town and country and the people who inhabit them. As Geuze puts it: 'The new city is airy metropolis, with villages, urban centers, suburbs, industrial zones, docks, airports, forests, lakes, beaches, nature reserves, and the monocultural acreages of high-tech agriculture.'"

Interpolis — Interpolis is an innovative Dutch insurance company with four core values: Trust, Freedom, Responsibility, Connection. This translates into "We trust our employees, so we give them all the freedom, which also means all the responsibility. It connects them deeper with the company." In support of these tenets, Interpol's headquarters in Tilburg has no fixed workstations for its fifteen-hundred-man-strong staff, nor does it waste space on, for instance, one enormous cafeteria that will be occupied for only two to three hours a day. Instead, Nel Verschuuren of the legendary interior design firm Kho Liang Ie Associates commissioned eight different designers—Irene Fortuyn, Ellen Sander, Jurgen Bey, Piet Hein Eek, Joep van Lieshout, Bas van Tol, Marcel Wanders, and Marc Warning—to each create a separate environment: "communication areas" or "clubhouses" in the

building where people could plug in their laptop, meet with colleagues and clients, and have a cappuccino and tuna sandwich at the same time. Wanders's meeting rooms are located in Flintstonian boulders adorned with gold-rimmed flower petals, Bey opted for a stately seventeenth-century living room, and Irene Fortuyn re-created the romance of a train-station cafeteria. In addition, West 8 created a corporate garden where employees can similarly spend a productive day of work.

Piet Hein Eek — Furniture and interior designer Piet Hein Eek's work is made with straight-forward methods and means. His fame comes largely from the furniture he made of recycled wood from beat-up doors, old church windows, discarded ledges, and one-hundred-year-old oak-wood roofs that had been buried in rubble for twenty years. Artfully transformed into many-colored cupboards, tables, and chairs with peeling paint, cracked and faded wood, and rusty nails, these pieces are little monuments of past and present, while at the same time they posit a sustainable future. As Eek explains: "I don't make impersonal products for the masses, but unique products from the worthless waste material of industry and nature. I do not seek to minimize the production process but to take my time." Eek would rather not call himself a designer: "The designer often stops after making the design; I want to hammer it together too."

Concrete — At the end of the '90s, the peak of the economic boom years, the fortunate in Amsterdam hung out in interiors designed by Concrete. A takeaway cappuccino from the Coffee Company, a new shirt from the Laundry Industry, lounging at Café Bep, dining in the giant bed at Supperclub, dancing the night away at More before, as a final boost, passing around the aphrodisiac candies bought that afternoon from the Australian Aboriginal chocolate bar. It seems only appropriate that Concrete's first eye-catching project of the new millennium would be a pharmacy. In the Lairesse Pharmacy in Amsterdam they fluidly brought modern and traditional medicine together, surrounding an old tree trunk with transparent medicine shelves, epitomizing their distinct ability to meld opposites into a new, coherent whole.

hampered by misplaced or naïve inclinations to reform the world." In the context of the booming economic climate of the time, Ibelings stated that "the Dutch evidently feel that they can permit themselves such frivolities… and designers have acquired an additional task: to amuse people." Meyer en Van Schooten fit the hedonist bill. In 2002, for the new headquarters of the ING Group, they created a shiny, elevated landmark above the South Axis freeway of Amsterdam, symbolizing the banking and insurance conglo-merate as a dynamic, fast-moving international network. Transparency, innovation, eco-friendliness, and openness were the starting points for the design of the bizarre flag-ship building, and, with its long list of high-tech innovations, the architects definitely succeeded in dressing the emperor in a new set of clothes.

Meyer en Van Schooten — In his 2000 book **The Artificial Landscape**, author Hans Ibelings described a rising trend in turn-of-the-millennium Dutch architecture toward "hedonistic landscapes," in which there is "place for comfort, luxury, and allure." "Designers today," he wrote, "are not

Corporate garden for the insurance company Interpolis's headquaters, Tilburg, by West 8, 1999
Swamp Garden for the Spoleto Festival in Charleston, South Carolina, USA, by West 8, 1997

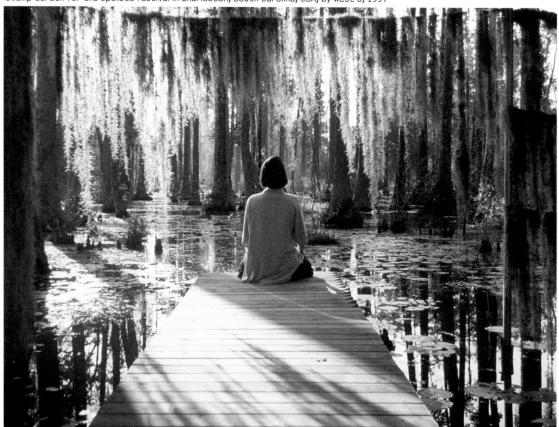

Clubhouse-Capsule, part of the Flexible Office Project commissioned by insurance company Interpolis for their headquarters, Tilburg, by Marcel Wanders, 2003

Interiors for the Flexible Office Project commissioned by insurance company Interpolis for their headquarters,
Tilburg, by Jurgen Bey (above) and Bas van Tol (below), 2003

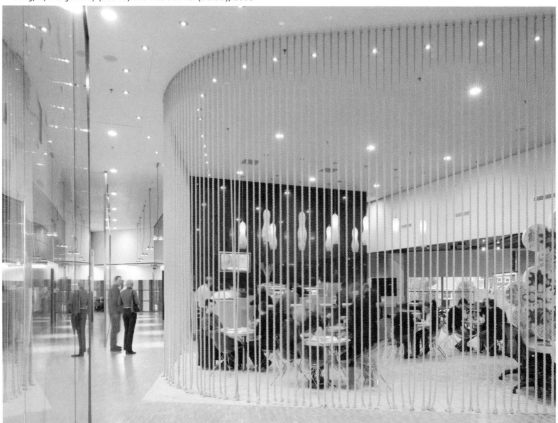

Interiors for the Flexible Office Project commissioned by insurance company Interpolis for their headquarters, Tilburg, by Piet Hein Eek, 2003

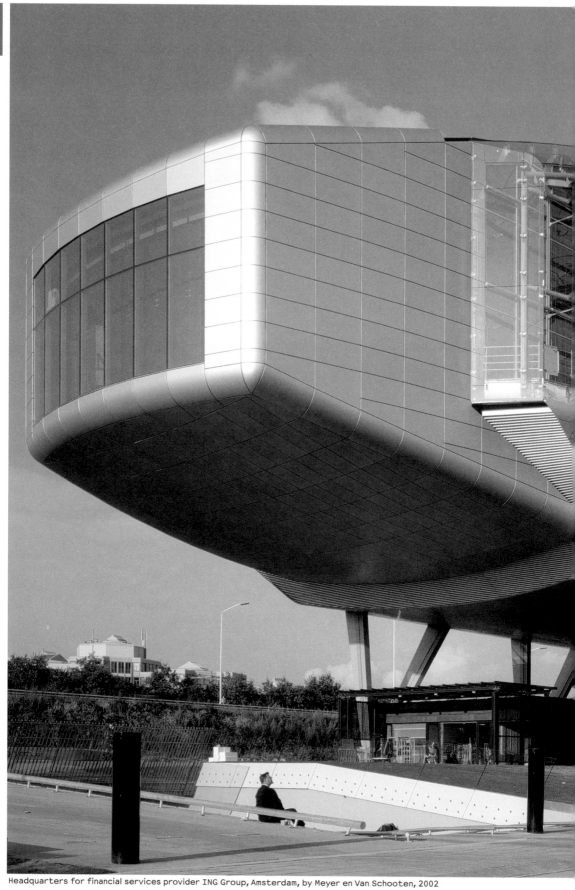
Headquarters for financial services provider ING Group, Amsterdam, by Meyer en Van Schooten, 2002

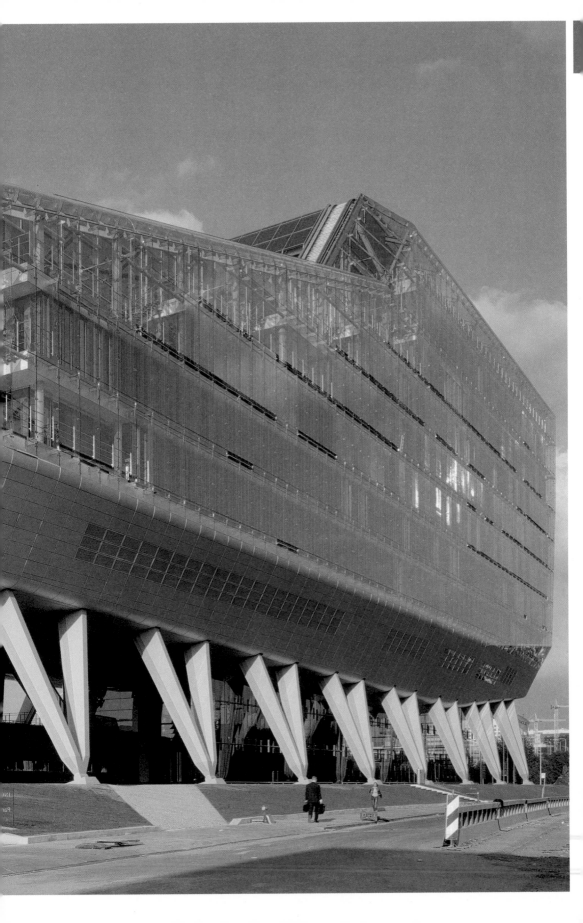

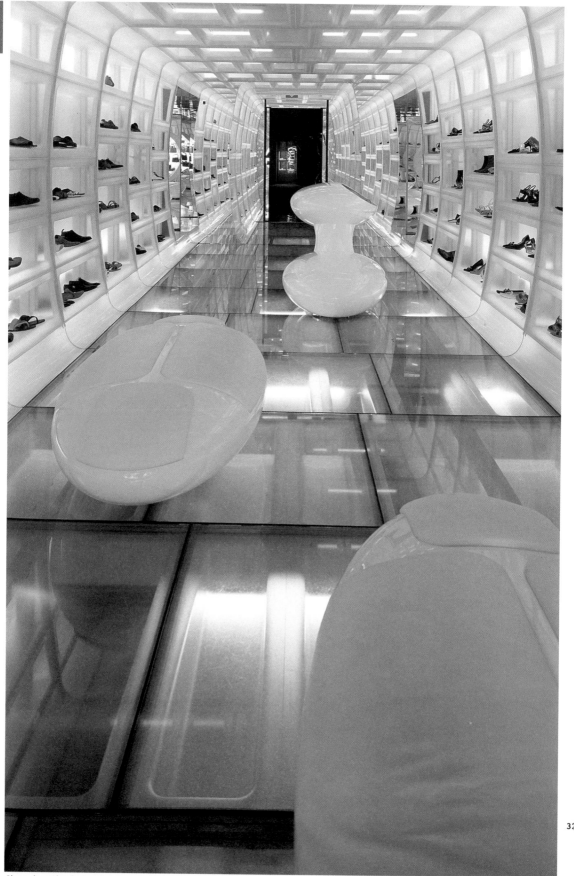

Shoe shop Shoebaloo, Amsterdam, by Meyer en Van Schooten, 2003

The Middle Road to Truth

In the middle of a street called the Blaak, on the southern edge of Rotterdam's central business district, the city has built a skateboard park. While office workers look down through the glass walls of anonymous twelve-story buildings on either side, kids swoop back on forth on steel-clad curved ramps. There is nothing particularly fancy about the place, nor do its forms appear any different from those in any other such park. Quarter-circles face each other, their stumpy tops providing dropping-in points. It is only in the way the different runs have been set against each other that you begin to notice that somebody actually thought about how the thing would look. It looks like an installation of abstract sculpture.

The skateboard park is actually the result of careful and lengthy negotiations among representatives of youth groups, recreation officials, business groups, and neighborhood associations. It was designed by the City Works Department in close consultation with some of the best skateboarders they could find. As a result, it now attracts skaters from all over Europe because of the excellence of its runs. The city, for its part, has found an attractive object, somewhat reminiscent of the designs sculptor Isamu Noguchi made for parks in the United States in the 1960s and 1970s, to occupy an otherwise dreary boulevard. People in the residential area just to the south are happy that kids are congregating there and not on street corners. I even imagine that the office clerk looking down on the whole thing gets some vicarious kicks out of the effortless motion and the spectacular falls taking place below him.

The skateboard park is a perfect example of what happens when the polder model works. The first lesson of that political system is that nobody should walk away from the negotiating table unhappy. Compromises are supposed to be about finding ways for everybody to understand what their true needs are, rather than feeling that they have to give in. The polder model also continues a long Dutch tradition in which aberrance and plain bizarreness are accepted, as long as they have a proper place. It is even valued as a useful safety valve and source of renewal. It is by applying this construction that the Dutch have managed to transform their economic and political system from a welfare state into a complex combination of entrepreneurial activity and targeted subsidy. It is by no means a perfect system, and its death is already being pronounced because of an economic slowdown and a sense that compromises in, for instance, education and health care have not always led to the optimal result. Still, it has turned the Dutch economy into one of the world's success stories, and it has let designers develop portfolios they can now export.

Skatepark Blaak with environmental graphics by 75B, Rotterdam, 2000
Still from film documenting the Skatepark Blaak, Rotterdam, by 75B, 2000

Still from film documenting the Skatepark Blaak, Rotterdam, by 75B, 2000

One of the main things that makes the system work so well is a great influx of money. The Dutch have lived off trade and foreign investment since the seventeenth century and continue to do so. Indeed, The Netherlands is the model of the near utopia the Western world creates by removing unpleasant reality to other places. It is thus not all sunshine and roses, and in fact most production does not take place in The Netherlands. True manufacturing is done in the third world; even the growing of food takes place increasingly in North Africa or South America. Of course, this means that pollution and poverty remain in those places too. Agriculture that is deemed undesirable, such as intensive pig farming, which produces great amounts of nitrates, is zoned out of existence, or at least exported to other countries such as Poland. Only the presence of migrant workers reminds the Dutch of that other place, the world. Though it is an increasingly powerful reminder; within the next few decades, non-native Dutch will become a majority of the population. Minarets are appearing on the skylines of most Dutch cities, and their design has little to do with Dutch traditions. People from Islamic countries have different ways of using public space and want their homes to have more communal spaces than the Dutch housing corporations or developers are used to providing.

How the Dutch will cope with this on a political, economic, or cultural level remains unclear. What is of particular interest, however, is how they are fixing the polder model in real life. This model, after all, defines and reflects the artificial land on which they live. The political system is itself a translation of the making of this semi-utopia through cooperation against the forces of nature. Now that the land is more or less secure (though global warming and its attendant rising sea levels are a substantial threat) and new polders are few and far between, the Dutch are engaged in the next stage of poldering: the development of ever more intensive and complex uses for the land. The polder is turning into VINEX locations, while older suburbs are turning into three-dimensional puzzles in which different groups' needs are not weighed against each other but stacked one on top of the other. That is the model for the core of Almere, the new town in the middle of the most recent polder. It is also happening in the older town of Utrecht, where a 1960s-era urban-renewal scheme is under redevelopment. In both cases, the demands for different functions (more recreation facilities, more homes, more offices) are met by satisfying everybody and finding architects who can squeeze them all onto the site.

As the Dutch intensify to accommodate, they are also building polders to contain a new foreign threat: globalization. Already, the Dutch have lost the guilder to the euro and their army is being dissolved into a pan-European force in which the coordination with German brigades, for instance, is so intense that the Dutch army operates as a virtual division. Most consumer goods are made by companies that are parts of huge multinational corporations. Flag carriers such as the national airline, KLM (Royal Dutch Airlines), are or may soon be disappearing altogether. And, as immigration and higher birthrates in the population of recent immigrants continue, not only will the Dutch soon be as much Mediterranean and Middle Eastern in heritage as they will be Teutonic or Saxon, but by the middle of this century Islam, not Calvinism, will be the largest religion in The Netherlands. So what in The Netherlands remains Dutch?

Barcode, an amalgamate of the flags of current member states of the European Union, by Rem Koolhaas/AMO, 2001
YES, illustration from the study "Airport Island," by Rem Koolhaas/OMA, 1999

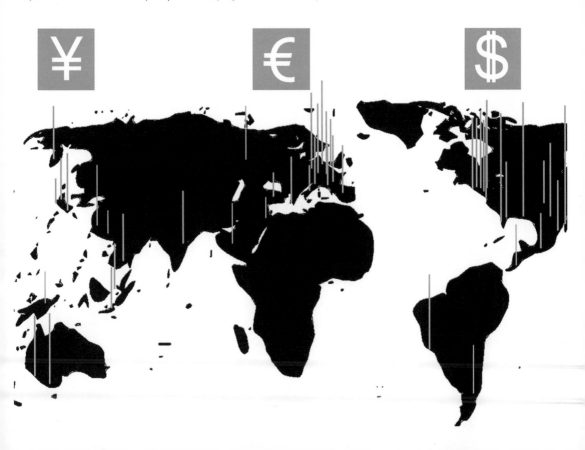

The answer is the middle class's ability to assimilate both high and low culture into a carefully designed and rather neutral, accepting, and flat zone somewhere in between. Culture here is everywhere, and everything can become culture. Learning from Rotterdam is just as much fun as learning from Las Vegas. To me, the hybrid place that appears out of all this borrowing and subsequent disciplining is most clearly evident in the work of graphic designers such as Goodwill, 75B, Mieke Gerritzen, Samira Ben Laoua, and Jop van Bennekom. Each has a very different approach, but all have a common goal: to accept and riff on the products of popular culture, and to use their considerable composition and typography skills to discipline or sharpen those impulses. What lets them get away with it is a combination of fascination with their subject and wry humor.

Take _Butt_ magazine, for instance. It is the handiwork of Jop van Bennekom, who had earlier started another high/low publication, _Re-Magazine_. That quarterly has turned into a slick glossy sold around the world. Each cover presents a simple portrait photograph, not of a celebrity, but of a normal person that, through a combination of the portraitist's skill and the flat presentation of the image, manages to look out at the viewer in a slightly attractive and slightly disturbing manner. Inside, van Bennekom's friends discuss the state of Dutch culture. The notion of representation is central to every issue, which means that most of the articles ask the question of how things, people, or institutions are present and how they present themselves. It also means that the magazine's style is so straightforward that one almost doesn't notice it. _Re-Magazine_ looks just like any high-end magazine, except that the balance on each page is near perfect and at times edit marks suddenly appear, as if the designer had forgotten to clean up the pages before sending them to the printer.

Butt magazine is even more casual. Printed on a pinkish paper and staple-bound, it is a literary version of a gay porn magazine (though most of the content is pretty mild). It presents itself as a cheap rag that somebody ran off at a copy shop—except that each spread is again perfectly composed. There is a kind of cheapness about this publication that goes beyond its price. Bennekom chose the type to look as if the magazine came off a typewriter, prints what look like amateur photographs, and kept the format small. _Butt_ is not only not slick, but it works so hard at its casualness that you begin to believe that it is almost rote, like the "improvised" guitar licks the pop star performs at every concert.

What Bennekom and several other of his compatriots are able to pull off is a sense that they have submerged their professional skills completely in the popular culture they inhabit. They use their compositional skills to organize the culture around them, even if that culture speaks English or Arabic instead of Dutch and recognizes brands more than traditional Dutch signs of home and hearth. The Netherlands is becoming, like everywhere else in the world, a cultural soup, and Dutch designers have to try, like their foreign colleagues, to make something new out of it.

STEPHEN GALLOWAY HYSTERICAL BALLET DANCER AND ARTIST AND CHOREOGRAPHER AND STYLE CONSULT- ANT AND R&B SINGER IN GERMANY LOVES POPPERS

Interview by Tim Groen
Portraits by Viviane Sassen

American-born Stephen Galloway moved to Frankfurt as a teen in the mid-eighties to dance with William Forsythe's Ballett Frankfurt. These days, he still dances and still lives in Germany, but his curriculum has expanded to include singing, costume designing, and giving his opinion on various matters such as how the models should pose in a Calvin Klein ad campaign. Stephen and I have been friends for years, but we never seem to be on the same continent for more than a few days. In his room in the posh Hotel George V in Paris, where he is staying as part of the entourage of the Rolling Stones, we catch up. We start by discussing the night before, when a bunch of us had dinner and then retired, while Stephen and I decided to meet again later at cruising dungeon Le Depot.

Spreads from **Butt** magazine, by Jop van Bennekom, Spring 2004

MARTIN DEGVILLE HORSE HUNG FORMER SINGER OF SIGUE SIGUE SPUTNIK HAD HIS FANTASTIC LOOKS NICKED BY GAULTIER IN THE EIGHTIES

Interview by Alex Needham
Portrait by Andreas Larsson

Martin Degville spent his pre-fame years designing and selling clothes in his shops YaYa and Degville's Dispensary, abetted by the likes of Boy George. Then he gained worldwide notoriety as a singer with Sigue Sigue Sputnik, thanks to their sole big hit *Love Missile F1-11*. These days, he's regularly seen around the gay dives of London dressed in some outlandish outfit and pouncing drunkenly upon unsuspecting teenagers. When we arranged to meet in Bar Aquida in Covent Garden, I was worried about recognising him. Needless to say, his outfit of red high heels, torn white bondage trousers, a vest bearing the slogan 'So Long Suckers' and a camouflage rucksack – all topped off with electric blue contact lenses – ensured that he still stood out a mile. He recently left Sigue Sigue Sputnik in hotly contested circumstances.

These are generally young designers targeting a young audience. Subsidy culture allows for experimentation, and experimentation is something the young do—both designer and nondesigners. Instead of vestiges of the past, whether Dutch or not, the young wear the latest clothes and use the latest signs. Companies targeting a young audience are quick to pick up on designers' ability to clothe the images coming out of their targets' culture with a veneer of good design, because they know that youth culture is where acceptance of their products starts. But they are not alone. Firms such as Rotterdam's 75B have quickly moved into designing catalogs and posters for cultural institutions, while their former rivals, Dept, even designed a stamp for the Post Office. 75B is exceptionally skilled at appropriating the images that come out of the dance-music scene—a combination of Japanese *manga* comics, 1970s revival fluidity, and graffiti-like lettering—and has abstracted this vernacular style just to the point where it can communicate information more clearly.

The Netherlands permits youth culture, including the use of soft drugs. It also recognizes its music and graphics as legitimate forms of expression. There is a pop center in the town of Breda, and several cities are vying for the chance to build the country's first cartoon museum. New theaters have to be able to accommodate both rock and classical concerts. Graffiti artists show their work in major museums like the Stedelijk in Amsterdam. Beyond such culling of "high-quality" popular culture for elite showcases, the Dutch genuinely seem to make little distinction between what in the United States is called "pop" and "high" culture. They are both forms of representation that, if they are good enough, are worth collecting, mapping, and mirroring in one's (collective) home.

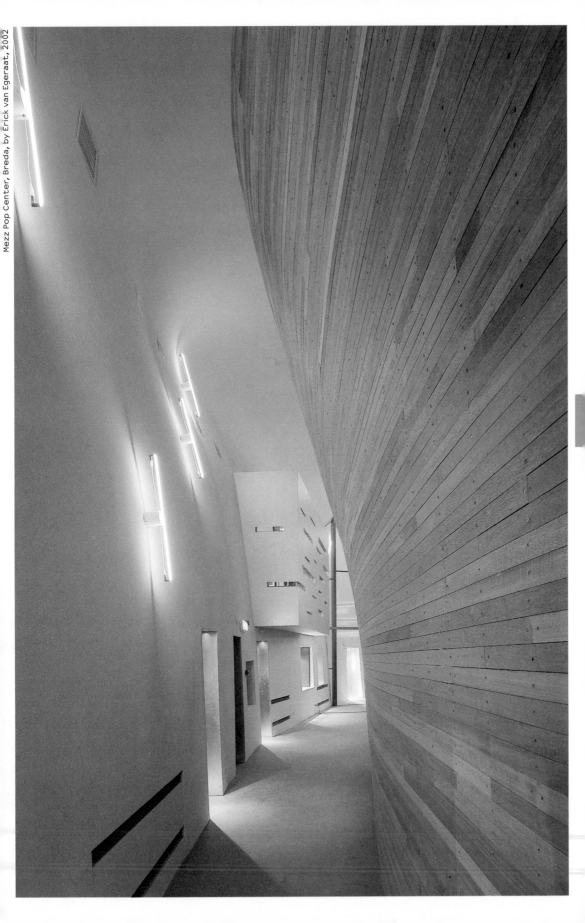

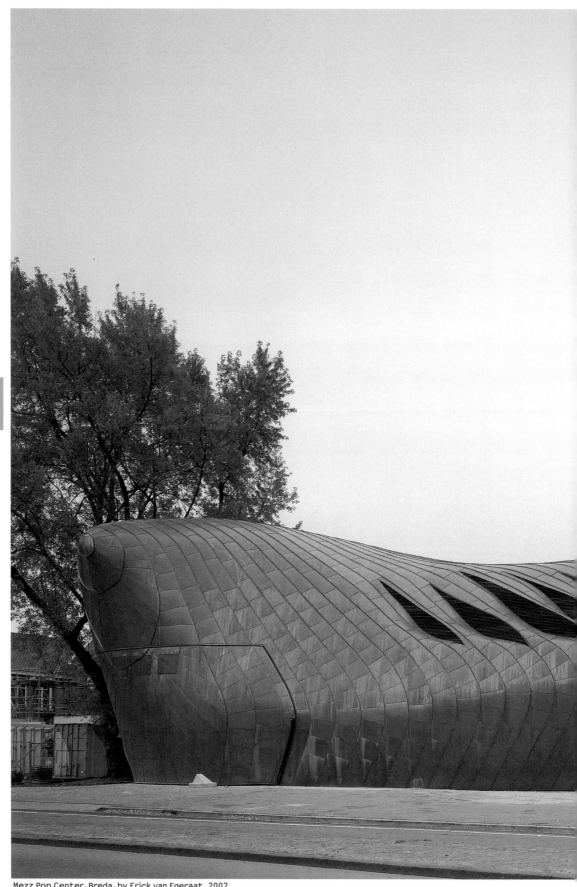

Mezz Pop Center, Breda, by Erick van Egeraat, 2002

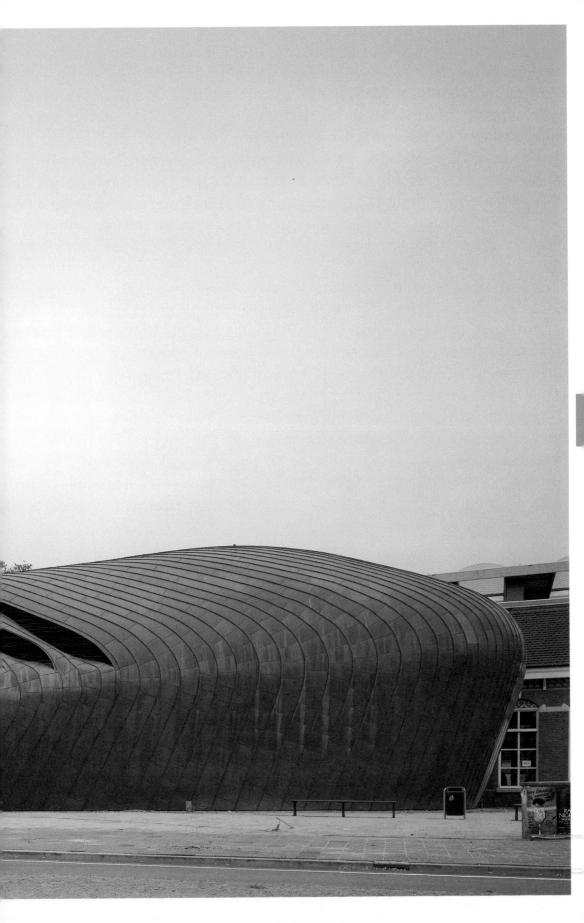

Industrial designers and artists try to get in on the act as well. Joep van Lieshout has made trailers that look as if they are 1970s lower-middle-class pleasure domes and is currently displaying gyms that exaggerate the sexual tensions inherent in such places of self-improvement. In a recent exhibition at the Hague Municipal Museum, designers such as Hella Jongerius were asked to play with the tradition of Delft Blue, a manner of painting ceramics that is not just a tourist favorite but also part of the myth of Dutch culture. Jongerius married the old forms to materials such as plastic and continued the elaborate meandering of Delft Blue decoration into patterns sewn onto napkins. Others broke the pottery or used the old techniques to depict modern scenes. The Dutch craft tradition seems capable of absorbing it all.

To become part of popular culture, some designers argue, the object itself might have to disappear. If Bennekom makes magazines that look like photocopies, then Felix Janssens prefers to design "relational structures" for communities. They are open-ended systems of communication, developed mainly in digital media, that invite participation in cultural projects such as the program for public art in Leidsche Rijn. Droog Design collaborated with the advertising firm KesselsKramer in 2000 in Milan on Do Create. Instead of presenting finished products, they proposed that users make their own design with the help of designers working as consultants or facilitators. My favorite was an exercise where people could employ sledgehammers to instantly adapt their environment to reflect their moods and their needs.

Architecture has the hardest time removing itself from its own elitism, though when it builds social housing it has by its very nature adapted to the needs of a wide audience. Rem Koolhaas and OMA, by espousing a kind of "dirty realism," paved the way toward an architecture that does not remove itself from its audience. The incorporation of traditional building elements and pieces of "found nature" makes designs such as the Kunsthal not merely startling but open to interpretation, challenging and sucking the viewer into its world. In another project, the renovation of a rock club in The Hague, OMA recently embraced the scruffiness such places take on by exposing and highlighting industrial materials. New buildings could and should look like extensions of the urban scene in which they appear, Koolhaas pointed out, which means that they should have all the anonymity, off-the-cuffness, and even alienating appearance of the glass-and-steel office buildings, concrete warehouses, and brick row houses 3 that make up the Dutch city. Architecture is a way of tracing and hyping this world, rather than a way of commenting on it or detaching from it.

do
hit

Posters for Do Hit, by Marijn van der Pol, and Do Add, by Jurgen Bey, part of the Do Create furniture collection , developed by KesselsKramer in collaboration with Droog Design, 2000

do
add #1

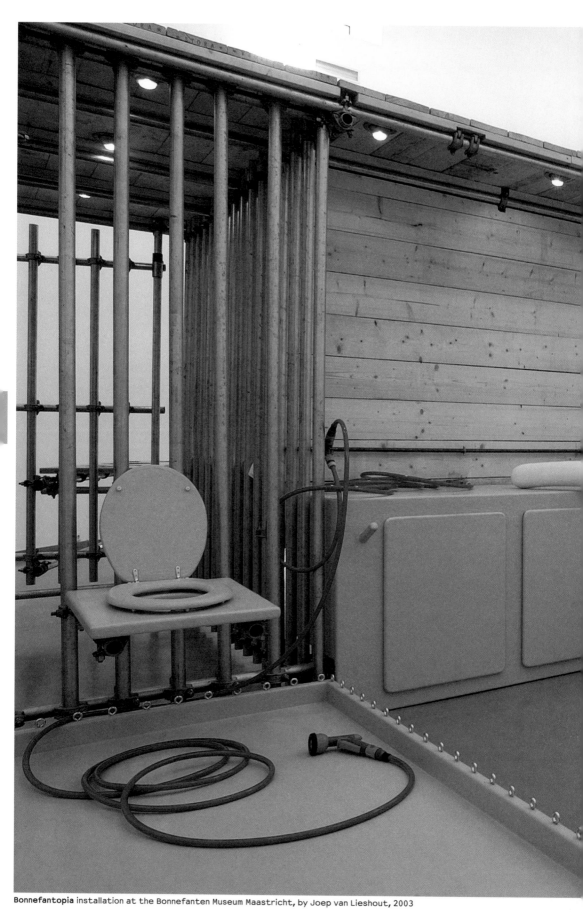

Bonnefantopia installation at the Bonnefanten Museum Maastricht, by Joep van Lieshout, 2003

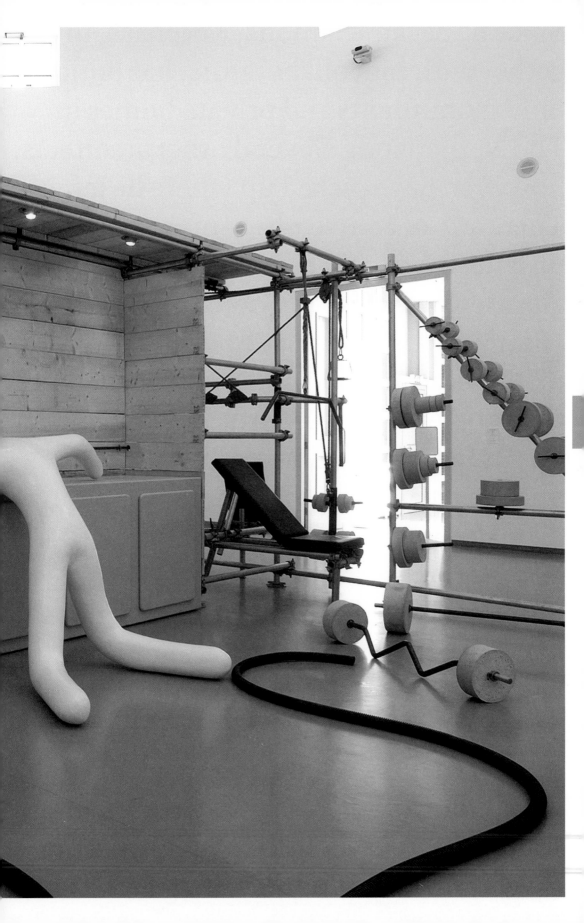

Since he became famous, Koolhaas, together with his collaborators, has built only monuments and private homes in The Netherlands. Several other architects, however, have picked up where he left off. There are, of course, the same sort of populist designers in The Netherlands as there are elsewhere. Sjoerd Soeters, for example, continues to build postmodern shopping malls because, as he puts it, "that is what the people want." UN Studio Van Berkel & Bos, however, has shown in Emmen that one can create shopping centers in which display, watching and being watched, and all the other rituals of shopping become the script for a building with varying degrees of transparency and translucency. And the work of Kees Christiaanse often disappears completely into the cityscape. On a large scale, his blocks of housing are abstracted versions of standard types. On a smaller scale, he is not averse to making pop-art kiosks for street vendors selling French fries

Breevaarthoek residential building, Gouda, by Kees Christiaanse, 2002

My favorite piece of high-low culture in The Netherlands is the campus bar NL Architects designed for the University of Utrecht. It sits next to Koolhaas's Educatorium and opposite the Minnaert Building and takes its cues from both of them, combining shifting levels and a kind of enigmatic, "dumb" appearance within a simple box shape. By sinking the bar slightly into the ground, and designing a skateboard-friendly, brightly colored ramp down into it, NL establishes a new relationship to that tyrannical flat ground plane, and also makes the bar look like the sort of sunken living room so popular in the 1970s, thus evoking the landscape in which the designers grew up. They crowned the building with a fenced basketball court emblazoned with the building's name. This is both an homage to popular culture and an amenity for the students. It also increases the small bar's scale to the point that it can hold its own among the institutional behemoths around it.

The sense that high and low culture can mix is also closely connected to the awareness of the artificiality of the environment. Another NL project, a comment on tourism, had as its most famous image a photograph of one of Amsterdam's canals on a beautiful sunny day, in which the water had turned chlorine blue and a swimmer was making his way past the seventeenth-century gables. The acceptance that the proper appearance of things is only a point of packaging and that everything can be cleaned up and be made useful is part of what makes the Dutch environment work. The fact that there is a pristine beach as the result of building the new Rotterdam harbor and that people can go hang gliding or can run around naked there is not something that causes a great deal of discussion.

When I was growing up, many Dutch engaged in "berm tourism." This involved driving to or along one of the then fairly new freeways, parking on the shoulder, pulling out the picnic basket, and watching the cars zoom by. This space next to technology (cars) and infrastructure (roads) was a proper site for visual consumption. Though the novelty has worn off and many Dutch can now afford to fly to Spain to watch cars crawl along the Mediterranean coast, the sense that popular culture is for viewing has not disappeared.

BasketBar, De Uithof, Utrecht, by NL Architects, 2003

For me, the place where all this comes together is a discount dry goods emporium, HEMA, which sells everything from cheap clothes to sausages. What distinguishes HEMA from other such businesses is that good design has a central role. The stores were recently renovated according to designs by Merkx + Girod in a clear, simple, and strong composition of reds, blues, and whites. Not everything HEMA sells is fantastically designed, but products are all obvious in form and clear in their lines. The idea seems to be that items should be as simple as possible so that there is no waste and so they can be used by as many different people in as many different situations as possible, again without wasting any material or effort. This also means they are very cheap and easy to accept. I am not sure whether this is high design, but it isn't just a reflection of popular culture either. Somebody (the Dutch love "experts") thought about the design. It is simply useful and beautiful stuff. My favorite is the kettle, which was designed by Nicolaï Carels while he was still a student. It is an abstraction of the classic type, its beachwood handle giving a tactile alternative to the usual plastic and its aluminum body shining in geometric perfection. This is good design that is part of everyday life.

Indeed, this is what makes so much of Dutch design so good. It is part of the everyday landscape without drawing attention to somebody at work. There is no philosophical difference between the way the road is laid out, the signage that tells you where to go, the buildings around the road, and the furniture inside the houses. It is an exaggeration to say all of those things are well designed, but there is a general sense of coherence that comes from the fact that, compressed into tight confines, these objects, images, and spaces make up an integrated world. What does not fit are all the advertisements, the McDonald's, and the tall office buildings invading The Netherlands as the country dissolves into the global economy. It is enough to make you nationalistic even if you aren't a citizen. Good designers, however, are hard at work co-opting even these signs. The architecture firm Claus en Kaan, which specializes in elegantly minimalist structures, has worked for the Golden Arches, and graphic designers such as 75B have used McDonald's graphics in their work.

If everything that can be seen can be known and made, then everything one makes is worth contemplating. The Netherlands is the ultimate middle-class country, and this may be a very bourgeois attitude. "Seeing is knowing is making" means that the fantastical has no privilege and that the rare and expensive object that only a few can afford is not necessarily more worthy of our attention than a well-designed, mass-produced vase or a nightclub flyer. As the designer Jurgen Bey puts it, "All those things you throw away turn out to have their own story, if you just look at them with enough attention and clearly enough." Our surroundings create the proper arena for work and enjoyment. The appearance of the world as one has made it is worth something, both in monetary and intellectual terms.

Terra-cotta tile typeface designed for the HEMA restaurants, by René Knip, 1998

The only thing about this that has changed in the last few decades is that the actual work itself has disappeared. This is true in a literal sense, as computers have replaced factories and screens present images so fleeting it is difficult to "know" them. It is also the case on a larger, socio-economic level. Fewer and fewer people work either on the land or in factories—as is true in most Western economies—and most goods and foods are imported from far away. What one sees instead is a kind of packaging, from the heavily subsidized agricultural areas that make up the country's Green Heart to the port areas whose wharves are now lined with warehouses for people rather than for goods.

This is not a particularly Dutch phenomenon, and therein lies a problem for this culture and its designers. As The Netherlands becomes integrated not just into the European Union and the global economy but also into a <u>worldwide culture</u> dominated by the United States, more and more of what made the Dutch model work is disappearing. As companies and state agencies become global, they commission fewer and fewer Dutch designers. As the European Union sets new guidelines for government commissions, more and more foreign architects receive commissions, such as the Spanish architects Cruz y Ortiz, who are renovating the Rijksmuseum. As kids listen to American music and buy clothes designed in Italy and made in China, there is little to distinguish them from their peers in England or Mexico.

What The Netherlands still has to offer is that "polder model": an awareness that one lives in an artificial environment made collectively through human ingenuity and that the only way to keep it dry and prosperous is to collaborate and cooperate. Central to this model is self-representation; the making of things that are concrete results of one's efforts. It is for that reason that the Dutch continue to invest in culture as well as in infrastructure. Yet today some voices are supporting the idea of redirecting those energies by reducing subsidies and support systems and by trying to compete on an international level by supporting information industries instead. I would argue that the Dutch will never be able to compete with larger countries in computer sciences or other abstract manipulations of data but that they are strong as a visual culture. The visual arts let the Dutch create a strong, coherent sense of who they are.

In fact, the Dutch have produced a model that other countries can follow. The knowledge that we live in an artificial environment we have collectively created and must collectively use is something that is true everywhere, even in the United States, where an acre a day of open desert is being swallowed by the suburbs of Phoenix. The ability to use directed subsidies and lengthy negotiation, rather than force or might, to achieve goals would seem like a good thing to adopt in other countries. The attempt to create a common culture not through heroic images or propaganda but by encouraging experimentation, the reuse of commonly accepted and used forms, and the assimilation of the melting pot of youth culture should serve as a model. We all need to look in the mirror and map out a better world that we can collectively inhabit.

We Are
The World.

In a concrete sense, the Dutch have provided some intriguing strategies for ordering the phenomenon of sprawl. Around the world, our cities are melting, turning into loosely connected assemblages of human dwellings spread out over vast stretches of land. They are organized around communications and transportation hubs (such as highway interchanges), and especially around certain "magnets" whose size and economic significance draws construction to them: shopping malls, stadiums, airports, and theme parks, to name a few. The central city, meanwhile, becomes just a command and control center, where the security systems, political decision-making apparatus, headquarters of the major corporations, and the makers of high-culture imagery are located.

The problem with sprawl is not just that it dissipates the perhaps romantic image we have of the city and nature. Sprawl also creates severe ecological problems, as well as a physical distance between those on the fringes and those in power, who generally sit at the center. Yet the Dutch have lived with sprawl for centuries. The *randstad* or ring of cities occupying most of the central part of the country is made up not just of its four main cities (Amsterdam, Rotterdam, The Hague, and Utrecht), but of countless small villages, towns, and intersections that have existed there for centuries. Covering about the same amount of space and containing almost the same amount of people as Los Angeles, the *randstad* is a historic prototype for sprawl.

The Dutch have managed to turn this loose agglomeration of open and built-up spaces, residential areas, industrial parks, agriculture, and recreational facilities, denseness and openness, and many different transport systems into a highly organized <u>hybrid landscape</u>. By not separating functions into monocultural areas (industrial zones versus residential areas, for instance), by fostering competition among the various hubs or cities, and by engaging in the continual discussions proper to the polder model, they have managed to create a coherent landscape. Each small zone within this hybrid landscape is whole and visible, from the small historic cores to the VINEX locations to the farms supported by subsidies, and yet each is also clearly and closely dependent on another. Ecological and economic considerations are weighed against each other in each development, and in some cases new "nature" is created to balance residential construction. Even the conflicting purviews of state and local government, which give politicians fodder for endless discussions about who should get more power, create a situation in which physical sprawl is mirrored and organized through fractured power relationships.

Now these hubs are becoming more congested, and the open spaces protected with ever more care. Cultural facilities and shopping malls are appearing not just in the towns but in the villages and VINEX locations as well. From where I live, opposite one of Europe's largest shopping malls, I can just as easily go to a well-appointed theater in the tiny town of Gouda, or to a good restaurant in a meadow to the south, or to my accountant to the north, as I can go to the traditional downtown of Rotterdam. It is possible to live anywhere in the randstad and feel as if you are part of a large semiurban, semirural human culture. "<u>Dig up imagination from under the surface</u>," the Parisian rebels of 1968 exhorted us. The Dutch, by spreading and sprawling, connecting and negotiating, have dug imagination up from the meadows and the streets alike, creating a working model by which sprawl might be livable.

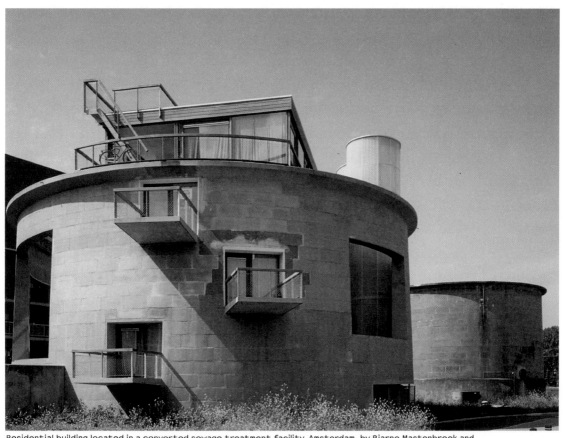

Residential building located in a converted sewage treatment facility, Amsterdam, by Bjarne Mastenbroek and
Dick van Gameren/De Architectengroep, 2000

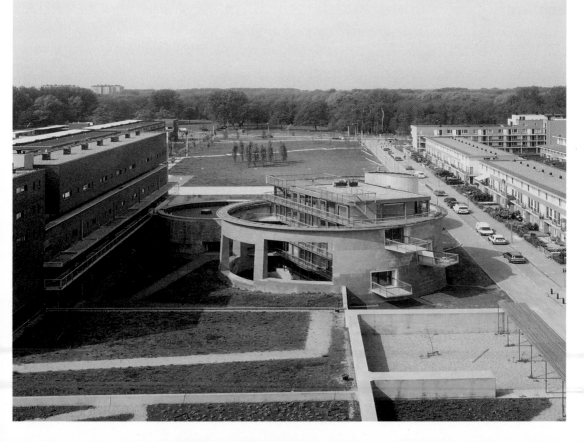

The beauty of The Netherlands is nearly invisible. Because it is so flat, it is difficult to get a perspective on its contours. Because it is so built up, one has no long vistas, and there is little sense of grandeur. There are, as Henry James said, no roads that lead elsewhere. Or so it seems. In reality, The Netherlands is just the end of the Rhine and a great distribution center. It also produces something: value. The ability to make money out of a reality that exists elsewhere is at the core of this trading country's success, and it fuels the polder model. It begets abstract art, complex modernist design, and a sense that the most important task of a society is the arrangement of that most invisible of physical attributes, space, to soak up all that value into more and larger homes. Piet Mondrian is a Dutch treasure because he summed up the whole place in what appears to be a flat and almost empty canvas but which is both spiritually and monetarily worth a fortune.

There is actually one place where you can see all of The Netherlands. It is called Madurodam, and it is a tiny theme park in the heart of The Hague. Here all the most significant buildings in The Netherlands are reproduced in miniature. It is the ultimate polder model, both representing the whole artifice and leaving nothing out by making it small and pushing it together. Visitors walk like giants through condensed and rearranged versions of Amsterdam, look down at the perfect but fictional little village, and survey the industrial areas that have long since moved elsewhere. Here the whole country has become an object of self-admiration and inspection. I can even wander through this tiny country, this glorification of compact organization, and see my own office. The Netherlands Architecture Institute lies—at least in Madurodam—at the intersection of a neighborhood of "modern architecture" monuments and Rotterdam, which prides itself as being the "architecture city of The Netherlands." I like seeing myself there, because that is where the achievements of Dutch design lie. This is the lesson I have learned gliding along the false flats of The Netherlands: out of the country's own logic and seeming sameness, the Dutch have made a world that delivers highly concentrated versions of itself which are visible, knowable, and inspiring.

Cover of the Begane Grond Center for Contemporary Art newsletter, featuring an image of Madurodam, by Kummer & Herrman, 2001

Decembergedachten (December Thoughts) stamps for the Dutch Post Office (TPG Post), by Experimental Jetset, 2002

WE ARE THE WORLD

GREG LYNN AND HANI RASHID ARCHITECTURAL LABORATORIES

NAi PUBLISHERS

THE IMPACT THAT DIGITAL TECHNOLOGIES HAVE ON ARCHITECTURAL FORM CAN NO LONGER BE DENIED. TWO ARCHITECTS WHO PUSH THE BOUNDARIES WITHIN THE DESIGN PRACTICE TO THEIR MAXIMUM ARE GREG LYNN AND HANI RASHID. ARCHITECTURAL LABORATORIES TAKES YOU INTO MORE THAN 30 PROJECTS IN SEARCH OF THE INTER-ACTION BETWEEN RESEARCH AND DESIGN AND PRESENTS AN UNDERSTANDING OF SPATIAL CONFIGURATIONS AND BUILDING

COMA — COMA is Cornelia Blatter and Marcel Hermans. With one foot in Amsterdam and the other in New York, the couple have established themselves on both sides of the Atlantic as graphic designers whose style, in Anthon Beeke's words, is "fiercely analytical and organized and at the same time adventurous and experimental." Receiving commissions mainly from the cultural sector, they demonstrate an unusual sensitivity toward their subject matter, rigorously structuring artists' work in their precise yet playful catalogs, monographs, and other publications. They are deep-seated humanists, creating personal projects that tenderly reveal the emotions, longing, and encounters unifying us all. "Describe Something Sweet" is such a project: "What defines ordinary?" COMA asks. "How do we capture the perfectly common? Tell a story about something fleeting (not theoretical, intellectual, or solid) but insignificant, glancing, innocent, simple? We asked people of varying ages, professions, and countries to 'describe something sweet.' The responses revealed silliness, openness, romance, lust, hunger, and loyalty—an infinite universe. We took each small story and told it on sugar cubes, in the handwriting of the people received."

Mikon van Gastel — "Don't get me wrong, I love what a Mevis & Van Deursen do, except I couldn't do that, I had to leave," Mikon van Gastel said in a 1998 interview. He left for Cranbrook Academy in Michigan, USA, then joined the motion-graphics powerhouse Imaginary Forces in Los Angeles. Soon he was elected partner and asked to set up and head its New York office, leading them into new terrain by creating the eOffice environment for IBM in Chicago and the permanent exhibit design for the BMW museum in Germany, and—taking this merging of design and architecture one step farther—playing an integral part in bringing a "critical charge" to the United Architects team presenting their finalist entry for the World Trade Center competition. Van Gastel is the perfect Dutchman, bringing his innate ability to work within limitations, seek collaboration, and create a fertile middle ground amid a corporate world often dominated by adversity.

Eng San Kho — Eng San Kho grew up in the shadow and legacy of his father, the legendary Dutch interior designer Kho Liang Ie, who died when Kho was still young. In his early twenties he left for New York and worked with publisher Joost Elffers among others on his book **Play with Food** while simultaneously teaching himself the rudiments of HTML, Macromedia Director, and Adobe After Effects. He eventually landed a job as motion designer at Pseudo, the first Web-TV enterprise. Kho explains, "I suddenly remembered VPRO and the minimal graphics of Max Kisman that created this crucial flow between the programs. Pseudo was my VPRO, and I was going to be Kisman." Since Pseudo's demise, Kho has gone on to a stellar career as motion-graphics creative director at the prestigious Los Angeles and New York-based company Hornet.

UN Studio Van Berkel & Bos — Established heavyweights on the Dutch architecture scene, Ben van Berkel and Caroline Bos have, since the founding of their first self-named firm in 1988, built an impressive oeuvre of iconic designs and contributed substantially to contemporary architectural discourse. In 1998, the partners re-created themselves as UN (United Network) Studio. More than just a continuation of their previous practice, the new firm sought to actively "employ intensive forms of collaboration for carrying out ambitious building projects that will serve as influential nodes." In this vein, they joined United Architects in 2002, an international coalition consisting of Foreign Office Architects, Kevin Kennon, Reiser + Umemoto, Imaginary Forces, and Greg Lynn's Form: "a worldwide multidisciplinary organization of architects and graphic designers dedicated to working together to create a better tomorrow...six innovative firms who share a desire to design new visions for buildings and cities that reflect the way we live today." With their shared interests and expertise in digital techniques, they wish for their unified banner to create something greater than the sum of its parts. One of six finalists for the World Trade Center competition in 2002, their proposal for intertwining and hugging towers took the concept of the vertical city to new heights.

Lars Spuybroek/NOX — In an attempt to marry modernity and technology, one school within the architectural field sees the computer and its software programs as a means to "discover a new form of beauty and elegance in the voluptuous, rhythmic, and undulating forms of the differential calculus" (Greg Lynn). Architect Lars Spuybroek and his Rotterdam-based studio NOX have, since the early '90s, been valued contributors to the blobular agenda, visualizing this world of computer-induced change in a range of videos, essays, books, Web sites, installations, and buildings. Armed with new perspectives on spatial concepts, Spuybroek designs architecture that incorporates the five senses and reacts and interacts with the user. With the help of questionnaires and a specially designed Web site, his D-tower in Doetinchem, for instance, continually translates the town's emotions into "Emotion Landscapes," changing color to reflect how the inhabitants feel.

Maurice Nio — NOX cofounder Maurice Nio started his own architecture firm, Nio Architects, in 2000 "to infect the soft with the hard. The liminal with the crystalline. The virtual with the real. The clever with the stupid." A filmmaker and writer but first and foremost an architect, he succeeded in his objectives in 2003 when he built "Fluid Vehicle," a 130-meter-long bus station made of five massive polystyrene foam parts glued together and protected by a sprayed-on polyester skin. Before starting manufacture, the architect stabbed and burned the materials and discovered they would be vandal proof, and the road was clear to make the world's largest synthetic structure, within the budget of a mere one million euro. Projected to withstand the elements for at least twenty years, the building caused quite a ruckus at the offices of the esteemed **Architectural Review** in London. Awarding the bus stop their "ar+d, the world's leading emerging architecture award," they begrudgingly wrote, "Well, it must be faced: the jury gave an award to a blob, not withstanding the AR's deep distaste for the blob movement... The jury was impressed by the spatial and technical élan and ingenuity of the building...What the place needed was a shelter and a landmark: it got both, and now the bus station clearly adds to the life of the city."

Self-commissioned project "Describe Something Sweet," by COMA, 1998
Spread from **Peter Halley—Maintain Speed,** by COMA, 2000

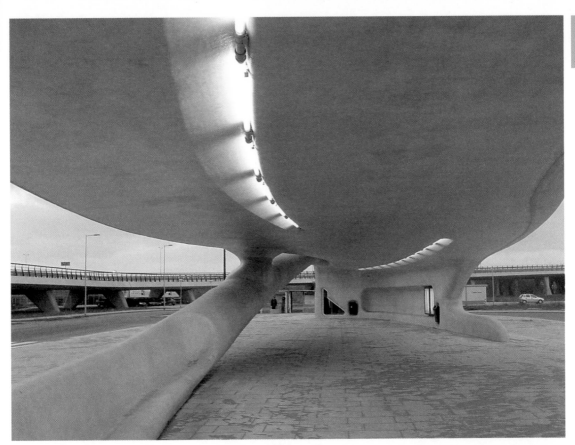

Bus station made of styrofoam, Hoogdorp, by Maurice Nio, 2003

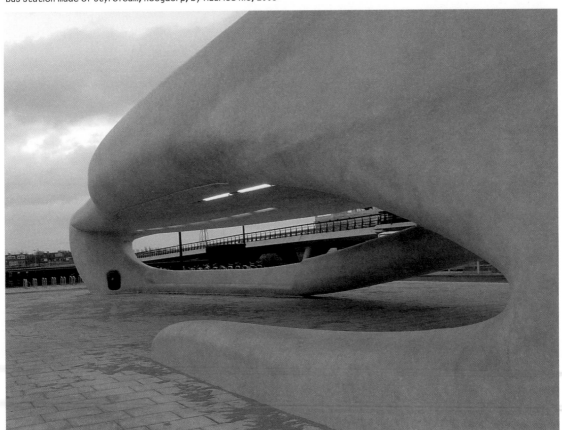

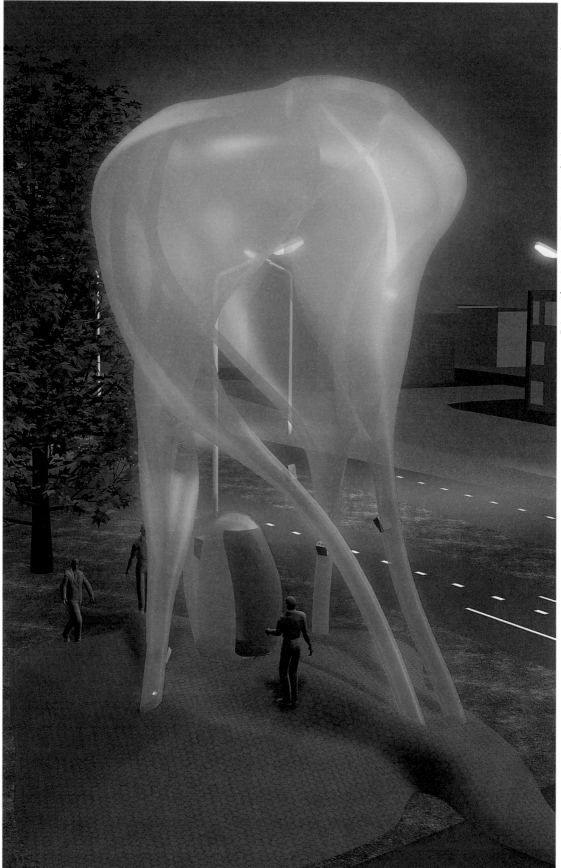

Interactive structure D-Tower, Doetinchem, by Lars Spuybroek/Nox, 2003

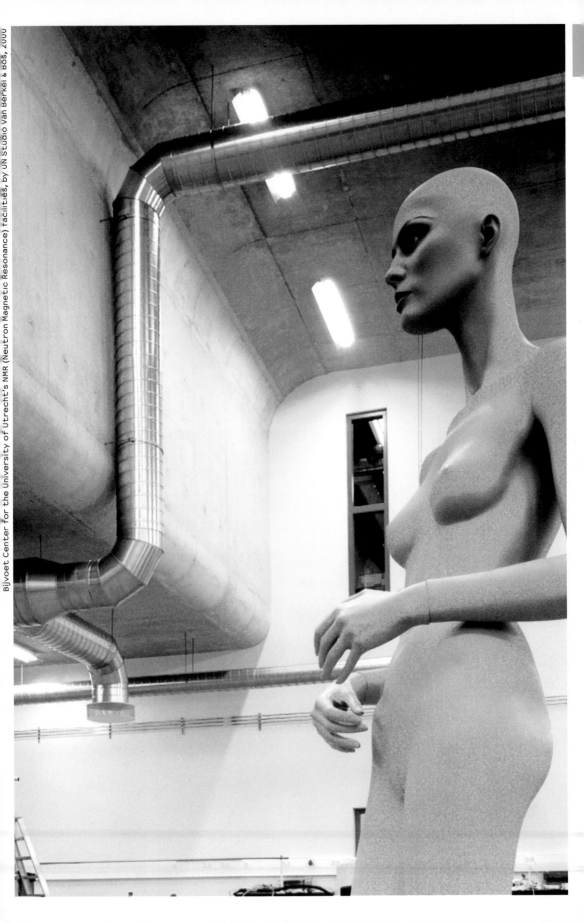

(States of Humanity)

Alex Vermeule

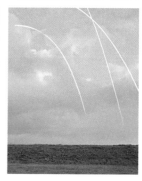

3

75B — The design trio 75B, consisting of Robert Beckand, Rens Muis, and Pieter Vos, have been together since they graduated from the Academy of Arts in Rotterdam in 1997. The studio—closed on Fridays—uses its time willfully, wisely, and with great efficiency to create a body of work that spans the whimsical to the solid. Influenced by skateboarding, graffiti, and video games, 75B soon cornered the market for "youth-culture assignments" in Rotterdam, splattering the city walls with multicolored Space Invaders posters for gallery MAMA, designing sticker modules that glued together to form "crazy goals" during the Euro 2000 soccer championship, and creating billboards for the club night Now & Wow, each one introducing the latest catchphrase to the hip vernacular. They delight in reappropriating the omnipresent logos of multinational corporations, making tiny formal adjustments or clustering them together to assemble a new coat of arms for their city, Rotterdam. A deeper sensitivity becomes apparent in the books they've designed for the Museum Boijmans van Beuningen, 010 Publishers, and, in particular, André Platteel's poetic masterpiece **Tales of Red and Orange**.

Maurice Scheltens — Designers' photographer of choice Maurice Scheltens combines the extravagant richness of fashion with the puritanical strictness of graphic design to create images that obliterate the boundaries between conceptual and applied, art and commercial, familiar and peculiar, reality and illusion: he unites them all, often in a single shot. For a recent series of immaculately composed photographs, he cut out images of lusciously pictured food from supermarket catalogs and culinary magazines and arranged and hung them together in a cardboard box, conjuring up the solemn tradition of seventeenth-century still-life painting. Expanding on this idea for the MS **Westerdam**, a new Holland America cruise ship, he created a mural in the restaurant using the same technique, evoking the old glory of the golden age, when the Dutch ruled the seas.

Goodwill — Graphic designer Goodwill (Will Holder) frequently collaborates with Maurice Scheltens. Together with Mo Veld of Fanclub, they conceived a celebrated advertorial for Adidas in **Blvd. Magazine**. One spread shows three rockets shooting up into the air in an arch of seventy-five degrees over a flat rural landscape. Twenty pages later, another spread shows the rockets in disarray on their fall back to Earth, depicting that what goes up must come down. This concept subtly and elegantly, if abstractly, demonstrated how Adidas—with its famous logo consisting of three stripes—could not only be a brand for winners but also embrace losers (a much larger audience). Devoid of any dogma, Goodwill's work illustrates a deep strain of all-inclusive idealism. The Dutch magazine **Metropolis M** quite succinctly described Goodwill as a "witty rebel" and chose him, in 2003, to become their art director, after Mevis & Van Deursen had been at the reins forever.

Piet ("Rockwell") Parra — A ten-year-old picture of Goodwill looking like a Duran Duran fashion model is taped to Piet Parra's studio door ("just to remind him that I know him from other times"), located in a building he shares with media artist Arno Coenen, graffiti legend Delta, video-game kings Blammo, photographer Maurice Scheltens, and the design group Machine. On his desk is his latest work, a highly glossy catalog for the Japanese clothing brand Complete Finesse. (Its cover features an illustration of a yellow horse in red high heels sniffing a flower and two sultry Asian teenage girls staring straight at you; inside the catalog, the girls slowly undress while Parra's creatures and typography interact with them from all sides.) On his wall are posters for Footlocker—a continuation of the sneaker-in-your-face series started by Michael Schaeffer and Niels Meulman while at FHV-BBDO. On his computer is a design for his T-shirt label Rockwell: the text reads, "So hot it hurts."

Barend and Jeroen Koolhaas — Dre Urhahn, protagonist of the Weblog Blammo, calls Barend and Jeroen Koolhaas "the hottest designers in The Netherlands right now…Bami and Jeruniverse, they have mad skills." The two are brothers (and second cousins to their famous uncle Rem); Barend recently finished his architectural training at the University of Delft, while Jeroen just completed his education at the Design Academy in Eindhoven. They live and work together, organizing club nights, inventing ways to project images, and shooting clips in Ghana, all the while scheming to put their mark on their respective professions. Barend, who interned at OMA, designed a school parasite building for the WiMBY! project that shines in its eloquent ingenuity, and Jeroen, who interned at 2 X 4 in New York, created posters for the hip-hop event Knock Out that are pure carnal delights.

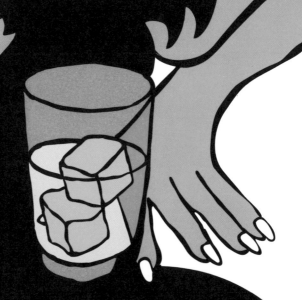

Chocolate

NOW THROWING JAMS IN ROTTERDAM AND TILBURG. CHECK WWW.BLAMMO.NL FOR DATES AND INFO

CHOCOLATE IS OVERSEEN BY DJ MR WIX / SP / CODE RED / REAL / EDZON / GEE / ROLLAROCKA / DJ / DRE / PARRA / Q / MADHEAS / MARUE / CRAIG / MELEDDIE / DREW / WORRYMAN / CHAOS / PRECISE / L BOPA / ARMAGEDDEON SOUNDS / FRIELJE / FAANTJE / NICA

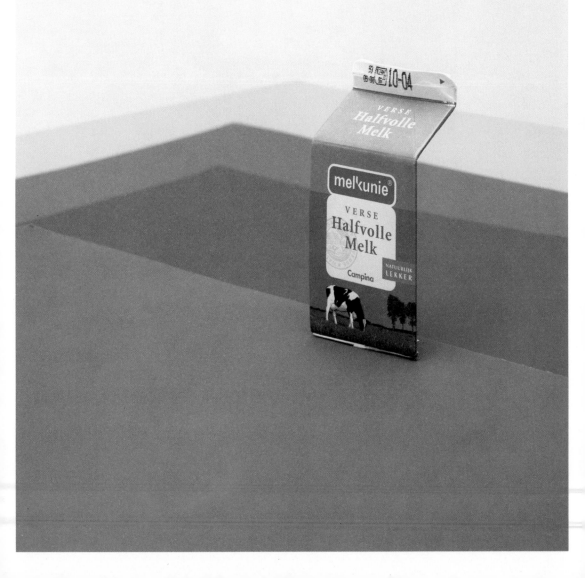

ME
WE Muhammad Ali

Self-Portrait, by Jeroen Koolhaas, 2003

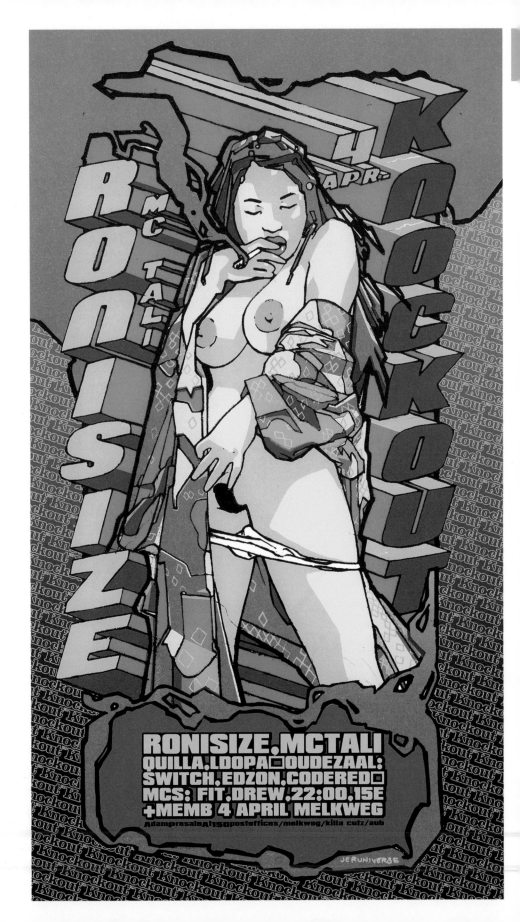

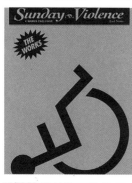

3

Maurer United Architects — Marc and Nicole Maurer of Maurer United Architects (MUA) have been known to call themselves "MC Architects." Sampling and mixing elements from graffiti, video games, fashion, and hip-hop and working with "kindred spirits" from all these fields, the two are indeed veritable architectural MCs. In one unorthodox collaboration that resulted in cutting-edge forms, they worked with graffiti artists Delta and Zedz to translate the art of graffiti into architecture, using the discipline's aesthetic and compositional principles to create real structures. MUA's monograph **Play** illustrates the fruits of such cross-disciplinary adventures, which incorporate contemporary social and cultural phenomena with a particular emphasis on architectural subculture. MUA write: "Besides sounding out the limits of architectural composition, we focus on the limits of the profession itself….In our work meaning takes priority over form…"

Boris "Delta" Tellegen — Since the '80s, Boris Tellegen, AKA Delta, has found worldwide acclaim for his spectacular graffiti pieces. Although the spray can has now largely been replaced by a computer, his complex style has evolved into applications in industrial and exhibition design, public art, fashion, toys, perfume packaging, album covers, and magazines. For the exhibition **Playtime**, Tellegen, in collaboration with Maurer United Architects, designed five arcade-game consoles where players would compete against the virtual backdrop of the exhibition space. In 1995, Tellegen designed three insectoids composed of letters forming the word "MESS," and he envisioned a time he could unleash these creatures into the virtual and real world and have them roam public spaces, attacking walls, and introducing his unique style of lettering. Years later, the city of Utrecht got adorned with sixty giant prints of 3-D sculptural parasites crawling along its buildings' facades.

PJ "Angel" Frith — On his Web site, StarArena.net, game developer and illustrator PJ "Angel" Frith unveils his master plan to take on the world with the characters he has been designing and developing for the past fifteen years. First in line are "God's Vicious Babies," three test tube–born brothers, named Angel, Ice, and Arson, whose adventures were printed in numerous comics. In their many, heavily armored guises the trio have also adorned fast-selling T-shirts, Paradiso's B-Boy Extravaganza posters, Vandal Comics greeting cards, and a monthly page in the video-game magazine **Power Unlimited**. Provided sufficient funding, Frith hopes to develop the Babies into an animated series, create action figures, and introduce the characters into every genre of video game. The second pillar of the master plan is the Star Arena board game accompanied by an array of collectible card decks featuring a cast of characters that includes everyone from Viking warriors to Oriental dragons to cyber amazons. Currently in beta-test mode by players worldwide, the game has the art, the fun, and the ambition to be the latest craze in the global game culture.

Niels "Shoe" Meulman — Signing as "Shoe," Niels Meulman received initial recognition within graffiti culture. But his career soon evolved into formal typography, graphic design, and global brand communication, recently culminating in a fashion line for the British sports brand UMBRO, including a signature shoe design. What began as a brand project resulted in the "Brilliance through Contrast" campaign, for which he developed a catalog and a line of reversible tops, stickers, and footwear that convey on the inside and outside word combinations like "Love" and "Hate," "Victory" and "Defeat," "Home" and "Away," "East" and "West," and "Praise the Lord" and "Allah Is Great." Executed in Meulman's masterful typography, the work captures the range of emotions sport travels and demonstrated how inclusive a successful worldwide brand can be. A graffiti legend at the age of eighteen (he is banned for life from Germany for "bombing" their trains), Meulman became apprentice to Dutch graphic-design master Anthon Beeke. Throughout the '90s Meulman ran his own design studio, Caulfield & Tensing, before joining FHV/BBDO as creative director. Currently Meulman is a partner in Unruly with Dennis Polak, a two-man outfit that specializes in brand concepts and art direction.

Do Normal/Dutch Design Dead — At the **Do Normal, Recent Dutch Design** exhibition at the San Francisco Museum of Modern Art in 1998, the haphazard collective named Holland International (HI) hijacked the limelight of the opening night by handing out their catalog **Dutch Design Dead** for free, while the official **Do Normal** catalog by Mexican designer Rebeca Méndez was still under lock and key. The ragtag collaboration between photographer Maurice Scheltens and the designers Goodwill, 75B, as well as the now-disbanded studios Dept and Caulfield & Tensing formed HI and published **Dutch Design Dead** to proclaim that there is no longer such a thing as Dutch design, that there are no boundaries to their inspiration and influences. The anthology—produced with no government support—contained a "best of" of each member's work, including the Microsoft swastika by Michael Schaeffer, first published in the 1995 debut installment of Caulfield & Tensing's weekly Web column "What's Up." It illustrates, with HI's critical twist, their underlying message: We are all global now; there is no going back.

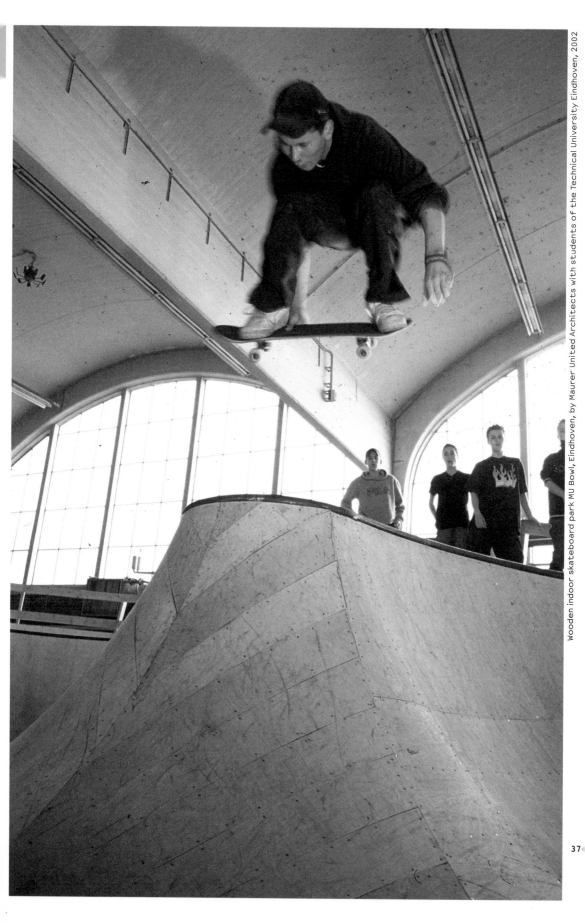

relax

夏だから海の特集です。今年も。

2001|08 54
リラックス

MONTHLY 定価680yen
AUGUST 2001

2001年8月1日発行(毎月1回1日発行)第6巻第8号
平成12年3月17日　第三種郵便物認可

特集
海へと
デルタ
テルミン

Shoe for sportswear company Umbro, by Niels "Shoe" Meulman/Unruly, 2003

3

BRILLIANCE THROUGH CONTRAST

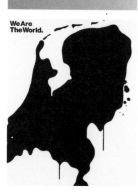
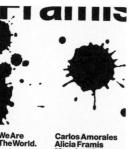

Machine — In 2001, after five successful years together, design collective Dept divided into two companies. Paul du Bois-Reymond and Mark Klaversteijn continued as Machine, a studio "that operates at the exact border of design, (media) arts and club culture." With this approach they continue to design album covers, develop typography, launch brand campaigns, create live-video animation performances, and direct video clips for clients ranging from the Dutch Post Office to Heineken to artist Rob Birza. Taking the idea of video beaming a step further, they developed—in collaboration with former Dept member Leonard van Munster—the "Beam-mobile," a van with a video projector in the back, in which they drove through Moscow at night using (with and without official permission) the city's walls, facades, and monuments as the surface for their moving "light graffiti." Machine also bombarded the city with stickers that in Russian conveyed cryptic messages like "Machine is lost," "Feed the machine," and "Question the machine" but also ones with a more confronting character: "Trust me" and "You deserve better." Distinctly more direct and political since 9/11 are the signature graphics they print on T-shirts, animate in videos, and spread through the Web, questioning the hypocrisy surrounding religion and war.

Leonard "Don Leo" van Munster — Operating under the moniker "Don Leo" since the split-up of the design studio Dept, Leonard van Munster produces installations, media works, graphic design, and Web projects. These disciplines all came together for the identity he designed for TV7, an imaginary television network for a drama series on the most innovative Dutch national public-broadcast channel, VPRO. He developed a complete visual style, including graphic design, a logo, typography, stage-set design, Web sites, and video leaders. His works for the Web are charmingly innovative (see duyves.com) and, at times, proudly irritating: take RSI, for instance, a game that when played properly to the end will result in a repetitive strain injury for the player. Another entertaining strain in the work of Van Munster is his adoration for every pixel of a woman's body, not only illustrated slyly on his own Internet peep show, but also elaborated on in many of his commercial pieces.

Thomas Buxó — Balder than Jop van Bennekom, headier than Daniel van der Velden and Maureen Mooren, stricter than Design Politie, deeper than Goodwill, and more extreme than Experimental Jetset, Thomas Buxó is a Frenchman who studied graphic design at the Rietveld Academy and has never left Amsterdam since, creating work that is more Dutch than Dutch. For Maurice Nio's book **You Have the Right to Remain Silent**, Buxó used Bible-thin paper, implicitly presenting the author's word as gospel. Working with the photographer Juul Hondius, he conceived **A Complex Newspaper**, placing Hondius's macabre, dramatized refugee photographs in a newspaper design, surrounded by computer-generated headlines. The absurd word combinations in the oversize publication created a surreal context in which Hondius's images could become fully relevant. Through the public-art infrastructure of De Veemvloer, Buxó also collaborates with editor Miklós Beyer to produce the art project La Cinca, which has taken on the form of a magazine, exhibition, and debate. De Geuzen, a foundation for multivisual research for which Buxó designed the publication **Testing the Surface of the Real**, has aptly commented that the Frenchman's design operates "in a speculative space…teetering at the brink of representation and pure abstraction…where the impostor reveals truths and has the power to make the hypothetical a reality."

Experimental Jetset — Experimental Jetset—consisting of Danny van den Dungen, Marieke Stolk, and Erwin Brinkers—is a self-conscious design collective with a high-concept-maximum-impact body of work. Revered design critic Rick Poynor struggles to define the group: "I admire the ingenuity of Experimental Jetset's thinking. They have the makings of incisive critics of visual culture. But the aridity of their visual contributions…threatens to negate the values they otherwise defend." Poynor admires Jetset's zest to create designs as autonomous objects but is confused by their "humorless" and "dogmatic" execution, forever tied to the use of the evenly blunt Helvetica font. Regular contributors to the magazine **Dot, dot dot**, Jetset have offered their own explanation for their radical viewpoints: they seek to find "Utopia **in** design, not **through** design," where the "ultimate form of rebellion is perfection, rationality, consistency and construction…The system **is** the revolution." A seminal piece in the impressive Jetset oeuvre is the Anti T-shirt, which was designed to "achieve a sense of hermetic self-reference, in an attempt to get away from the representative side of graphic design." The red T-shirt with the white 456-point Helvetica letters raises the question: "Anti what?" "Whatever you want it to be" is the only possible reply. This single T-shirt embodies Jetset's quest to design an objective piece of design matter that is perceived and interpreted in an autonomous, purely subjective manner.

We Are the World — **We Are the World** is the Experimental Jetset-designed catalog for the Dutch pavilion at the 2003 Venice Biennale, an art exhibition and publication meant to deliver an "artistic statement championing the qualities of a multicultural society." **We Are the World** is a confrontational juxtaposition of installations by five artists of different cultural origins, all living and working in The Netherlands. The central theme of the show was the issue of cultural equilibrium within today's social and political framework, in which multiculturalism, especially that of The Netherlands, was forcefully questioned. Their findings revealed that behind the facade of an ideally tolerant country striving for the integration of its rapidly growing non-Western community lay a deeply divided nation, frustrated and antagonized by the issues surrounding the "multicultural drama." Throughout the catalog, maps of the world and of The Netherlands are depicted in Rorschach-like forms dripping in the manner of Pollock paintings, accompanying a title that suggestively evokes the melody of the '80s feel-good anthem "We Are the World." When placed in the larger context of the inquiry as to "Why Dutch Design Is So Good," the title wins new meaning and resonance. Dutch design is not about nationality; it is an attitude and a wealth to be shared.

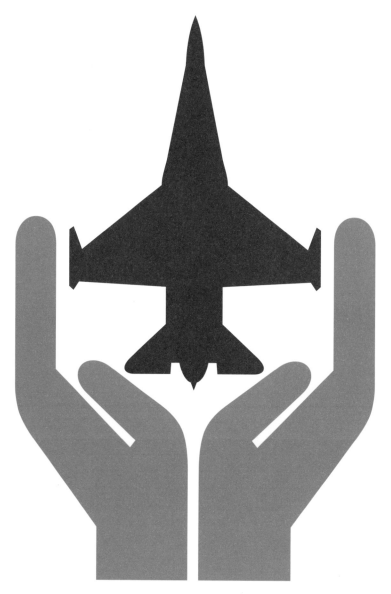

WAR★R

SHIP

Self-commissioned "Warship" illustration, by Machine, 2001

CD cover for Praful's **One Day Deep,** by Machine, 2001

Spreads from Maurice Nio's book You Have the Right to Remain Silent, by Thomas Buxó, 1998

1992 DE ORDE DER MUTANTEN

DE MUTA NTEN

Ondanks al onze pogingen om de wereld te zuiveren van haar biologische en technologische uitwassen, neigt ze er juist naar alle uitwassen en excessen vrij spel te laten. Gelukkig maar, want anders zouden die dubieuze, duistere legeringen van lichaam en techniek het licht nooit hebben gezien. Natuurlijk zullen er altijd enkelen zijn die vinden dat de kloof tussen mens en techniek beangstigend groot is geworden en dat de technologen en wetenschappers ons naar de rand van de afgrond voeren. Maar er gaan ook euforische stemmen op die zeggen dat de techniek op heilzame wijze met de mensheid is te integreren en uiteindelijk bijdraagt tot de heelheid, totaliteit en zuiverheid van het menselijk bewustzijn.

Zowel de pessimisten als de optimisten stellen echter steeds weer voorop dat de techniek 'in principe' een goed hulpmiddel is om de mens vooruit te helpen en, sterker nog, dat er in de technologische ontwikkelingen een *logica* en een *doel* schuilt. We hoeven slechts een blik terug in de tijd te werpen om te zien dat de techniek continu haar doel voorbijschiet. Tegenwoordig is ze zelfs ver voorbij het point of no return geraakt en ijlt ze voort in het delirium van de vooruitgang, van de logica, van

268-267 # GARRY WINOGRAND AUSTIN, TEXAS: 1974

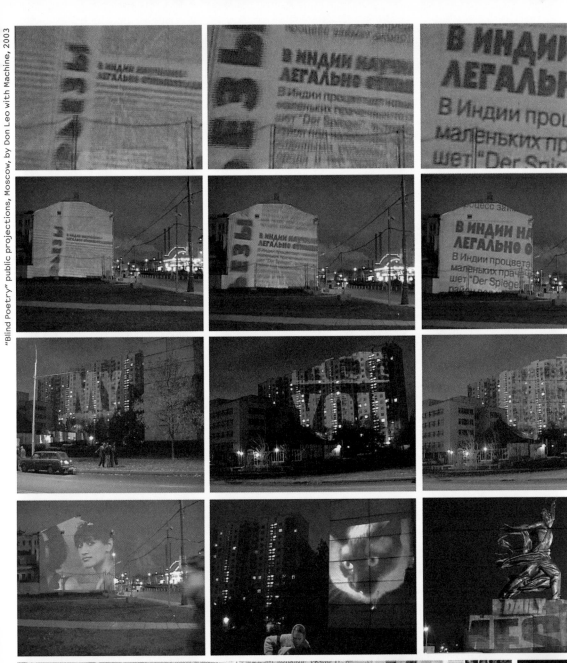

"Blind Poetry" public projections, Moscow, by Don Leo with Machine, 2003

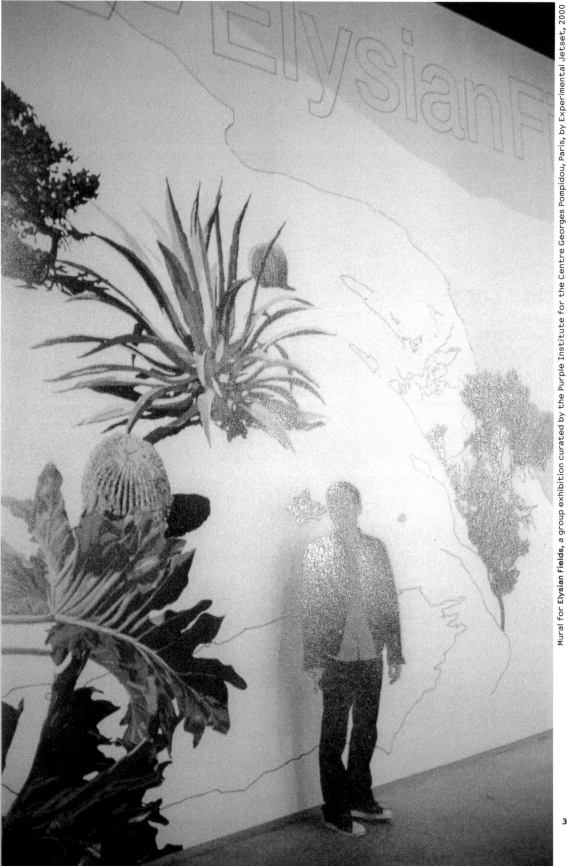

Mural for **Elysian Fields**, a group exhibition curated by the Purple Institute for the Centre Georges Pompidou, Paris, by Experimental Jetset, 2000

We Are The World.

Taken from:
Ron J. Steele
The Mark of the Beast:
The Black Messiah Phenomenon

Published in:
Apocalypse Culture 1
Edited by Adam Parfrey
Feral House 1987

Quote:
"...In Michael's Jackson's song *We Are The World*, for example, there are things which are very sinister. He said that God has shown us how to turn rocks into bread. Well, God never did that; Satan did. It was Satan's first temptation to Jesus, when Jesus was out in the desert for forty days, fasting.
Now let's take a look at Captain EO (a new attraction at Disneyland, a special 3-D musical made by Francis Ford Coppola and George Lucas, starring Michael Jackson).
The word 'captain' means 'someone in charge', and 'EO' means 'light'. So Michael Jackson plays the captain of light, and that is exactly what Lucifer was; Lucifer was known as the light bearer..."

Anti T-shirt, by Experimental Jetset, 2001

BIBLIOGRAPHY

General Cultural, Historical, and Art Historical Background Information

- Alpers, Svetlana. **The Art of Describing. Dutch Art in the Seventeenth Century** (Chicago: The University of Chicago Press, 1983).

- Alpers, Svetlana. **Rembrandt's Enterprise: The Studio and the Market** (Chicago: The University of Chicago Press, 1988).

- Fokkema, Douwe, Frans Grijzenhout. **Rekenschapt 1650–2000. Nederlandse cultuur in Europese context** (Den Haag: Sdu Uitgevers, 2001).

- Friedman, Mildred (ed.). **De Stijl: Visions of Utopia, 1917–1931** (New York: Abbeville Press, 1982).

- Jong, Jan de; Bart Ramakers, Herman Roodenburg, Frits Scholten, Mariet Westermann, eds. **Wooncultuur in de Nederlanden 1500–1800 Nederlands Kunsthistorisch Jaarboek 2000, Deel 51** (Zwolle: Uitgeverij Waanders, 2001).

- Kossmann, E.H. **The Low Countries 1780–1940** (Oxford: Oxford University Press, 1978).

- Lakerveld, Carry van (ed.). **Opkomst en bloei van het Noordnederlandse stadsgezicht in de 17de eeuw** (Amsterdam: Landshoff Uitgeverij, 1977).

- Schama, Simon. **The Embarrassment of Riches: An Interpretation of Dutch Culture in the Golden Age** (Berkeley, CA: The University of California Press, 1988).

- Swaan, Abram de. **Zorg en de staat; welzijn, onderwijs, gezondheidszorg in Europa en de Verenigde Staten in de Nieuwe Tijd** (Amsterdam: Uitgeverij Bert Bakker, 1989).

- Taverne, Ed. **In 't land van belofte: in de nieue stadt. Ideaal en werkelijkheid van de stadsuitleg in de Republiek 1580–1680** (Maarssen: Gary Schwartz, 1978).

- Tilroe, Anna. **Het Blinkende Stof: Op zoek naar een nieuw visioen** (Amsterdam: Querido Uitgeverij, 2002).

- Troy, Nancy J. **The De Stijl Environment** (Cambridge, MA: The MIT Press, 1983).

- Winner, David. **Brilliant Orange: The Neurotic Genius of Dutch Football** (London: Bloomsbury Publishing, 2001).

Rotterdam

- Beeren, Wim, Paul Donker Duyvis, Talitha Schoon, Charlotte Wiethoff. **Het Nieuwe Bouwen in Rotterdam 1920–1960** (Delft: Delft University Press, 1982).

- Crimson, Pedro Gadanho, Bart Lootsma, Roemer van Toorn. **Post. Rotterdam. Architecture and City after the Tabula Rasa** (Rotterdam: 010 Publishers, 2001).

- Laar, Paul van der. **Stad van formaat. Geschiedenis van Rotterdam in de negentiende en twintigste eeuw** (Zwolle: Waanders Uitgeverij, 2000).

- Palmboom, Frits. **Rotterdam, verstedelijkt landschap** (Rotterdam: Uitgeverij 010, 1987).

- Schoor, Arie van der. **Stad in Aanwas. Geschiedenis van Rotterdam tot 1813** (Zwolle: Uitgeverij Waanders, 1999).

Modern and Contemporary Dutch Architecture

There are monographs on almost every Dutch architect of the last century. Listed here are only general reference works and critical surveys of particular interest. In addition, the annual of Dutch architecture, published by NAI Publishers, is also a useful source.

- Barbieri, S. Umberto (ed.). **Architectuur en Planning: Nederland 1940-1980** (Rotterdam: Uitgeverij 010, 1983).

- Casciato, Maristella, Franco Panzini, Sergio Polano. **Architektuur en volkshuisvesting Nederland 1870-1940** (Nijmegen: Socialistiese Uitgeverij Nijmegen, 1980).

- Colenbrander, Bernard. **Reference: OMA. The Sublime Start of an Architectural Generation** (Rotterdam: NAI Publishers, 1995).

- Crimson. **Mart Stam's Trousers: Stories from behind the Scenes of Dutch Moral Modernism** (Rotterdam: 010 Publishers, 1999).

- Crimson. **Too Blessed to be Depressed: Crimson Architectural Historians 1994-2001** (Rotterdam: 010 Publishers, 2002).

- Cusveller, Sjoerd, Oene Dijk, Kirsten Schipper. **Remaking NL: Cityscape Landscape Infrastructure** (Amsterdam: S@M stedebouw & architectuurmanagement, 2000).

- Haan, Hilde de, Ids Haagsma. **Een onderwerp van voort- durende zorg. Het na-oorlogse bouwen in Nederland** (Utrecht: Kluwers algemene informatieve boeken, 1983).

- Heeling, Jan, Han Meyer, John Westrik. **Het ontwerp van de stadsplattegrond. De kern van de stedebouw in het perspectief van de eenentwintigste eeuw Deel 1** (Amsterdam: Uitgeverij SUN, 2002).

- Heuvel, Wim J. **Structuralisme in de Nederlandse Architectuur** (Rotterdam: Uitgeverij 010, 1992).

- Ibelings, Hans (ed.). **The Artificial Landscape: Contemporary Architecture, Urbanism, and Landscape Architecture in the Netherlands** (Rotterdam: NAI Publishers, 2000).

- Ibelings, Hans. **Nederlandse architectuur in de twintigste eeuw** (Rotterdam: NAi Uitgevers, 1995).

- Loghem, Ir. J.B, van. **Bouwen/Bauen/Batir/Building-Holland. Een dokumentatie van de hoogtepunten van de moderne architektuur in Nederland van 1900 tot 1932** (Nijmegen: Socialistiese Uitgeverij Nijmengen, 1980).

- Lootsma, Bart. **SuperDutch: New Architecture in the Netherlands** (London: Thames & Hudson, 2000).

- Rossum, Hans van, Frank van Wijk, Lodewijk Baljon. **De stad in uitersten; verkenningstocht naar Vinex-land** (Rotterdam: Nai Uitgevers, 2001).

- Vreeze, Noud de (ed.). **6,5 miljoen woningen. 100 jaar woningwet en wooncultuur in Nederland, 1901-2001** (Rotterdam: Uitgeverij 010, 2001).

- Wit, Wim de (ed.). **The Amsterdam School: Dutch Expressionist Architecture, 1915-1930** (Cambridge, MA: The MIT Press, 1983).

- Woud, Auke van der. **Waarheid en karakter: Het debat over de bouwkunst 1840-1900** (Rotterdam: NAi Uitgevers, 1997).

Landscape

- Baart, Theo, Tracy Metz, Tjerk Ruimschotel. **Atlas van de verandering. Nederland herschikt** (Rotterdam: NAi Uitgevers, 2000).

- Berkhout, J.G, D.G. Carasso, Th. M. Koornwinder-Wijntjes, R.H. van der Leeuw-Kistemaker, C.H. Slechte (eds.). **Het land van Holland. Ontwikkelingen in het Noord- en Zuidhollandse landschap** (Amsterdam: Amsterdams Historisch Museum, 1978).

- Dam, Frank van, Margit Jokovi, Anton van Hoorn, Saskia Heins. **Landelijk Wonen** (Rotterdam: NAi Uitgevers, 2003).

- Dammers, Ed, Hanna Lara Palsdottir, Frank Stroeken, Leon Crommentuijn, Ellen Driessen, Friedel Filius (eds.). **Scene. Een kwartet ruimtelijke scenario's voor Nederland** (Rotterdam: NAi Uitgevers, 2003).

- Metz, Tracy. **Nieuwe Natuur. Reportages over veranderend landschap** (Amsterdam: Uitgeverij Ambo, 1998).

- Meyer, Han (ed.). **Transformaties van het verstedelijkt landschap. Het werk van Palmboom & van den Bout** (Amsterdam: SUN Uitgeverij, 2003).

- Sijmons, Dirk. **Landscape** (Amsterdam: Architectura & Natura, 2002).

- Bekkers, Gaston. **Jac. P. Thijsse Park: Designed Dutch Landscape** (Amsterdam: Architectura & Natura, 2000).

- Wal, Coen van der. **In Praise of Common Sense: Planning the Ordinary. A Physical Planning History of the New Towns in the IJsselmeerpolders** (Rotterdam: 010 Publishers, 1997).

Design

There are monographs of or by most significant contemporary Dutch designers, though historical figures do not appear as frequently. The BNO (the Dutch Design Association) also publishes a useful annual survey.

- Staal, Gert (ed.). **Holland in vorm: Dutch design 1945–1987** (Amsterdam: Stichting Holland in Vorm, 1987)

- Broos, Kees, Paul Hefting. **Een eeuw grafische vormgeving in Nederland** (Amsterdam: Uitgeverij L.J. Veen, 1993).

- Eliens, Titus M., Marjan Groot, Frans Leidelmeijer (eds.). **Dutch Decorative Arts 1880–1940** (Kingston, NY: Battledore Ltd., 1997).

- Kras, Reyer, Petra Dupuits. **Industrie & vormgeving in Nederland 1860–1950** (Delft: Delft University Press, 1985).

- Prat, Ramon, Tomoko Sakamoto. **HD Holland Design New Graphics** (Barcelona: Actar, 2001).

- Purvis, Alston V. **Dutch Graphic Design 1918–1945** (New York: John Wiley & Sons, 1992).

- Ramakers, Renny, Gijs Bakker. **Less + More: Droog Design in Context** (Rotterdam: 010 Publishers, 2002).

- Ramakers, Renny, Gijs Bakker. **Simply Droog: 10+1 Year of Creating Innovation and Discussion** (Amsterdam: Droog Design, 2004).

- Rijk, Timo de (ed.). **Designers in Nederland. Een eeuw productvormgeving** (Amsterdam: Ludion Uitgeverij, 2004).

- Staal, Gert, Nikki Gonnissxen, Erik Kessels, Jacques Koeweiden, Daniel van der Velden, Willem Velthoven (eds.). **Apples & Oranges 01: Best Dutch Graphic Design** (Amsterdam: BIS Publishers, 2001).

- Vlassenrood, Linda. **Reality Machines: Mirroring the Real in Contemporary Dutch Architecture, Photography and Design** (Rotterdam: NAI Publishers, 2003).

Web Sites

- www.vrom.nl
 Ministry of Spatial Planning, Housing, and the Environment

- www.minocw.nl
 Ministry of Education, Culture and Science

- www.rpb.nl
 Spatial Planning Agency

- www.nai.nl
 Netherlands Architecture Institute

- www.premsela.org
 Dutch Design Institute

- www.bna.nl
 Dutch Architects Association

- www.bno.nl
 Dutch Designers Association

- www.archined.nl
 News site

- www.ikcro.nl
 News site

- www.vivid.nl
 News site

AUTHORS' ACKNOWLEDGEMENTS

The research for his book was supported by a generous grant from the Mondriaan Foundation. It was in part a result of an exhibition I organized at the San Francisco Museum of Modern Art in 1997, entitled **Do Normal: Recent Dutch Design**, which was supported by the same foundation. The Ministry of Education, Culture, and Science of the Dutch government supported many lectures I have given around the world, and these helped me to discipline and shape the book. Adam Eeuwens was a much-valued collaborator on the exhibition, as well as on this book. Karen Stein of Phaidon Press commissioned and enthusiastically supported the development of this book, and Patrick Busse edited it with great verve and accuracy. Irma Boom literally shaped this volume in her inimitable manner. Anthon Beeke, Jop van Bennekom, Ben van Berkel, Max Bruinsma, Bernard Colenbrander, Chris Dercon, Adriaan Geuze, Jos Holtkamp, Richard Hutten, Hans Ibelings, Hella Jongerius, Rem Koolhaas, Dingeman Kuilman, Bart Lootsma, Reyn van der Lugt, Winy Maas, Mieke Gerritzen, Tracy Metz, Patrick van Mil, Willem Oomens, Frits Palmboom, Renny and Leon Ramakers, Timo de Rijk, Gert Staal, Saskia van Stein, Marc Visser, Martien de Vletter, Linda Vlassenrood, Lucas Verweij, Mariet Willinge, and many others helped refine the ideas (sometimes unwittingly), while Hans Ibelings also suggested the title. My oldest friend, Mattijs Numans, helped provide the deep background for the flat landscape, as did Albert Gieskes, Bets Knottenbelt, Hermien van Ree, and Gary Schwartz. Claudia Backes went beyond the call of duty in assisting me with many of the logistics. I am grateful to my parents, Seymour Betsky and Sarah Betsky-Zweig, who brought me to The Netherlands and guided me through its country and culture; to my sister, Celia McGee, who helped me assess and evaluate that culture, and, as always, to my husband, Peter Christian Haberkorn, without whom I could not have done any of this.
Aaron Betsky

My gratitude goes out to Aaron Betsky, Irma Boom, and Patrick Busse. You are my heroes, the three of you, it is so nice to be in the company of your brilliance. To my friends in Amsterdam: Willem Henri Lucas for giving me your couch to sleep on, your studio to work in, and your mind to share; Mike Rosenberg for driving me around the countryside; Niels Meulman for burning the midnight oil; Bas and Liz le Clercq who thought the book was very good already because it meant I spent a lot of time in The Netherlands. To my brother Daniel for being the coolest, my brother Derk for being the strongest, my sister Nicola for being the sweetest, and my parents Chris and Elaine for being the most loving. To the designers who contributed to this book, every single one an inspiration. To Julius Vermeulen who sent his private stamp collection. To Jeroen Musch, Faati Mizbani, Becky Sundling, and Esther van Driesum for your encouraging words. To Ineke Schwartz, Wouter Vanstiphout, and Bruno Felix for sharing your insights; to Louis Stiller and Ben de Dood for being my mentors; to Robert Kloos and Lisa Darling for giving access. To my friends in my new home of Los Angeles: Agustin Garza for your faith and patience in me; to Jorge Verdin for your friendship; Benjamin Bratton for your geniality; Jose Caballer and Carlos Battilana for the use of your The Groop extranet; Esperanza and Nikolai Garcia for your presence; and the Mèndez family for your love. To my beautiful wife Rebeca Mèndez.
Adam Eeuwens

Phaidon Press Limited
Regent's Wharf
All Saints Street
London N1 9PA

Phaidon Press Inc.
180 Varick Street
New York, NY 10014

www.phaidon.com

First published 2004
Reprinted in paperback 2008 (twice)
© 2004 Phaidon Press Limited

ISBN 978 0 7148 4861 7

A CIP catalogue record of this book is
available from the British Library.

Designed by Irma Boom
Printed in Hong Kong

Aaron Betsky is director of the Cincinnati Art Museum. From
2001 to 2006 he was director of the Netherlands
Architecture Institute (NAI) in Rotterdam, and from 1995 to
2001 he was Curator of Architecture, Design, and Digital
Projects at the San Francisco Museum of Modern Art, where
he curated, among other exhibitions, "Do Normal: Recent
Dutch Design" in 1998.

Adam Eeuwens is a Dutch writer living in southern California.
He is a partner in the design firm Rebeca Méndez Design, and
co-curated "Do Normal" with Aaron Betsky.